FRANS HALS
PHAIDON EDITION

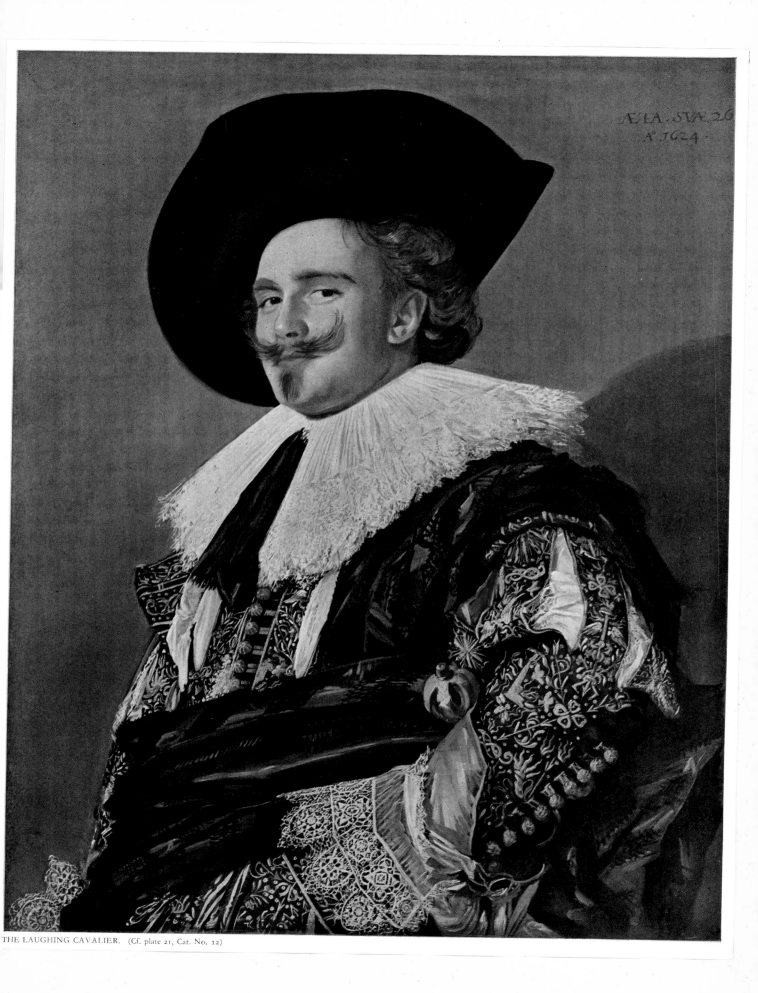

ÆTA · SVÆ 26
Aº 1624 ·

THE LAUGHING CAVALIER. (Cf. plate 21, Cat. No. 12)

THE PAINTINGS OF FRANS HALS

THE PHAIDON PRESS
COMPLETE EDITION
BY N · S · TRIVAS

OXFORD UNIVERSITY PRESS · NEW YORK

FIRST ISSUED LONDON 1941
PRINTED IN GREAT BRITAIN
BY HARRISON & SONS, LTD · 44–47, ST. MARTIN'S LANE · LONDON · W.C.2
PRINTERS TO H.M. THE KING

INTRODUCTION

MORE than three hundred books and articles on Frans Hals have been published during the last fifty-**seven** years and it might be doubted whether there is any grave reason for adding another publication to their number. " Are you going to refute the attributions of previous writers ? " was one of the questions frequently asked the author. " Have you discovered many new Frans Hals's ? " was the next standard inquiry.

Yet neither the publication of spectacular " finds " nor the refuting of previous attributions is the leading idea of this book. If there might be found on its pages a hitherto unpublished painting or if there are missing others generally believed to be by the master, these changes are, so to say, a by-product of the method followed by the author.

This method is based upon the new trend in viewing, appreciating, and collecting works of art. It has developed during the last decade and will very likely become the leading principle of the younger generation of art students and collectors. The new tendency emphasizes the importance which the condition of a painting, its state of preservation, has for the general appreciation of the work. Nobody would seriously term " Gothic " a building erected during the Baroque period on earlier Gothic foundations or completed in a " would-be-Gothic " style in the 19th century. But frequently enough we see the name of Frans Hals attached to a painting which might have been conceived or even begun by the artist but was completed by others, or painted over to such an extent that Frans Hals's original brushwork has disappeared among later additions.

The first thing in a painting that attracts the attention of the average spectator is the SUBJECT, the " story " represented. As long as the subject is all that interests the spectator, his æsthetic appreciation is not very much developed. Nevertheless during certain periods the painted story was the main criterion for both the public and the painter. The next phase of the evolution is attained when the spectator asks himself : " Who is the MAN who painted these stories ? " With this question comes the interest in the painter, in the painter's name and personality. During this second period of æsthetic evolution the public admires famous names more than the subjects painted, even more than the works of art themselves.

The following stage is reached when we ask ourselves : " How does this man paint ? " When we are so far, the viewing of a painting can give us almost the same emotional satisfaction as it gave the artist who created it, and this is about the highest enjoyment art can provide. But to study the technic of an artist, his pictorial handwriting, his way of solving problems and expressing himself through the means of pictorial material, we need, as a matter of course, a work which is unaltered, the surface of which shows the original technic of the master. This is the reason why the condition of a painting plays such an important part in its appreciation.

The present volume contains the authentic works by Frans Hals which are in a sufficiently good state of preservation to permit the study and appreciation of the artist's facture. Restorations have been noted in the catalogue, for so far as they could be detected with the bare eyes and a magnifying glass. Modern technical equipment, like ultra-violet rays, X-rays, etc., was available only in a few cases. Practically every old painting has suffered to a certain extent during the centuries of migration from one owner to the other. Where these damages were carefully repaired the paintings are listed in this catalogue. In certain cases restorers preferred, however, to repaint a picture instead of repairing it. The repainted parts are frequently much wider than the parts damaged. Works where the repaints prevail have, as a general rule, not been included in this volume. However, it is difficult to trace an exact line and say : " This restored picture can just

be included in the catalogue ; that other one is just too much repainted." This is a matter of critical feeling and to a certain extent everyone must judge for himself if he considers a restoration disfiguring the original or not. Every case was carefully examined and weighed. However, the author admits that there are pictures which could be included in the catalogue as well as left out, so far as their condition is concerned.

The following categories of paintings have not been included in this catalogue : genuine but badly damaged and restored works by Frans Hals ; works executed by Hals in collaboration with other artists, or completed by other artists, or executed in Hals's workshop by his pupils with occasional corrections and additions by the master ; works of which there exist a considerable number of replicas ; a few works, which probably are genuine, but which I had not the opportunity to re-examine. This refers in the first place to some paintings in English and Scotch collections which I have been unable to see because of the war.

As to the replicas, I must confess that the mere comparison of photographs does not enable me to state which of a dozen replicas is the very original. Photographs are made under different conditions of lighting, with different lenses and filters, on different kinds of plates ; some are retouched ; the positives are printed more or less carefully. Altogether this forms a poor basis for scientific judgment. The only safe way of finding the original would be to assemble all replicas of one composition and to examine them under appropriate conditions. Such an exhibition would be a meritorious task for an art convention.

The method of selection followed here resulted in reducing the number of paintings listed in this volume to approximately one-third of what is generally attributed to Hals. The author feels that a detailed analysis of every picture omitted and a statement of the reasons why it has been eliminated would have greatly added to the value of this book. However this would have tripled the volume and instead of a book on Frans Hals, would have produced a publication on " Frans Hals, His School, His Followers, and His Imitators, with a Catalogue of Posthumous ' Fisher-Boys.' " The documentation for such a publication is nearly complete. But the amount of material makes it prohibitive for the present series devoted to the authentic works of the great masters.

THE LIFE OF FRANS HALS

FRANS HALS was born in Antwerp about 1585 (according to some authors about 1580) and died in Haarlem, the 29th of August, 1666. In Haarlem he had spent practically all his life, a long life full of artistic success, financial difficulties, and bitter need. If we try to reconstruct this life, using the documents preserved in the Haarlem archives, we will find it an endless chain of lawsuits instituted against the painter by his creditors. The man who had created some of the world's most fascinating paintings, who had portrayed all the prominent citizens of Haarlem, was unable to pay for his bread, for butter, cheese, shoes, sometimes even for his canvases.

Of course one may say that in an artist's life the only important events are his works and that such trivial things as debts, claims, shoes, or butter do not matter. Seen from this idealistic point of view, Frans Hals's life was a steady evolution, a chain of masterworks, an unparalleled success. Unfortunately, in those hard times of some 300 years ago, in that tiny realistic country of Holland, just emerged out of a long war, there was no place for sentiment. Genius or not, one had to pay for rent and for food. A painting was merchandise like anything else, and an ox sold for ninety florins while a good portrait averaged sixty.

The contradiction between Hals's artistic successes and his financial debacle was but a seeming one. His troubles were not accidental. He was in every respect a virtuoso. His painting, his very technic was virtuous. He did not struggle with pictorial problems like Cézanne. He did not meticulously build up his pictures like Leonardo. He merely painted, and the solution of the problems came readily and naturally during the work. With a similar unaffectedness and ease he might have approached the problems of his daily life expecting that there, too, a ready solution would present itself. Unfortunately he was no financial virtuoso. Whether he remained until the end of his days the "Jolly Frans," as some romantic biographers have depicted him, or whether he became shy and unsociable as he now looks on some of his presumed self-portraits, is a matter of conjecture. But the virtuoso trait of his character will help us explain the psychologic situation with the ups and downs of this tragic life.

The painter's parents, the cloth-maker Franchois Hals and his wife Adriaentgen (Adriana) van Geertenryk, came from Mechlin and settled in Haarlem shortly after Frans's birth. At that time they had two sons, Frans and Joost; both became painters although so far no work by Joost Hals has been discovered. In 1591 a third son, Dirk, was born, who also became a painter. This talented family was not very prosperous. In 1599 the painter's father had to pawn his furniture for a debt of 37 florins. Between 1600 and 1603 Frans Hals studied painting with Karel van Mander. However, his master's style did not leave any perceptible trace in his own work. Around 1608 he married Annetje (Anna) Harmansdr. (Harman's daughter), who died in 1615 leaving him a house and two children. The number and the names of the children from this marriage varies with Hals's biographers. Four, three, and two have been mentioned. The only one whose name and birth date has been established, is Harmen Hals, born September 2nd, 1611.

No dated pictures of this early period have been found until now. However, we know by the engravings of Jan van de Velde that Hals painted the portrait of the Haarlem archdeacon Jacobus Zaffius in 1611 and that of Johannes Bogaert in 1614. A fragmentary copy of the first is in the Frans Hals Museum, Haarlem. The earliest dated work by the master that has been preserved is the large group portrait, the "Banquet of the Officers of the Haarlem Civic Guard of St. Joris

(St. George)," painted in 1616 (Cat. 4 ; Haarlem). Hals would probably not have obtained this important commission if he had not achieved some good portraits before. They were not dated or have not yet been traced. Whether the " Man Holding a Skull " (Cat. 2 ; Birmingham) or the " Nurse " (Cat. 1 ; Berlin) were executed before the group of 1616 is not sure, but rather probable.

After he had finished the " Banquet " Hals left for Antwerp where he might have seen work by Rubens and possibly met the master. In later years, Rubens as well as Van Dyck seem to have visited Hals in Haarlem. During his trip to Antwerp, three claims were filed in Haarlem against the painter. Two of them involved an amount of F.37 : 4 : 0, the remainder for one year's alimony for his children by the first marriage.

" The defendant does not appear ",—says the record of the proceedings found in the Haarlem archives. " His mother (the father died before 1612) recognizes the debt to an amount of 30 florins and says to be willing to pay this amount within two days."

The court granted permission to withdraw the amount at the " Nieuwe Doelen " and to charge the artist's account there. The Doelen was the clubhouse of the Civic Guards and the money was probably part of the payment due the artist for the " Banquet of the Officers "*.

On November 15th, 1616, Hals was back in Haarlem and appeared in court. The same Neeltgen Leenders was sueing for payment of the remaining F.7 : 4 : 0. The court ruled that he had to pay F.3 : 12 : 0 and Hals authorized the usher Heermans to receive 16 florins from Jan Napels, Captain of the Civic Guards of St. Joris. The usher brought the amount in court and Hals paid the F.3 : 12 : 0 to the plaintiff.

Two months later the painter took out a marriage licence and under the date of February 12th, 1617, the registrar noted :

" *Married upon the attest from Haarlem at Sparendam the 12th of February 1617.*	*frans hals widower from Antwerp, residing in the peuselaar steege, and Lysbeth Reyniers from Haarlem, residing in the Smeestraat.*"

Nine days later their first child, Sara, was born. The following year another child, Frans Fransz. (Fransz. = son of Frans) was christened in Haarlem.

We know nothing about Lysbeth Reyniers' family. She seems to have been a simple woman who could not even write her name ; instead she signed documents with a cross. Twice she was involved in brawling parties and called into court. She probably did not have an easy life with the painter. But she gave him at least ten children and stayed at his side during all the difficult years until his death. Surviving him and most of her children, she died in poverty in 1675.

In 1618 and 1619 Hals was a member of the Rhetoric Society " Liefde boven Al " (Love above all). During the following years he painted a number of Haarlem patricians and their wives. About 1623–1624 he was commissioned to paint his second group portrait, the " Banquet of the Officers of the Cluveniers Doelen " (Cat. 11; Haarlem) and in 1627 he painted the third " Banquet " (Cat. 31; Haarlem). During this period there originated a series of genre paintings ; portraits followed. But at the same time the artist is repeatedly sued for debts, so in 1629 for F.5 : 17 : 0 for bread, in 1630 about the same amount for shoes, etc. (see : Chronological Table). Although he had numerous pupils and apprentices, the master failed to earn enough money to keep his family alive. That pupils were a most desirable source of income, reveals a lawsuit instituted against Hals by his former pupil Judith Leyster, who sued him for receiving an apprentice who had deserted her workshop. For the rest, these financial difficulties did not affect his standing. So in 1633 he received another important commission : the group portrait for the Cluveniers Doelen (Cat. 44 ; Haarlem). His fame had spread far outside the limits of Haarlem and the Amsterdam Civic Guards of St. George commissioned him to do their group portrait. This was

*A. Bredius, Archiefsprokkels, Oud Holland, 1914. The documents mentioned in this biography are partly transcribed from the records of the Gemeente Archief, Haarlem, partly from the " Archiefsprokkels " published by A. Bredius in " Oud Holland."

a great honour, because Amsterdam had its own able and famous painters and last but not least Rembrandt. Hals went a few times to Amsterdam making sketches of the officers. He prepared the huge canvas and started painting. Then he stayed away. The Amsterdam officers waited, inquired, urged, and finally wrote to the Haarlem municipality asking that the painter be summoned to appear in Amsterdam and finish the work. Hals replied that his expenses for travelling and food were larger than the amount he received for his work. He complained that he had to wait for his models, wasting time. No accord was reached and the painter Pieter Codde was commissioned to finish the painting, which at present is at the Ryksmuseum, Amsterdam.

Grave domestic troubles might have added to Hals's uneasiness and his unwillingness to leave Haarlem at that time. He faced one of the tragic problems of life. His son Pieter was an imbecile, or, as the more pitiful expression of that time read, an " innocent." It had become impossible to keep the child in the small crowded house and there was no money to place it elsewhere. Early in February, 1637, the Haarlem municipality ruled that the boy be awarded an amount of money out of the city's funds and placed in the workhouse, outside Haarlem. The workhouse was at that time the city prison. But asylums, sanatoriums, or rest-houses were unknown and it was stipulated that the boy should be taken care of and given only such work as he might prove able to do. Three different institutions provided the funds which amounted to 100 florins a year.

" *The 9th of February 1637*

Pieter Franssen Hals, the innocent son's alimentation.	*Pieter Franssen Hals, the innocent son of Frans Hals is granted to receive every year from the Elisabeth Hospital 50 flor., from the Leprosorium 25 flor., and from the Schael (fund for the poor) 25 flor. These amounts to be used outside the city and to serve as well for all further alimentation, clothes, etc."*

And a few years later, the 13th of June, 1642 :

" *The Regents of the Workhouse are ordered to place Pieter Fransz. Hals, the innocent son of Frans Hals, in a special room of said workhouse without the community of other persons and to let him do work if he is able to do such, and further to provide him with food, clothes, etc. . . ."*

It seems that the boy was not only an imbecile but dangerous.

These tragic events did not interrupt the artist's work. Another series of Haarlem notables was portrayed during the following years and in 1641 he was commissioned to paint his sixth group portrait, the " Governors of the St. Elisabeth Hospital " (Cat. 81 ; Haarlem). But the debts stayed, the lawsuits continued, the misery did not go. From some of those dull and unmerciful documents we learn Hals's address. According to the inventory of the estate of Commertje Jacobsz., widow, the painter lived in 1640 in the Lange Bagynestraat. In May of that year he owed the estate 66 florins for rent, probably a year's rent. In later documents his address is given as at the corner of Nobelstraat and at Oude Gracht.

We have come to another dark page of the painter's family life. Here is the story as recorded by the documents in the Haarlem archives :

" *Memorial of the Mayors.* The 31st of March 1642
The wife of Frans Hals asked, also in the name of her husband, that their eldest daughter, Sara (born 1617), for reasons told by mouth, be brought into the Workhouse of this city, in the hope of improvement. Hereupon there is ordered by the Mayors that same Hals first see the Regents of the Workhouse. If they agree, the Mayors will give order that same (Sara) be brought into custody by the Captain of the nightwatch."

Those " reasons told by mouth " were later revealed in the following testimony :

" *The 7th of May 1642.*
Today appeared . . . Marijtje Willems, Widow of Assuerus Stevensz., 71 years of age, Marijtje Cornelisdr., wife of Mr. Pieter Holsteyn, 49 years of age, and Barbara Hendricksdr., 40 years of age, wife of Corstiaen Pietersz., maker of ebony frames, and have . . . upon request of Mr. (Master) Frans Hals, Mr. Painter, sincerely and truthfully declared that they witnesses were present in the house of mother Lysbeth, in the Achterstraat, Haarlem, and that they have seen that Sara, the daughter of said Mr. Frans Hals, was delivered of a girl. And that they have heard her say in her deepest distress, being questioned by said midwife, that Abraham Potterloo (Potter de Loo), son of Susanna Masse, was the father of her child and no else. . . . Upon further questioning by said midwife, if she had not been with some other men, she replied : Yes, I have been with more."

That year, 1642, Hals's name appeared on the list of the Guild members who had failed to pay their membership fees. The amount due was but F. 0 : 4 : 0, however, even this was probably too much for him. He remained nevertheless a member of the Guild and was named on its Board of Officers in 1644. In later years (1661) his membership fee was cancelled. Meanwhile, his children had become grown up. Harmen left Haarlem. In 1642 he is reported in Vianen. The next year Frans Fransz. was married. Reynier was in India ; he returned at the end of 1645. In 1648 another son, Johan, was married and in 1650 took place the wedding of the painter's grandson, Bartel, a son of Harmen.

Toward the 'fifties and past this date the commissions of portraits became scarcer. This did not cause things to run smoother :

" *The 17th of January 1647.*
Inventory of the estate of Otto Gerritsz., shoemaker : . . . *Frans Hals owes the estate* . . . *F. 59 : 8 : 0.*"

" *The 24th of November 1648.*
. . . . *Claim against Frans Hals* . . . *F. 5 : 2 : 0 for delivered canvas.*"

" *The 28th of January 1651.*
Heyndrick Heyndrickxsz. . . . *claims F. 4 : 0 : 0 for a cupboard.*"

And so on, and so on. In 1654 he is even compelled to pawn his belongings and his paintings with the baker Ykess whom he owes F.200—for delivered bread and borrowed money.

There are no dated portraits executed by Hals after 1650. However, this does not mean that he quit painting. He continued to work, and created during these distressed years such magnificent portraits as " Stephanus Geraerdts " (Cat. 99 ; Antwerp), " Isabella Coymans " (Cat. 100 ; Coll. Rothschild, Ferrières), or the fascinating " Man with a Large Hat " of the Cassel Museum (Cat. 107). From the artistic point of view these last years brought the highest achievements. But the very one thing that he could not attain during his maturity was denied him even at the end of his years : he could not earn enough to keep himself and his wife alive. At last, on his " most urgent request," the City of Haarlem granted him a subsidy.

" *Memorial of the Mayors.* *The 9th of September 1662.*
Frans Hals, Mr. Painter, citizen and son of a former citizen of this city, is granted, upon his written request and seen the reasons therein exposed, a subsidy being an amount of F.50—to be paid immediately, and further for the time of one year an amount of hundred and fifty florins . . . *beginning with the first of October of this year 1662.*"

The relief continued until 1666, but was hardly sufficient to keep the painter from starving. He was unable to buy fuel and, upon another request, the city provided him with three carloads of turf during the winter of 1663 and 1664. The painter rewarded it in a magnanimous way. This same year, 1664, he painted for the Haarlem Almshouse the two matchless group portraits of the Regents and Regentesses of the Almshouse (Cat. 108, 109 ; Haarlem) which range among the most human and fascinating works ever achieved with brush and oil colours.

For the last time the painter's name appears on the accounts of the City Treasurer in 1666 : he received 150 florins for the first nine months of the year. The City of Haarlem saved 50 on that year's budget, and a very last entry stated laconically :

" *The 1st of September 1666. Account of the Gravemakers. One opening in the Groote Kerk (Cathedral) for Mr. Frans Hals*
 . . 4.*"

THE WORKS OF FRANS HALS

1. TECHNIC

THE STYLE of an artist is always influenced by the general æsthetic trend of the epoch and of the country in which he works. His desire to express himself, to give us the picture of the world as he visualizes it, forces the painter to use some technical means. He must materialize an ideal world which exists quite ready and perfect in his mind. He must bring it down on a sheet of paper, a canvas, a panel, or any other material. This would not be possible without some technical process. The way from the painter's eye to the canvas is a long and hard one, full of obstacles and deceptions. In physics friction caused by obstacles creates heat. In art too.

The better an artist's technic, the easier and closer to his ideal will he be able to transmit his conception. Technic must be learned. To a certain extent it can be learned by everyone. But past this critical point, there is a wide field where the perfect manipulation and timing of the technic becomes a matter of artistic intuition. It will never, of course, become sheer improvisation. Gradually it develops into a personal style like handwriting. And like we can recognize a friend's handwriting without reading the content of a letter, we may recognize the work of an artist without looking at the signature.

On a previous occasion it has been said that Hals was a virtuoso. This does not mean that he was a dilettante or an infant prodigy who painted without having learned the basic technics. On the contrary, Hals had developed a very ingenious and very personal technic and handled it in a masterly manner. His virtuosity lay in the nearly somnambulistic assurance with which he applied his technic and solved pictorial problems. It would be vain to try here a full and exact description of this technic. I refer the reader to the plates reproducing characteristic details of the master's paintings. The reproductions in the actual size permit the study of the shape and proportions of the brushstroke. Comparison with works of other painters will be greatly enlightening. The following remarks are intended as a guidance in this study.

There are elements which we will find in any of Hals's works : the directness of approach, the simplicity of treatment, the clear and open facture, and the economy of means. The last factor is of great importance. With a minimum of means the master produces a maximum of effect. Hals paints for the spectator. His models create a direct contact with the public. Most of them are looking or moving toward the spectator. Sometimes their gestures seem to break through the frame. Body, head, and eyes are frequently turned to a different degree. On the portrait of I. Massa (Cat. 20), for instance, the model is seated to the right, his head *en face*, and looking toward the left. This was in no way a novel invention. The dynamic and emotional style of the Baroque was the style of the epoch. In Italy, at about the same time, Lorenzo Bernini applied the same principles to his spendid sculptured portraits ; of course, without any contact with Hals. The Baroque principles were currently used in Holland, where Cornelis van Haarlem charged his compositions with more movement and dynamics than they reasonably could bear. The difference with Hals's works is obvious : dynamic in their conception they are perfectly balanced and strictly logical in construction and composition.

The simplicity of the master's composition is astonishing. Most of his portraits are painted against a light, plain background. The light always falls from the left. The shadow projected by the body accentuates the space. The whole is like a " close-up ". The model is placed in the foreground of the picture and a slightly stressed perspective makes the objects of the first plane look larger while the volumes in the background are reduced. This corresponds, of course, with the artist's æsthetic intention : the attention of the spectator is quite logically concentrated on the main things in the foreground.

Realism was one of the strongest currents in 17th century art, especially in Holland ; and Hals was, of course, a realist. But here again he moulded the principle of the epoch in a very personal way. He did not attempt to transform Haarlem housewives into Graces or beer brewers into Olympic gods. But he put into his portraits a striking note of " heroic realism " rather unique in Dutch art. Even his genre paintings are never on the level of his followers like Adriaen Brouwer or A. van Ostade. His sense of harmony always preserved the right balance without falling into dull academism. It seems that like some musicians who have an absolute ear, Hals had an absolute pictorial taste.

The most personal, unique, and inimitable element of his style is his facture. According to contemporary witnesses the master worked rapidly. He did not make preparative drawings, but started sketching the contours of his composition with brush and colour, laying at once the tones, which served at the same time for the expression of volume and space, perspective, material, light, etc. This is a most important and characteristic point in Hals's technic. An interesting study of this technic, as seen by a modern painter and restorer, has been published by M. M. van Dantzig in his book " Frans Hals, Echt of Onecht " (Amsterdam, 1937). The following is partly condensed from the introduction to Van Dantzig's book.

When Hals's brush touches the canvas it creates drawing and painting, volume and colour simultaneously. Some other painters do this separately. They may later change the form or the colour. Hals cannot, because changing the colour he would alter the form and *vice versa.* He gives light and shadow merely as a difference in colour ; he paints fabrics by reproducing their colour and pattern, *i.e.,* the repartition of light and shadows. Every brushstroke in his painting expresses at the same time relief, light, movement, material. The form of the brushstroke indicates the form of the whole ; for instance, the light on the nose moulds the form of the tip of the nose. His colours are always forceful ; his black never becomes greyish, his skin-colour is bright. He never paints a thick black shadow near a light without an intermittent tone.

The brushstrokes themselves are constantly modulating. They start thick, become thin, and sometimes end thick again. Or they start thin to become thick, etc. This can easily be seen on the detail reproductions of this volume, especially on the fragments of mouth and lips. Very characteristic for Hals is the form he usually gives the noses and fingers of his models. He accentuates every joint of the finger, the transition of the finger into the hand, of the hand into the arm, and so on. His noses seem painted in a triple movement : the brush starting from the forehead changes twice its direction ; but the noses never look fractured. This accentuation of constructive details is not confined to noses and fingers. Glasses, knives, all kind of accessories, every object, indeed, is painted the same way.

During the decades of his career Hals perfected and varied his technic, but the main elements can be found in his early works as well as in the late ones. The early works have a stronger and more contrasting colouring. In his mature works the dominating gamma is blond and the late paintings show a predilection for a variety of delicate greys. This evolution corresponds with the general trend in taste and fashion of the epoch. Toward the middle of the century the bright colours had disappeared from the costumes of the burghers and their wives. Black and white became predominant.

In later years Hals frequently used a kind of " shorthand " interpretation for the accessories of his paintings. A key, a bow, or some other detail is indicated by a few brushstrokes without being finished. It seems that the painter's eye was quicker than his hand and that, marking the essential features of the object, he turned to some more important part, leaving the task of completing the sketchy contours to the spectator's eye. This method incites the spectator to a semi-creative activity and gives him a peculiar artistic satisfaction. The present generation which has learned to see the beauty of drawings and sketches, appreciates this style more than former generations did. On the other hand, the public's predilection for the sketchy manner and for the seeming nonchalance with which details are painted, provoked numerous modern imitations of this

late Frans Hals style. Most of these post-Hals products can be recognized easily by the lack of logic in their construction. What for Hals was merely a means and an accessory becomes, for the forgers, the main issue. Where Hals was brief, they are sloppy.

To recognize the master's work we should always keep in mind his method of painting : the rapid and sure movement of his brush, the spontaneity of creative conception and execution, his strict logic, and his pictorial taste. Stiff or hesitantly drawn contours, a dull and dead surface, every inconsequence or exaggeration should meet with scepticism as to the picture's authenticity, even if it bears the famous monogram. This monogram " FH " is supposed to stand for " Frans Hals ", but frequently enough it might better be read : " Forged Hals."

2. CHRONOLOGY

Hals's earliest dated painting, the " Banquet of the Officers " of 1616 (Cat. 4) was certainly not one of his first works. The reader will find that three portraits, the " Nurse " of the Berlin Museum (Cat. 1), the " Man Holding a Skull " of the Barber Institute, Birmingham (Cat. 2), and the " Woman " of the Duke of Devonshire's collection (Cat. 3) have been placed before this group. There is no documentary evidence for dating them and some authors believed the " Nurse " executed as late as 1630–1635. But stylistic elements in these portraits point to an earlier date. The reasons are given in the chronologically arranged catalogue (pag. 24). The elimination of a considerable number of doubtful attributions and school works made the remainder more homogeneous and facilitated the dating. However, there are still problematic cases and I am far from considering the proposed datings as beyond improvement.

The starting point for the dating of a non-inscribed portrait is the master's style and technic. Another important point is the costume of the model and sometimes dated companion pieces, chronicles, and documents of the period are a helpful factor. So, a printed diary allowed Dr. J. G. van Gelder to establish the date of 1633 for Hals's portrait representing the pioneer, captain, and adventurer Pieter van den Broecke (Cat. 42). Formerly this portrait was dated about 1637. Costumes seldom furnish us with a precise date. A ruff or gown which came up in 1630 was still worn in 1635, and by some elderly or conservative persons even in 1640. For instance, the famous broad-brimmed hat or sombrero was generally worn through twenty years, from 1620 till 1640, and with some modifications we find this same hat as early as on the group portrait of 1616 (Cat. 4) and as late as on the group portrait of 1664 (Cat. 108). The master's style and technic evolve slowly and gradually and do not permit a dating to the year. As to the companion pieces, there is no reason to believe that they were always painted the same year.

For the series of genre pictures, showing a strong influence of the Utrecht school, a date " around 1627 " is suggested here. Formerly some of these pictures have been dated as late as 1640 and even 1650. One of them, the so-called " Mulatto " (Cat. 34) has, however, been engraved by J. de Gheyn II, who died in 1629. Besides this fact, an earlier dating of this series fits much better into the general development of genre painting in Holland. As the dated " Banquet " of 1616 was not Hals's first painting, so the two group portraits of 1664, the " Regents " and " Regentesses " of the Haarlem Almshouses " (Cat. 108, 109) were probably not his last ones. The " Man with the Large Hat " in Cassel (Cat. 107) might have been executed after the two groups. But as there are no inscribed dates on the master's portraits after 1650, this remains a matter of conjecture and is more interesting from the psychological point of view than important from the artistic angle.

3. PUPILS, FOLLOWERS, IMITATORS

Adriaen Brouwer (1605 ?–1638), Jan Miense Molenaer (1610–1668) and his wife Judith Leyster (c. 1610–1660), Adriaen van Ostade (1610–1684), Philips Wouwerman (1619–1668), and Vincent van der Vinne (1629–1772) are believed to have been pupils of Frans Hals. BROUWER, who died young, was probably the most outstanding painter in this group. He developed his own style and his works can hardly be mistaken for those of his master's. JAN MOLENAER's early compositions, large-sized pictures of drinking and laughing people, reveal a rather distinct influence of Hals. This is, however, confined to the subject and his technic is quite different. His wife, JUDITH LEYSTER, whom he married in 1636, was a gifted painter and unusually adaptive to the master's influence. A great number of her works used to be attributed to Frans Hals and some still bear a plaque with this famous name. The conception of her life-size genre compositions is very much à la Hals indeed. But she lacks the assurance and the infallible technic of her master. Her later compositions with small figures are in a different and more personal style. In Haarlem her paintings were much admired and an old chronicler calls her " the Leading Star," an allusion to her name (Ley-ster = leading star).

OSTADE and WOUWERMAN can hardly be confounded with Hals, and paintings by V. VAN DER VINNE have not yet been found. DIRK HALS (1591–1656), Frans's younger brother, used a technic somewhat similar to the latter, but his work lacks in every respect the directness and spontaneity of Frans Hals. Nevertheless his influence on contemporary painters was considerable.

Not less than seven of Hals's sons were painters, according to A. Bredius. By five of them we know signed works. HARMEN HALS (1611–1669) seems to have been rather productive. C. Hofstede de Groot recorded 40 paintings by his hand and many others of his are probably still attributed to his father. In some works he shows a predilection for a red-brown colouring. His subjects are mostly genre scenes and a number of the so-called "Fisher-Boys " and " Girls " attributed to Frans Hals, are possibly " adjusted " works by Harmen.

JOHANNES or JAN HALS (1613 or 1616 or 1623–1674), nicknamed " The Golden Ass," visited Italy, where he was a member of the Dutch Painters' " Bent ". His paintings were much appreciated during his life and obtained high prices. A. Bredius mentions life-size portraits by him, very much in the style of his father. Besides this he painted genre scenes and probably had his part in the large-scale production of " Laughing Boys " turned out by the Hals workshop. FRANS HALS THE YOUNGER (1618–1669), to whom C. Hofstede de Groot hypothetically attributed the " Armourer " of the Leningrad Hermitage, was certainly the most talented of the younger Hals generation, at least if this attribution is correct.

REYNIER HALS (1627–1671) went as cabin-boy to India. He returned in 1645 and later settled in Amsterdam. Only a few of his paintings, small genre scenes, have been rediscovered.

NICOLAES or CLAES HALS (1628–1686) lived in Haarlem, where he became a member of the Painters' Guild in 1656 and a Commissary in 1682. He inherited his father's financial bad luck without inheriting his artistic genius. The Ashmolean Museum, Oxford, possesses a signed landscape by him.

From the artistic point of view, the Haarlem painter JAN DE BRAY (1627–1697) came closer to Frans Hals than his sons and most of his pupils. De Bray's conception of the portrait is very similar to Hals's, but his technic is, of course, different. JOHANNES VERSPRONCK (1597–1662) and PIETER DE GREBBER (1570–1649) may be mentioned among the artists whose works were sometimes wrongly attributed to Frans Hals. To this group belong also numerous Flemish painters whose portraits, if not given to Rubens, used to be attributed to Frans Hals.

Hals's works have been copied, imitated, and forged extensively. Even during his life there were copies after his works in Dutch collections. So the inventory of the estate of Franchoys Tartarolis (Leiden, December 7th, 1656) lists " two copies after Frans Hals ". Toward the end of his life

Frans Hals was no longer *en vogue* with the younger generation, which preferred the more elaborated portraits in the " French style ". Prices for his pictures went down and this continued during the 18th and the beginning of the 19th century, especially for the genre pictures. These, of course, did not respond to the powdered and perfumed official style of the Rococo nor to the academic style of the Empire. As a matter of fact, the " Malle Babbe " would have been a strange companion piece to " Madame de Récamier".

However, it is a romantic legend that Frans Hals had been forgotten. Even during the 18th century there have always been collectors interested in his works. Many of his works have been engraved during this period or copied in drawing and water-colour. Artists like J. Stolker, C. van Noorde, A. Delfos, W. Hendriks, J. G. Waldorp, H. Pothoven, J. Buys, J. Quinkhardt, and many others have worked on this. During the 19th century H. Numan, A. Claterbos, and others continued. The master's own works as well as the workshop production, portraits as well as genre pictures were engraved by J. Suyderhoef, J. van de Velde, A. Matham, F. Blackmore, J. Faber, P. de Mare, W. Vaillant, G. Edelinck, J. Ledeboer, W. Bailly, J. de Groot, L. B. Coclers, G. White, J. Dixon, etc. In those times engraving meant a considerable expense, which certainly would not have been incurred for a forgotten artist. But Hals had still his admirers among the amateurs.

It could be objected that the engravers and amateurs were interested merely in the subject and not in the artist's name. But this was not so. Not only is Hals's name mentioned on all these engravings, but even paintings by other artists (like Rembrandt's pupil, G. van den Eeckhout) were engraved with the enticing inscription " Painted by Frans Hals." We see that in the field of wrong attributions the modern art historians had their predecessors.

Copies after Frans Hals are listed in numerous sale catalogues of the 18th and 19th centuries. Before the Frans Hals boom started, these copies were usually catalogued as such, sometimes even with the mention of the copyist's name. For instance in the sale at Leiden, April 13th, 1772 : " L. de Moni *after* Frans Hals " ; or in the Sale C. Stroo, Alkmaar, July 29th, 1811 : " No. 20, J. P. van Harstock *after* Frans Hals, Head of a Child." As soon as the Frans Hals rush had begun, these too exact mentions disappeared from the catalogues and every " Head of a Child " became the very work of the master himself. This period was marked by two coinciding factors : W. von Bode's research work and the enthusiastic studies published by him and by other authors on Hals ; and the appearance in European sales rooms of a new and powerful group of buyers, the Americans. The main factor was, however, the congeniality of Hals's style with the taste of the late 19th century formed under the influence of G. Courbet and later E. Manet.

Soon the demand for Hals's paintings " at any price " became greater than the number of originals, school works, and old copies available. As a result forgeries began to inundate the market. Indirectly this was the fault of a certain type of collectors, who wanted not merely a work by Frans Hals, but one which would exactly fit above the chimney in their newly built drawing rooms. Where there was no such Frans Hals it was to be invented. And invented they were, because the new customers paid well and took the authenticity for granted as long as the picture had a plaque on the frame, a nice pedigree, and some handwritten certificate.

CHRONOLOGICAL TABLE

F.H. = Frans Hals ; *c.* = *circa* (about). Numbers between parentheses () refer to the Catalogue. With a few exceptions, approximate or uncertain dates are not mentioned.

YEAR.	BIOGRAPHICAL DATES.	DATED WORKS.
c. 1585	F.H. born in Antwerp.	
1591	Dirk Hals born in Haarlem.	
1599	Feb. 18, F.H.'s father pawns his furniture for a debt of 37 florins.	
1600–1603	F.H. is a pupil with K. van Mander in Haarlem.	
c. 1608	F.H. marries Annetje Harmansdr.	
1611	Sept. 2, Harmen Hals, eldest son by F.H.'s first marriage, is christened in Haarlem. F.H.'s father dies before 1612.	(*Lost*) Portrait Jacobus Zaffius.
1614		(*Lost*) Portrait Johan Bogaert.
1615	First wife, Annetje, dies in Haarlem. Aug. 5, F.H. appears as guardian of his two children ; sale of a house.	
1616	Aug., trip to Antwerp.	(4) Banquet of the Officers of St. Joris Doelen (Haarlem), Plate 6.
	Aug. 6, P. Ruyschaver, representing J. F. v. Backum, claims from F.H. payment of F.4:15:0 for paintings. F.H. not present, said to be in Antwerp. Sept. 6, Neeltje Leenders claims from F.H. payment of F.5:0:0. Sept. between 4 and 11, one of F.H.'s children dies ; name not mentioned. Nov. 8, Neeltje Leenders claims F.37:4:0 for alimentation of F.H.'s children. F.H. not present. Nov. 15, same case ; F.H. appears in court.	
1617	Jan. 15, F.H. takes out a marriage licence in Haarlem. Feb. 12, F.H. marries Lysbeth Reyniers in Sparendam, near Haarlem. Feb. 21, born Sara Hals, eldest daughter by second marriage.	
1618	May 16, christened in Haarlem Frans Fransz. Hals, son of F.H.	
1618 and 1619	The names of F.H. and Dirk Hals appear on the list of members of the Haarlem Rhetoric Society " Liefde boven Al."	
1620		(7) Portrait Beeresteyn (Louvre), Plate 12. (8) Portrait Cath. v. d. Eem (Louvre), Plate 13.
1622		(9) Portrait of a Man (Coll. Devonshire), Plate 14.
c. 1623		(11) Banquet of the Officers of the Cluveniers Doelen (Haarlem), Plate 16. (12) Portrait of an Officer (Wallace Coll.), Plate 21.
1624	Dec. 13, christened in Haarlem Jacob Hals, son of F.H. Dec. 20, Jan Jansz. claims from F.H. payment F.3:6:0 for a fur jacket.	
1625		(16) Portrait of a Man (Berlin), Plate 28. (17) Portrait of a Man (Bache), Plate 29. (18) Portrait Olycan (The Hague), Plate 30. (19) Portrait Aletta Hanemans (The Hague), Plate 31.

Year.	Biographical Dates.	Dated Works.
1626	May 26, Claes Huygensz's widow claims from F.H.'s wife F.20.– Defendant does not appear; sentenced to pay F.6.–; in July still unpaid. Oct. 16, F.H. and Dirk H. cancel seizure of K. van Mander's (the Younger) property, acting on behalf of their deceased brother, Joost Hals.	(20) Portrait Massa (Coll. Wood), Plate 32.
1627	Feb. 11, christened in Haarlem Reynier Hals, son of F.H.	(24) Portrait Le Febure (Berlin), Plate 37. (31) Banquet of the Officers of St. Joris Doelen (Haarlem), Plate 44.
	May 11, Cornelis Dircxz claims from F.H. payment F.7:0:0 for butter, etc. July, Corn. Dircxz receives F.4.–	
1628	July 25, christened in Haarlem Nicolaes Hals, son of F.H. Sept. 1, Abram de Nyse claims F.4.– for delivered merchandise. F.H. does not appear.	
1629	F.H. receives from the City Treasurer F.24.– for restoring of paintings. July 10, a baker claims F.5:17:0 for delivered bread. F.H. not present; sentenced. Aug. 21, B. van Eeckhout claims F.11:17:0 for wages. F.H. not present; sentenced.	
1630	March 29, F.H. and Dirk H., as witnesses, sign a document before notary public W. Crousen. Nov. 5, v. Otclaff Jansz.'s widow claims F.5:5:0 for shoes. F.H. not present; sentenced.	(37) Portrait of a Man (Buckingham Palace), Plate 54.
1631	Aug. 18, F.H. present as witness at the signing of Michael de Decker's (of Middelburg) testament. Aug. 26, a butcher claims F.42.– the remainder for an ox. Sept. 6, F.H. pays the butcher F. 29.– and promises the remainder in six weeks. Nov. 12, born Maria Hals, daughter of F.H.	(38) Portrait N. v. d. Meer, Mayor of Haarlem (Haarlem), Plate 56. (39) Portrait of Cornelia Voogd, his wife (Haarlem), Plate 57.
1632	Sept. 17, the same butcher claims F.3– for estimation of an ox.	
1633	Jan. 7, F.H. claims from Hillegard Reyniers (sister-in-law?) F.15.– being the remainder of a larger amount.	(41) Portrait of a Woman (Washington), Plate 59. (42) Portrait v. d. Broecke (Ken Wood), Plate 60. (43) Portrait of a Man (London), Plate 61. (44) Meeting of the Officers of the Cluveniers Doelen (Haarlem), Plate 62. (46) Portrait of a Man (Wildenstein), Plate 68. (47) Portrait of a Woman (Detroit), Plate 69. (50) Protrait of a Man (Berlin), Plate 72.
1634	March 10, Bouwen Fransz. claims F.23:17:2 for bread; will restitute pawned paintings after payment. March 14, same case.	
1635	March 1, died A. J. Coets; in the inventory of his estate: F.H. and Dirk H. debit F.90.– for an ox. Sept. 4, Judith Leyster sues F.H. for receiving an apprentice who deserted her workshop.	(58) Portrait Feyntje v. Steenkiste (Amsterdam), Plate 80. (59) Portrait of a Woman (Frick), Plate 81.
1636	May 9, Symon de Bray guarantees for F.H.'s rent (debt F.80.–). May 23, claim against F.H. for payment of F.0:35:0 for food.	

Year.	Biographical Dates.	Dated Works.
1636	July 26, the Amsterdam Civic Guard requests the City of Haarlem to compel F.H. to finish the Amsterdam group portrait. Aug. 28, Gerrit Govaertsz. claims payment of F.16:19:0 for bread.	
1637	Feb. 9, F.H.'s "innocent" son Pieter is placed in the workhouse. Feb. 25, same case.	
1638		(67) Portrait of a Man (Stockholm), Plate 90. (68) Portrait of a Woman (*ibid.*, Plate 91. (69) Portrait of a Man (Frankfort), Plate 92. (70) Portrait of a Woman (*ibid.*), Plate 93. (71) Portrait v. d. Horn (Katz), Plate 94. (73) Portrait Maria Voogd (Amsterdam), Plate 96.
1639	Aug. 4, sentence : " Peace ordered between the wife of F.H. and Wouter Barentsz. and all acts prohibited."	
1640	Jan. 13, claim for rent F.33.– Feb. 3, Inventory of the estate of Commertje Jacobs's widow : F.H. debit for rent per May F.66.– Aug. 25, Gerrit Philipsz. is sentenced to pay 6 flor. for the poor, for " using force against the wife of Mr. F.H."	(80) Portrait of a Woman (Cologne), Plate 107.
1641		(81) Regents of the St. Elisabeth Hospital (Haarlem), Plate 108.
1642	March 31, Sara Hals is placed in the workhouse. Same case May 7 and Nov. 5. Sept. 5, Heyndrick Heyndrickxsz. claims payment of F.5.– for a bed. Nov. 6, F.H. signs a request of a group of painters with regard to sales of paintings. F.H. fails to pay his membership fee for the Guild (F.0:4:0). Harmen Hals is mentioned in Vianen.	
1643	Nov. 29, Frans F. Hals, son of F.H., marries Hester v. Groeneveld.	(85) Portrait of a Man (New York), Plate 115. (86) Portrait of a Woman (Payson), Plate 116. (87) Portrait of a Man (Barnes), Plate 117.
1644	Jan. 18, F.H. is elected to the Board of Officers of the Guild. Feb. 27, Jan Mersjant claims payment of F.5:2:0 for canvas. May 10, Claes Ouwele claims payment of F.1:9:0 for consumption. The defendant's wife acknowledges the debt and asks " terribly " for respite. Must pay within a month.	
1644	Aug. 23, Jan Joosten claims payment of F.3:10:0 for consumption. F.H. does not appear ; acquitted.	
1645	Oct. 13, F.H. receives F.100.– on behalf of his son Reynier, returned from India.	(91) Portrait Hoornbeeck (Brussels), Plate 122.
1647	Aug., Inventory of the estate of the shoemaker Otto Gerritsz., F.H. debit F.59:8:0.	
1648	Jan. 12, Johannes Hals, son of F.H., marries Maria de Wit in Bloemendael, near Haarlem. Nov. 24, claim against F.H. for payment of F.5:2:0 for canvas.	93) Portrait of a Woman (Boston), Plate 124.

YEAR.	BIOGRAPHICAL DATES.	DATED WORKS.
1649	June 4, Johannes Hals, son of F.H., marries Saartje Gerritsdr. in Haarlem.	
1650	Nov. 26, F.H. is sued for unpaid consumption (F.31:10:4) ; pleads not guilty.	(95) Portrait of a Woman (van Bewcen), Plate 126.
	Bartel Harmensz. Hals, grandson of F.H., marries in Heemstede, near Haarlem.	
1651	Jan. 28, Heyndrick Heyndrickxsz. claims payment of F.4.– for a cup-board. F.H. does not appear ; sentenced.	
	Oct. 7, F.H. gives his wife power of attorney to receive from the East India Company money due to their son Anthony.	
1654	March 10, the baker Jan Ykess seizes property and paintings for a debt of F.200. for bread and borrowed money.	
1655	March 29, Nicolaes Hals, son of F.H., marries Jannecke Hendrix.	
1656	May, 17, Dirk Hals dies.	(102) Portrait Tyman Oosdorp (Berlin), Plate 133.
	Nov. 2, Nicolaes Hals, son of F.H. is received member of the Guild.	
1660	F.H. and Pieter Molyn estimate the value of paintings for Coenraet Coymans.	
1661	Dec. 13, F.H. is sued for payment of F.21:16:0 for paintings acquired ; sentenced.	
	Harmen Hals mentioned in Gorinchem.	
1662	Sept. 9, the Mayors of Haarlem grant F.H. a subsidy of F.50.– at once and F.150.– yearly.	
1663	Account of the City Treasurer : paid F.H. F.162:10:0.	
	Harmen Hals mentioned in Noordeloos near Vianen.	
	A grandson (son of Reynier) born.	
1664	Jan. 17, the City provides F.H. three carloads turf.	(108) Regents of the Haarlem Almshouse (Haarlem), Plate 142.
	Feb. 1, accounts of the City Treasurer : yearly subsidy for F.H., F.200.–.	(109) Regentesses of the Haarlem Almshouses (Haarlem), Plate 146.
	Aug . 31, another three carloads turf.	
1665	Jan. 22, F.H. signs a guarantee of F.458:11:0 for his son-in-law Hendrik Hulst.	
1666	City Treasurer's account : subsidy for F.H. (9 months) F.150.–.	
	Aug. 29, F.H. dies in Haarlem.	
	Sept. 1, Frans Hals buried in the Choir of the Haarlem Cathedral.	

Some dates after 1666 :

1669	Feb. 15, Harmen Hals, son of F.H., dies.
	Apr., Frans F. Hals, son of F.H., dies.
1671	Reynier Hals, son of F.H., dies.
1674	June 11, Johannes Hals, son of F.H., buried in Haarlem.
1675	June 26, F.H.'s widow receives a subsidy of 0:14:0 the week.
1675	Lysbeth Reyniers, widow of Frans Hals, dies.

BIBLIOGRAPHY

The art student will find a complete bibliography on the subject in the extremely useful book of H. van Hall, Repertorium voor de Geschiedenis der Nederlandsche Schilder-en Graveerkunst, sedert het begin van de 12de eeuw tot het eind van 1932, The Hague 1936. (Bibliographic Index for the history of painting and engraving in the Netherlands from the 12th century till the end of 1932.) A list of publications up to date can be found in the American *Art Index*.

The following notes are intended for the guidance of the reader who is not an art scholar :

C. Hofstede de Groot, Catalogue Raisonné of the Dutch painters of the 17th century ; 8 volumes. (The original German edition, Beschreibendes u. kritisches Verzeichnis der Werke der hervorragendsten holländischen Maler des 17. Jahrhunderts, Esslingen, Paris, 1907–1928, contains 10 volumes.)
This publication, planned along the lines of the old John Smith's Catalogue Raisonné, is still our main source of information with regard to the Dutch painters described in it. Hofstede de Groot and his assistants accomplished pioneer work, searching, examining, and compiling hundreds of thousands of notes out of old catalogues, inventories, archives, books, etc. The work is not illustrated, except for a few reproductions in the *De Luxe* edition. The paintings are listed systematically. The existing as well as the lost works are mentioned. Captions of paintings examined by Hofstede de Groot himself are printed in capital letters.
The work of Frans Hals is catalogued in Vol. III (1910) ; it contains 437 numbers, some of them subdivided in (*a*), (*b*), etc. In the present volume Hofstede de Groot's Catalogue Raisonné is referred to as " HdG."

W. von Bode, M. J. Binder, Frans Hals, his Life and his Works, Berlin, 1914, 2 volumes (German and English editions).
This luxuriously illustrated publication contains 286 reproductions on 194 plates and can be used as an album to Hofstede de Groot's Catalogue Raisonné. The text is by M. J. Binder. The catalogue contains references to HdG. The authors emphasize that they have reproduced authentic works by F. Hals as well as works by his pupils. The publication was printed in a limited edition and has become rare.

W. R. Valentiner, Frans Hals, des Meisters Gemälde in 322 Abbildungen mit einer Vorrede von K. Voll. First edition 1921, second edition 1923. Vol. 28 of the series " Klassiker der Kunst." In the present volume referred to as " Kl.d.K."
This book can also be called an illustrative part to Hofstede de Groot's Catalogue Raisonné. Among its 322 reproductions are practically all the pictures reproduced by Bode-Binder, except some replicas. The latter's statement that authentic as well as school works are listed to-gether, is however missing. An appendix shows a few reproductions after fakes and wrong attributions. The pictures are arranged chronologically.

W. R. Valentiner, Frans Hals' Paintings in America Westport, Conn., 1936.
The book contains a biography and a catalogue of the paintings which at the time of publication were in American collections. Every painting described is reproduced.

F. Dülberg, Frans Hals, ein Leben und ein Werk, Stuttg., 1930. Illustr.
The author sketches the artistic life in Haarlem before and during Hals's activity in the city. In this he succeeds better than in the critical part of the book.

E. W. Moes, Frans Hals, sa Vie et son Oeuvre, Brussels, 1909. Illustr.
The main accent is placed on the biographical part of the book. The catalogue is mere summary.

G. S. Davies, Frans Hals, London, 1902 and 1904. Illustr.
From the scientific point of view this book is actually out of date. As a matter of fact, it was published nearly 40 years ago when modern art criticism was still in its making. I mention it here because it is one of the few books in the English language and still consulted by English readers.

M. M. van Dantzig, Frans Hals, Echt of Onecht (Genuine or Not Genuine), Amsterdam, 1937. Illustr.
The author, a painter and restorer, wrote this book on the occasion of the Frans Hals Exhibition in Haarlem. He approaches, analyses, criticizes, and considers the paintings exclusively from the technical point of view. This made him reject some traditional attributions and caused his book to be hushed up by the official critics. While disagreeing with the author on various occasions, I found in the introduction to the book some very fine and exact observations on the artist's technic. Unfortunately the style of the book is very technical and makes reading difficult.

A. Bredius's Archiefstrokkels (Transcription of documents found in Dutch archives) are mentioned after " Oud Holland " 1913, 1914, 1917, 1921, 1923-1924.

CATALOGUE

" When in doubt, withhold the name."

LIST OF ABBREVIATIONS

App. Appendix.

Art Dlr. Art Dealer.

Acad. Academy.

Bode (1883) . . . W. Bode, Studien zur Geschichte d. Holländischen Malerei, 1883.

Bode-Binder . . . W. Bode, Frans Hals, his Life and his Works. Text by M. J. Binder. Berlin, 1914. (German and English editions.) 2 vol. *See* Bibliography.

c. *circa.*

Cat. Catalogue.

cf. compare.

Coll. Collection.

d. died.

diff. prop. . . . different properties.

Exhib. Exhibition, exhibited.

F. Florins (Dutch currency. 1914, $1.– = F.2.50 ; 1940, $1.– = F.1.83).

FARL Frick Art Reference Library, New York.

Fr. Francs (French, Belgian, and Swiss currency. 1914, $1.– = Fr.5.– ; 1940, $1.– = French Fr.36.– = Belgian Fr.32.– = Swiss Fr.2.10 (approximately).

Gns. Guineas (1 guinea = £1/1/– = (1914) $5.25 = (1940) $4.20 approximately.

HdG. C. Hofstede de Groot, Beschr. u. krit. Verzeichn. d. Werke d. hervorrag. holl. Maler d. 17. Jahrh., vol. III. (Frans Hals, Ostade, Brouwer), 1910. The German edition was used. The title of the English edition is : Catalogue Raisonné of the Dutch Painters of the 17th Century. Translated and edited by E. G. Hawke. See also Bibliography.

Hist. History.

ibid. *ibdem ;* at the same place, in the same publication.

id. *idem ;* the same.

Icon. Bat. . . . E. W. Moes, Iconographia Batava, 1897–1905.

Kl.d.K. Klassiker der Kunst, vol. 28, Frans Hals, des Meisters Gemälde eingeleitet u. herausg. von W. R. Valentiner mit einer Vorrede von K. Voll. (The mention " p.20/15 " refers to the editions of 1921 and 1923 and means : page 20 of the first edition and page 15 of the second edition ; the mention " p.–/62 " means ; not mentioned in the first edition, page 62 of the second edition.) *See* Bibliography.

Kr. Kroner, Krone (Scandinavian currency also used in Austria. 1914, $1.– = Swedish Kr.2.10 ; 1940, $1.– = Swedish Kr.4.– approximately).

Lit. Literature.

Mk. Mark (German currency : 1914, $1.– = Mk.4.20 ; 1918–1923 inflation ; 1923, $1.– = Mk.100,000,000,000.– ; 1923–1931, $1.– = Mk. 4.20).

p. page.

Pl. Plate.

RKD Ryksbureau voor kunsthistorische documentatie (Netherlands Institute for Art History and Art Reference Library), The Hague.

repr. reproduction, reproduced.

NOTE TO THE CATALOGUE

The SIZES are given in inches and centimetres for the paintings and in millimetres for the engravings and drawings ; height precedes width. Where it proved impossible to have the paintings re-measured, I give the size as mentioned in the latest publication, for instance, in the Catalogue of the Frans Hals Exhibition, Haarlem, 1937. According to a statement of Mr. G. D. Gratama, Director of the Frans Hals Museum, Haarlem, every picture shown at the Exhibition has been re-measured.

CONDITION.—A few paintings were examined with quartz-light. The rest were searched with the bare eye and a magnifying glass. As stated in the Introduction, practically every old painting has suffered to a certain degree. The main idea of mentioning the condition of the paintings described is to direct the scholar who wants to study the artist's facture, his pictorial handwriting, which cannot be found in the parts of the painting damaged or painted over.

Numbers in BRACKETS [3] refer to books and other sources of information listed under " Lit. and Sources." This method, which I found in use with the Frick Art Reference Library, New York, has at least three merits : it unveils the sources of the author's knowledge, limits his responsibility, and spares him undeserved laurels.

LIT. and SOURCES.—For the full titles of the books mentioned see the List of Abbreviations. Bode (1883) " Studien zur Geschichte der Holländ. Malerei " is only mentioned if the painting in question was for the first time published by this author or if he gives an opinion differing from others. E. W. Moes, Frans Hals, sa vie et son œuvre, 1909, is not mentioned at all. The value of this book is in the biographical part ; the catalogue is a mere list of captions without any detail and lacking exactitude. The sources mentioned are numbered. The numbers continue under the literature given for the copies, if any.

ENGR.—The modern engravings and lithographs are not mentioned, except if they are important for the history of the painting. (See, for instance, No. 64.)

Dutch NAMES like Pietersz. or Jansz. should read : Pieterszoon, Janszoon and mean " son of Pieter," etc. The abbreviation for female names is : Andriesdr. = Andriesdochter = " daughter of Andries."

CATALOGUE

1. NURSE AND CHILD. Kaiser - Friedrich - Museum, Berlin. Pl. 1, 2, 3.

Canvas : $33\frac{7}{8}$ by $25\frac{5}{8}$ inches (86 × 65 cm).

The yellow dress of the child dominates the colour scheme. Black costume of the nurse with grey lights ; white cap and ruff. Dark-grey background.

Condition : Head, cap and ruff of the nurse are very thin and bear repaints (Pl. 3). The line between the lips has been painted over. Compare how animated and nervous this line is on better preserved portraits (Pl. 13, 21, 65). The hand of the nurse and the figure of the child are in better condition.

Dating : According to Bode[1] and HdG.[2] executed between 1630 and 1635. Comparison with dated works of this period (Pl. 56, 57, 62–65) shows, however, that it must have been done much earlier. Kl.d.K.[4] suggests 1620 in analogy with the (undated) Cassel portrait No. 5 (Pl. 11). A still greater analogy exists, however, between the " Nurse " and the " Group " of 1616 (Pl. 6). Compare, for instance, the hands on both pictures (Pl. 2 and 8). The dress of the child also points to an earlier date. Tentatively I have placed the " Nurse " before the " Group " of 1616, dating it 1615–1617.

Hist. :

Sale Ilpenstein Castle, Amsterdam, Dec. 3, 1872, No. 16 (F.4,500.– Roos for Suermondt)[2].
Coll. Suermondt, Aix-la-Chapelle, Germany, 1874[2].

Lit. :

1. Bode (1883) 87.
2. HdG. 429.
3. Bode-Binder 131 Pl. 74.
4. Kl.d.K. p. 20/15.
5. Cat. Kaiser-Friedrich-Museum, Berlin, 1931, No. 801–G.

2. MAN HOLDING A SKULL. The Barber Institute, Birmingham. Pl. 4.

Companion piece to No. 3.

Panel : 37 by $28\frac{1}{2}$ inches (94 × 72.5 cm.).

Inscr. :

..ITA MORI
AETAT SVAE 60

Black dress and coat, white ruff and cuffs ; blond beard, brown hair, dark eyes. Dark-grey background. Coat-of-arms : red horse in black field.

Dating : Kl.d.K.[3] dates it 1610–1612 ; Hofstede de Groot, in a handwritten comment to Kl.d.K., places it " not before 1616 "[4] ; the Cat. of the Frans Hals Exhib.[8] suggests " 1620–1626." These authors have seen the portrait before it was cleaned. The painting is obviously connected with the period of the first group portrait of 1616 (Pl. 6, 7). Whether it was executed a few years earlier

Dating :—continued.

or later remains a matter of conjecture. Even before 1616 Hals must have been able to paint a portrait like this " Man with a Skull " or he probably would never have received such an important order as for the painting of the " Banquet " of 1616 (Pl. 6).

Hist. :

Coll. Cornelius de Young, Lord of Elmeat[6].
Coll. Lord Patrick Elibank, 1778[6].
Coll. Patrick Murray, Esq.[6].
Coll. Hon. Mrs. Yves of Moynes Park, Halstead[6].
Art Dlr. Sulley & Co., London, c. 1914[2].
Art Dlr. Horace A. Buttery, London, c. 1914[2, 3].
Sale Duke of Leinster and diff. prop., London, May 14, 1926, No. 75 (Gns. 3,600.- Leggatt)[5].
Art Dlr. Horace A. Buttery, London[6, 7, 8].
Exhib. Dutch Art, London, 1929, No. 116 (owner : Buttery).
Exhib. Frans Hals, Haarlem, 1937, No. 7 (owner : Buttery).
Lent to the National Gallery, London, 1938 (by the Barber Institute).
(Mr. H. A. Buttery was mentioned as owner of the portrait by Bode-Binder, 1914[2], in the Cat. of the Dutch Exhib., 1929[6], and in the Cat. of the Frans Hals Exhib., 1937[8]. In the meantime, however, the picture appeared at a London sale in 1926 and was bought by Leggatt. This seeming contradiction may be explained in two ways. Either the painting had been sold by Buttery previously to 1926, placed in the 1926 sale by the next owner, bought by Leggatt, and acquired—for a second time—by Buttery who kept it until 1938. Or the portrait was owned by Mr. Buttery all the time from c. 1914 till 1938 and in 1926 placed in the sale by himself and acquired by Leggatt acting as Buttery's agent.)

Lit. and Sources :

1. HdG. (not listed).
2. Bode-Binder 88 Pl. 42a.
3. Kl.d.K. p. 4/4.
4. Unpublished notes by Hofstede de Groot in the RKD.
5. Cat. Sale Duke of Leinster and diff. prop., London, May 14, 1926.
6. Cat. Dutch Art Exhib., London, 1929, No. 116 (first mention of the portrait as companion piece to No. 3).
7. Commemor. Cat. of the Dutch Art Exhib., London, 1929, p. 51.
8. Cat. Frans Hals Exhib., Haarlem, 1937, No. 7, repr. 9.
9. Van Dantzig, Frans Hals, No. 38 (" possibly by Hals, but probably by an earlier artist ").

3. PORTRAIT OF A WOMAN. The Duke of Devonshire, London. Pl. 5.

Companion piece to No. 2.

Panel : 37 by 28 inches (94 × 71 cm.).

Inscr. (near coat-of-arms ; invisible on the reproduction and scarcely visible on the original) : " AETA SVAE 37 ".

Wine-red dress, black jacket, white ruff and cap ; ruddy face, brown hair, grey-brown eyes ; gold chain ; dark, greenish-grey background. Coat-of-arms at left, indistinct under the varnish.

Dating : Bode[1] dates the portrait 1628 ; HdG.[2] 1630–1635 ; however, in an unpublished note[8] Hofstede de Groot accepts the opinion of Bode and states, referring to the date of c. 1619 proposed by Kl.d.K. (1921)[4] : " 1619 too early, must be second half of the ' twenties ' " ; in the second edition of Kl.d.K. the date is changed to 1626–1628. A comparison of the painting with the (dated) portrait of Catherina van Eem (Pl. 13) of 1620 shows, however, that the Devonshire painting must have been executed before 1620. The costume as well as the technic (laces, etc.) points in this direction. There can be little doubt of its being executed in the period 1615–1618.

Hist. :

Exhib. Whitechapel Art Gallery, London, 1904, No. 284 (owner : Devonshire)[2].

Exhib. of Dutch Art, London, 1929, No. 53 (owner : Devonshire)[6, 7].

Lit. :

1. Bode (1883) 145 (owner : Devonshire).
2. HdG. 382.
3. Bode-Binder 91 Pl. 44.
4. Kl.d.K. p. 14/48.
5. S. A. Strong, Cat. of the Devonshire Coll., 1901, No. 27, repr.
6. Cat. Dutch Art Exhib., London, 1929, No. 53 (repr. in the Souvenir).
7. Commemor. Cat. Dutch Exhib., London, 1929, p. 46.
8. Unpublished notes by Hofstede de Groot in the RKD.

4. BANQUET OF THE OFFICERS OF THE ST. JORIS-DOELEN IN HAARLEM (THE CIVIC GUARDS OF ARCHERS OF ST. GEORGE). Frans Hals Museum, Haarlem. Pl. 6, 7, 8, 9.

Canvas : 69 by 127½ inches (175 × 324 cm.).

Inscr. (at left, on the armchair) : " 1616 ". Bode[1] and HdG.[2] mention a monogram " FH " which probably was a later addition and disappeared when the picture was cleaned.

The deep black of the costumes dominates, broken by the red and white of the sashes, the gold of the pommels, and the white of the sleeves and of the table cloth. Brown background. The landscape in the centre cut

diagonally by the red-and-white-and-orange banner. A yellowish-grey drapery in the left corner.

Hist. :

Stadsdoelen, Haarlem.

Frans Hals Exhib., Haarlem, 1937, No. 3.

Lit. :

1. Bode (1883) 1.
2. HdG. 431.
3. Bode-Binder 92 Pl. 44.
4. Kl.d.K. p. 7, 8, 9/8, 9, 10.
5. Cat. Museum, Haarlem, 1865, No. 46.
6. Cat. Frans Hals Museum, Haarlem, 1924, No. 123.
7. Cat. Frans Hals Exhib., Haarlem, 1937, No. 3, repr. 7.
8. Van Dantzig, Frans Hals, No. 1.

The names of the persons portrayed are : 1. Pieter Jacobsz. Schout (Colonel) ; 2. Johan van Napels, 3. Job Claesz. Gyblaut, 4. Outgert Pietersen, 5. Jacob Schoneus (Captains) ; 6. Dirk Dirksz. Schipper, 7. Hendrik Jacobsz. Coning, 8. Pieter Adriaensz. Verbeek (Lieutenants) ; 9. Gerardt Cornelisz. Vlasman, 10. Jacob Cornelisz. Schout (Ensigns).

5. PORTRAIT OF A MAN. Staatliche Gemäldegalerie, Cassel. Pl. 10.

Companion piece to No. 6.

Canvas mounted on panel ; 39¾ by 30⅜ inches (101 × 77 cm.).

Black costume and hat, white ruff and cuffs, embroidered belt ; blond hair.

Dating : HdG.[1] as well as Kl.d.K.[3] date this portrait and its companion c. 1620. The Cat. of the Cassel Gallery[4] suggests even a later date, 1620–1625. The costumes, especially the dress of the woman, indicate, however, a date prior to 1620. The technic appears to be quite close to the 1616 " Group " (No. 4). On the other hand, the composition, particularly the using of the space as an element of composition, shows that these two paintings are more mature and thus of a later period than the No. 2 (Birmingham) and No. 3 (Devonshire). It is therefore probable that the Cassel portraits were executed between 1618 and 1620.

Lit. and Sources :

1. HdG. 265.
2. Bode-Binder 97 Pl. 48.
3. Kl.d.K. p. 18/18.
4. Cat. Staatl. Gemäldegalerie, Kassel, 1929, No. 213.
5. Mentioned in the " Hauptinventar " of 1749, No. 687.

6. PORTRAIT OF A YOUNG WOMAN. Stattliche Gemäldegalerie, Cassel. Pl. 11.

Companion piece to No. 5.

Canvas mounted on panel : 39¾ by 32⁵⁄₁₆ inches (102 × 82 cm.).

Richly coloured, painted against a grey background :
frock of pink silk shot with violet and blue-green ;
stomacher, violet with yellow spots ; black gown with-
out sleeves ; white cap, ruff, and cuffs ; gold (chrome)
chain.
Dating : see companion portrait.
Lit. and Sources :

 1. HdG. 374.
 2. Bode-Binder 98 Pl. 49.
 3. Kl.d.K. p. 19/19.
 4. Cat. Staatl. Gemäldegalerie, Kassel, 1929, No.
 214.
 5. Mentioned in the " Hauptinventar " of 1749,
 No. 688.

7. PAULUS VAN BEERESTEYN. Louvre, Paris, Pl. 12.

Companion piece to No. 8.
Canvas ; 54¾ by 40⅜ inches (139 × 102 cm.).
Inscr. (under the coat-of-arms) :
 " AETAT SVAE 40
 16 20
Face, ruff, hands and cuffs stand out from the dark
brownish-grey background and the black of the costume.
Gold-embroidered sleeves ; dark hair, dark-blond
beard and moustache. At right a table with a dark-
green tablecloth. Red coat-of-arms in the background,
repeated in the ring.
Condition : The " 4 " of the age and the zero of the
 year are painted over and possibly changed.
 Except this, the portrait is in an excellent con-
 dition.
Date : HdG.[2] and Kl.d.K.[4] read the date as 1620 ;
 the Louvre Cat.[6] gives it as 1629. If the person
 represented is PAULUS van Beeresteyn and if the
 age of 40 is correct, the date must be 1629. How-
 ever, the " 4 " of the 40 has also been painted over
 and probably changed. The style of the painting
 and the costume point to the earlier date of 1620.
Hist. : 1884 acquired by the French Government from
 the Governors of the Hofje van Beeresteyn (the
 Van Beeresteyn Foundation), Haarlem, together with
 its companion piece No. 8 and a " Family
 Portrait " sold as a work by Frans Hals, but actually
 not by him (Louvre Cat. No. 2388), at the price of
 Fr. 100,000.–.
Lit. :

 1. Bode (1883) 9 (" Nicolaas van Beeresteyn ").
 2. HdG. 154.
 3. Bode-Binder 121 Pl. 66.
 4. Kl.d.K. p. 16/16.
 5. Moes, Icon. Bat., No. 519, 2.
 6. Cat. Louvre, III, Ecoles du Nord, (L. De-
 monts) 1922, No. 2386.
Biogr. : Paulus van Beeresteyn (1588–1636), " Com-
 missaris van de kleine Bank van Justitie " (judge)
 in Haarlem from 1615–1617, was the father of the
 founders of the " Hofje van Beeresteyn." His

Biogr. :—continued.
 third wife was Catharina van der Eem (see com-
 panion portrait).

8. CATHARINA BOTH VAN DER EEM, THIRD WIFE OF PAULUS VAN BEERESTEYN. Louvre, Paris. Pl. 13.

Companion piece to No. 7.
Canvas : 54¾ by 40⅜ inches (139 × 102 cm.).
Inscr. (under the coat-of-arms) :
 " AET
 A° . . 29 " (?)
The gold-coloured stomacher stands out from the
black dress and the dark-grey background. White cap,
ruff, and cuffs. Brown armchair. Coat-of-arms : red,
grey, and black.
Date : HdG.[2] and Kl.d.K.[4] date this portrait 1620 ,
 according to Van Thienen[5] it belongs to the
 " early 'twenties " ; the Louvre Cat.[6] reads :
 1629. The date inscribed on the painting seems
 to be 1629. However, the style of the costume and
 of the painting point to the earlier period of c. 1620.
Hist. : see companion piece.
Lit. :

 1. Bode (1883) 10.
 2. HdG. 155 (" A° 1620, Aet. 38 ").
 3. Bode-Binder 122 Pl. 67.
 4. Kl.d.K. p. 17/17.
 5. Van Thienen, Das Kostüm der Blütezeit
 Hollands, p. 100.
 6. Cat. Louvre, III. Ecoles du Nord (L. Demonts),
 1922, No. 2387.
Biogr. : see companion piece.

9. PORTRAIT OF A MAN. The Duke of Devonshire, London. Pl. 14.

Canvas mounted on panel : 42 by 33½ inches (107 ×
85 cm.).
Inscr. (in the top left corner) : " AETAT SVAE 36 "
Inscr. (in the top right corner) : " AN° 1622 ".
Black costume with gold-embroidered sleeves ; black
cloak and hat ; white ruff and cuffs ; blond moustache
and beard, brown eyes ; dark background. Red-
brown painted oval.
According to Valentiner[7] this painting is a self-
portrait by Frans Hals as are (according to the same
author) Nos. 10, 20, and the man in the " Merry
Company " (Metropolitan Museum, New York, No.
H.16–4) ; the latter picture is not included in this
catalogue.
Condition : Cleaned in 1928[8]. The face and the left
 hand are rather thin.
Dating : Bode[1] dates it " about 1622 ". HdG.[2]
 and Kl.d.K.[4] place it later, respectively 1630–1635
 and c. 1625. Some fifty years after the publication
 of Bode's " Studien," the date of 1622 was re-
 discovered inscribed at the top of the portrait,
 proving that Bode's supposition was correct.

Hist. :

Exhib. Whitechapel Art Gallery, London, 1904, No. 280 (owner : Devonshire)[1, 8].

Exhib. Dutch Art, London, 1929, No. 48 (owner : Devonshire)[5].

Lit. :

1. Bode (1883) 137.
2. HdG. 287 (wrong size).
3. Bode-Binder 152 Pl. 90 (wrong size).
4. Kl.d.K. p. 42/41 (wrong size).
5. Cat. Dutch Art Exhib., London, 1929, No. 48, repr. in Souvenir.
6. Cemmemor. Cat. Dutch Art Exhib., London, 1929, p. 45.
7. Valentiner, New Additions, etc. (Art in America, 1935, p. 95 ; referred to as " Self-portrait," date 1622 mentioned).
8. Letter from Mr. Francis Thompson, Librarian and Keeper of Collections at Chatworth.

10. VERDONCK. The National Gallery of Scotland, Edinburgh. Pl. 15.

Panel : 18¼ by 13½ inches (46.5 × 34 cm.).

Monogr. (at right, above the collar) : " FHF " (connected).

Ruddy face, yellowish beard and moustache, bloodshot eyes ; dark-grey coat, white collar ; grey background.

Condition : Cleaned by Dr. M. de Wild in 1927[4]. " When presented to the Gallery in 1895, this picture was called ' The Toper,' and represented an unknown man, wearing a large claret-coloured cap of velvet and holding a short-stemmed glass in his hand. In 1927 Dr. de Wild suggested that the hat and the glass were later additions. This was confirmed by X-ray photographs. . . . Dr. de Wild was then asked to remove these repaints and the original painting was found intact and in perfect condition beneath."[4].

Dating : The Edinburgh Cat.[4] dates the picture " before 1623," probably on the assumption that the engraving made after it is by J. van de Velde I., who died in 1623. The engraving is, however, by J. van de Velde II, who lived later than 1641. Valentiner[8] dates the portrait c. 1626, and the Cat. of the Haarlem Exhib.[5] 1620-1623. The brushwork is very similar to that of the " Boy with Beer Jug " (No. 15). Both pictures could have been done during the period 1624-1627.

Hist. : Coll. of Vaile family, Kent, till 1895[4].

Sale Lawrence W. Vaile, Christie's, London, 1895 ; bought by Agnew[9].

Coll. John J. Moubray of Naemoor[4].

Presented to the Nat. Gallery of Scotl., 1916[4].

Exhib., Frans Hals, Haarlem, 1937, No. 6[5].

Lit. and Sources :

1. HdG. 235 (listed as " lost " ; described after the engraving).
2. Bode-Binder 297 (id.).
3. Moes, Icon. Bat., No. 8369.
4. Cat. National Gallery of Scotland, Edinburgh, 1929, p. 31.
5. Cat. Frans Hals Exhib., Haarlem, 1937, No. 6, repr.
6. Van Dantzig, Frans Hals, No. 7.
7. Pantheon 1928 p. 521 repr. before and after cleaning.
8. Valentiner, New Additions, etc. (Art in America, 1935, p. 101).
9. Records of the Frick Art Reference Library, New York.
10. Cat. Sale Nardus & Bourgeois, Paris (Drouot), May 31, 1924, No. 20.
11. Unpublished notes by Hofstede de Groot in RKD.

Engr. : by J. van de Velde II. (1593—after 1641), in the reverse direction, with the verse :

" Dit is Verdonck, die stoute gast
Wiens kaekebeen elk een aen tast.
Op niemant, groot noch kleyn, hy past,
Dies raeckte hy in 't Werckhuis vast."

Signed : " Velde fecit ".

The Frans Hals monogram is not reproduced on the engraving. Size : 189 × 175 mm.

Copy : Sale Nardus & Bourgeois, Paris (Drouot), May 31, 1924, No. 20, listed as " School of Frans Hals," " The Toper, large red hat, grey doublet, silver coupe in his right hand." Canvas : 62 × 48 cm. [10] or 61 × 48.5 cm.[11]. Acquired by J. Bruinse.

11. BANQUET OF THE OFFICERS OF THE CLUVENIERS–DOELEN IN HAARLEM. Frans Hals Museum, Haarlem. Pl. 16-20.

Canvas : 72 by 105 inches (183 × 266.5 cm.).

Monogr. (left side, on the armchair) : " FH " (connected).

The colour scheme is brighter and more interesting than of the " Group " of 1616 (No. 4) . The black of the costumes is no more dominating but balanced by the light-blue, orange, and violet of the doublets, sashes, and plumes. Light-grey background. The coat-of-arms in the window is pink ; the banner orange, white, and red.

Dating : The banquet represented on this painting took place on October 18, 1622, the day of the company's departure for Bergen and Hasselt[1]. For this reason Kl.d.K.[3] dates the " Group " 1623-1624. An inscription on the frame, which is of a later period, gives the date as 1627.

Hist.

Stadsdoelen, Haarlem[4, 5].

Frans Hals Exhib., Haarlem, 1937, No. 28[6].

Lit. :
1. HdG. 433.
2. Bode-Binder 112 Pl. 60 (" monogr. HF ").
3. Kl.d.K. p. 36/37.
4. Cat. Haarlem Museum, 1865, No. 48.
5. Cat. Frans Hals Museum, Haarlem, 1924, No. 125.
6. Cat. Frans Hals Exhib., Haarlem, 1937, No. 28, repr.
7. Van Dantzig, Frans Hals, No. 10.

The *names* of the persons portrayed are : 1. Willem Voogd (Colonel) ; 2. Johan Damius (Treasurer) ; 3. Willem Warmond, 4. Johan Schatter (also represented in the " Group " No. 44), Gillis de Wit (Captains) ; 6. Nicolaas van Napels, 7. Oudgert Akkersloot. 8, Matthijs Haaswindius (Lieutenants) ; 9. Adriaen Matham, 10. Lot Schout, 11. Pieter Ramp (Ensigns) ; 12. Servant.

The disposition is :

```
          10
             2  12  11    7    6
      9
             1   4   5    3       8
```

12. PORTRAIT OF AN OFFICER, CALLED THE LAUGHING CAVALIER. Wallace Collection, London. Pl. 21.

Canvas : 33 by 26¼ inches (84 × 67 cm.).

Inscr. (top right corner ; restored ?) :

· " AETA SVAE 26
 A° 1624. "

Richly embroidered doublet (black with gold, green, red, white, etc.) ; gold buttons, black hat and coat worn over the left shoulder and draped across the middle ; white ruff with black bow ; white lace cuffs and red silk cuffs ; blond hair, moustache, and imperial beard ; blue-grey eyes. Light-grey background, a dark-grey shadow at right.

Hist. :
Sale J. H. van Heemskerk, The Hague, March 29, 1776, No. 44 (F.180.– Locquet)[1].
Sale P. Locquet, Amsterdam, Sept. 22, 1783, No. 129 (F.247.– Fouquet)[1].
Sale Jan Gildemeester, Amsterdam, June 11, 1800, No. 64 (F.300.– Achtienhoven)[1].
Sold by Nieuwenhuys to Count De Pourtalès (£80.–)[1].
Sale Comte de Pourtalès-Gorgier, Paris, March 27, 1865, No. 158 (Fr.51,000.– Lord Hertford)[1, 4].
Coll. Sir Richard and Lady Wallace, London[1, 4].
Exhib. at Bethnal Green Branch of South Kensington Museum, London, 1872–1875, No. 236[5].
Exhib. Royal Acad., London, Winter 1888, No. 75[1] (owner : Sir R. Wallace).

Lit. :
1. HdG. 291.
2. Bode-Binder 100 Pl. 51.
3. Kl.d.K. p. 37/38.
4. Cat. Wallace Collection, London, 1928, No. 84, repr.
5. C. C. Black, Cat. of Paintings . . . lent for the Exhib. in the Bethnal Green Branch of the South Kensington Museum by Sir Richard Wallace, No. 236.

13. YOUNG COUPLE IN LANDSCAPE. Ryksmuseum, Amsterdam. Pl. 22, 23.

Canvas : 55¼ by 65⅝ inches (140.5 × 166.5 cm.)[5].

The blond-haired man in black and the blond woman in a black costume with reddish vari-coloured stomacher, seated on the ground ; green landscape ; blue sky with clouds ; yellowish-grey soil in the foreground. The woman's cap embroidered with salmon and red. Different authors tried to identify the couple. According to Kl.d.K.[3] the portrait may represent Frans Hals and his wife. According to Bode-Binder[2], it is the likeness of Dirk Hals and his wife. The Cat. of the Ryksmuseum[4] suggests the name of Massa (see No. 20). The man is, without doubt, the same as on the portrait No. 9.

Condition : Repainted in the lower left-hand corner.

Dating : Kl.d.K.[3] dates the painting *c.* 1621. Hofstede de Groot suggests in an unpublished note [10] the date *c.* 1630, adding : " the man's lace collar does not occur on earlier paintings." However, according to Van Thienen[9], the costumes were worn between 1620–1630. The " Couple " could have been executed 1624–1627.

Hist. :
Sale J. Six, Amsterdam, Apr. 6, 1702 (rebought)[1].
Sale H. Six van Hillegom, Amsterdam, Nov. 25, 1851, No. 15[1].
Exhib. of Dutch Art, London, 1929, No. 64[5].
Exhib. Frans Hals, Haarlem, 1937, No. 10[7].
In the Ryksmuseum since 1852[4].

Lit. and Sources :
1. HdG. 427.
2. Bode-Binder 96 Pl. 47.
3. Kl.d.K. p. 21/20.
4. Cat. Ryksmuseum, Amsterdam, 1934, No. 1084.
5. Cat. Dutch Art Exhib., London, 1929, No. 64, repr. in Souvenir (" Man and Wife ").
6. Commemor. Cat. Dutch Art Exhib., London, 1929, p. 48, repr.
7. Cat. Frans Hals Exhib., Haarlem, 1937, No. 10 repr.
8. Van Dantzig, Frans Hals, No. 2.
9. Van Thienen, Das Kostüm der Blühtezeit Hollands.
10. Unpublished notes by Hofstede de Groot in RKD.

14. TWO SINGING BOYS WITH A LUTE.
Staatliche Gemäldegalerie, Cassel. Pl. 24.

Canvas : 26 by 20½ inches (66 × 52 cm.).

Monogr. (left-hand corner below, on the book) : " FH " (connected).

Black costumes ; brown lute ; the books with pink edges and parchment covers ; grey background.

Dating : Bode[1] c. 1625 ; Kl.d.K.[4] c. 1627. Belongs to the same series as No. 15 and was probably executed in the same period 1624–1627.

Hist. :
 1783 in the Cassel Palace, No. 75[2].
 Frans Hals Exhib., Haarlem, 1937, No. 31[7].

Lit. and Sources :
 1. Bode (1883) 98.
 2. HdG. 134
 3. Bode-Binder 52 Pl. 21.
 4. Kl.d.K. p. 53/56.
 5. Mentioned in the Cassel " Hauptinventar " of 1749, No. 623[2].
 6. Cat. Staatl. Gemäldegalerie, Kassel, 1929, No. 215.
 7. Cat. Frans Hals Exhib., Haarlem, 1937, No. 31, repr. 10.
 8. Van Dantzig, Frans Hals, No. 34 (" work by a pupil with corrections by F. Hals ").

Engr. : By W. Vaillant (1623–1677), in the reverse direction, the composition slightly changed. Size : 270 × 211 mm.

Copies :
 (a) 1907 at Klencke's, London[2].
 (b) Sale H. R. Willet, London, Apr. 20, 1895, No. 106.
 The copies (a) and (b) are not identical[2].
 (c) Sale (L. Nardus) at F. Muller & Co., Amsterdam, June 5, 1917, No. 6. Panel : 33.5 × 28 cm. From the Donaldson Coll. ; (F.26.000.– Baron van Voorst). This picture seems to be a modern copy made after the engraving by Vaillant. Another or more probably the same modern copy, was at the Art Dlr. A. L. Nicholson, London (March, 1929).

15. LAUGHING BOYS WITH BEER JUG.
Hofje van Aarden, Leerdam, Holland. Pl. 25–27.

Canvas : 27⅜ by 22⅞ inches (69.5 × 58 cm.).

Monogr. (at right, above the jug) : " FH " (connected).

Dating : Kl.d.K.[4] dates it 1627–1630. The brush-work is similar to that on the Verdonck portrait (No. 10). Both pictures were probably executed in the period 1624–1627.

Hist. :
 Exhib. Pulchri Studio, The Hague, 1890, No. 37[5].
 Exhib. Amsterdam, 1910, No. 16[8].
 Exhib. Frans Hals, Haarlem, 1937, No. 33[6].

Lit. and Sources :
 1. Bode (1883) 29.
 2. HdG. 125.
 3. Bode-Binder 43 Pl. 17a (no size mentioned).
 4. Kl.d.K. p. 67/69.
 5. Cat. Exhib. Pulchri Studio, The Hague, 1890, No. 37.
 6. Cat. Frans Hals Exhib., Haarlem, 1937, No. 33 repr.
 7. Van Dantzig, Frans Hals, No. 3 (same period as the " Couple," No. 13).
 8. Unpublished notes by Hofstede de Groot in RKD.

Copies :
 (a) A smaller copy showing both boys was in the Mesdag Collection, The Hague[2]. Later this picture came into the possession of the Art Dlr. Larsen, London (1928)[8] and the Art Dlr. P. de Boer, Amsterdam (1930)[9].
 Lit. :
 9. Kunsthandel P. de Boer, Amsterdam, Catalogus, 1930, No. 46 (as original).
 (b) A copy representing the one boy only is at the Brooklyn Institute of Arts, Brooklyn, N.Y. Panel : 8½ by 7⅛ inch (21.5 × 18 cm.). The background seems to be not older than the 19th century ; the whole is rather doubtful. Hist. : Max Kann Coll. and Sale, Paris, March 3, 1879 (Fr.1,520.–) ; Art Dlr. Ch. Sedelmeyer, Paris ; Maurice Kann, Paris ; Michael Friedsam, New York (bequeathed to the Brooklyn Institute).
 Lit. :
 10. HdG. 68 (as original ; wrong size).
 11. Bode-Binder 43 Pl. 17b.
 12. Kl.d.K. notes to p. 67/69 (workshop copy).
 13. Valentiner, F. Hals in America, No. 25 as original.
 14. Cat. Max Kann Sale, Paris, March 3, 1879.
 15. Ch. Sedelmeyer, " 300 Paintings," Paris, 1898, No. 50.

16. PORTRAIT OF A HUNCH-BACKED MAN.
Kaiser-Friedrich-Museum, Berlin. Pl. 28.

Panel : 9⅞ by 7⅞ inches (25 × 20 cm.).

Dated (on the reverse side) : 1625.

Black silk doublet (grey lights), matching cloth coat and hat ; white ruff and cuffs ; ochre gloves with pink cuffs light grey background.

Condition : Blisters in hat and background.

Hist. : Coll. Suermondt, Aix-la-Chapelle, Germany, 1874[1, 4].

Lit. :
 1. HdG. 255.
 2. Bode-Binder 94 Pl. 46b.
 3. Kl.d.K. p. 43/44 (" a certain resemblance with Hals' pupil Palamedes ").
 4. Cat. Kaiser-Friedrich-Museum, Berlin, 1931, No. 801–F.

17. PORTRAIT OF A BEARDED MAN. Mr.
Jules S. Bache, New York. Pl. 29.

Canvas ; 30 by 25 inches[6] (76.2 × 63.5 cm.).

Inscr. (at right, near chin) : " AETAT 36
 AN° 1625 "

Black doublet and cloak, white ruff ; black hair and
beard ; in a painted grey oval with dark corners.

Hist. :

 Art Dlr. Ayerst H. Buttery, London[4, 6].
 Frans Hals Exhib., Detroit, 1935, No. 3 (owner :
 Bache)[5].

Lit. :

 1. HdG. (not listed).
 2. Valentiner, Frans Hals in America, No. 13.
 3. Valentiner, Rediscovered Paintings by F. Hals
 (Art in America, 1928, p. 247, repr.).
 4. Valentiner, New Additions, etc. (ibid., 1935, p.
 101).
 5. Cat. Frans Hals Exhib., Detroit, 1935, No. 3,
 repr.
 6. Cat. of Paintings in the Bache Coll., New York,
 1938, No. 35, repr.

18. JACOB PIETERSZ. OLYCAN. Mauritshuis,
The Hague. Pl. 30.

Companion piece to No. 19.

Canvas : 49 1/16 by 42 1/4 inches (124.6 × 97.3 cm.).

Inscr. (at right, near ruff) : " AETAT SVAE 29
 A° 1625 "

Black costume, white ruff and cuffs ; standing against
a light brownish background. His right sleeve is of a
transparent dark brownish-red fabric with black
horizontal stripes. The coat-of-arms, suspended from a
light-blue ribbon, shows yellow vases in azure field and
white herons in black field.

Condition : The coat-of-arms is a later addition[5].

Hist. :

 Sale, Amsterdam, May 16, 1877, No. 9 and 10
 (F.19,580.– together with the companion piece ;
 rebought)[1, 5].
 Acquired by the Netherlands Government from
 the Van Sypenstein family, together with the
 companion piece, 1880 (F.10,000.–)[1, 5].
 Exhib. in the Mauritshuis from Jan., 1881[5, 6].

Lit. :

 1. HdG. 208.
 2. Bode-Binder 102 Pl. 53 (wrong size).
 3. Kl.d.K. p. 40/42.
 4. Moes, Icon. Bat., No. 5537.
 5. Cat. Mauritshuis, The Hague, 1935, No. 459,
 repr.
 6. V. de Stuers (De Nederl. Kunstbode, 1881,
 p. 44).

Biogr. : Born July 9, 1596, in Haarlem ; married July
 14, 1624, at Zwolle, Aletta Hanemans (see com-
 panion piece) ; buried in Haarlem, Dec. 4, 1638.
 In the " Group " No. 31 Frans Hals painted him
 again (see detail Pl. 46). Besides Jacob Olycan's

Biogr. :—continued

 wife (No. 19), Hals portrayed several other members
 of the family : Jacob's brother Nicolaes (in the
 " Group " No. 44), Maritge Voogt (No. 73), her
 sister Cornelia Vooght (No. 39), etc.

19. ALETTA HANEMANS, WIFE OF JACOB
OLYCAN. Mauritshuis, The Hague. Pl. 31.

Companion piece to No. 18.

Canvas : 48 7/8 by 38 18/19 inches (124.2 × 98.2 cm.).

Inscr. (at left, near face) : " AETAT SVAE 19
 AN 1625 "

Gold-embroidered stomacher, frock of lilac-coloured
silk shot through with red ; black dress, white cap,
ruff, and cuffs ; white gloves with red lacing, embroid-
ered with gold, green, and red, lined with red silk ; gold
chain ; gold bracelet with coat-of-arms. Light-brown
background. The coat-of-arms in the top right corner,
suspended on a light-blue ribbon, shows a red cock in
yellow field.

Condition : The coat-of-arms is a later addition[5].

Hist. : See companion piece.

Lit. :

 1. HdG. 209.
 2. Bode-Binder 103 Pl. 54.
 3. Kl.d.K. p. 41/43.
 4. Moes, Icon. Bat., No. 3134.
 5. Cat. Mauritshuis, The Hague, 1935, No. 460.

Biogr. : Born 1606 in Zwolle ; married July 14, 1624,
 Jacob Pietersz. Olycan (see companion piece) and
 on January 29, 1641, Nicolaas van Loo ; died
 February 9, 1653.

20. ISAAK ABRAHAMSZ. MASSA. Mr. Frank
P. Wood, Toronto, Canada. Pl. 32, 33.

Canvas : 31 1/2 by 25 5/8 inches (80 × 65 cm.)[9].

Inscr. (on the armchair) : " AETA 41 1626 ".

Seated on a brown chair holding a sprig of holly.
Black doublet and hat ; white ruff and cuffs. In the
background a grey wall with an opening on a forest
landscape.

Condition : Lower part possibly cut down[1]. Re-
 paints in cuff ; details in landscape and window
 by another hand[10].

Hist. :

 Coll. Earl Spencer, Althorp[1, 4].
 Art Dlr. Duveen Bros., London and New York[4].
 Exhib. Royal Acad., London, Winter 1907, No.
 41[1] (owner : Spencer).
 Exhib. Dutch Art, London, 1929, No. 376 (owner :
 Wood)[7].
 Exhib. Frans Hals, Haarlem, 1937, No. 25 (owner :
 Wood)[9].

Lit. :

 1. HdG. 246 (" Portrait of Man ").
 2. Bode-Binder 108 Pl. 58 (" Man ").
 3. Kl.d.K. p. 44/45 (" Man ").

Lit. :—*continued.*

4. Valentiner, F. Hals in America, No. 14 (" Self-portrait ").

5. Moes, Icon. Bat., No. 4865.

6. Valentiner (Art in America, 1925, p. 148–154).

7. Cat. Dutch Art Exhib., London, 1929, No. 376, repr. in Souvenir (" Man " ; 32 by 26 inches).

8. *id.* Commemor. Cat. p. 55, repr.

9. Cat. Frans Hals Exhib., Haarlem, 1937, No. 25, repr. 27 (" Massa ").

10. Van Dantzig, Frans Hals, No. 4 (" landscape by another hand, was perhaps sketched by Hals and finished by another artist ").

11. J. van Ryckevorsel (Historia, Aug. 1937).

Biogr. : Born 1585 in Haarlem ; went to Russia where he was active in the silk trade ; he seems, however, to have had higher ambitions ; in 1614 he became Netherlands Commercial Agent in Russia and arranged for the import of grain from Russia and Poland into Holland. In 1626 he submitted to the government of the United Netherlands a petition, asking for a monopoly of the grain trade with Russia. It is possible that for this reason he stayed in Holland in 1626 when he was painted by Hals. The monopoly was not granted and it seems that he was not on such good terms with the government after this date. In 1627 he lived in Lisse near Haarlem. He died in 1655.—Condensed from[11].

Valentiner[4] sees in this painting a " Self-portrait " by Hals. However, the likeness to a portrait of Massa, engraved by A. Matham after another painting by Hals, is much more conclusive than the likeness to other so-called self-portraits by the artist. The identification of the sitter as Isaak Massa was first made by J. van Ryckevorsel[9 and 11].

21. SARA ANDRIESDR. HESSIX, WIFE OF M. J. VAN MIDDELHOVEN. Mr. C. S. Gulbenkian, Paris. Pl. 34.

Canvas : 33⅞ by 27⅛ inches (86 × 69 cm.).

Black dress, white cap, ruff, and cuffs. Prayer-book with reddish cover. Brown chair (yellow lights) ; back of chair red. Greenish shadows on the face and hands. Yellowish-grey background.

Condition : Background heavily repainted.

Dating : Kl.d.K.[4] dates it 1626, because this date is inscribed on the companion piece, the Portrait of M. J. van Middelhoven in the former Coll. Schloss, Paris. I was not able to see this latter painting and for this reason it is not reproduced here. The Cat. of the National Gallery[9] dates the painting " before 1626."

Hist. :

Coll. Comte André Mniszech, Paris[1, 2, 5].

Art Dlr. Kleinberger, Paris[2].

Coll. A. de Ridder, Cronberg, Germany[5].

Sale A. de Ridder, Paris, June 2, 1924, No. 24

Hist. :—*continued.*

(Fr.900,000.– Gulbenkian)[6].

Exhib. of Dutch Art, London, 1929, No. 66 (owner : Gulbenkian)[7].

Lent to the National Gallery, London[9].

Lit. :

1. Bode (1883) 58.

2. HdG. 203.

3. Bode-Binder 142.

4. Kl.d.K. p. 46/47.

5. Cat. Coll. A. de Ridder, Cronberg (by Bode).

6. Cat. de Ridder Sale, Paris, June 2, 1924, No. 24, repr.

7. Cat. Dutch Art Exhib., London, 1929, No. 66.

8. *id.* Commemor. Cat., p. 48.

9. Cat. Gulbenkian Loan to the National Gallery, London, 1937, No. 17.

Biogr. : Married 1586 Michiel Jansz. van Middelhoven, who during the years 1602–1634 was preacher in Voorschoten, near Leiden.

22. LUCAS DE CLERCQ. Ryksmuseum, Amsterdam. Pl. 35.

Companion piece to No. 58.

Canvas : 49¾ by 36⅝ inches (126·5 × 93 cm.).

Black doublet and cloak ; white ruff, yellowish gloves ; dark-blond hair, sandy beard and moustache. Light grey-brown background.

Dating : HdG.[1] suggests " mid-thirties " ; Kl.d.K.[3] dates it 1635 because of it being the companion piece to the (dated) portrait of Feyntje van Steenkiste (No. 58). However, even if these two paintings were companion pieces, this would not necessarily mean that they were painted the same year. The costume as well as the technic of the De Clercq portrait point to an earlier date, about 1627 ; compare " Group " No. 11.

Hist. : Presented to the City of Amsterdam by the De Clercq family, 1891. Lent by the City of Amsterdam to the Ryksmuseum.

Lit. :

1. HdG. 165.

2. Bode-Binder 160 Pl. 96.

3. Kl.d.K. p. 127/138.

4. Moes, Icon. Bat., No. 1563.

5. Cat. Ryksmuseum, Amsterdam, 1934, No. 1086.

6. J. Six (Onze Kunst., Oct. 1916, p. 1 : doubts authenticity of the portrait).

23. YOUNG MAN WITH A LARGE HAT. National Gallery of Art, Washington, D.C. Lent by the A. W. Mellon Educational and Charitable Trust. Pl. 36.

Panel : 11⅛ by 8⅜ inches (28·5 × 22·5 cm.).

Brown doublet ; white falling band with red loose tie ; white cuffs ; brown-grey hat ; blond hair and dark eyes. Light background.

Hist. :
 Coll. van der Hoop[5].
 Coll. Slochteren[5].
 Coll. Gerard Bredius, Amsterdam, who secured it
 from an inheritance, as a work by J. M. Molenaer,
 for F.60.–[2].
 Art. Dlr. Knoedler & Co., Paris and New York.
 Coll. A. W. Mellon, Washington, D.C.
 Lent to the Mauritshuis, The Hague, 1919[2].
Lit. and Sources :
 1. HdG.–
 2. H. Schneider, Ein neues Bild von F. Hals
 (Kunstchronik und Kunstmarkt, N.F., 1918–1919,
 p. 368).
 3. Kl.d.K. p. 50/51 (wrong size).
 4. Valentiner, F. Hals in America, No. 16 (wrong
 size).
 5. Records of the RKD.

24. PORTRAIT OF A MAN, POSSIBLY NICO-
LAES LE FEBURE. Kaiser-Friedrich-Museum,
Berlin. Pl. 37.
Copper : 7½ by 5½ inches (19 × 14 cm.).
Inscr. (top right corner) : " 1627," the last digit not
quite distinct.
Grey-violet doublet, dark-grey cloak ; white ruff ;
ruddy face, blond beard and moustache ; light-grey
background ; red-brown painted oval. The hand
rather weak.
Hist. :
 Coll. Reimer, Berlin.
 Sold to the Museum, 1843.
Lit. :
 1. HdG. 252.
 2. Bode-Binder 110 Pl. 59b.
 3. Kl.d.K. p. 51/54.
For the identification of the sitter as Nicolaes Le Febure
compare the first person from the right in the lower
row of the " Group " No. 31.
Biogr. : Nicolaes Le Febure was, about 1627, Captain
 of the St. Joris Company of the Civic Guards in
 Haarlem.

25. SINGING BOY WITH A FLUTE. Kaiser-
Friedrich-Museum, Berlin. Pl. 38.
Canvas : 25⅝ by 21¼ inches (65 × 54 cm.).
Monogr. (at right, between sleeve and edge) : " FH "
(connected).
Pale blue doublet, violet-brown cloak lined with light
blue. Light-blue plume on black cap. Blond hair.
Light-grey background.
Dating : The series of Hals's genre paintings representing
 boys, like Nos. 26, 27, show a strong influence of
 the Utrecht school, where similar compositions
 were popular about 1620–1630. The Cat. of the
 Berlin Museum dates the " Singing Boy " c. 1625 ;
 Kl.d.K.[3] suggests c. 1627.

Hist. :
 Sale B. Ocke, Leiden, Apr. 21, 1817, No. 45 (F.78.–
 Lelie)[1].
 Sale Amsterdam, Dec. 16, 1856, No. 19 (" Panel ·
 68 × 56 cm.")[1].
 Coll. Suermondt, Aix-la-Chapelle, 1874[1, 4].
Lit. :
 1. HdG. 81.
 2. Bode-Binder 56 Pl. 23b.
 3. Kl.d.K. p. 52/55.
 4. Cat. Kaiser-Friedr.-Museum, Berlin, 1931, No.
 801–A.

26. BOY WITH A SKULL (THE SO-CALLED
HAMLET). Mr. Granville Proby, London. Pl. 39.
Canvas : 36 by 31¾ inches (91·5 × 80·5 cm.).
Red cap ; light-grey background. Same model as
Nos. 27.
Dating : According to Kl.d.K.[3] : " 1645 or earlier."
 According to Van Dantzig[6], c. 1627. This
 painting belongs to the same series as Nos. 25, 27,
 and must have been executed in the same period,
 1625–1627.
Hist. :—
 Coll. Sir James Steuart (d. 1849), for whom the
 painter Andrew Geddes bought this painting[7].
 Coll. Mrs. Stuart Johnson[7].
 Art Dlr. Durlacher Bros., London[1].
 Coll. Earl of Carysfort (1895), who bought it
 through Lawrie & Co.[7].
 Exhib. National Gallery, Dublin, 1896[1].
 Exhib. Frans Hals, Haarlem, 1937, No. 93 (owner :
 Proby)[5].
 Exhib. of 17th Century Art, London, 1938, No. 132
 (owner : Proby)[7].
Lit. and Sources :
 1. HdG. 102.
 2. Bode-Binder 64 Pl. 28b.
 3. Kl.d.K. p. 214/227.
 4. Borenius and Hodgson, Cat. of Elton Hall, 1924,
 No. 24 (detailed history and bibliography).
 5. Cat. Frans Hals Exhib., Haarlem, 1937, No.
 93, repr.
 6. Van Dantzig, Frans Hals, No. 9.
 7. Cat. Exhib. of 17th Century Art, London, 1938,
 No. 132.
 8. Unpublished notes by Hofstede de Groot in
 RKD.
Copy : " A small copy on panel, the boy leering badly,
 seen at Galerie Locarno (Art Dlr.), Paris,"[8]

27. THE MERRY LUTE PLAYER. Mr. John R.
Thompson, Jr., Chicago. Pl. 40.
Canvas : 35½ by 29½ inches (90 × 75 cm.)[11].
Monogr. (at right, between hand and edge) : " FH "
(connected).
Black costume and cap ; lute, striped light and dark
brown, with red border, lying on the end of a pale

green table. Dark blond hair, brown eyes. Light-grey background. Same model as No. 26.

Dating : This painting belongs to the same group as Nos. 25, 26, and must have been executed between 1625 and 1627. Kl.d.K.[3] and Van Dantzig[12] date it 1627.

Hist. : The history of this painting as given by HdG.[1], in reality contains the history of two pictures, the original and a copy. Owners of the copy are mentioned as being owners of the original. Hofstede de Groot himself discovered this error and noted it in the preface to vol. IV of his Catalogue Raisonné and in the unpublished notes actually with the Ryksbureau voor kunsthistorische documentatie, The Hague.

The Hist. of the original :
Sale Capello, Amsterdam, May 6, 1767, No. 28 (F.58.–)[1].
Coll. Count Bonde, Stockholm[1].
Art Dlr. M. Colnaghi, London[1].
Coll. Jules Porgès, Paris[14].
Coll. Ferdinand von Rothschild, Waddesdon Manor, England[1].
Coll. A. Veil-Picard, Paris [2, 5].
Coll. Edmond Veil-Picard, Paris[3].
Art Dlr Duveen Bros., Paris, New York (1923)[3 2nd edit., Notes.]
Coll. John R. Thompson, Chicago[7].
Exhib. Royal Acad., London, Winter 1891, No. 72[1, 14]. (owner : Porgès).
Exhib. Jeu de Paume, Paris 1911, No. 55[5] (owner : Veil-Picard).
Exhib. Detroit Institute of Arts, 1925, No. 4 (owner : Thompson)[6].
Exhib. of Dutch Art, London, 1929, No. 372 (owner : Thompson)[7].
Exhib. Century of Progress, Chicago, 1933, No. 62 (owner : Thompson)[9].
Exhib. Frans Hals, Detroit, 1935, No. 9 (owner : Thompson)[10].
Exhib. Frans Hals, Haarlem, 1937, No. 30 (owner : Thompson)[11].

Lit. and Sources :
1. HdG. 82 and vol. IV, p. II (owner : Sir Vincent, who in fact owned the copy (a) ; erroneous history).
2. Bode-Binder 58 Pl. 25 (Coll. Veil-Picard).
3. Kl.d.K. p. 55/58 (Coll. Veil-Picard).
4. Valentiner, F. Hals in America, No. 20 (Coll. Thompson ; 36 by 30 inches).
5. Cat. Exhib. Jeu de Paume, Paris, 1911, No. 55.
6. Cat. Exhib. of Dutch Paintings, Detroit, 1925, No. 4.
7. Cat. Dutch Exhib., London, 1929, No. 372, repr. in Souvenir.
8. id. Commemor. Cat., p. 54.

Lit. and Sources :—continued.
9. Cat. Exhib. Century of Progress, Chicago, 1933, No. 62, repr.
10. Cat. Frans Hals Exhib., Detroit, 1935, No. 9, repr.
11. Cat. Frans. Hals Exhib., Haarlem, 1937, No. 30, repr. 31.
12. Van Dantzig, Frans Hals, No. 8.
13. Sedelmeyer, 100 Paintings, 1896, No. 19.
14. Cat. of the Royal Acad. Exhib., Winter 1891, No. 72.
15. Unpublished notes by Hofstede de Groot in RKD.
16. Records of the Frick Art Reference Library, New York.

Copies :
(a) A modern copy (fake) was first reported as an original in the possession of the Art Dlr. Martin H. Colnaghi, London[13], who also owned the genuine painting. From there it went to the Art Dlr. Ch. Sedelmeyer, Paris[13]. Sedelmeyer's catalogue[13] describes it as on panel 35 by 29½ inches (89 × 75 cm.), signed with the monogram " FH " and acquired " from Mr. Martin H. Colnaghi, who bought the picture in Stockholm " [sic]. The Art Dlrs. Wertheimer, London [1], Gooden, London (1896)[1], Thos. Agnew and Sons, London[1] also traded this picture, whether the original or the copy, is difficult to say. HdG.[1] and Kl.d.K.[3] (Notes) list the fake as being in the coll. of Sir Edgar Vincent, Esher, England.

(b) Fake : Circular panel, 6⅜ inches (16·2 cm.) diameter. Coll. Sir Edward Hutchinson ; Sale Ch. Robertson of London, at Anderson Galleries, New York, Febr. 20, 1922, No. 129[16].

28. BOY HOLDING A FLOWER. Pl. 41.
See Appendix No. 1

29. A BOY DRINKING. Museum, Schwerin. Pl. 42.
Companion piece to No. 30.
Circular panel : 15 inches (38 cm.) diameter.
Monogr. (at right, between glass and edge) : " FH " (connected).
White ruff, blond hair. Light-grey background.
Dating : Kl.d.K.[3] : 1626–1627.
Lit. :
1. HdG. 11.
2. Bode-Binder 8 Pl. 5b.
3. Kl.d.K. p. 48/52.
4. Cat. Museum, Schwerin, 1882, No. 445.
Copy : Museum, Lille, France. Panel : 21¼ by 17 inches (54 × 43 cm.). Hist. : Coll. A. Brasseur, 1885. Lit. : 5. Cat. Musée de Lille, 1893, No. 371 ; 6. HdG. 66.

30. LAUGHING BOY WITH A FLUTE. Museum, Schwerin. Pl. 43.

Companion piece to No. 29.

Circular panel : 14¾ inches (37·5 cm.) diameter.

Dating : See companion piece.

Lit. :

 1. HdG. 32.

 2. Bode-Binder 9 Pl. 5c.

 3. Kl.d.K. p. 49/53.

 4. Cat. Museum, Schwerin, 1882, No. 444.

 5. Unpublished notes by Hofstede de Groot in RKD.

Engr. by J. Verkolje (died before 1763), mezzotint, in the reverse direction. Size : 123 × 100 mm.

Copies :

 (a) Art Museum, Gothenburg (Sweden). Panel : 17 by 15 inches (43 × 38 cm.). Monogr. : " FH " (connected). Hist. : Sale London, May 3, 1902, No. 96 (£819.– H. P. Lane)[6] ; Coll. H. P. Lane, Dublin[6] ; Art Dlr. Dowdeswell & Dowdeswell, London[6] ; Art Dlr. Sir G. Donaldson, London[7] ; Coll. Ernst Elliot, Stockholm[9] ; presented to the Gothenburg Art Museum by Gustav Werner, 1923[9] ; Exhib. Guildhall, London, 1903, No. 164[6].

 Lit. :

 6. HdG. 84 (as original ; according to a later note[5], a copy).

 7. Bode-Binder 7 Pl. 5a.

 8. Kl.d.K. Note to p. 49/53 (" one of the best replica ").

 9. Cat. Art Museum, Gothenburg, No. 744, repr.

 (b) Coll. A. Keller, New York. Panel : 15 inches (38 cm.) diameter. Hist. : Coll. Jules Porgès, Paris[10] ; Art Dlr. Ch. Sedelmeyer, Paris[5] ; Sale Duchange, Brussels, June 25, 1923, No. 84[11].

 Lit. :

 10. HdG. 31–A.

 11. Cat. Sale Duchange, Brussels, 1923.

Among Hofstede de Groot's unpublished papers[5] there is a note on the Schwerin " Boy with Flute " reading : " A copy at Sedelmeyer and Porgès ; bought by A. F. Ph. . . . in a Brussels sale ; too hard and unfeeling for an original. April 1924." It probably refers to the copy (b).

 (c) Same composition ; diamond-shaped : each side 11½ inches (29 cm.). Exhib. Grafton Galleries, London, 1895, No. 215[5].

 (d) Sale L. Neumann and diff. prop., London, July 4, 1919, No. 74[5].

 (e) Museum, Lille, France. Panel : 21¼ by 17 inches (54 × 43 cm.). Hist. : Coll. A. Brasseur, 1885.

 Lit. :

 HdG. 83.

 Cat. Musée de Lille, 1893, No. 372.

Copies :—continued

 (f) The Frick Art Reference Library, New York, possesses a photograph of another circular copy. A note on the photograph reads : " Porgès, Paris, 1921, No. 80." It might be the same copy as (b).

31. BANQUET OF THE OFFICERS OF THE ST. JORIS-DOELEN IN HAARLEM (THE CIVIC GUARDS OF ARCHERS OF ST. GEORGE). Frans Hals Museum, Haarlem. Pl. 44–46.

Canvas : 70½ by 101½ inches (179 × 257·5 cm.).

There is less contrast than in the " Group " of c. 1623 (No. 11) because it lacks the light background of the latter. The colouring is not so bright but the brush-strokes are broader. Black costumes and hats, yellow jackets and sashes, white-red-orange banner ; all this painted against a brown-lilac-coloured drapery (at left) and a grey wall (at right).

Dating : The year 1627 inscribed in 18th century digits on a plaque attached to the frame.

Hist. :

 Stadsdoelen, Haarlem[1, 4].

 Frans Hals Exhib., Haarlem, 1937, No. 29[6].

Lit. and Sources :

 1. HdG. 432 (sight size).

 2. Bode-Binder 113 Pl. 61.

 3. Kl.d.K. p. 58/63.

 4. Cat. Haarlem Museum, 1865, No. 47 (sight size).

 5. Cat. Frans Hals Museum, Haarlem, 1924, No. 124.

 6. Cat. Frans Hals Exhib., Haarlem, 1937, No. 29, repr.

 7. Van Dantzig, Frans Hals, No. 11 ("partly unfinished and restored ").

The names of the persons portrayed are : 1. Aernout Druyvesteyn (Colonel) ; 2. Michiel de Wael, 3. Nicolaes Le Febure (see also No. 24), 4. Nicolaes Verbeek (Captains) ; 5. Cornelis Boudewynsz., 6. Frederik Coning, 7. Jacob Olycan (see also No. 18) (Lieutenants); 8. Boudewyn van Offenberg, 9. Dirk Dirksz. Scheepgen, 10. Jacob Schout (Ensigns) ; 11. Servant.

The disposition is :

5		9	11	10
	4 8 7		6	
1		2		3

Copies :

 (a) DRAWING by W. Hendriks " Banquet of the Officers of the St. Joris-Doelen, 1627 ; after F. Hals ; coloured " ; Sale, Amsterdam, Febr. 14, 1855, No. 8 (F.90.– Vos).

 (b) Portrait of Aernout van Druyvesteyn (the first from the left in the lower row of the " Group "). Coll. The Hon. Oscar B. Cintas, Havana, Cuba. Canvas : 32 by 26 inches (81·3 × 66 cm.)[10]. Hist. : Sale, probably in Haarlem, Aug. 10, 1785,

Copies :—*continued.*

No. 134 (F.25.– Wubbels)[13] ; Coll. John G. Johnson, Philadelphia[9] (sold because authenticity was doubted) ; Art Dlr. Kleinberger, Paris[8] ; Sir Hugh Lane, London[10] ; John Levy Galleries, New York[10] ; Frans Hals Exhib. Detroit, 1935, No. 8 (owner : Cintas) ; Masterpieces of Art Exhib., World's Fair, New York, 1939, No. 176 (owner : Cintas).

Lit. :

8. Bode-Binder 118 Pl. 64b.

9. Kl.d.K. p. –/62.

10. Valentiner, F. Hals in America, No. 19.

11. Cat. Frans Hals Exhib., Detroit, 1935, No. 8.

12. Cat. Masterpieces of Art Exhib., New York, 1939, No. 176.

In all these books the portrait is mentioned as an authentic work by Frans Hals.

13. HdG. 175 merely copies the description of the 1785 Sale Cat., without identifying the portrait of this sale with the painting in the Cintas Coll.

14. Unpublished notes by Hofstede de Groot in RKD, stating that after examination of the Cintas portrait and comparing it with the " Group " he considers it to be a copy.

The weakest part of the portrait is the left hand which is invisible on the " Group " and which the copyist had to imagine instead of just copying it. The rendering of the damask and the facial expression are also less convincing than on Hals's " Group."

(c) *Drawing* by C. van Noorde " Portrait of Aernout Druyvesteyn, bust, natural size, black crayon washed with Indian ink, heightened with white ; on blue paper " ; Sale A. van der Willigen, The Hague, June 10, 1874, No. 110.

32. THE MERRY DRINKER. Ryksmuseum, Amsterdam. Pl. 47, 48.

Canvas : $32\frac{1}{8}$ by $26\frac{3}{4}$ inches (81·5 × 68 cm.)[6, 7].

Monogr. (at right, on shoulder level) : " FH " (connected).

Yellow camisole ; brown-yellow doublet ; white ruff (blueish lights), white cuffs with red laces at the right. Black hat. Silver-coloured belt with gold medallion bearing the portrait of Prince Maurits of Orange. Blond hair and beard, grey eyes. Light grey background.

Dating : Bode[1] dates this painting 1625–1630 ; Kl.d.K.[4] (first edition) : 1627–1630, and (second edition) : c. 1627. The work is closely related to the series of " Boys " Nos. 25–27 (compare the hands of this and of No. 25), but shows an improvement of technic. It was probably done about 1627.

Hist. :

Sale Baronesse van Leyden van Warmond, Warmond, July 31, 1816, No. 13 (F.325.–)[2].

Exhib. of Dutch Art, Paris, 1921, No. 21[6].

Exhib. of Dutch Art, London, 1929, No. 61[7].

Exhib. Frans Hals, Haarlem, 1937, No. 32[9].

Lit. and Sources :

1. Bode (1883) 17.

2. HdG. 63 (wrong size).

3. Bode-Binder 53 Pl. 22a (wrong size).

4. Kl.d.K. p. 59/61 (wrong size).

5. Cat. Ryksmuseum, Amsterdam, 1934, No. 1091 (81 × 66·5 cm.).

6. Cat. Exhib. Dutch Art, Paris, 1921, No. 21.

7. Cat. Exhib. Dutch Art, London, 1929, No. 61, repr. in Souvenir.

8. *id.* Commemor. Cat. p. 48, repr.

9. Cat. Frans Hals Exhib., Haarlem, 1937, No. 32, repr.

10. Van Dantzig, Frans Hals, No. 5, repr.

11. Unpublished notes by Hofstede de Groot in RKD.

Copies :

(a) The head only. Coll. Mrs. Bischoffsheim, London. Canvas : $23\frac{5}{8}$ by $19\frac{3}{4}$ inches (60 × 50 cm.) Hist. :

Exhib. Burlington Fine Art Club, London, 1905, No. 22.

Lit. :

12. Bode-Binder 54 Pl. 22b.

13. Kl.d.K. Note to p. 61 (" copy ").

(b) Different in colour. Sale Cleveland and diff. prop., London, Apr. 8, 1902, No. 96 (£21.–). Lit. :

14. HdG. 63 (copy). May be the same as (c) or (d).

(c) Sale Mich. Abrahams and diff. prop., London, Apr. 5, 1897, No. 96. Might be the same as (b) or (d).

(d) Sale Art Dlr. Ehrich Galleries, New York, at American Art Association and Anderson Galleries, New York, Apr. 18–19, 1934, No. 55, repr. Circular panel : $24\frac{3}{4}$ inches (63 cm.) According to the sale cat. attributed by A. Bredius to Nicolaes Claes Hals. Might be the same as (b) or (c).

33. MALLE BABBE. Kaiser-Friedrich-Museum, Berlin. Pl. 49.

According to Kl.d.K.[3], a companion piece to No. 34.

Canvas : $29\frac{1}{2}$ by $25\frac{1}{4}$ inches (75 × 64 cm.).

Inscr. (on the reverse side) :

" Malle Babbe van Haerlem

P. Frans Hals ".

Grey dress with black shadows and white lights ; white ruff and cap. Ruddy face (black shadows, ochre lights). Some ochre in the feathers of the owl. White lights in the silver-grey jug. Brownish background.

Dating : According to HdG.[1], c. 1650 ; according to Kl.d.K.[3], 1635–1640. The picture obviously belongs to the same group as No. 34 and 35, executed about 1628.

Hist. :

Sale, Amsterdam, Oct. 1, 1778, No. 58 (F.9,5.-Altrogge)[5].

Sale, Nymegen, June 10, 1812, No. 88[5].

Sale J. F. Signault and J. J. Limbeek, Amsterdam, May 12, 1834, No. 92 (F.9.– Roos ; on panel !)[5] ; size : 28 by 23 inches[6].

Sale Stockbroo van Hoogwoud en Aertswoud, Hoorn, Sept. 3, 1867[1], No. 69 (F.1,660.– ; on canvas)[7].

Coll. Suermondt, Aix-la-Chapelle, 1874.

Exhib. Brussels, 1873, No. 19[5].

Lit. and Sources :

1. HdG. 108.
2. Bode-Binder 68 (not 65 as stated by [3]) Pl. 31.
3. Kl.d.K. p. 131/142.
4. Cat. Kaiser-Friedr.-Museum, Berlin, 1931, No. 801–C.
5. Unpublished notes by Hofstede de Groot in RKD.
6. Cat. Sale Signault and Limbeek, 1834.
7. Cat. Sale Stockbroo, 1867.

Copies, imitations :

(a) Copy by Gustave Courbet, coll. Chéramy ; repr. "Les Arts," Nov. 1906, No. 59.

(b) Repetition by a contemporary of Frans Hals. The Metropolitan Museum, New York. Grey-brown dress, soiled white ruff, white cap, brownish background. Canvas : 29½ by 24⅟₁₆ inches (74·5 × 61 cm.). Monogr. : " FH " (connected). Dating : According to HdG.[8], c. 1650 ; Kl.d.K. [10], 1635–1640. Hist. : Coll. Cornet, Brussels[8] ; coll. Lord Palmerstone, Broadlands[8] ; purchased by the Metropolitan Museum, 1871[8] ; Frans Hals Exhib., Haarlem, 1937, No. 62[14].

Lit. :

8. HdG. 109.
9. Bode-Binder 69 Pl. 32a.
10. Kl.d.K. p. 130/141.
11. Valentiner, F. Hals in America, No. 57.
12. Moes, Icon. Bat., No. 7482.
13. Cat. of Painting, Metropolitan Museum, New York, 1931, No. H.161–1 (" By F. Hals the Younger ").
14. Cat. Frans Hals Exhib., Haarlem, 1937, No. 62, repr. 64.
15. Van Dantzig, F. Hals, No. 97 (" Fake ").

All above-mentioned books, except [13] and [15], attribute the painting to Frans Hals himself. Engr. by L. B. Coclers (1740–1817), in the reverse direction. Size : 161 × 132 mm.

(c) " Malle Babbe with a Smoking Youth," attributed to Frans Hals the Younger, Staatl. Gemäldegalerie, Dresden. 38⅜ by 48¾ inches

Copies, imitations :—continued

(97·5 × 124 cm.). Monogr. ; " FHF " (connected). Hist. : Sale, Amsterdam, Jan. 26, 1869, No. 26, as a work by Frans Hals and Abraham van Beyeren [5] ; Sale W. C. P. Baron van Reede van Oudtshoorn, Amsterdam, Apr, 14, 1874, No. 13 (F.1,900.– Rosman ; canvas : 99 × 124 cm.). The smoking youth is reproduced from a painting by Adr. Brouwer in the Louvre. The whole seems to be a fake.

(d) Sale H. von Kilényi, Budapest, Nov. 26, 1917, No. 56, as work by F. Hals the Younger after F. Hals. Canvas : 29⅛ by 23¼ inches (74 × 59 cm.). Monogr. : " FH " (connected). A copy after the Berlin painting.

Several pictures, erroneously attributed to Frans Hals, represent women supposed to look like the " Malle Babbe " (Museum, Lille, France ; Coll. R. J. Cooper, London ; etc.).

34. THE SO-CALLED MULATTO. Museum der bildenden Künste, Leipzig. Pl. 50.

According to Kl.d.K.[3], a companion piece to No. 33. Canvas : 29¾ by 25 inches (75·5 × 63·5 cm.). Monogr. (at right, near elbow) : " FH " (connected). Red-brown jacket with yellow trimmings ; red-yellow cap. Grey background.

Dating : Kl.d.K.[3] dates the picture 1635–1640 ; an engraving after it, made by Jacob de Gheyn II, who died March 29 or 31, 1629, proves that Hals must have painted it before this date. Other genre studies apparently belonging to the same group (No. 33–36), were painted in the same period.

Hist. : Sale D. P. Sellar (of London), Paris, June 6, 1889, No. 38[1].

Art Dlr. Ch. Sedelmeyer, Paris, 1889 (sold to Thieme)[1].

Coll. A. Thieme, Leipzig[1], bequeathed to the Leipzig Museum, 1916[4].

Exhib. Royal Acad. London, Winter 1887, No. 80[1] (owner : Sellar).

Exhib. Munich, 1892[1].

Lit. and Sources :

1. HdG. 96.
2. Bode-Binder 65 Pl. 29.
3. Kl.d.K. p. 132/143.
4. Cat. Museum der bild. Künste, Leipzig, 1924, No. 1017.
5. Unpublished notes by Hofstede de Groot in RKD.
6. Records of the Frick Art Reference Library, New York.

Engr. by Jacob de Gheyn II (1585–1629), in the reverse direction. Size : 240 × 154 mm.

Copies :

(a) " A replica of this picture was with a German art dealer a few years ago " (1910)[1].

Copies :—*continued*.

(b) " A second study of the same model in the Wiesbaden Museum "[1].

(c) Sale Mniszech, Paris, Apr. 9, 1902, No. 127 (F.16,000.–) ; 27¾₆ by 21¼ inches (69 × 54 cm.)[5].

(d) Sale Dollfus, Paris, May 20, 1912, No. 49 ; panel ; 21 by 19 inches (61 × 48 cm.)[5].

(e) Sale W. Locket Agnew and diff. prop., London, June 15, 1923, No. 102[6] ; panel ; 12 by 9¾ inches (30 × 24.7 cm.).

(f) " Replica on green background, smaller size [than the original] monogr., coll. Onnes van Nyenrode "[5].

(g) Coll. M. von Nemes, Budapest and Munich[5]. Copy (c) might be identical with (g), (d) with (f).

35. THE DRINKER OR " MONSIEUR PEECKL-HAERING." Staatliche Gemäldegalerie, Cassel. Pl. 51.

According to Kl.d.K.[4], a companion piece to No. 33(b).

Canvas ; 29⅛ by 24 inches (74 × 61 cm.).

Signed (at right, near shoulder) ; " F. Hals f."

Brown-red jacket with yellow trimming and matching cap.

Dating ; Bode[1] dates it c. 1640 ; Kl.d.K.[4] 1635–1640. This late date was suggested because of the broad and vigorous brushstroke. However, this picture is closely related to the Leipzig so-called " Mulatto " (No. 34) which was engraved by J. de Gheyn II., before 1629. The Cassel " Drinker " was probably executed in the same period, as were the Nos. 33, 34, 36. As to the style, we have the same broad and brilliant brushwork in the Amsterdam " Drinker " of c. 1627 (No. 32).

Documents : A painting called " Monsieur Peecklhaering " (see the inscription on the engraving) is mentioned in several old inventories : Henric Bugge, Leiden, 1666 ; Hendrick Huyck, Nymegen, Jan. 10, 1699 ; Jan Zeeuw and Marie Bergervis (d. 1690)[2].

Listed in the Cassel " Hauptinventar " of 1749, No. 363[2].

Lit. and Sources ;
1. Bode (1883) 97.
2. HdG. 95.
3. Bode-Binder 66 Pl. 30a.
4. Kl.d.K. p. 129/140 (the picture reproduced is the replica (a) and not the Cassel original).
5. Cat. Staatl. Gemäldegalerie, Kassel, 1929, No 216.
6. Nugae Venales sive Thesaurus ridendi, etc., Anno 1648 (frontispiece engraving).

Engr. :
By J. Suyderhoef (1613–1686) as " Monsieur Peecklhaering," in the reverse direction ; inscr. (near shoulder) ; " F. Hals Pinxit ". Size : 271 × 234 mm.

By an anonymous engraver, for the book " Nugae Venales "[6], 1648 ; in the reverse direction. Size : 108 × 59 mm.

The Cassel " Drinker " is represented in the background of a picture by Jan Steen " The Christening," Kaiser-Friedrich-Museum, Berlin, Cat. No. 795–D., HdG. I. 137.

Replica and copy ;
(a) Art Dlr. D. Katz, Dieren, Holland. Canvas : 30⅞ by 26⅜ inches (78·5 × 67·5 cm.) Hist. : Coll. Jules Porgès, Paris[7] ; Art Dlr. Knoedler, Paris, New York[11] ; Exhib. Art Dlr. Kleykamp, The Hague, 1928, No. 11, repr. (canvas : 77 × 67 cm.) ; Frans Hals Exhib., Haarlem, 1937, No. 65, repr. 67.

Lit. and Sources :
7. HdG 99-a (" seems to be a repetition of the Cassel picture ").
8. Bode-Binder 67 Pl. 30b.
9. Kl.d.K. p. 129/140 (erroneously reproduces this picture instead of the Cassel original; states in a note that this replica " can hardly be authentic ")
10. Van Dantzig, Frans Hals, No. 6 (" authentic," c. 1627).
11. Information from Messrs. D. Katz, Dieren.

(b) Sale Vicomte de Buisseret, Brussels, Apr. 29, 1891, No. 41 ; 29⅛ by 26 inches (74 × 66 cm.)[2].

36. THE SO-CALLED GYPSY GIRL. Louvre, Paris. Pl. 52, 53.

Panel ; 22⅞ by 20½ inches (58 × 52 cm.).

Bright colours. The red of the bodice and the white of the blouse dominate the colour scheme. Brown hair, held together by a narrow red ribbon. Grey sky.

Condition : Excellent ; the eyes slightly retouched ; yellow varnish.

Dating : Bode[1] : c. 1630 ; Kl.d.K.[4] ; c. 1635. The painting, belonging to the same series as the Nos. 33–35, must have been executed about 1628.

Hist. :
Sale Marquis de Ménars[2] et de Marigny (brother of Madame de Pompadour), Paris, the end of February, 1782, No. 39 (Fr.301.– Rémy). The sale catalogue gives no exact date ; the picture is described as " Bust of a Woman, wearing a Blouse."

Coll. Rémy[2].

Coll. La Caze, Paris[2, 5].

La Caze Bequest, 1869[2, 5].

Lit. :
 1. Bode (1883) 41.
 2. HdG 119.
 3. Bode-Binder 73 Pl. 34.
 4. Kl.d.K. p. 121/130.
 5. Cat. Louvre, III. Ecoles du Nord (L. Demonts), 1922, No. 2384.
 6. Cat. La Caze, 65.

37. PORTRAIT OF A MAN. Buckingham Palace, London. Pl. 54, 55.
Canvas ; 44⅞ by 33⅞ inches (114 × 86 cm.).
Inscr. (at right, near the head) ; " AETAT SVAE 36
 AN 1630 "
Black coat, white ruff and cuffs, cream-coloured gloves. Blond hair and beard. Grey background looking yellowish because of a thick layer of varnish.
Hist. :
 Bought by George, Prince of Wales, 1809[4].
 Exhib. Royal Acad., London, Winter 1875, No. 102[1].
 Exhib. Royal Acad., London, Winter 1892, No. 124[1].
Lit and Sources :
 1. HdG 286.
 2. Bode-Binder 126 Pl. 71.
 3. Kl.d.K. p. 82/84.
 4. Inscription on the frame.

38. NICOLAES VAN DER MEER, MAYOR OF HAARLEM. Frans Hals Museum, Haarlem. Pl. 56.
Companion piece to No. 39.
Panel ; 50⅜ by 39⅝ inches (128 × 100·5 cm.).
Inscr. (under the coat-of-arms) ; " AETAT SVAE 56
 AN° 1631 "
Black doublet with grey pattern, white ruff and cuffs ; dark hair, blond beard and moustache. Light brownish background. Brown chair with gold pattern in the green leather of the back. Coat-of-arms suspended on a dark-blue ribbon.
Condition : A vertical split in the centre of the panel.
Hist. :
 Coll. Jhr. Fabricius van Leyenburg ; bequeathed to the Museum, 1883[1].
 Exhib. Frans Hals, Haarlem, 1937, No. 40[6].
 Exhib. Masterworks of Art, Golden Gate Exposition, San Francisco, 1939, No. 77[7].
Lit. :
 1. HdG 200.
 2. Bode-Binder 134 Pl. 76a.
 3. Kl.d.K. p. 91/94.
 4. Moes, Icon, Bat., No. 4927.
 5. Cat. Frans Hals Museum, Haarlem, 1924, No. 131.
 6. Cat. Frans Hals Exhib., Haarlem, 1937, No. 40, repr.
 7. Cat. Masterworks of Art Exhib., San Francisco, 1939, No. 77, repr.
 8. Van Dantzig., Frans Hals, No. 13.

39. CORNELIA CLAESDR. VOOGHT, WIFE OF NICOLAES VAN DER MEER. Frans Hals Museum, Haarlem. Pl. 57.
Companion piece to No. 38.
Panel ; 49¾ by 39¾ inches (126·5 × 101 cm.).
Inscr. (at left, near shoulder) ; " AETAT SVAE 53
 A° 1631 "
Black dress with gold buttons and piping ; brown fur ; white cap, collar, and cuffs. Grey-brown background. Black hair, blue eyes. Brown-green back of the chair with gold nails. Coat-of-arms ; white geese on black field and black storks on red field ; suspended on a dark-blue ribbon.
Hist. :
 Coll. Jhr. Fabricius van Leyenburg ; bequeathed to the Museum, 1883[1].
 Exhib. Frans Hals, Haarlem, 1937, No. 41[5].
 Exhib. Masterworks of Art, San Francisco, 1939, No. 78[6].
Lit. :
 1. HdG 201.
 2. Bode-Binder 135 Pl. 76b.
 3. Kl.d.K. p. 92/95.
 4. Cat. Frans Hals Museum, Haarlem, 1924, No. 132.
 5. Cat. Frans Hals Exhib., Haarlem, 1937, No. 41, repr.
 6. Cat. Masterworks of Art Exhib., San Francisco, 1939, 78, repr.
 7. Van Dantzig, Frans Hals, No. 14.

Biogr. : Born 1578. Her sister, Maria Claesdr. Vooght, had also been painted by Frans Hals (No. 73).

40. PORTRAIT OF A MAN. The Frick Museum of Art, New York. Pl. 58.
Companion piece to No. 41.
Canvas ; 45½ by 36 inches (114·2 × 90·5 cm.).
Black doublet and cloak, white ruff ; ruddy face, grey hair, dark-blond beard and moustache. Light-brown background. On the first plane, the black leather back of a chair with gold-coloured pattern and gold nails.

Dating : HdG[1] dates this portrait 1627 ; Bode-Binder[2] : 1635 : Kl.d.K.[3] : 1633, the year inscribed on the companion piece. According to the costume, the portrait might have been executed about 1631. However, the brushstroke is broader than on the (dated) portrait No. 38 and the Frick painting seems to have been done later, possibly between 1631 and 1633.

Hist. :
 Coll. Lord Arundell, Wardour Castle[1].
 Art Dlr. Ch. J. Wertheimer, London (sold Jan. 10, 1895 for 74,265.–)[5] ; the currency of the sale price is not mentioned).
 Art Dlr. Ch. Sedelmeyer, Paris, Jan. 1895[1, 5].

Hist. :—*continued.*
> Coll. Maurice Kann, Paris (105,000.–)[1, 5] ; currency not mentioned.
> Art Dlr. Duveen Bros., New York ; bought Aug., 1909[6].
> Coll. Henry Clay Frick, New York ; acquired 1910[6].
> Exhib. National Loan Exh., London, Grafton Gallery, 1909, No. 37 (owner ; Duveen)[6].
> Exhib. Fine Art Museum, Boston, 1910, No. 6 (owner ; Frick)[6].

Lit. and Sources :
> 1. HdG 303 (wrong size).
> 2. Bode-Binder 149 Pl. 87 (wrong size).
> 3. Kl.d.K. p. 102/108.
> 4. Valentiner, F. Hals in America, No. 40.
> 5. Unpublished notes by Hofstede de Groot in RKD.
> 6. Records of the Frick Art Reference Library, New York.

41. PORTRAIT OF AN ELDERLY WOMAN.
National Gallery of Art, Washington, D.C. Pl. 59.
Companion piece to No. 40.
Canvas ; 48 by 36 inches (122 × 91·4 cm.).
Inscr. (at left, near head) ; " AETAT SVAE 60
 AN° 1633 "
Black dress ; white cap, collar, and cuffs ; brown book ; ruddy face ; brown-yellow background.
Hist. :
> Coll. Comte de la Rupelle[1].
> Coll. Comtesse de la Rupelle ; sold Apr. 21, 1904 (15,220.–)[8] ; currency of the sale price not stated.
> Art Dlr. Ch. Sedelmeyer, Paris, 1905[1] ; sold to James Simon (132,000.–)[8] ; currency not stated.
> Coll. James Simon, Berlin[1].
> Art Dlr. Duveen Bros., New York[7].
> Exhib. Sedelmeyer, Paris, 1905[7].
> Exhib. Berlin, 1906, No. 49[1, 6].
> Exhib. Masterpieces of Art, New York, 1939, No. 179[7].
> This portrait is probably the No. 20 of the Jurrians Sale, Amsterdam, Aug, 28, 1817 (F.200.– Roos)[1].

Lit. and Sources :
> 1. HdG 371 (wrong size).
> 2. Bode-Binder 138 Pl. 79 (wrong size).
> 3. Kl.d.K. p. 103/109 (wrong size).
> 4. Valentiner, F. Hals in America, No. 41
> 5. Cat. Exhib. of Old Paintings (Sedelmeyer), Paris 1905, No. 13, repr.
> 6. Cat. Exhib. Silver Wedding Festival, Berlin, 1906, No. 49, repr.
> 7. Cat. Masterpieces of Art Exhib., New York, 1939, No. 179.
> 8. Unpublished notes by Hofstede de Groot in RKD.

42. PIETER VAN DEN BROECKE. The Iveagh Bequest, Kenwood House, London. Pl. 60.
Canvas ; 26⅜ by 21¼ inches (67 × 54 cm.)[3].
Black doublet and dark hair painted against a light-brown background. White ruff and cuffs. Dark-brown eyes, dark-blond moustache and chin tuft. Gold chain. Yellow cane or admiral's baton.
Condition : The painting has considerably suffered, perhaps as a result of relining. Face, belt, and background are rather thin.
Dating ; According to Kl.d.K.[3], c. 1637. J. G. van Gelder[9] proves, however, that the portrait was painted in 1633. Pieter van den Broecke's diary [10], published in 1634 and mentioned by Van Gelder, contains a portrait of the author engraved by A. Matham after the Frans Hals painting. A marginal inscription reads : " Co. PIETER VAN DEN BROECKE. VAN ANTWERPEN. AETATIS SVAE 48. ANNO CIꝹ. CXXXIII XXXIII." (1633).
Hist. ;
> Coll. John W. Wilson, Paris ; Sale at Paris, March 16, 1881 (Fr.78,100.–)[1].
> Sale E. Secrétan, Paris, July 1, 1889, No. 123 (Fr.110,500.– Agnew for Iveagh)[1, 11].
> Exhib. 100 Chef-d'oeuvres, Paris, 1883[1].
> Exhib. Royal Acad., London, Winter 1891, No. 121. (Coll. of Sir E. C. Guinness, Bt.)

Lit. and Sources ;
> 1. HdG. 161.
> 2. Bode-Binder 181 Pl. 113.
> 3. Kl.d.K. p. 151/163.
> 4. Moes, Icon. Bat., No. 1130.
> 5. Cat. Iveagh Bequest, No. 51, p. 17.
> 6. Cat. John W. Wilson Coll., 1873, p. 84 (engr. by L. Flameng).
> 7. Cat. Sale Wilson, Paris, 1881.
> 8. Cat. Sale Secrétan, Paris, 1889.
> 9. J. G. van Gelder, Dateering van F. Hals's Portret van P. van den Broecke (Oud Holland, LV., 1938, p. 154).
> 10. Korte historiael ende journaelsche Aenteykeninghe . . . door Pieter van den Broecke, gedrukt tot Haarlem . . . Anno 1634.
> 11. Records of the Ryksbureau voor kunsthistorische documentatie, The Hague.
> 12. Records of the Frick Art Reference Library, New York.

Engr. :
> By A. Matham, in the same direction, with the inscr. ; " F. Hals pinx.—A. Matham sc.—EEN VVR BETAELT HET AL " (and a verse praising Van den Broecke's exploits). Size : 165 × 123 mm.
> By J. Ledeboer, in the same direction, with the inscr. ; " F. Hals pix.—J. Ledeboer del. et sculp.— EEN UUR BETAALT HET AL.—PIETER van

Engr. :—*continued.*

den BROECKE eerste Directeur van Suratte, Persien en Arabien ". Size : 256 × 166 mm.

Copies :

(*a*) Sale T. Humphrey Ward, London, June 11, 1926, No. 5. 25½ by 20 inches (64·7 × 50·7 cm.). According to Hofstede de Groot[11] : " a weak copy."

(*b*) Sale Ch. H. Moore and diff. prop., at Robinson, Fisher & Harding, London, Jan. 15, 1925, No. 185. 25 by 21 inches (63·5 × 53·3 cm.)[12]. The copies (*a*) and (*b*) are possibly identical.

43. PORTRAIT OF A MAN. National Gallery, London. Pl. 61.

Canvas : 25 by 19½ inches (62·5 × 48·7 cm.).

Inscr. (at right, near ruff) ;

" FH (connected)
AETAT SVAE (the numbers cut off)
AN° 1633 "

Black silk doublet, white ruff (greenish shadows) ; ruddy cheeks ; brown hair, moustache, and chin tuft. Yellowish-grey background.

Condition : Cut down at right ; background rather thin.

Hist. : By the wish of Decimus Burton presented by his niece, Miss E. J. Wood, to the National Gallery in 1888.

Lit. :

1. HdG. 281.
2. Bode-Binder 139 Pl. 80a.
3. Kl.d.K. p. 105/110.
4. Cat. National Gallery, London, 1929, No. 1251.

44. MEETING OF THE OFFICERS OF THE CLUVENIERS–DOELEN IN HAARLEM. Frans Hals Museum, Haarlem. Pl. 62–65.

Canvas : 81½ by 131⅞ inches (207 × 337 cm.).

As a whole this group is less impressive than the earlier (Nos. 11, 31). The composition, as well as the colour scheme, is less uniform and balanced, but the portraits are beautifully painted and Hals's brushstroke attains a high grade of virtuosity.

Yellow-grey costumes with white or light-blue sashes ; black costumes with white, light-blue, or orange sashes ; white ruffs and cuffs. White, red, and yellow striped banner. Brownish background.

Condition : According to Van Dantzig[7], the leaves and the houses in the background are not by Frans Hals.

Dating : The year 1633 inscribed on the plaque.

Hist. :

Stadsdoelen, Haarlem[4].
Frans Hals Exhib., Haarlem, 1937, No. 45[6].

Lit. :

1. HdG. 434 (sight size).
2. Bode-Binder 137 Pl. 78 (sight size).
3. Kl.d.K. p. 101/107 (sight size).
4. Cat. Haarlem Museum, 1865, No. 49 (sight size).
5. Cat. Frans Hals Museum, Haarlem, 1924, No. 126.
6. Cat. Frans Hals Exhib., Haarlem, 1937, No. 45, repr.
7. Van Dantzig, Frans Hals, No. 17.

The *names* of the persons portrayed are : 1. Johan Claesz. Loo (Colonel), also on group No. 75 ; 2. Johan Schatter, also on group No. 11, 3. Cornelis Bakker, 4. Andries van der Horn, see also No. 71 (Captains) ; 5. Jacob Pieterszoon Buttinga, 6. Nicolaes Olycan, 7. Hendrik Pot, also on group 75 (Lieutenants) ; 8. Jacob Hofland, 9. Jacob Steyn (Ensigns) ; 10 Dirk Verschuil, 11. Baltes Boudaert, 12. Cornelis Janszoon Ham, 13. Hendrik van den Boom, 14. Barent Mol (Sergeants).

The disposition is :

	10	11		13	14	6
8 3		9	12			7
			2		4	
	1			5		

45. PORTRAIT OF A MAN. Museum Boymans, Rotterdam. Pl. 66, 67.

According to Kl.d.K.[3], a companion piece to No. 59.

Canvas ; 48⅝ by 37⅞ inches (123·5 × 95 cm.).

Black costume, white ruff and cuffs ; dark-blond hair, sandy beard and moustache, ruddy face ; gold ring with red stone. Light-grey background, slightly brown.

Dating ; HdG.[1] dates it *c.* 1640 ; Kl.d.K.[3]— *c.* 1635, because of the dated companion piece ; the catalogue of the Rotterdam museum suggests 1632. The costume worn by the model occurs as early as *c.* 1627 (see " Group " No. 31). According to the brushwork, the portrait may be placed among works of *c.* 1633 (*cf.* " Group " No. 44) or even later. The strength and severity of composition, the treatment of the costume, the hands, etc., places the Rotterdam picture much closer to " Feyntje van Steenkiste " (No. 58) than to his presumed companion piece, the " Woman " of the Frick Collection (No. 59). I see no decisive elements for a more precise dating than 1631–1635.

Hist. :

Sale, Rotterdam, Oct. 18, 1843, No. 24 (F.190.–Lamme) ; together with companion piece[1].
Sale A. de Beurs Stiermans (of Hamburg) and diff. prop., Rotterdam, Apr. 23, 1845, No. 48 (F.100.– rebought by Lamme) together with the companion piece[1].

Hist. :—*continued*.

Sale B. A. C. de Lange van Wyngaarden, Rotterdam, Apr. 22, 1846, No. 92[1] rebought.
Sale Mestern, Hamburg, 1865[1].
Acquired by the Museum, 1865[4].
Frans Hals Exhib., Haarlem, 1937, No. 58[5].

Lit. :

1. HdG. 313 (wrong size).
2. Bode-Binder 185 Pl. 116 (wrong size).
3. Kl.d.K. p. 125/136 (wrong size).
4. Cat. Museum Boymans, Rotterdam, 1927, No. 176, repr.
5. Cat. Frans Hals Exhib., Haarlem, 1937, No. 58, repr.
6. Van Dantzig, Frans Hals, No. 18.

46. PORTRAIT OF A MAN. Messrs. Wildenstein & Co., New York. Pl. 68.

Companion piece to No. 47.
Panel : 28¾ by 22 inches (73 × 56 cm.)[10].
Inscr. (at right, near the head) ;
 " AETA SVAE 48
 AN° 1634
 FH " (connected).
Black doublet, white ruff ; brownish-grey background.

Condition : Repaints in background, hand, costume. Monogram rather thin.

Hist. :

Coll. van der Willigen, Haarlem[2].
Coll. Weber, Hamburg (Cat. 1907, No. 223)[2].
Sale Weber, at Lepke's, Berlin, Febr. 20, 1912, No. 223[7].
Coll. Marcel von Nemes, Budapest[3].
Sale M. von Nemes, Paris, June 17, 1913, No. 53 (Fr.1,950.–)[8].
Coll. Baron M. L. Herzog, Budapest[4].
Exhib. Dusseldorf, 1904, No. 313[2].
Exhib. Frans Hals, Detroit, 1935, No. 23 (owner : Wildenstein)[9].
Exhib. Frans Hals, Haarlem, 1937, No. 50 (owner : Wildenstein)[10].
Exhib. Frans Hals, Schaeffer Gall., New York, 1937, No. 9 (owner : Wildenstein)[13].
Exhib. Rhode Island School of Design, Providence, 1938, No. 18 (owner : Wildenstein)[12].

Lit. and Sources :

1. Bode (1883) 111.
2. HdG. 280 (dated : 1624).
3. Bode-Binder 145 Pl. 85a (dated : 1624).
4. Kl.d.K. p. 117-124 (dated : 1634).
5. Valentiner, F. Hals in America, No. 46 (29 by 21 inches).
6. Les Arts, 1913, No. 138, repr.
7. Cat. Weber Sale, Berlin, 1912.
8. Cat. Nemes Sale, Paris, 1913.
9. Cat. Frans Hals Exhib., Detroit, 1935, No. 23.

Lit and Sources :—*continued*.

10. Cat. Frans Hals Exhib., Haarlem, 1937, No. 50, repr.
11. Van Dantzig, Frans Hals, No. 62 (" not by Frans Hals ").
12. Stechow, Dutch Painting in the 17th Century (Rhode Island Museum, Providence), 1938, No. 18, repr.
13. Cat. Exhib. Paintings by F. Hals, Schaeffer Gall., New York, 1937, No. 9.

47. PORTRAIT OF A WOMAN. The Detroit Institute of Arts, Detroit. Pl. 69.

Companion piece to No. 46.
Panel : 28 16/16 by 21⅞ inches (73·4 × 55·5 cm.).
Inscr. (at left, near the head, brown colour) :
 " AETA SVAE 34
 AN° . . . "
Black dress, white ruff and cap. Dark hair, brown eyes. Grey background.

Hist. :

Coll. Baron Albert von Oppenheim, Cologne[1, 7].
Sale Oppenheim, announced for Oct. 27, 1914, held at Lepke's, Berlin, March 19, 1918, No. 14 (Mk.230,000.–)[6].
Exhib. Dusseldorf, 1886, No. 131[1].
Exhib. Dutch Paintings, Detroit, 1925, No. 7[12].
Exhib. Frans Hals, Detroit, 1935, No. 24[9].
Exhib. Frans Hals, Haarlem, 1937, No. 51[10].
Exhib. Frans Hals, Schaeffer Gall., New York, 1937, No. 10[13].

Lit. and Sources :

1. HdG. 380.
2. Bode-Binder 157 Pl. 94a (wrong size).
3. Kl.d.K. p. 118/125 (dated 1635).
4. Valentiner, F. Hals in America, No. 47.
5. Cat. Oppenheim Coll., 1904, No. 13.
6. Cat. Oppenheim Sale, 1914 (1918), No. 14.
7. Cat. of Paintings, Detroit Institute of Arts, 1930, No. 92, repr. (dated 1635).
8. Cat. Exhib. of Dutch Paintings, Detroit, 1925, No. 7.
9. Cat. Frans Hals Exhib., Detroit, 1935, No. 24.
10. Cat. Frans Hals Exhib., Haarlem, 1937, No. 51, repr.
11. Van Dantzig, Frans Hals, No. 63 (" not by F. Hals ").
12. Records of the Frick Art Reference Library, New York.
13. Cat. Exhib. Paintings by F. Hals, Schaeffer Gall., New York, 1937, No. 10.

48. PORTRAIT OF A WOMAN. Stiftung Heylshof, Worms, Germany. Pl. 70.
Companion piece to No. 49.
Octagonal panel ; 25⅝ by 21⅝ inches (65 × 55 cm.).
Black dress, white ruff and cuffs ; white headgear.

Brown background. Black hair, dark-brown eyes. Yellow and brown spots in the fan.

Dating :

According to Kl.d.K.[3], between 1632 and 1634. Probably *c.* 1634 ; the ruff and headgear worn by the model occur more frequently on (dated) works of 1635 (*cf.* portraits by Rembrandt, Miereveld, etc.).

Hist. :

Sale Van Laanen, The Hague, Nov. 16, 1767, No. 28 (F.39.-)[1].

Coll. Sanderstead Court[1].

Coll. Henry Doetsch, London[1].

Sale Henry Doetsch, London, June 22, 1895, No. 372 (£200.- Shepard)[8].

Art Dlr. Ch. Sedelmeyer, Paris[5] ; sold to Heyl for Fr. or Mk. 43,225.-[8].

Coll. Freiherr von Heyl, Herrnsheim, Worms[1].

Exhib. : see companion piece.

Lit. and Sources :

1. HdG. 399.
2. Bode-Binder 132 Pl. 75a.
3. Kl.d.K. p. 99/104.
4. Swarzenski, Die Kunstsamml. im Heylshof zu Worms, 1927, No. 34, repr.
5. Sedelmeyer, Cat. of 100 Paintings, 1896, No. 17.
6. Cat. Frans Hals Exhib., Haarlem, 1937, No. 44, repr.
7. Van Dantzig, Frans Hals, No. 16.
8. Records of the Ryksbureau voor kunsthist. documentatie, The Hague.

49. PORTRAIT OF A MAN. Stiftung Heylshof, Worms, Germany. Pl. 71.

Companion piece to No. 48.

Octagonal panel ; 25⅝ by 21⅝ inches (65 × 55 cm.). Black doublet, white ruff and cuff ; ruddy cheeks, dark-grey eyes, black hair, dark-blond moustache and beard. Grey background, slightly brownish.

Dating : see companion piece.

Hist. :

Sale Van Laanen, The Hague, Nov. 16, 1767, No. 27 (F.40.-)[1].

Coll. Sanderstead Court[1].

Coll. Henry Doetsch[1] ; bought for £200.- through Mr. Carter[9].

Sale Henry Doetsch, London, June 22, 1895, No. 372 (£640.-)[1, 9].

Art Dlr. Ch. Sedelmeyer, Paris, 1895[1] ; sold to Heyl for Fr. or Mk. 43,910.-[9].

Coll. Freiherr von Heyl, Herrnsheim, Worms[1].

Exhib. Worms, 1902, No. 556 (owner : Heyl).

Exhib. Düsseldorf, 1904, No. 314 (owner : Heyl)[1]

Exhib. Berlin, 1906, No. 51 (owner : Heyl)[1, 6].

Exhib. Frans Hals, Haarlem, 1937, No. 43 (owner : Stiftung Heylshof)[7].

Lit. and Sources :

1. HdG. 326.
2. Bode-Binder 132 Pl. 75b.
3. Kl.d.K. p. 100/105.
4. Swarzenski, Die Kunstsammlung im Heylshof zu Worms, 1927, No. 33, repr.
5. Sedelmeyer, Cat. of 100 Paintings, 1895, No. 12.
6. Cat. Exhib. Silver Wedding Festival, Berlin, 1906, No. 51.
7. Cat. Frans Hals Exhib., Haarlem, 1937, No. 43, repr. 45.
8. Van Dantzig, Frans Hals, No. 15.
9. Records of the Ryksbureau voor kunsthistorische documentatie, The Hague.

The grain of the panel runs diagonally. The man looks to the left and the woman on the companion piece to the right. This is rather unusual with companion portraits of this period.

50. PORTRAIT OF A MAN. Kaiser-Friedrich-Museum, Berlin. Pl. 72.

Companion piece to No. 51.

Canvas : 29½ by 22⅞ inches (75 × 58 cm.). Black doublet and hat with grey lights ; white ruff and cuffs ; blond hair and moustache ; red stone in the ring. Light-grey background.

Condition : Restorations in left hand, hat, background.

Dating : HdG.[1] dates this portrait *c.* 1625. Kl.d.K.[3] states that the brushwork is similar to the 1626–1627 style, but that the costume of the companion portrait (No. 51) calls for a later date : 1631–1633. While accepting Kl.d.K.'s opinion that both portraits were painted later than suggested by HdG., I cannot find his way of demonstrating conclusive. Two companion portraits must not necessarily be painted the same year. The " Man's " costume can be found on Dutch portraits executed during the period 1625–1635. The dress of the " Woman " is of *c.* 1635. It seems quite possible that the portrait of the man was painted between 1633–1634 and the companion piece between 1634–1635. The catalogue of the Berlin museum suggests *c.* 1630 for both.

Hist. : Purchased 1840.

Lit. and Sources :

1. HdG. 253.
2. Bode-Binder 104 Pl. 55.
3. Kl.d.K. p. 94/98.
4. Cat. Kaiser-Friedr.-Museum, Berlin, 1931, No. 800.
5. Records of the Ryksbureau voor kunsthist. documentatie, The Hague.

Copies :

(*a*) " Portrait of Count Falkenstein," Coll. Bartlett, Boston (before 1910)[1].

(*b*) Art Dlr. Fritz Schneeberger, Bern, Switzerland, 1922. Panel : 9½ by 7⅜ inches (24 × 18.7 cm.)[5].

51. PORTRAIT OF A WOMAN. Kaiser-Friedrich-Museum, Berlin. Pl. 73.
Companion piece to No. 50.
Canvas : 29½ by 22⅞ inches (75 × 58 cm.).
Grey-black dress ; white collar, cuffs, and headgear ; gold necklace ; bracelets. Light-grey background.
Condition : Restorations in face and background.
Dating : See companion piece.
Hist. : Purchased 1841.
Lit. :
 1. HdG. 376.
 2. Bode-Binder 105 Pl. 56.
 3. Kl.d.K. p. 95/99.
 4. Cat. Kaiser-Friedr.-Museum, Berlin, 1931, No. 801.

52. PORTRAIT OF A MAN. Museum of Fine Arts, Budapest. Pl. 74.
Canvas : 31¾ by 27 1/16 inches (80.5 × 69 cm.).
Inscr. (at right, near head) :
 " AETA SVAE 26 (restored)
 AN° 1634 ".
Hist. :
 Coll. Maurice Kann, Paris[2].
 Art Dlr. F. Kleinberger, Paris (4).
 Acquired from Kleinberger, 1912 (Kr.234,860.–)[4].
 Exhib. Jeu de Paume, Paris, 1911, No. 61[4, 5] (owner : Kleinberger ; 87 × 68 cm.).
Lit. :
 1. HdG.—
 2. Bode-Binder 147 Pl. 86a.
 3. Kl.d.K. p. 84/86.
 4. Cat. Budapest Museum of Fine Arts, No. 501a.
 5. Cat. Exhib. Dutch Masters, Paris, 1911, No. 61.
 6. G. von Térey, Eine Zeichnung von Frans Hals (Kunstchronik, N. F., 1915, p. 469).
 7. Handzeichnungen alter Meister im Städelschen Kunstinstitut, Frankfurt a/M., 1914, Lief. XVII.
A *drawing*, probably *after* the portrait, is in the Städel Institute, Frankfurt, Germany[7]. G. von Térey published the drawing as a work by Frans Hals[6].

53. PORTRAIT OF A MAN. Mr. Julius Priester, Vienna, Austria. Pl. 75.
Panel : 27 3/16 by 23 1/16 inches (69 × 58.5 cm.).
Black brocaded doublet, white collar ; dark hair, blond moustache and chin tuft. Light-grey background.
Condition : over cleaned.
Dating : Kl.d.K.[3] dates it *c.* 1630. The style of the painting, as well as of the costume, is of somewhat later period, *c.* 1634 ; compare the " Man " in Budapest (No. 52), dated 1634.
Hist. :
 Coll. H. von Altenhaim, Vienna[3].
 Frans Hals Exhib., Haarlem, 1937, No. 37 (owner : Priester)[4].

Lit. :
 1. HdG.—
 2. Bode-Binder—
 3. Kld.K. p. 86/89.
 4. Cat. Frans Hals Exhib., Haarlem, 1937, No. 37, repr.
 5. Van Dantzig, Frans Hals, No. 12.

54. DANIEL VAN AKEN. Nationalmusei, Stockholm. Pl. 76.
Canvas : 26 by 22½ inches (66 × 57 cm.).
Brown-grey doublet with hat to match and white collar. Dark background.
Condition : The surface is rather thin ; numerous repaints in face, hat, background.
Dating : Kl.d.K.[3] dates this portrait between 1629 and 1630. The shape of the collar calls for a later date, about 1634 ; compare No. 49.
Hist. :
 Coll. Schlegel[1].
 Coll. Anckarswärd, 1844[1].
 Sale Gripenstedt, Stockholm, May 3, 1888[1].
 Purchased by the Museum in 1901 (Kr.33.500.–)[1].
 Frans Hals Exhibition, Haarlem, 1937, No. 35[7].
Lit. :
 1. HdG. 150.
 2. Bode-Binder 70 Pl. 37b.
 3. Kl.d.K. p. 73/76.
 4. Moes, Icon. Bat., No. 87.
 5. O. Granberg, Les Collections privées de la Suède, 1886, I., p. 115, No. 220.
 6. Cat. Nationalmusei Malningssamling, Stockholm, 1927, No. 1567.
 7. Cat. Frans Hals Exhib., Haarlem, 1937, No. 35, repr.
A *drawing* after this portrait, executed by Matthys van den Bergh, dated 1655, is in the Museum Boymans, Rotterdam. Drawn with pencil and traced with ink on white paper, 181 × 178 mm. ; signed in the lower right corner ; BERGH 1655 and inscribed by another hand : " . . . DAN van AKn' ".

55. SMALL PORTRAIT OF A MAN. Mauritshuis, The Hague. Pl. 77.
Panel : 9⅝ by 7 11/16 inches (24.5 × 19.5 cm.).
Black doublet with open sleeve ; white collar and shirt sleeves. Ruddy cheeks, dark hair, blond moustache and chin tuft, dark eyes. Light-grey background.
Dating : Kl.d.K.[3] *c.* 1636. Probably executed at the same period as the Dresden studies No. 56 and 57.
Hist. : Acquired from Art Dlr. Fred. Muller & Co., Amsterdam, 1898 (F.5,000.–)[4].
Lit. :
 1. HdG. 279.
 2. Bode-Binder 230.
 3. Kl.d.K. p. 146/155.
 4. Cat. Mauritshuis, The Hague, 1935, No. 618.

Copy : Art Dlr. D. Katz, Dieren, Holland, 1939 ; said
to have belonged to Madame L. de la Bégassière,
Paris, Canvas : 10¼ by 8½ inches (26 × 21·5 cm.).

56. SMALL PORTRAIT OF A MAN SEATED.
Staatliche Gemäldegalerie, Dresden. Pl. 78.
Companion piece to No. 57.
Panel : 9⅝ by 7⅝ inches (24·5 × 19·5 cm.).
Inscr. (of a later date ; in lower right corner) : " 2948 "
Yellow-grey doublet, white collar and cuffs, black hat.
Dark-blond hair, blond moustache and chin tuft.
Grey background. According to the inscription on the
Baillie engraving, a self portrait.

Dating : Bode[1] dates this portrait c. 1630 ; Kl.d.K.[4]:
c. 1636 ; the Dresden catalogue : c. 1635. It
seems that about this year there originated some
other small-sized portrait studies (No. 55-57).

Hist. :

There is a contradiction between the statement of
the Dresden catalogue asserting that the painting
entered the Dresden Gallery in 1741, having
previously been at the Wallenstein Collection,
Dux, and the inscription on the W. Baillie en-
graving of 1765, stating : " In the Collection of
John Blackwood Esqr." The portrait, which is
supposed to have remained in Dresden con-
tinuously since 1741, could not have been in the
Blackwood Coll. in 1765.
Frans Hals Exhib., Haarlem, 1937, No. 67.

Lit. :
 1. Bode (1883) 105.
 2. HdG. 271.
 3. Bode-Binder 232 Pl. 147a.
 4. Kl.d.K. p. 147/156.
 5. Cat. Staatl. Gemäldegalerie, Dresden, 1930,
 No. 1358.
 6. Cat. Frans Hals Exhib., Haarlem, 1937, No.
 67, repr. 69.
 7. Van Dantzig, Frans Hals, No. 20.

Engr. : By W. Baillie, 1765, in the reverse direction.
 Size : 288 × 285 mm. At Boston Fine Art
 Museum : four states. Inscr. : " W. Baillie
 sculp.—Franciscus Hals Pictor.—Se ipse pinxit
 [sic !]—In the Collection of John Blackwood
 Esqr."

Copies :
 (a) Panel : 9½ by 7½ inches (24 × 19 cm.)[9].
 Hist. : Sale James Orrock, London, June 4, 1904,
 No. 265 (£330.15.–)[11] ; in 1911 with the
 Munich Art Dlr. J. Böhler[8] ; c. 1914 Art Dlr.,
 Sulley & Co., London[9] ; Art Dlr. H. Ward,
 London[8] ; Sale Osborn Kling (of Stockholm),
 London, June 28, 1935, No. 29[12] ; Exhib.
 Burlington Fine Art Club, London, 1900, No.
 32.

Copies :—continued
 Lit. and Sources :
 8. Unpublished notes by Hofstede de Groot
 in RKD.
 9. Bode-Binder 233 Pl. 147b.
 10. Kl.d.K. Note to p. 147/156.
 11. Cat. Orrock Sale.
 12. Cat. Kling Sale.
 (b) In 1912 at Art Dlr. Kleinberger, Paris[8] ;
 later at Art Dlr. G. Neumans, Brussels and Paris[9].

57. SMALL PORTRAIT OF A MAN. Staatliche
Gemäldegalerie, Dresden. Pl. 79.
Companion piece to No. 56.
Panel : 9⅝ by 7⅞ inches (24·5 × 20 cm.).
Inscr. (of a later date ; lower right corner) : " 2947."
Black doublet, white collar and cuffs, black hat. Dark-
blond hair, blond moustache and chin tuft. Grey
background.

Dating : Kl.d.K.[4] c. 1636. Probably executed at
the same period as the companion piece No. 56.

Hist. :
 Coll. Wallenstein, Dux[5].
 In the Dresden Gallery since 1741[5].
 Frans Hals Exhib., Haarlem, 1937, No. 68[6].

Lit. :
 1. Bode (1883) 106.
 2. HdG. 272.
 3. Bode-Binder 231 Pl. 146b.
 4. Kl.d.K. p. 148/157.
 5. Cat. Staatl. Gemäldegalerie, Dresden, 1930,
 No. 1359.
 6. Cat. Frans Hals Exhib., Haarlem, 1937, No.
 68, repr. 70.
 7. Van Dantzig, Frans Hals, No. 21.

58. FEYNTJE VAN STEENKISTE, WIFE OF L.
DE CLERCQ. Ryksmuseum, Amsterdam. Pl. 80.
Companion piece to No. 22.
Canvas : 48 7/16 by 36⅝ inches (123 × 93 cm.).
Inscr. (at left, near head) : " AETAT SVAE 31
 AN° 1635 "

Black dress ; white gloves, collar, and cap. Dark-
brown hair, dark eyes. Chair of light-brown wood
with dark back. Light-brown background.
Hist. : Presented by the De Clercq family to the City
 of Amsterdam, 1891.

Lit. :
 1. HdG. 166.
 2. Bode-Binder 161 Pl. 97 (no size mentioned).
 3. Kl.d.K. p. 128/139 (wrong size).
 4. Moes, Icon. Bat., No. 7550.
 5. Cat. Ryksmuseum, Amsterdam, 1934, No. 1087.
 6. J. Six (Onze Kunst, 1916, Oct., Pl. 1 ; attri-
 butes the portrait to Judith Leyster).

59. PORTRAIT OF AN ELDERLY WOMAN.
The Frick Museum of Art, New York. Pl. 81.
According to Kl.d.K.[3], a companion piece to No. 45.
Canvas : 45⅛ by 35⅞ inches (114·4 × 91·3 cm.).
Inscr. (at left, near head) : " AETAT SVAE 56
 AN° 1635 "
Black silk dress with blue sheen ; black damask bodice ;
white cap, collar, and cuffs. Grey-brown background ;
at right a light vertical broad stripe. Ruddy face,
brown eyes, black hair. Chair of brown wood with
dark-blue back and red-lined pillow. Book with black
cover and pale pink edge.
Condition : Cleaned in 1939.
Hist. :

 Coll. J. Bernard, Amsterdam ; Sale Nov. 24,
 1834, No. 46 (F.160.– De Vries)[1].
 Sale, Rotterdam, Oct. 18, 1843 (see No. 45)[4].
 Sale A. de Beurs Stiermans (of Hamburg) and
 diff, prop., Rotterdam, Apr. 23, 1845[4], No. 48
 (see No. 45).
 Sale B. A. C. de Lange van Wyngaarden, Rotter-
 dam, Apr. 22, 1846, No. 92 (see No. 45)[5].
 Coll. D. P. Sellar, London ; Sale, Paris, June 6,
 1889, No. 36 (115 × 92 cm.)[1, 6].
 Coll. Charles Shiff, Paris, 1893[6].
 Coll. C. T. Yerkes, New York, Apr. 5, 1910, No.
 35 ($150,000.– Frick).
 Exhib. Royal Acad., London, Winter 1885, No.
 105 (owner : Sellar ; 44 by 35 inches or 111·7 ×
 89 cm. ; not 110 × 87·5 as stated by HdG[1]).
 Exhib. Boston Museum of Fine Arts, 1910, No. 5
 (owner : Frick)[6].
 Exhib. Art Dlr. Knoedler, New York, 1912, No. 41
 (owner : Frick)[6].

Lit. and Sources :
 1. HdG. 388 (wrong size) and 410.
 2. Bode-Binder 150.
 3. Kl.d.K. p. 126/137 (wrong size).
 4. Valentiner, Frans Hals in America, No. 49.
 5. Cat. Sale De Lange Wyngaarden, 1846.
 6. Records of the Frick Art Reference Library,
 New York.

60. NICOLAES HASSELAER. Ryksmuseum, Am-
sterdam. Pl. 82.
Companion piece to No. 61.
Canvas : 31⅛ by 26⅜ inches (79·5 × 66·5 cm.).
Black doublet, white collar and cuffs ; ruddy cheeks,
dark-blond moustache and beard, dark eyes. Chair of
brown-grey wood ; yellow cane. Brownish back-
ground.
Dating : Kl.d.K.[3] first edition : 1627–1630 ; second
 edition : 1632–1634. Compared with the dated
 portraits of 1635 (No. 58, 59), the Hasselaer
 portrait looks more mature. It could hardly have
 been painted before 1635.
Hist. : Presented to the Ryksmuseum by Jhr. J. S. R.
 van de Poll, 1885[1, 4].

Lit. :
 1. HdG 186 (wrong size ; erroneously called
 Dirk Pzn. Hasselaer).
 2. Bode-Binder 115 Pl. 63a (wrong size).
 3. Kl.d.K. p. 63/102 (wrong size).
 4. Cat. Ryksmuseum, Amsterdam, 1934, No.
 1089.
 5. J. Six (Onze Kunst, 1916, Oct. ; identifies the
 model as Nicolaes Hasselaer and not Dirk Pietersz.
 Hasselaer).
Biogr. : Born 1593, died 1635 ; was Mayor of the City
 of Amsterdam[4].

61. SARA WOLPHAERTS VAN DIEMEN,
SECOND WIFE OF NICOLAES HASSELAER.
Ryksmuseum, Amsterdam. Pl. 83.
Companion piece to No. 60.
Canvas : 31⅛ by 26⅜ inches (79·5 × 66·5 cm.).
Black dress with greenish-yellow pattern ; the open-
work sleeves show white silk. White collar and head-
gear. Brown hair, brown eyes. Light-brown back-
ground.
Dating : See companion piece.
Hist. : See companion piece.
Lit. :
 1. HdG 187 (wrong size ; erroneously called
 " Berchtje van Schooterbosch, wife of Dirk
 Hasselaer).
 2. Bode-Binder 116 Pl. 63b (wrong size).
 3. Kl.d.K. p. 64/103 (wrong size).
 4. Cat. Ryksmuseum, Amsterdam, 1934, No. 1090.
Biogr. : Born 1594, died 1667 ; second wife of N.
 Hasselaer (No. 60).

62. CLAES DUYST VAN VOORHOUT. Mr.
Jules S. Bache, New York. Pl. 84, 85.
Canvas : 32¾ by 26¾ inches (83 × 68 cm.).
Inscr. : The name of the model inscribed on the
 reverse side of the canvas.
Doublet of grey silk, white collar and cuffs, blueish-
black hat. Blond moustache and chin tuft, dark-
blond hair, grey-blue eyes. Background, dark-greenish-
grey on the left and yellowish-grey on the right.
Dating : Kl.d.K.[3] c. 1636.
Hist. :

 Coll. Colonel Egremont Wyndham, Petworth,
 1854[7].
 Coll. Lord Leconfield, Petworth[1].
 Art Dlr. Duveen Bros., New York[11].
 Exhib. of Dutch Art, London, 1929, No. 367
 (owner : Bache ; size : 31¾ by 26 inches, 80·5 ×
 66 cm.)[9].
 Exhib. Frans Hals, Detroit, 1935, No. 33 (owner :
 Bache)[11].
 Exhib. Frans Hals, Haarlem, 1937, No. 66 (owner :
 Bache)[12].
 Exhib. Masterpieces of Art, New York, 1939, No.
 174 (owner : Bache ; size : 31¾ by 26 inches)[13].

Lit. :
1. HdG. 176.
2. Bode-Binder 114 Pl. 62 (size : 96·5 × 67 cm.).
3. Kl.d.K. p. 145/154.
4. Valentiner, Frans Hals in America, No. 59.
5. Cat. of Paintings in the Bache Coll., New York, 1938, No. 34.
6. Colonel Egremont Wyndham, Cat. of Paintings at Petworth, 1850, No. 383[5].
7. Waagen, Treasures of Art in Great Britain, 1854, vol. III, p. 36.
8. C. H. Collins Baker, Cat. of the Pictures in Possession of Lord Leconfield (Petworth House), 1920, No. 383, repr.
9. Cat. Dutch Exhib., London, 1929, No. 367, repr. in Souvenir.
10. id. Commemor. Cat., p. 53.
11. Cat. Frans Hals Exhib., Detroit, 1935, No. 33.
12. Cat. Frans Hals Exhib., Haarlem, 1937, No. 66, repr. 68.
13. Cat. Masterpieces of Art Exhib., New York, 1939, No. 174.
14. Van Dantzig, Frans Hals, No. 19.

63. PORTRAIT OF A CAVALIER. Buckingham Palace, London. Pl. 86.
Study for No. 64.
Canvas : 24⅝ by 16½ inches (62·5 × 42 cm.).
Grey costume with matching hat ; yellow stockings and shoes ; dark-brown drapery in the background ; green-brown landscape with blue sky. The pleats of the costume marked with yellow.
Dating : According to Bode[1] c. 1628 ; according to Kl.d.K.[4] c. 1636.
Hist. : In the early 19th century at Kensington Palace, later at Hampton Court[2].
Lit. and Sources :
1. Bode (1883) 146.
2. HdG. 185 (wrong size).
3. Bode-Binder —
4. Kl.d.K. p. 143/152 (wrong size).
5. Cat. of Paintings at Hampton Court, 1898 No. 676.
6. L. Cust, The Royal Collection of Paintings, I. Buckingham Palace, 1905, repr.
7. L. Cust, Notes on pictures in the Royal Collections, XXXV : On a portrait sketch of a youth by F. Hals (Burlington Magazine, XXVIII, 1915–16, p. 186, repr.).
8. Unpublished notes by Hofstede de Groot in RKD.
Copy : Formerly at Art Dlr. F. Sabin, London ; later (1925) in the possession of Signor G. Camerino, Venice. According to Hofstede de Groot[8], " an old painting but not by the artist." Kl.d.K.[4] states : " hardly authentic." Canvas : 25⅝ by 17 inches (65 × 43 cm.).

64. WILLEM VAN HEYTHUYSEN. Liechtenstein Gallery, Vienna, Austria. Pl. 87.
Compare the study No. 63 (and the Frontis-piece).
Canvas : 80¾ by 53⅛ inches (205 × 135 cm.).
Black costume and hat, white ruff and cuffs ; purple drapery ; green landscape in the background.
Dating : Bode[1], 1630 ; HdG.[2], 1635 ; Kl.d.K.[4], c. 1636.
Hist. :
Sale G. W. van Oosten de Bruyn, Haarlem, Apr. 8, 1800[2] (F.50.–).
According to Frimmel[7], acquired about 1829 as a work by Bart. van der Helst. HdG's[2] statement that the picture was purchased in 1869 in Paris is a contradiction to the fact that a lithograph of it was made in Vienna as early as 1843.
Lit. :
1. Bode (1883) 123.
2. HdG. 191.
3. Bode-Binder 220 Pl. 140.
4. Kl.d.K. p. 144/153.
5. Moes, Icon. Bat., No. 3507, 1.
6. A. Kronfeld, Führer durch die Fürstl. Liechtensteinsche Gemälde Galerie, Wien, 1927, No. 75.
7. Th. Frimmel, Wann ist das Heythuysen Bildnis in die Liechtenstein Samml. gekommen ? (Blätter f. Gemäldekunde, Beilage, Lief. II, Mai 1907, p. 30).
Lithogr. by Robert Theer, Vienna 1843 ; inscr. " Barth. Helst pinx."
Copy : The photograph of a copy is at the Frick Art Reference Library, New York ; no details are recorded.

65. PIETER TJARCK. Mr. Harry Oakes, Nassau, Bahamas. Pl. 88.
Companion piece to No. 66.
Canvas : 33½ by 27⅝ inches (85 × 70 cm.)[8].
Black doublet and hat ; white falling collar ; dark hair, blond moustache and beard ; a pink rose with green leaves in his hand ; under his right elbow, the red back of a chair. Light-grey background.
Dating : Kl.d.K.[3] c. 1638.
Hist. :
Sale Comte d'Oultremont, Brussels, June 27, 1889, No. 3 (bought by Arnold & Tripp)[1, 5].
Art Dlrs. Arnold & Tripp, Paris[1].
Coll. Cuthbert Quilter, London[1].
Coll. Dowager Lady Quilter, Bawdsey Manor[2].
Exhib. Brussels, 1882[1], No. 86.
Exhib. Paris, 1889[1] (Exposition Mondiale).
Exhib. Royal Acad., London, Winter 1891, No. 69 (owner : Quilter)[1].
Exhib. of Portraits, The Hague, 1903, No. 36[1].
Exhib. of Dutch Art, London, 1929, No. 51 (owner : Sir Quilter)[6].

Hist. :—*continued.*

Exhib. Frans Hals, Haarlem, 1937, No. 75 (owner : Oakes)[8].

Exhib. Masterpieces of Art, New York, 1939, No. 182 (owner : Oakes)[9].

Lit. :

1. HdG. 231 (83 × 67·5 cm.).
2. Bode-Binder 178 Pl. 110 (size as HdG.).
3. Kl.d.K. p. 160/172 (size as HdG. ; owner : Quitler instead of Quilter).
4. Moes, Icon. Bat., No. 7993, 1 and 2.
5. Cat. Sale d'Oultremont, 1889, No. 3, repr.
6. Cat. Dutch Art Exhib., London, 1929, No. 51.
7. *id.* Commemor. Cat., p. 46.
8. Cat. Frans Hals Exhib., Haarlem, 1937, No. 75, repr. 76.
9. Cat. Masterpieces of Art Exhib., New York, 1939, No. 182.
10. Van Dantzig, Frans Hals, No. 35 (" by Verspronck with numerous corrections by Frans Hals ").

Copies :

(*a*) Museum, Liège, France[1] ; not in the Liège Cat. of 1904.

(*b*) A photograph of a copy, representing the model without the painted oval frame, was with a New York Art Dealer in 1939.

66. MARIA LARP, WIFE OF PIETER TJARCK. Misses Alexander, London. Pl. 89.

Companion piece to No. 65.

Canvas : 32½ by 26¼ inches (82·5 × 66·6 cm.).

Black dress, embroidered stomacher, white collar, cuffs, and cap. Light-grey background.

Dating : Kl.d.K.[3] *c.* 1638.

Hist. :

Coll. Mademoiselle de Wanenburg[6].

Coll. Comte d'Oultremont[6].

Sale Comte d'Oultremont, Brussels, June 27, 1889, No. 4 (bought by Arnold & Trip)[1, 5, 6].

Art Dlrs. Arnold & Trip, Paris[1].

Art Dlr. Colnaghi, London[6].

Coll. W. C. Alexander (bought from Colnaghi, 1891) [1]. Exhib. Brussels, 1882[1].

Exhib. Second National Loan Exh., London, 1913–1914, No. 66[6].

Exhib. of 17th Century Art, London, 1938, No. 135[6].

Lit. :

1. HdG. 232 (wrong size).
2. Bode-Binder 179 Pl. 111 (wrong size).
3. Kl.d.K. p. 141/173.
4. Moes, Icon. Bat., No. 4378.
5. Cat. d'Oultremont Sale, 1889, No. 4, repr.
6. Cat. 17th Century Art Exhib., London, 1938, No. 135, repr.

Copy : A copy, without the painted oval, was with the Art Dlr. D. Katz, Dieren, Holland, in 1939.

67. PORTRAIT OF A MAN. H.M. the King of Sweden, Royal Palace, Stockholm. Pl. 90.

Companion piece to No. 68.

Canvas : 31⅛ by 27⅞ inches (89 × 70 cm.)[5].

Inscr. (at right, near head) : " AETAT SVAE 38
 AN° 163·· "

Black costume and hat, white ruff and cuffs ; brown hair, moustache, and beard. Grey background.

Condition : The last digit of the year indistinct ; repaints in costume and shadows ; has probably suffered when relined.

Dating : Kl.d.K.[3] reads the inscribed date 1638.

Hist. :

Coll. Queen Joséphine[1].

Frans Hals Exhib., Haarlem, 1937[5].

Lit. :

1. HdG. 316 (size : 98 × 66 cm.).
2. Bode-Binder 171 Pl. 105a (size, as HdG.).
3. Kl.d.K. p. 161/174 (size, as HdG.).
4. O. Granberg, Les Trésors d'Art de la Suède, vol. I.
5. Cat. Frans Hals Exhib., Haarlem, 1937, No. 72, repr. 73.
6. Van Dantzig, Frans Hals, No. 59 (" not by Hals ").

68. PORTRAIT OF A WOMAN. H.M. the King of Sweden, Royal Palace, Stockholm. Pl. 91.

Companion piece to No. 67.

Canvas : 31⅛ by 27⅞ inches (89 × 70 cm.)[5].

Inscr. (at left, near shoulder) : " AETAT. SVAE 41
 AN° 1638 "

Black dress with gold embroidered stomacher ; white collar, cap, and cuffs. Grey background.

Condition : Seems to have suffered less than the companion piece.

Hist. : See companion piece.

Lit. :

1. HdG. 393 (size : 98 × 66 cm.).
2. Bode-Binder 172 Pl. 105b (size, as HdG.).
3. Kl.d.K. p. 162/175 (size, as HdG.).
4. O. Granberg, Les Trésors d'Art de la Suède, vol. I.
5. Cat. Frans Hals Exhib., Haarlem, 1937, No. 73, repr. 74.
6. Van Dantzig, Frans Hals, No. 60 (" not by Hals ").

69. PORTRAIT OF A MAN. Städelsches Kunstinstitut, Frankfort/Main. Pl. 92.

Companion piece to No. 70.

Oval panel : 37¼ by 27⅝ inches (94·6 × 70·2 cm.).

Inscr. (at right, near head) :
 " AETAT SVAE 44
 AN° 1638
 FH " (connected).

Black costume and hat ; white ruff and cuffs ; grey hair, moustache and beard. Grey background.

Condition : The inscription and the monogram seem
to have been retouched. Repaints in hat, costume,
shadow.
Hist. : Coll. J. F. Städel, Frankfort/Main.
Lit. :
 1. Bode (1883) 109.
 2. HdG. 276
 3. Bode-Binder 173 Pl. 106a.
 4. Kl.d.K. p. 163/176.
 5. Cat. Städelsches Kunstinstitut, No. 77.

70. PORTRAIT OF A WOMAN. Städelsches
Kunstinstitut, Frankfort/Main. Pl. 93.
Companion piece to No. 69.
Oval panel : 37 by 28 inches (94 × 71 cm.).
Inscr. (at left, near head) : " AETAT SVAE 4 . . .
 N 1638 "
Black dress ; white collar, cap, and cuffs ; dark back-
ground.
Condition : Not so good as companion piece.
Hist. : See companion piece.
Lit. :
 1. Bode (1883) 109.
 2. HdG. 378.
 3. Bode-Binder 174 Pl. 106b.
 4. Kl.d.K. p. 163/177.
 5. Cat. Städelsches Kunstinstitut, Frankfort/Main,
 No. 78.

71. ANDRIES VAN DER HORN. Messrs. D.
Katz, Dieren, Holland. Pl. 94.
Companion piece to No. 72.
Canvas : 34 by 26½ inches (86 × 67 cm.)[7] ; see
 differing sizes given by [3, 4, 5].
Inscr. (at right, near head) :
 " AETAT SVAE 38 (or 39)
 AN 1638 " (?)
Black costume and hat, white ruff and cuffs. Grey
background. Brown eyes, black hair, dark-blond
moustache and beard ; yellow cane. Coat-of-arms :
red escutcheon with three stars and a white wavy
stripe in azure field, bordered by straight yellow stripes.
Condition : Rather thin ; restoration in the forehead ;
 the brown varnish is only partly removed. The
 digits of the inscription are indistinct ; the " 38 "
 of the age could be a " 39 " ; the 1638 could be
 1639.
Hist. :
 Art Dlr. Arthur Seymour, London (whose father
 bought the portrait in Paris for £40.–)[1].
 Sale Arthur Seymour, London, Apr. 1, 1897, No.
 113 (Th. Agnew & Sons)[1].
 Coll. J. Pierpont Morgan, London[1] and New
 York[4].
 Exhib. Hudson-Fulton Celebration, New York,
 1909, No. 30 (owner : Morgan)[6].
 Exhib. of Dutch Art, London, 1929, No. 370
 (owner : Morgan)[7].

Lit. :
 1. HdG. 282.
 2. Bode-Binder 176 Pl. 108.
 3. Kl.d.K. p. 158/170 (size : 78·5 × 63·5 cm.).
 4. Valentiner, F. Hals in America, No. 64 (size :
 30 by 25 inches).
 5. Cat. J. P. Morgan Coll., London, 1907 (size :
 34 by 26 inches).
 6. Cat. Hudson-Fulton Exhib., New York, 1909,
 No. 30.
 7. Cat. Dutch Art Exhib., London, 1929, No.
 370, repr. in Souvenir.
 8. id. Commemor. Cat., repr. Pl. XXIV.
 9. K. Erasmus, Frans Hals and J. de Bray (Burl.
 Mag., Dec. 1939, p. 236, repr.).
The portrait was formerly called " Michiel de Wael "
[3, 4, 5]. K. Erasmus identified the model as A. van
der Horn[9].

Biogr. : Born 1600, married 1629 Maria Camersvelde,
 daughter of the Mayor of Leiden. Married a
 second time Maria Pietersdr. Olycan, daughter
 of the Mayor of Haarlem, July 25, 1638. Died
 1677. Held numerous offices in the communal
 administration of Haarlem and was Mayor of
 that city from 1660 till 1667. Hals painted him
 in the " Group " of 1633 (No. 44).

72. MARIA PIETERSDR. OLYCAN, WIFE OF
ANDRIES VAN DER HORN. Messrs. D. Katz,
Dieren, Holland. Pl. 95.
Companion piece to No. 71.
Canvas : 34 by 26½ inches (86 × 67 cm.)[7] ; see
 differing sizes given by [1, 3, 4, 5].
Black dress, white collar and cuffs, dark-blond hair,
black bonnet. Grey (?) fan ; gold earrings on red
ribbons. Grey background.
Condition : The fan seems to have been coloured ; the
 colours disappeared perhaps as a result of blistering;
 at present the fan looks grey. See note on con-
 dition of companion piece.
Dating : HdG.[1] dates it 1635–1640 ; Kl.d.K.[3]
 1638, like companion portrait.
Hist. :
 Art Dlr. Dowdeswell & Dowdeswell, London (who
 is said to have bought the picture on the Isle of
 Wight from the owner whose grandfather was
 cook for King George IV)[1] ; see also [5].
 Art Dlr. Ch. Wertheimer, London [1].
 Art Dlr. Ch. Sedelmeyer, Paris[1].
 Art Dlr. Th. Agnew & Sons, London[1].
 Coll. J. Pierpont Morgan, London[1] and New
 York[4].
 Exhib. Royal Acad., London, Winter 1903, No. 45
 (owner : Morgan)[1].
 Exhib. Hudson-Fulton Celebration, New York,

Hist. :—*continued.*

1909, No. 31 (owner : Morgan)[6].

Exhib. of Dutch Art, London, 1929, No. 371 (owner : Morgan)[7].

Lit. :

1. HdG. 384 (size : 78·7 × 63·7 cm.).
2. Bode-Binder 177 Pl. 109.
3. Kl.d.K. p. 159/171 (size : 78·5 × 63·5 cm.).
4. Valentiner, F. Hals in America, No. 65 (size : 30 by 25 inches).
5. Cat. J. P. Morgan Coll., London, 1907 (size : 31½ by 25½ inches. " About 1893 offered at a small sale on the Isle of Wight for less than £20.- to a London dealer "). See also [1].
6. Cat. Hudson-Fulton Exhib., New York, 1909, No. 31.
7. Cat. Dutch Art Exhib., London, 1929, No. 371, repr. in Souvenir.
8. *id.* Commemor. Cat., repr. Pl. XXIV.

Note and Biogr. : see companion piece.

73. MARITGE CLAESDR. VOOGT. Ryksmuseum, Amsterdam. Pl. 96.

Canvas : 50⅜ by 37¼ inches (128 × 94·5 cm.).

Inscr. (at right, near head) : " AETAT SVAE 62
AN° 1639 "

Black dress with grey pattern, gold buttons, brown fur ; white collar, cap, and cuffs. Grey-brown background. Book in black cover with silver clasps and gold edges. Chair of brown wood with red back. Coat-of-arms, suspended on light-blue ribbon, shows white and black swans with red legs on black and ochre fields.

Condition : Excellent, minor restorations on left hand.

Hist. :

Sale, Amsterdam, Nov. 24, 1834.
Coll. Van der Hoop, Amsterdam[1].
Bequeathed to the City of Amsterdam, 1885 ; lent to the Ryksmuseum[1].

Lit. :

1. HdG. 212.
2. Bode-Binder 182 Pl. 114.
3. Kl.d.K. p. 170/181.
4. Moes, Icon. Bat., No. 8653, 1.
5. Cat. Ryksmuseum, Amsterdam, 1934, No. 1088.

Biogr. : Born 1577, died 1644. Wife of Pieter Jacobsz. Olycan. Compare portraits of other members of the Olycan family painted by Frans Hals ; Nos. 18, 72, and on the " Groups " Nos. 31, 44.

74. PORTRAIT OF AN OFFICER. National Gallery of Art, Washington, D.C. Pl. 97.

Canvas : 33 by 26½ inches (83·8 × 67·2 cm.).

Yellowish jacket, steel breastplate, red sash ; black hat. Greenish landscape, grey wall.

Condition : Forehead and left eyelid suffered from strong cleaning.

Dating : Bode[1] dates it *c.* 1635 ; Kl.d.K.[4] suggests a much later date, 1646–1647 (in the first edition) and 1648 (in the second edition). In another publication[5] W. R. Valentiner, the author of Kl.d.K., states, however, that this portrait has " more colour than other works of this period." This is quite true and by his style as well as colouring the picture is closely related to the " Group " of 1639 (No. 75).

Hist. :

Hermitage, Leningrad ; acquired by Catherine II.
Coll. Andrew W. Mellon, Washington, D.C.

Lit. and Sources :

1. Bode (1883) 131.
2. HdG. 310.
3. Bode-Binder 214 Pl. 137.
4. Kl.d.K. p. 222/235.
5. Valentiner, Frans Hals in America, No. 92.
6. Waagen, Ermitage, 1870, p. 172 (" very excellent ").
7. Cat. Hermitage, St. Petersburg, 1901, No. 773.

75. OFFICERS OF THE ST. JORIS-DOELEN (THE CIVIC GUARDS OF ARCHERS OF ST. GEORGE), HAARLEM. Frans Hals Museum, Haarlem. Pl. 98–102 and 152.

Canvas : 81¾ by 165¼ inches (218 × 421 cm.).

Inscr. (on the plaque) : " Officieren van de St. Joris Doelen afgegaen 1639 ". (Officers of the St. Joris-Doelen, retired 1639).

In colouring and composition the least interesting of the eight Haarlem group portraits. The composition is merely a grouping of the officers in two rows. Black costumes and hats in the first row, except the yellowish costume of the treasurer. Yellowish and black costumes in the upper row. Orange and light-blue sashes and banners. Orange prevails on the left side of the picture, light-blue on the right. Brownish landscape, grey sky. The second head from the left in the upper row is a self-portrait by Frans Hals (cf. Plate 152).

Hist. :

Stadsdoelen, Haarlem.
Frans Hals Exhib., Haarlem, 1937, No. 76.

Lit. :

1. HdG. 435 (sight size).
2. Bode-Binder 180 Pl. 112 (sight size).
3. Kl.d.K. p. 167/180.
4. Cat. Haarlem Museum, 1865, No. 50 (sight size).
5. Cat. Frans Hals Museum, Harlem, 1924, No. 127.
6. Cat. Frans Hals Exhib., Haarlem, 1937, No. 76, repr.
7. Van Dantzig, Frans Hals, No. 22 (" background not by Hals ").

The *names* of the persons portrayed are : (1) Johan
van Loo (Colonel) ; (2) Michiel de Wael (Treasurer) ;
(3) Quiryn Damast, (4) Florens van der Hoef, (5)
Nicolaas Grauwert (Captains) ; (6) Hendrik Pot, (7)
Francois Wouters, see also " Group " No. 81, (8)
Cornelis Coning, (9) Hendrik Coning (Lieutenants) ;
(10) Dirk Dirx, (11) Lambert Woutersz., (12) Pieter
Schout, (13) Mr. Jacob Druyvesteyn (Ensigns) ; (14)
Gabriel Loreyn, (15) Lucas van Tettrode, (16) Nicolaas
van Loo, (17) Cornelis Symonsz. van der Schalken, (18)
Pieter de Jong (Sergeants) ; (19) Frans Hals (Painter).
Disposition :

18		19 13	6 16 17 9									
	11	14 1	7	2	8	4	5	15	3	10	12	

76. PORTRAIT OF A YOUNG MAN. Hermi-
tage, Leningrad. Pl. 103.
Canvas : 33⅛ by 26½ inches (84 × 67 cm.).
Monogr. (at right, near head) : " FH " (connected).
Black costume and hat ; white collar ; blond hair and
moustache ; yellowish gloves. Dark-grey background.
Condition : Enlarged by adding strips of canvas at the
 sides and on top[5].
Dating : Bode[1] dates it 1650 ; HdG.[2], 1640 ;
 Kl.d.K.[4], 1642. Similar costumes can be
 found in the " Group " of 1639 (No. 75) as well as
 in that of 1641 (No. 81). The style seems, how-
 ever, more related to the 1639 group than to that
 of 1641 or even to the Cologne portrait of 1640
 (No. 79).
Hist. : Acquired by Catherine II.
Lit. :
 1. Bode (1883) 129.
 2. HdG. 308.
 3. Bode-Binder 194 Pl. 123a.
 4. Kl.d.K. p. 183/197.
 5. Cat. Hermitage, St. Petersburg, 1901, No. 771.
 6. Waagen, Ermitage, 1870, p. 172.

77. PORTRAIT OF A YOUNG MAN. Kunst-
historisches Museum, Vienna, Austria. Pl. 104.
Canvas : 31 by 26¼ inches (78·5 × 66·5 cm.)[5].
Black costume and hat, white collar ; dark-blond hair.
Grey background.
Condition : The picture was cut down to oval and has
 recently been reformed to its rectangular shape.
 The surface has suffered a good deal.
Dating : Bode[1] and HdG.[2] date it *c.* 1650 ;
 Kl.d.K.[4] suggests in the first edition : 1638–
 1640 ; in the second edition : 1635–1638. It
 must have been executed at about the same time
 as the Leningrad portrait No. 76.
Hist. :
 Stallburg, Vienna[5].
 Belvedere, Vienna[3].
 Frans Hals Exhib., Haarlem, 1937, No. 74[6].

Lit. :
 1. Bode (1883) 121.
 2. HdG. 321 (wrong size).
 3. Bode-Binder 195 Pl. 123b.
 4. Kl.d.K. p. 165/178 (wrong size).
 5. Cat. der Gemälde Galerie d. Kunsthistor.
 Museums, Wien, 1938, No. 1297.
 6. Cat. Frans Hals Exhib., Haarlem, 1937, No.
 74, repr. 75.
 7. Van Dantzig, Frans Hals, No. 76 (" not by
 Hals ").

78. PORTRAIT OF A MAN. National Gallery,
London. Pl. 105.
Canvas ; 30½ by 26¼ inches (77 × 66 cm.).
Black costume and hat ; white collar ; yellowish
gloves. Blond moustache and chin tuft, dark eyes.
Greenish-grey background. Almost monochrome.
Dating : HdG.[1] dates it 1640–1650 ; Kl.d.K.[3]
c. 1640.
Hist. :
 Sale Cholmondeley and diff. prop., London, Feb.
 1, 1902, No. 40 (£3,780.– Agnew)[1].
 Coll. George Salting, London (bought from Agnew,
 1902)[1].
 Salting Bequest, 1910[4].
Lit. :
 1. HdG. 289.
 2. Bode-Binder 190 Pl. 120a.
 3. Kl.d.K. p. 176/190.
 4. Cat. National Gallery, London, 1929, No. 2528.

79. PORTRAIT OF A MAN. Wallraf-Richartz-
Museum, Cologne. Pl. 106.
Companion piece to No. 80.
Canvas : 47⅝ by 38 inches (121.2 × 96.4 cm.).
Black costume and hat ; white collar. Grey back-
ground.
Condition. Corroded varnish.
Dating : 1640 as the (dated) companion piece.
Hist. :
 Perhaps the No. 71 of the Huybert Ketelaar Sale,
 Amsterdam, June 19, 1776 (size : 104 × 92.5 cm.)
 [1].
 Coll. Hobson, Rugby[1].
 Art Dlr. Lesser, London[1].
 Art Dlr. Orrick, London[1].
 Art Dlr. Colnaghi, London[1].
 Coll. A. von Carstanjen, Berlin[1].
 Lent to the Alte Pinacothek, Munich.
 Lent to the Wallraf-Richartz-Museum, Cologne.
 Purchased with the Carstanjen Collection, 1936.
 Exhib. Dusseldorf, 1904, No. 316[1].
 Exhib. Frans Hals, Haarlem, 1937, No. 82[5].
Lit. :
 1. HdG. 256 (wrong size).
 2. Bode-Binder 186 (not 117 as stated by [5]),
 Pl. 117.

Lit. :—*continued*

3. Kl.d.K. p. 173/186 (wrong size).
4. Wegweiser (Guide) Wallraf-Richartz-Museum, Cologne, 1936, No. 2529.
5. Cat. Frans Hals Exhib., Haarlem, 1937, No. 82, repr. 80.
6. Van Dantzig, Frans Hals, No. 24.

80. PORTRAIT OF A WOMAN. Wallraf-Richartz-Museum, Cologne. Pl. 107.
Companion piece to No. 79.
Canvas : 47$\frac{3}{8}$ by 37$\frac{5}{8}$ inches (121.3 × 95.6 cm.).
Inscr. (at left, near head) :
" AETA SVAE 32
 AN 1640
 FH „ (connected).
Black dress ; white collar and cap ; yellowish gloves. Grey background.
Condition : See companion piece.
Hist. :

See companion piece.
Perhaps No. 72 of the Ketelaar Sale (F.145.– Yver) (size : 104 × 92.5 cm.)[1].
Exhib. Dusseldorf, No. 317[1].
Exhib. Frans Hals, No. 81[5].

Lit. :

1. HdG. 368 (wrong size).
2. Bode-Binder 187 Pl. 118 (wrong size).
3. Kl.d.K. p. 174/187 (wrong size).
4. Wegweiser (Guide) Wallraf-Richartz-Museum, Cologne, 1936, No. 2530.
5. Cat. Frans Hals Exhib., Haarlem, 1937, No. 81, repr.
6. Van Dantzig, Frans Hals, No. 23.

81. GOVERNORS (" REGENTEN ") OF THE ST. ELISABETH HOSPITAL, HAARLEM. Frans Hals Museum, Haarlem. Pl. 108–111.
Canvas : 60 by 99 inches (153 × 252 cm.).
Much more mature than the previous groups (Nos. 4, 11, 31, 44, 75). Composition and colour scheme are perfectly balanced. The black-and-grey gamma dominates ; black costumes, grey wall ; white collars and cuffs ; green table-cloth ; dark-red-backed chairs and dark-red edges of the book.
Condition : Restorations in the hand on the book[7].
Dated (on the frame) : 1641.
Hist. :

St. Elisabeth Gasthuis (Hospital), Haarlem[5].
Frans Hals Exhib., Haarlem, 1937, No. 84[6].
Lit. and Sources :
1. HdG. 436 (sight size).
2. Bode-Binder 196 Pl. 124 (sight size).
3. Kl.d.K. p. 180/194 (sight size).
4. Cat. Haarlem Museum, 1865, No. 51 (sight size).
5. Cat. Frans Hals Museum, Haarlem, 1924, No. 128.

Lit. and Sources :—*continued*.

6. Cat. Frans Hals Exhib., Haarlem, 1937, No. 84, repr.
7. Van Dantzig, Frans Hals, No. 25.
8. Records of the Ryksbureau voor kusthistor. documentatie, The Hague.
The *names* of the persons represented are (from right to left) ; 1. Francois Wouters, see also " Group " No. 75 ; 2. Dirk Dirks Del ; 3. Johan van Clarenbeek ; 4. Salomon Cousaert ; 5, Sivert Sem Warmont.
Copies :

(*a*) Watercolour by W. Hendriks after Frans Hals. Sale P. Yver, Amsterdam, March 31, 1788, No. 5 (F.22.– Van der Schley)[8].
(*b*) Drawing by De Bray " Meeting of the Men Guardians " (Regenten), Indian ink ; Sale L. van Ouderkerke, Haarlem, May 19, 1818, No. 2[8].
(*c*) Coloured drawing by W. Hendriks after Frans Hals. Sale, Amsterdam, Febr. 14, 1855, No. 8 (F.90.– Vos)[8].
(*d*) Watercolour by W. Hendriks. Museum Teylor, Haarlem (W. 41–45).
(*e*) Drawing at the Albertina, Vienna[3].
The copies (*a*), (*c*) and (*d*) are probably identical.

82. PORTRAIT OF A MAN. Staatliche Gemäldegalerie, Cassel. Pl. 112.
Companion piece to No. 83.
Panel : 11$\frac{7}{8}$ by 9$\frac{1}{16}$ inches (30 × 23 cm.).
Black doublet and hat, white collar and cuffs ; blond hair, sandy moustache and chin tuft. Dark background.
Dating : Bode[1] dates it *c.* 1655 ; HdG.[2], *c.* 1650 ; Kl.d.K.[4], 1646–1647. The shape of hat and collar as well as of the hair-dress point more to an earlier date. Although the brushwork is broader than on the 1641 group (No. 81), it is no proof of a later date but can be explained by the sketchy character of the study. A series of similar portrait studies was probably executed between 1641 and 1644 (Nos. 83, 84, 88).
Hist. : Altstadt Castle, Cassel, 1783, No. 213[2].
Lit. and Sources :
1. Bode (1883) 103.
2. HdG. 267.
3. Bode-Binder 215 Pl. 138a.
4. Kl.d.K. p. 220/232.
5. Cat. Staatl. Gemäldegalerie, Kassel, 1929, No. 218.
6. First Supplement to the " Hauptinventar " of 1749, No. 1071[2].

83. PORTRAIT OF A MAN. Staatliche Gemäldegalerie, Cassel. Pl. 113.
Companion piece to No. 82.
Panel : 11$\frac{7}{8}$ by 9$\frac{1}{16}$ inches (30 × 23 cm.).

Black dress and hat ; white collar, cuffs, and gloves.
Blond hair and moustache. Grey background.
Dating : See No. 82.
Hist. : Altstadt Castle, Cassel, 1783, No. 212[2].
Lit. and Sources :
 1. Bode (1883) 102.
 2. HdG. 266.
 3. Bode-Binder 216 Pl. 138b.
 4. Kl.d.K. p. 221/233.
 5. First Supplement to the " Hauptinventar " of
 1749, No. 1070[2].

84. PORTRAIT OF A MAN. Mrs. J. Goekoop-de
Jongh, Breda, Holland. Pl. 114.
Canvas mounted on panel : 25¾ by 18⅞ inches (65.5 ×
 48 cm.).
Monogr. (at right, near hand) : " FH " (connected).
Black doublet (greenish lights) and matching hat ;
white collar ; ruddy cheeks, blond moustache and
beard ; yellowish coloured hand. Yellowish
cover and red edges of the book. Greenish-brown
background.
Condition : Numerous restorations. The monogram
 is retouched and may be a later addition.
Dating : Kl.d.K.[2] dated it c. 1645. It can easily be
 ranged among the series of portraits executed
 between 1641 and 1644.
Hist. :
 Coll. James Simon, Berlin ; Sale Berlin, March 20,
 1900, No. 65[1].
 Art Dlr. Kleinberger, Paris[1].
 Art Dlr. Sulley & Co., London[1].
 Coll. Preyer, The Hague[3].
 Exhib. Haarlem, July-Oct. 1919[5].
 Exhib. Art Dlr. Kleykamp, The Hague, 1926, No.
 16[6].
 Exhib. Frans Hals, Haarlem, 1937, No. 92 (owner :
 Goekoop-de Jongh)[7].
 Exhib. Rotterdam (Queen's Jubilee), 1938, No. 82
 (owner : Goekoop-de Jongh)[8].
Lit. and Sources :
 1. HdG. 290.
 2. Kl.d.K. p. 211/224.
 3. Valentiner, F. Hals in America, No. 81 (lists
 the picture as being at the Walters Gallery, Balti-
 more, where actually there is only a copy of the
 portrait. The history is given of the original.
 The reproduction, as far as I can see, is also of
 the original).
 4. Cicerone, Febr. 1913.
 5. Jaarverslag Frans Hals Museum, Haarlem, 1919.
 6. Cat. Exhib. at Kleykamp's, The Hague, 1926,
 No. 16.
 7. Cat. Frans Hals Exhib., Haarlem, 1937, No. 92,
 repr.
 8. Cat. Jubilee Exhib., Rotterdam, 1938, No. 82.
 9. Van Dantzig, Frans Hals, No. 28.

Copy : Walters Art Gallery, Baltimore. Canvas :
 25 by 19 inches (63.5 × 48.2 cm.). Purchased as
 an original ; actually catalogued as copy ; stored.

85. PORTRAIT OF A MAN. The Metropolitan
Museum of Art, New York. Pl. 115.
Canvas : 47⅛ by 37 inches (119.8 × 94 cm.)[5] ; see
 differing sizes given by [1, 3].
Inscr. (at right, near head) :
 " AETAT SVAE 37
 AN° 1643
 FH " (connected).
Black costume and hat ; white collar and cuffs, cream-
coloured gloves ; dark hair, brown eyes. Light grey-
brown background.
Hist. :
 Sale Ad. Jos. Bösch, Vienna, Apr. 28, 1885, No. 20
 (F.14,010.– Kaiser)[1].
 Coll. Mrs. C. P. Huntington, New York[5].
 Given to the Museum in 1926[5].
 Exhib. Hudson-Fulton Celebration, New York,
 1909, No. 35[6].
 Exhib. Frans Hals, Detroit, 1935, No. 38[7].
Lit. :
 1. HdG. 360 (size : 116 × 69 cm.).
 2. Bode-Binder 273 (not 282 as stated by [5]),
 Pl. 179.
 3. Kl.d.K. p. 192/208 (size : 115·7 × 87·6 cm.).
 4. Valentiner, F. Hals in America, No. 74.
 5. Cat. of the Paintings, Metropolitan Museum,
 New York, 1931, No. H.16–7.
 6. Cat. Hudson-Fulton Exhib., New York, 1909,
 No. 35.
 7. Cat. Frans Hals Exhib., Detroit, 1935, No. 38.

86. PORTRAIT OF A WOMAN. Mrs. Charles
S. Payson, New York. Pl. 116.
Companion piece to No. 87.
Canvas : 31½ by 25⅝ inches (80 × 65 cm.), sight size.
Inscr. (at left, near ruff) : " AETAT SVAE 52
 AN° 1643 "
Black dress trimmed with brown fur ; white ruff and
bonnet ; dark-brown hair and eyes ; yellowish gloves.
Brown background, dark at left, light at right.
Condition : The painting of forehead, lips, neck is
 rather thin. The inscription is probably restored.
 The type of letters and digits is different from the
 one used by Hals during this period.
Hist. :
 See companion piece.
 Senff Sale, 1928, No. 25[5] ($55.000.– Knoedler)[6].
Lit. and Sources :
 1. HdG. 402 (described after the Waldorp drawing
 and the Cat. of the Merkman Sale).
 2. Bode-Binder 200 Pl. 127b.
 3. Kl.d.K. p. 191/203.
 4. Valentiner, Frans Hals in America, No. 70.

Lit. and Sources :—*continued*.

5. Cat. Senff Sale, New York, March 28, 1928, No. 25.

6. Records of the Frick Art Reference Library, New York.

A *drawing* by J. G. Waldorp after this portrait is in the Amsterdam Print Room. It is signed ; " FHals pinx. 1643.—J. G. Waldorp del. 1780." Black chalk on parchment : 310 × 250 mm. Same provenance as the drawing after the companion piece.

87. MAN HOLDING A WATCH. The Barnes Foundation, Merion, Penns. Pl. 117, 118a.
Companion piece to No. 86.
Canvas : 32⅜ by 26¼ inches (82·2 × 66·2 cm.).
Inscr. (at right, near shoulder) :

" AETAT SVAE 57
AN° 1643 "

Black costume and hat, white collar ; grey beard and moustache, dark-grey hair. Grey background. Gold watch. The attention of the spectator is first attracted to the face and the watch.

Condition : Cleaned shortly after 1928[7]. Restorations in hat, hair, costume, background. The inscription appears retouched. The type of letters and digits is different from the one used by Hals during this period.

Hist. :

Sale Widow Merkman, née J. van Leeuwaerden, Haarlem, Sept. 21, 1773, No. 5[1].
Coll. Comte d'Espeilles[5].
Art Dlr. Durand-Ruel, New York, 1889[5].
Coll. Ch. H. Senff, New York[5].
Sale Mrs. Ch. H. Senff, at Anderson Galleries New York, March 28, 1928, No. 26[5] ($47,500.- Barnes)[6].

Lit. and Sources :

1. HdG. 332 (describes the picture after the drawing by Waldorp and the cat. of the Merkman Sale).
2. Bode-Binder 199 Pl. 127a (wrong size).
3. Kl.d.K. p. 191/203.
4. Valentiner, Frans Hals in America, No. 69 (wrong size).
5. Cat. Senff Sale, New York, March 28, 1928.
6. Records of the Frick Art Reference Library, New York.
7. Information from Dr. A. C. Barnes.

A *drawing* by J. G. Waldorp after this portrait is in the Amsterdam Print Room. It is signed ; " FHals pinx 1643.—J. G. Waldorp del. 1780 ". Black chalk on parchment : 310 × 266 mm. Sale Carl Schoeffer, Amsterdam, May 30, 1893, No. 457 ; Sale Jhr. Alfred Boreel and diff. prop., Amsterdam, June 15, 1908, No. 653 (bought by the Amsterdam Print Room).

88. PORTRAIT OF A MAN. Ryksmuseum, Amsterdam. Pl. 118b, 119.
Panel : 14½ by 11¾ inches (37 × 29·8 cm.).
Monogr. (at right, near shoulder) : " FH " (connected).

Black costume and cap, white collar ; dark-blond hair, blond moustache and chin tuft. Grey background.

Dating : Kl.d.K.[3] dates it 1653–1655. The costume as well as the technic is, however, more closely related to the works of 1641–1644. Compare Nos. 82, 83.

Hist. :

Purchased from Mr. J. B. Luyckx, Hilversum, Holland, 1916 (F.30,000.–)[7].
Exhib. Pittura Olandese, Rome, 1928, No. 43[8].
Exhib. Frans Hals, Haarlem, 1937, No. 106[5].

Lit. and Sources :

1. HdG.—
2. Bode-Binder —
3. Kl.d.K. p. 254/269.
4. Cat. Ryksmuseum, Amsterdam, 1934, No. 1090-a.
5. Cat. Frans Hals Exhib., Haarlem, 1937, No. 106, repr.
6. Van Dantzig, Frans Hals, No. 69 (" School of Rembrandt ").
7. M. D. H. (Henkel), Ein neuer Frans Hals im Ryksmuseum (Kunstchronik, N. F., 1916, p. 359.
8. Records of the Frick Art Reference Library, New York.

When purchased from Mr. Luyckx, a calendar was pasted on the painting[7].

89. PORTRAIT OF A MAN. Baron Louis von Rothschild, Vienna, Austria (1938). Pl. 120.
Canvas : 42⅜ by 31 inches (107·5 × 78·7 cm.)[1].
Black costume and hat. White collar. Grey background.

Dating : Kl.d.K.[3] dates it as late as 1649–1650. I see more correspondence to the (dated) portrait of the Metropolitan Museum (No. 85) of 1643.

Hist. :

Sale J. H. C. (Cremer), Brussels, Nov. 25–26, 1868, No. 31 (Fr.5,900.– Sedelmeyer)[1, 4].
Sale Gsell, Vienna, March 14, 1872, No. 3, (Kr.25,000.– Sedelmeyer)[1, 5].
Coll. G. R. von Epstein, Vienna, 1873[1].
Art Dlr. Ch. Sedelmeyer, Paris[1].
Coll. Baron Albert von Rothschild, Vienna[1].
Exhib. Vienna, 1873, No. 103[1].

Lit. and Sources :

1. HdG. 322.
2. Bode-Binder 248 Pl. 157.
3. Kl.d.K. p. 233/246.
4. Priced Cat. of the J. H. C. Sale, Brussels, 1868 (at the Frick Art Reference Library, New York).

Lit. and Sources :—*continued.*

5. Priced Cat. of the Gsell Sale, Vienna, 1872 (*ibid*).

6. Sedelmeyer, Cat. of 300 Paintings, No. 52.

90. **MARIA VERNATTI.** Mrs. Catalina von Pannwitz, Heemstede near Haarlem. Pl. 121.

Panel : 13¾ by 11 inches (35 × 28 cm.).

Black dress ; white cap, collar, and cuffs. Warm grey background. Black hair, brown eyes, ruddy cheeks. Gold bracelets and necklace. Black fan with grey-and-red ribbon.

Dating : Kl.d.K.[3] dates it *c.* 1644. The collar and head-gear worn by the model occur more frequently at *c.* 1650. The style of the painting, especially the treatment of the pleats, points to an earlier period. The date of 1644–1650 suggested here is hypothetical.

Hist. :

Coll. Earl of Gainsborough (according to an inscription on the reverse side of the panel).

Coll. C. von Hollitscher, Berlin[4],

Exhib. Frans Hals, Haarlem, 1937, No. 87 (owner : Pannwitz)[6].

Lit. :

1. HdG.—
2. Bode-Binder 236 Pl. 149.
3. Kl.d.K. p. 201/215.
4. Cat. Coll. C. von Hollitscher, Berlin, No. 41.
5. Cat. Coll. C. von Pannwitz, Heemstede, vol I, No. 31, repr.
6. Cat. Frans Hals Exhib., Haarlem, 1937, No. 87, repr.
7. Van Dantzig, Frans Hals, No. 26.

Biogr. : The Vernatti are a Dutch family who came to England during the 17th century. Sir Philip Vernatti introduced the Dutch methods of drainage in Lincolnshire. The present Earl of Gainsborough is descended from an heiress of the Vernatti. (From an inscription on the back of the picture.)

91. **JOHANNES HOORNBEECK.** Musée Royal des Beaux-Arts, Brussels. Pl. 122.

Canvas : 31 5/16 by 26¾ inches (79·5 × 68 cm.).

Inscr. (lower right corner) : " AET . . . SVAE

27

16 . . " (?)

Black robe and cap ; white collar ; black hair, moustache, and chin tuft ; brown eyes ; ruddy face and hand. Dark-grey background.

Condition : Hair, cap, and hand are rather " flat," possibly as a result of relining.

Hist. :

Sale D. Vis Blokhuyzen (of Rotterdam), Paris, Apr. 1, 1870, No. 22 (Fr.11,600.– Gauchez)[1, 11].

Hist. —*continued.*

Purchased by the Museum from the Art Dlr. Gauchez, Paris, 1870 (Fr.20,000.–)[5].

Exhib. of Dutch Art, London, 1929, No. 353[7].

Exhib. Frans Hals, Haarlem, 1937, No. 90[9].

Lit. and Sources :

1. HdG. 193.
2. Bode-Binder 224 Pl. 143a (reproductions of original and replica (*a*) are confounded).
3. Kl.d.K. p. 211/223.
4. Moes, Icon. Bat., No. 3728, 1.
5. Cat. Musée Royal, Brussels, 1882.
6. Cat. Musée Royal, Brussels, 1927, No. 202.
7. Cat. Dutch Art Exhib., London, 1929, No. 353.
8. *id.* Commemor. Cat., p. 52, repr.
9. Cat. Frans Hals Exhib., Haarlem, 1937, No. 90, repr. 91.
10. Van Dantzig, Frans Hals, No. 27.
11. Records of the Ryksbureau voor kunsthist. documentatie, The Hague.

Engr. :

By J. Suyderhoef (1613–1686) ; inscr. near head : " Aetatis XXXIV A° MDCLI " ; inscr. below : " Iohannes Hoornbeeck, S. Theol. Doctor in Ecclesia & Academia Ultraiectina Pastor atq Professor.—J. Suyderhoef sculps.—Pieter Goos excu." Size : 331 × 260 mm.

By J. Suyderhoef (?) ; inscr. below : " IOHANNES HOORNBEECK. S.S. Theologiae Professor Lugd. Bat." Size : 353 × 253 mm.

HdG.[1] lists these two engravings as the second and first state of the same plate.

Biogr. : Born 1617 in Haarlem, died 1666 in Leiden ; professor of theology in Utrecht and Leiden.

Replica and copies :

(*a*) According to Valentiner[15], a preliminary study. Coll. Emery L. Ford, Detroit. Panel : 12⅛ by 9¾ inches (30·7 × 24 cm.)[15], or 29½ by 23½ inches (75 × 60 cm.)[12, 14, 16]. Hist. : Coll. Miss James, London[12] ; Sale, June 20, 1891 (£241.10.–)[11] ; Coll. Mrs. Joseph, London [12] ; Art Dlr. Knoedler, New York[11] ; Art Dlr. Reinhart, New York[17] ; Exhib. Royal Acad., London, Winter 1871, No. 250[12], (owner : Miss James) ; Frans Hals Exhib., Detroit, 1935, No. 42 (anonymously lent)[16].

Lit. and Sources :

12. HdG. 194.
13. Bode-Binder 225 Pl. 143b (this portrait and the Brussels version confounded).
14. Kl.d.K. p. 209/222.
15. Valentiner, F. Hals in America, No. 78.
16. Cat. Frans Hals Exhib., Detroit, 1935, No. 42.
17. Records of the Frick Art Reference Library, New York.

(*b*) University, Leiden[1]. Moes, Icon. Bat., No. 3728, 3.

Replica and copies :—*continued.*

(c) University, Utrecht[1]. Moes, Icon. Bat., No. 3728, 2.

(d) On canvas. Sale, Amsterdam, Aug. 21, 1799, No. 57 (F.51.- Coclers) ; Sale L. B. Coclers, Amsterdam, Aug. 7, 1811, No. 26 (F.51.- Josi)[1].

(e) On canvas. Sale Jurriaans, Amsterdam, Aug. 28, 1817[1], No. 19 (F.120.- ; size : 31 by 26 inches).

(f) On canvas. Sale, Amsterdam, March 15, 1842, No. 9 (F.29.- De Vries)[1].

(g) On canvas. Suppl. Sale, Amsterdam, May 6, 1845, No. 270 (F.20.- De Vries)[1].

(h) On canvas. Sale, Amsterdam, May 1, 1849, No. 63[1].

(i) *Fake* (or copy painted over and changed). Canvas : 29⅛ by 23 inches (74 × 58.5 cm.). Coll. F. Woltereck, Basle, Switzerland[11].

(j) Drawing after the Suyderhoef engraving ; chalk ; signed : " S. de Bray, 1650 ". Kupferstichkabinett, Berlin[1].

(k) Drawing, the head only ; probably after the Suyderhoef engraving. Pencil : 165 × 143 mm. Sale Francis Wellesley, at Sotheby's, London, July 1–2, 1920, No. 411 (catalogued as " Frans Hals, A Gentleman ").

92. PORTRAIT OF A MAN. National Gallery of Art, Washington, D.C. Pl. 123.

Canvas : 26¾ by 21¾ inches (68 × 55.2 cm.).

Monogr. (at right, near shoulder) : "FFH " (connected).

Black costume and hat, white collar ; black hair ; brown cane. Warm-grey background.

Dating : The Hermitage Catalogue[6] dates it *c.* 1655, which is too late ; Kl.d.K.[4] suggests 1646–1647.

Hist. :

Coll. Sir Robert Walpole, First Earl of Orford, Houghton Hall[2], who sold his collection to Catherine II of Russia, 1777[6].

Hermitage, Leningrad, No. 770[6].

Coll. Andrew W. Mellon, Washington, D.C.

Lit. :

1. Bode (1883) 128 (" perhaps by Harmen Hals ").
2. HdG.307.
3. Bode-Binder 213 Pl. 136.
4. Kl.d.K. p. 219/234.
5. Waagen, Ermitage, 1870, p. 172.
6. Somoff, Cat. Hermitage, St. Petersburg, 1901, No. 770.

Engr. :

By J. B. Michel, 1777 ; in the reverse direction ; size : 184 × 139 mm. Inscr. : " FRANCIS HALLS. In the common Parlour at Houghton. Size of the picture F I, 1 ¾ by F I, 1 7½ high. Pub-

Engr. :—*continued.*

lished May 1st 1777 by John Boydell Engraver in Chapside London. F. Hals Pinxit. G. Farington del. J. B. Michel sculpsit."

Several attempts have been made to identify the sitter. The Walpole catalogue and Waagen[5] assume the picture to be a selfportrait. The Hermitage catalogue[6] calls it : " Portrait of Harmen Hals by Frans Hals." None of these identifications is convincing.

93. PORTRAIT OF A WOMAN, SITTING. The Boston Museum of Fine Arts, Boston, Mass. Pl. 124.

Canvas : 48 by 38½ inches (122 × 97.7 cm.).

Inscr. (at left, near shoulder) :

" AETATIS SVA (!) 47
1648
FH " (connected).

Black costume ; white cap, collar, and cuffs. Brown-grey background. Dark-blond hair, grey eyes. Brown chair, black Bible with yellow edges and silver clasps. Dark-green chair-pillow.

Condition : Restorations in hands, shadow of cap, costume, and in the background. A hole under the inscription has been repaired.

Hist. :

Sale Cecil Miles, London, May 13, 1899, No. 91 (£2,100.- Lawrie)[1].

Blackslee, New York[6].

Acquired 1901[6].

Frans Hals Exhib., Detroit, 1935, No. 45[5].

Frans Hals Exhib., Schaeffer Gall., New York 1937, No. 11[7].

Lit. :

1. HdG. 372.
2. Bode-Binder 251 (not 271 as stated by [3, 4, 5]) Pl. 160.
3. Kl.d.K. p. 224/237.
4. Valentiner, Frans Hals in America, No. 94.
5. Cat. Frans Hals Exhib., Detroit, 1935, No. 45.
6. Records of the Boston Museum of Fine Arts.
7. Cat. Exhib. Schaeffer Gall., New York, 1937, No. 11.

94. PORTRAIT OF AN ELDERLY WOMAN. Louvre, Paris. Pl. 125.

Canvas : 42½ by 31½ inches (108 × 80 cm.).

Black dress ; white collar, cap, cuffs, and gloves. Grey-brown background. Ruddy colour of face and hands.

Dating : Kl.d.K.[3] dates it 1650–1652 ; according to the costume and style it seems to have been painted before 1650, about 1647–1650.

Hist. :

Coll. La Caze, Paris.

Bequeathed to the Louvre, 1869.

Lit. :

1. HdG. 389.
2. Bode-Binder 269 Pl. 175.

Lit. :—*continued.*

3. Kl.d.K. p. 243/257.
4. Cat. La Caze, 66.
5. Cat. Louvre, III. Ecoles du Nord (L. Demonts), 1922, No. 2385.

95. PORTRAIT OF AN ELDERLY WOMAN, SEATED. Mr. Michael M. van Beuren, Newport, R.I. Pl. 126.

Canvas mounted on panel : 32⅜ by 25½ inches (82.2 × 64.7 cm.).

Inscr. (at left, near head) : " AETAT 62
1650 "

An inscription on the reverse side of the picture gives the name of the model as Elisabeth van der Meeren, countess van Hoorne. According to H. Schneider[6], his identification is erroneous.

Hist. :

Coll. Marquess of Cholmondeley, Cholmondeley Castle, Malpas, Cheshire[6].
Art Dlr. Knoedler & Co., New York[3].
Art Dlr. Matthiesen, Berlin[6].
Art Dlr. Knoedler, New York[7].
Exhib. at Messrs. Kleykamp, The Hague, 1929, No. 20[8].
Exhib. Frans Hals, Detroit, 1935, No. 47[7].

Lit. :

1. HdG.—
2. Bode-Binder —
3. Kl.d.K. –/259 (size : 80.7 × 64 cm.).
4. Valentiner, F. Hals in America, No. 99 (" Elisabeth van Meeren ").
5. Alec Martin (Burl. Mag., 1922, p. 225, repr.).
6. H. Schneider, note in "The Unknown Masterwork " edit. by W. R. Valentiner, p. 5, repr.
7. Cat. Frans Hals Exhib., Detroit, 1935, No. 47.
8. Cat. Exhib. at Kleykamp's, The Hague, 1929, No. 20.

96. PORTRAIT OF A MAN. Hermitage, Leningrad. Pl. 127.

Canvas : 33⅛ by 26½ inches (84 × 67 cm.).
Monogr. (at right) : " FH " (connected).

Black costume and cloak, white collar and cuff ; brown hair. Brown-grey background.

Condition : There is a peculiar dark shadow on top of the head. Perhaps a hat worn by the model has been painted over, either by the artist himself or by a restorer.

Dating : Bode[1] dates this portrait very late, c. 1660 ; HdG.[2] suggests a date " after 1645 " and Kl.d.K. [4] places it at 1650–1652.

Hist. : Acquired by Catherine II of Russia[5].

Lit. and Sources :

1. Bode (1883) 130.
2. HdG. 309.
3. Bode-Binder 266 Pl. 173b.
4. Kl.d.K. p. 244/258.

Lit. and Sources :—*continued.*

5. Somoff, Cat. Hermitage, St. Petersburg, 1901, No. 772.
6. Waagen, Ermitage, 1870, p. 172.
7. J. Q. van Regteren Altena, Frans Hals Teekenaar (Oud Holland, XLVI, p. 149).
8. Records of the Ryksbureau voor kunsthist. documentatie, The Hague.

The British Museum possesses a *drawing* published by J. Q. van Regteren Altena[7] as an original sketch by Hals for the Hermitage portrait (Pl. 159). Among the numerous drawings attributed to Hals this one (Cat. Hind, 1926, p. 110, No. 3 ; black and white chalk on blue-grey paper) is, without any doubt, the most outstanding. However, as there is no evidence that Frans Hals made drawings at all, I hesitate to attribute the one at the British Museum to the artist himself. On the drawing the model wears a hat which cannot be discerned on the painting. A cleaning or X-raying of the Hermitage portrait would show if a hat has been painted over or if the sitter was painted without a hat.

Copy : Coll. H. E. ten Cate, Almelo, Holland. Panel : 8⅛ by 7¾ inches (20.5 × 18.3 cm.). According to Hofstede de Groot[8], an original study of the artist.

97. PORTRAIT OF A PAINTER (SELF-PORTRAIT ?). The Frick Museum of Art, New York. Pl. 128.

Companion piece to No. 98.

Canvas : 39½ by 32½ inches (100 × 82.5 cm.).
Monogr. (at right, near elbow) :
" FH (connected) (?)
165.. " (?)

Black doublet and hat, grey-brown cloak (violet shadows), white collar and cuff. Brown hair and eyes, blond moustache. Brown chair with red back. The background, dark-grey at left becomes light-brown at right.

Condition : The painting is rather thin, especially in the dark tones of the costume ; repairs in the index-finger, the middle-finger, and the ring-finger. The monogram is suspicious and probably a later addition. The date is indistinct.

Dating : According to HdG.[2] and Kl.d.K.[4], " dated 1635 " ; according to Valentiner[5], c. 1645. The costume as well as the style and facture of painting show more similarity with works of c. 1650 (No. 99) than with works of 1645.

Hist. :

Coll. S. K. Mainwaring, Otley [1].
Exhib. Royal Acad., London, Winter 1882, No. 87[1].
Exhib. Hudson-Fulton Celebration, New York, 1909, No. 28 (owner : Frick)[9].
Exhib. Boston Museum of Fine Arts, 1910, No. 4 (owner : Frick)[10].

Lit. and Sources :

1. Bode (1883) 140 (" Man ").
2. HdG. 147 (" Selfportrait ").
3. Bode-Binder 151 (" Man ").
4. Kl.d.K. p. 119/126 (" Selfportrait ").
5. Valentiner, F. Hals in America, No. 83 (" Selfportrait ").
6. Valentiner (Art in America, 1925, p. 148 : " Selfportrait ").
7. Valentiner (ibid. 1935, p. 85 : " 1645 ").
8. C. H. Collins Baker (Burl. Mag., 1925, p. 42).
9. Cat. Hudson-Fulton Exhib., New York, 1909, No. 28.
10. Records of the Frick Art Reference Library, New York.

98. PORTRAIT OF A WOMAN (THE ARTIST'S WIFE, LISBETH REYNIERS ?). The Metropolitan Museum of Art, New York. Pl. 129.

Companion piece to No. 97.

Canvas : 38⅜ by 31¾ inches (97.4 × 80.5 cm.).

Black dress, pink apron, bodice striped black and yellowish-brown ; white collar and cuffs ; red-and-white key-ribbon. Black headgear set with pearls. Blond hair ; gold bracelet, grey fan. In the background grey pillars and black-grey buildings against a pale sunset sky.

Condition : The background looks like a later addition. The painting is rather thin, especially of hands, face, and hair.

Dating : See companion piece.

Hist. :

Coll. Earl of Bessborough[1] ; Sale at Christie's, London, Febr. 5-7, 1801, No. 50[6].
Coll. Lewis Jarvis[1], Middleton Towers, King's Lynn, Norfolk ; Sale at Christie's, London, June 21, 1890, No. 35[7].
Art Dlr. M. Colnaghi, London[1].
Coll. H. G. Marquand, New York[1, 5].
Marquand Gift, 1890[5].
Exhib. Hudson-Fulton Celebration, New York, 1909, No. 40[8].

Lit. :

1. HdG. 387 (" Woman ").
2. Bode-Binder 175 Pl. 107 (" Woman ").
3. Kl.d.K. p. 120/127 (" The Artist's Wife ").
4. Valentiner, F. Hals in America, No. 84 (" The Artist's Wife ").
5. Cat. Metropolitan Museum, New York, 1931, p. 149 No. H–16–3 (" erroneously called The Wife of the Artist ").
6. Cat. Bessborough Sale, London, 1801, No. 50 (" A Lady's Portrait by F. Hals ").
7. Cat. Jarvis Sale, London, 1890, No. 35 (" The Artist's Wife ").
8. Cat. Hudson-Fulton Exhib., New York, 1909, No. 40.

99. STEPHANUS GERAERDTS. Musée Royal des Beaux-Arts, Antwerp. Pl. 130.

Companion piece to No. 100.

Canvas : 45⅜ by 34⅜ inches (115·4 × 87·5 cm.).

Gold embroidered costume, black mantle, white collar and shirt sleeves. Dark hair. Dark-grey background.

Condition : Corroded varnish.

Dating : HdG.[1], c. 1645 ; Kl.d.K.[3], 1650–1652 ; the latter is more in accordance with the style of the costume.

Hist. :

Coll. C. J. Nieuwenhuys ; Sale, London, May 10, 1833, No. 26 (bought by Yates)[10].
Art Dlr. E. Warneck, Paris (acquired the portrait and the companion piece in England)[9].
Art Dlr. Stephan Bourgeois, Cologne and Paris[9].
Coll. Prince Demidoff, San Donato, Italy (returned both portraits to Bourgeois)[9].
Art Dlr. Stephan Bourgeois (separated the companion pieces selling the " Man " to the Antwerp Museum and the " Woman " to Rothschild)[9].
Musée des Beaux-Arts, Antwerp (purchased from the Art Dlr. Bourgeois, Cologne, for Fr.85,000.–, 1886)[1, 6].
Exhib. Royal Acad., London, Winter 1877, No. 29[1].
Exhib. Frans Hals, Haarlem, 1937, No. 102[7].

Lit. and Sources :

1. HdG. 180.
2. Bode-Binder 258 Pl. 167.
3. Kl.d.K. p. 247/262.
4. Moes, Icon. Bat., No. 2688.
5. Bredius (Zeitschr. f. bild, Kunst, 1880).
6. Cat. Musée Royal des Beaux-Arts, Antwerp, I., 1920, No. 674.
7. Cat. Frans Hals Exhib., Haarlem, 1937, No. 102 repr.
8. Van Dantzig, Frans Hals, No. 29.
9. Unpublished notes by Hofstede de Groot and records of the Ryksbureau voor kunsthist. documentatie, The Hague.
10. C. J. Nieuwenhuys, A Review, London, 1834, p. 129.

Copies :

(a) Bust only. On paper : 8 by 7 inches (20·3 × 17·5 cm.). Hist. : Coll. H. E. ten Cate, Almelo, Holland ; Art Dlr. D. Katz, Dieren, Holland ; Art Dlr. H. Schaeffer, New York[9].
(b) Sale J. C. O'Connor and diff. prop., London, July 5, 1928, No. 203 ; sold as original ; according to Hofstede de Groot[9], an " old copy."

100. ISABELLA COYMANS, WIFE OF STEPHANUS GERAERDTS. Baron Robert de Rothschild, Ferrières, France. Pl. 131.

Companion piece to No. 99.

Canvas : 45¾ by 33⅞ inches (116 × 86 cm.).

Hist. :

Coll. C. J. Nieuwenhuys ; Sale, London, May 10, 1833, No. 25 (£22.– Pennel)[5].
Coll. Newman Smith, London[1].
Art Dlr. E. Warneck, Paris (this and companion portrait)[1].
Art Dlr. Stephan Bourgeois, Paris (sold this and companion portrait to Demidoff)[1].
Coll. Prince Demidoff, San Donato, Italy (owned both companion portraits ; returned them to Bourgeois)[1, 6].
Art Dlr. Stephen Bourgeois, Paris (separated the companion pieces selling the " Woman " to Rothschild and the " Man " to the Antwerp Museum)[1, 6].
Coll. Alphonse de Rothschild, Paris[1].
Coll. Edmond de Rothschild, Ferrières[2, 3].
Exhib. Royal Acad., London, Winter 1877, No. 38[1].

Lit. and Sources :

1. HdG. 181.
2. Bode-Binder 259 Pl. 168.
3. Kl.d.K. p. 248/263.
4. Moes, Icon. Bat., No. 1785.
5. C. J. Nieuwenhuys, A Review, 1834, p. 129.
6. Records of the Ryksbureau voor kunsthist. documentatie, The Hague.

Copy : Canvas ; 45¼ by 34¼ inches (115 × 87 cm.). At what time and for whom this modern copy was made is difficult to say. It can be traced to the end of the 19th century and to the Rudolphe Kann Collection, Paris. The Art Dlr. Durand-Ruel, Paris, sold it as an original to P. A. B. Widener, Philadelphia. It appeared, still as the original, in the Hudson-Fulton Exhibition, New York, 1909, No. 38 (wrong size), repr., and was included in the catalogue of " Pictures of P. A. B. Widener . . . at Lynnewood Hall," 1913 (by W. R. Valentiner and C. Hofstede de Groot). The exact date of the exposure is not known. But in an anonymous sale at Fred. Muller & Co., Amsterdam, Oct. 14, 1918, this fake reappeared under the modest caption of " No. 32, Haarlem School, Smiling Lady " and was sold for F.750.

101. PORTRAIT OF A MAN. Mr. I. M. Stettenheim, New York. Pl. 132.

Canvas : 26 by 19½ inches (66 × 49·5 cm.).
Monogr. (at right, near arm) : " FH " (connected).
Dating : HdG.[1] dates it c. 1640, Kl.d.K.[3] c. 1650, and Valentiner[4] 1650–1655. Compared with the Berlin portrait of 1656 (No. 102), this portrait cannot be earlier than 1655.

Hist. :

Coll. Rudolphe Kann, Paris : in 1907 this collection was purchased by the Art Dlrs. Wildenstein & Co., and Duveen Bros.[1].
Art Dlr. Duveen Bros., Paris[1].

Coll. Arth. Granfell, Roehampton[3, first edition].
Art Dlr. Knoedler & Co., Paris[7].
Art Dlr. Duveen Bros., New York[4].
Exhib. Frans Hals, Detroit, 1935, No. 48 (owner : Stettenheim)[6].

Lit. and Sources :

1. HdG. 301.
2. Bode-Binder 239 (not 237 as stated by [4]) Pl. 151b.
3. Kl.d.K. pl. 241/254.
4. Valentiner, Frans Hals in America, No. 98.
5. Cat. Coll. Rud. Kann, Paris, 1907, No. 42.
6. Cat. Frans Hals Exhib., Detroit, 1935, No. 48.
7. Records of the Frick Art Reference Library, New York.

102. TYMAN OOSDORP. Kaiser - Friedrich - Museum, Berlin. Pl. 133.

Canvas : 31⅛ by 27⅝ inches (89 × 70 cm.).
Inscr. (on a label attached to the back of the picture, in 18th century handwriting : " Tyman Oosdorp " ; in another handwriting : " F. Hals p. 1656. Tyman Oosdorp ")[1, 6].
The attention is first attracted by the face, the blond (ochre) hair, and the grey-blue eyes. Black-grey costume and mantle ; white collar ; black hat. Greybrown background.

Hist. :

Coll. Von Liphart zu Ratshof[5].
Purchased 1877[1] from a Cologne Art Dlr.[5].

Lit. :

1. HdG. 213.
2. Bode-Binder 277 Pl. 182.
3. Kl.d.K. p. 258/274.
4. Moes, Icon. Bat., No. 5559.
5. Posse, Cat. Kaiser-Friedr.-Museum, Berlin, 1911, No. 801–H.
6. Cat. Kaiser-Friedr.-Museum, Berlin, 1931, No. 801–H.

Biogr. : Born in Delft ; died in Haarlem, 1668. Married Hester Olycan ; later, in 1658, Margarete Schillinger (1611–1668)[1].

103. PORTRAIT OF A MAN. Mr. W. H. Bixby, St. Louis, Mo. Pl. 134.

Panel : 12½ by 10 inches (31·8 × 25·5 cm.).
Black costume, white collar ; dark hair ; dark background.
Dating : Bode[6] dates this portrait 1655–1660 ; Valentiner[4, 5], 1660.

Hist. :

Coll. Wilh. Gumprecht, Berlin[1] ; acquired in London 1882[9].
Sale W. Gumprecht, at Cassirer's, Berlin, March 21, 1918, No. 24[9].
Coll. H. Heilbuth, Copenhagen[4, 10].

Hist. :—*continued.*

Exhib. Berlin, 1883, No. 78[9].

Exhib. Berlin, 1890, No. 81[9].

Exhib. of Portraits, The Hague, 1903, No. 40[7, 8, 9].

Exhib. Copenhagen, Danish Museum of Fine Art, Autumn 1920, No. 59[10].

Exhib. Frans Hals, Detroit, 1935, No. 50[11].

HdG. and Valentiner[2, 5, 11] state that this picture was in the Richard Foster Sale, London, June 3, 1876. The catalogue of this sale does not contain any such portrait.

Lit. :

1. Bode (1883) Note p. 612.
2. HdG. 257.
3. Bode-Binder 275 Pl. 180.
4. Kl.d.K. p. 270/286.
5. Valentiner, Frans Hals in America, No. 105.
6. Bode (Jahrb. d. preuss. Kunstsamml., IV., p. 61).
7. Cat. Exhib. of Portraits, The Hague, 1903, No. 40.
8. Hofstede de Groot, Meisterwerke der Porträt-malerei im Haag, 1903, p. 15, Pl. 27.
9. Cat. Sale W. Gumprecht, Berlin, 1918, No. 24.
10. Cat. Exhib. Coll. Heilbuth, Copenhague, 1920, No. 59, repr.
11. Cat. Frans Hals Exhib., Detroit, 1935, No. 50.

104. WILLEM CROES. Ältere Pinakothek, Munich. Pl. 135.

Panel : 18½ by 13⅜ inches (47 × 34 cm.).

Monogr. (lower left corner) : " FH " (connected) (?). Black doublet and cloak, white collar and cuffs. Grey background.

Dating : Bode[1], HdG.[2], and the Munich Cat.[6] date the portrait *c.* 1658 ; Kl.d.K.[4] suggests 1653–1655 ; it can hardly be prior to 1655.

Hist. :

Coll. Steengracht, The Hague[2].

Coll. Baron C. C. A. van Pallandt, The Hague[2].

Coll. Countess van Lynden, née van Pallandt, Lisse[2].

Coll. Van Stolk, Haarlem[2].

Purchased from the Van Stolk Coll., 1906[2, 6] (Mk.85,000.-)[10].

Exhib. Amsterdam, 1872[2].

Exhib. The Hague, 1881, No. 150, and as a loan to the Mauritshuis, The Hague[2].

Exhib. Arte Olandese, Rome, 1928[7].

Lit. :

1. Bode (1883) 26.
2. HdG. 171.
3. Bode-Binder 276 Pl. 181 (wrong size).
4. Kl.d.K. p. 252/267.
5. Moes, Icon. Bat., No. 1808.
6. Cat. Aelt. Pinakothek, Munich, 1925, No. 8402.

Lit. :—*continued.*

7. Cat. Mostra del Arte Olandese, Roma, Palazzo Borghese, 1928, p. 39, repr. 42.
8. Voll (Münchner Jahrbuch, 1906, p. 33).
9. Frizzoni (Rassegna d'Arte, 1908, Nov., p. 252 ; " the only unquestioned work by F. Hals in Munich ").
10. M. D. H. (Henkel), Ein neuer Frans Hals im Ryksmuseum (Kunstchronik, N. F., 1916, p. 359).

105. PORTRAIT OF A MAN. Musée Jacquemart-André, Paris. Pl. 136, 137.

Canvas : 27³⁄₁₆ by 23¹⁸⁄₁₆ inches (69 × 60·5 cm.)[6]. Almost monotonous. The ruddy face stands out from the grey background. Grey doublet, gold shoulder-belt, white collar ; dark hair (black with yellow lights). Ochre, brown, red, white, and black brushstrokes in the chair.

Condition : Corroded varnish. Traces of relining, especially in the background.

Dating : Bode[1] dates the picture *c.* 1655 ; HdG.[2] notes, " according to Bredius, 1650–1655 " ; Kl.d.K.[4] : 1661–1663 ; the Cat. of the Haarlem Exhib.[6], *c.* 1660. Costume and style call for a later date : 1660–1663.

Hist. :

Purchased from Rupprecht, Munich, 1884[5].

Exhib. Jeu de Paume, Paris, 1911, No. 52 (owner : Mme. Ed. André)[8].

Exhib. Frans Hals, Haarlem, 1937, No. 110[6].

Lit. :

1. Bode (1883) 69.
2. HdG. 300.
3. Bode-Binder 265 Pl. 173a (wrong size).
4. Kl.d.K. p. 272/288.
5. Cat. Musée Jacquemart-André, Paris, No. 427 (sight size).
6. Cat. Frans Hals Exhib., Haarlem, 1937, No. 110, repr.
7. Van Dantzig, Frans Hals, No. 30.
8. Cat. Exhib. Dutch Artists, Jeu de Paume, Paris, 1911, No. 52 (sight size).

106. PORTRAIT OF A YOUNG MAN. Lady Desborough, Panshanger (1929). Pl. 138.

Canvas : 27¾ by 23¼ inches (70·5 × 59 cm.).

Dating : Bode[1] and HdG.[2] date the portrait *c.* 1650 ; Kl.d.K.[4] places it much later, between 1664 and 1666. According to the style it must have been done after the Jacquemart-André portrait (No. 105) and before the Cassel portrait (No. 107) : about 1661–1663.

Hist. :

Coll. Earl of Cowper, Panshanger[1, 2].

Coll. Lord Desborough, Panshanger[4].

Exhib. of Dutch Art, London, 1929, No. 109 (owner : Lady Desborough)[5].

Lit. :

1. Bode (1883) 152.
2. HdG. 283.
3. Bode-Binder 278 Pl. 183a.
4. Kl.d.K. p. 276/292.
5. Cat. Dutch Art Exhib., London, 1929, No. 109.
6. *id.* Commemor. Cat., p. 50, repr.

107. PORTRAIT OF A MAN. Staatliche Gemäldegalerie, Cassel. Pl. 139, 140.

Canvas : 31⅛ by 25⅝ inches (79 × 65 cm.).
Monogr. (at left, near shoulder) : " FH " (connected).
Black costume and hat, white collar and cuff. Ruddy face. Grey wall and grey-blue sky in the background.
Condition : Corroded varnish, probably coloured.
Dating : Bode[1], 1660 ; Cassel Cat.[5], " after 1660 " ; Kl.d.K.[4], 1661–1663. Probably executed at the same period as the " Group " of 1664 (No. 108) or shortly before, 1661–1664.
Hist. : Frans Hals Exhib., Haarlem, 1937, No. 113[6].
Lit. and Sources :

1. Bode (1883) 101.
2. HdG. 268.
3. Bode-Binder 280 Pl. 184.
4. Kl.d.K. p. 273/289.
5. Cat. Gemäldegalerie, Kassel, 1929, No. 219.
6. Cat. Frans Hals Exhib., Haarlem, 1937, No. 113, repr.
7. Van Dantzig, Frans Hals, No. 31.
8. " Hauptinventar " of 1749, No. 833[2].

Copy : " A copy with an English art dealer "[2].

108. GOVERNORS (" REGENTEN ") OF THE OLD MEN'S ALMSHOUSE, HAARLEM. Frans Hals Museum, Haarlem. Pl. 141–145.

Companion piece to No. 109.
Canvas : 67⅞ by 100½ inches (172·5 × 256 cm.).
Among the black costumes painted against a dark-grey background shines forth the brick-red knee of the first man from the right. White collars and cuffs. Vellum cover and pale pink edge on the book. Dark-red table-cloth.
Dating : HdG.[1] and Kl.d.K.[3] : " painted 1664 ".
Hist. :

Oude-Mannenhuis (Old Men's Almshouse), Haarlem, till 1862.
Frans Hals Exhib., Haarlem, 1937, No. 114.

Lit. and Sources :

1. HdG. 437 (sight size).
2. Bode-Binder 287 Pl. 189 (sight size).
3. Kl.d.K. p. 274/290.

Lit. and Sources :—*continued*

4. Cat. Haarlem Museum, 1865, No. 52 (sight size).
5. Cat. Frans Hals Museum, 1924, No. 129.
6. Cat. Frans Hals Exhib., Haarlem, 1937, No. 114, repr.
7. Van Dantzig, Frans Hals, No. 32.
8. Records of the Ryksbureau voor kunsthistor. documentatie, The Hague.

The *names* of the persons represented are : Jonas de Jong, Mattheus Everswyn, Dr. Cornelis Westerloo, Daniel Deinoot, Johannes Walles.
Copy : Coloured drawing. " Men Guardians (Regenten) and Women Guardians (Regentessen) of the St. Elisabeth Hospital (should probably read, " Old Men's Almshouse) after the painting by F. Hals, by W. Hendriks, 1777 ". Sale La Clé, Haarlem, Sept. 25, 1827, No. 2 (F.42.–)[8].
See also, Museum Teylor, Haarlem (W. 41–45) : five water-colours by W. Hendriks after the group portraits by Frans Hals.

109. WOMEN GOVERNORS (" REGENTESSEN ") OF THE OLD MEN'S ALMSHOUSE, HAARLEM. Frans Hals Museum, Haarlem. Pl. 146–151.

Companion piece to No. 108.
Canvas : 67⅛ by 87 inches (170·5 × 249·5 cm.).
Black-grey gowns with white collars and caps painted against a dark-grey background. Dark-red table-cloth. Vellum book with pale pink edges. Brown drapery and a brownish landscape in the background.
Dating : see companion piece.
Hist. :

Oude-Mannenhuis (Old Men's Almshouse), Haarlem, till 1862.
Frans Hals Exhib., Haarlem, 1937, No. 115.

Lit. :

1. HdG. 438 (sight size).
2. Bode-Binder 286 (not 288 as stated by [3]), Pl. 190.
3. Kl.d.K. p. 275/291 (sight size).
4. Cat. Haarlem Museum, 1865, No. 53 (sight size).
5. Cat. Frans Hals Museum, Haarlem, 1924, No. 130.
6. Cat. Frans Hals Exhib., Haarlem, 1937, No. 115, repr.
7. Van Dantzig, Frans Hals, No. 33.

The *names* of the persons represented are : Adriaentje Schouten, Marijtje Willems, Anna van Damme, Adriana Bredenhof.
Copy : see companion piece.

APPENDIX

The following pictures were ascribed to Frans Hals at various times. Their compositions have most probably been invented by the artist and, owing to their success, copied in his workshop as well as outside of it. The "Rommelpot Player," for instance, exists in more than twenty variants. Reproduction of a variant does not imply that the author considers the painting to be an original by Frans Hals.

App. 1. BOY HOLDING A FLOWER. Amsterdam art dealer. Pl. 41.
Canvas : 30¼ by 25⅝ inches (76·5 × 65 cm.).
This composition exists in several variants. One of them, apparently a copy, has a later added background showing the portrait of a " Man Reading " placed on an easel. It is known as " Le peintre ambulant " (Louvre, Paris. Inscribed " FH 1648 ").

App. 2. THE SO-CALLED YONKER RAMP. The Metropolitan Museum of Art, New York. Pl. 153.
Canvas on panel : 41½ by 31³⁄₁₆ inches (105·4 × 79·2 cm.).
The composition exists in several variants of different size. None of those examined by me bears the characteristics of Hals' style. The New York version is closely related to the " Lute Playing Banterer " (App. 4) ascribed to Judith Leyster. Compare the hands, for instance.

The New York picture is said to come from the J. Enschedé Sale, Haarlem 1786. In this sale there was not the original by Hals but a copy described in the catalogue as : " No. 54. The Portrait of Yonker Ramp and his Sweetheart, beautifully drawn in the manner of C. Visser, by C. van Noorde, after the painting by Frans Hals."

App. 3. THE ROMMELPOT PLAYER. Sir Frederick Cook, Richmond. Pl. 154.
Canvas : 42⅜ by 32 inches (117·5 × 81·2 cm.).
This composition must have been very popular with the public for a long time. It exists in more than twenty variants of different size. Two have been engraved by F. Hubert and P. de Mare.

App. 4. LUTE PLAYING BANTERER. Ryksmuseum, Amsterdam. Pl. 155.
Canvas : 26⅜ by 23⅝ inches (67 × 60 cm.).
Four variants of this composition are known. The two better are in the Ryksmuseum, Amsterdam (ascribed to Judith Leyster), and in the collection of Baron R. de Rothschild (ascribed to Frans Hals). The here reproduced Amsterdam version is probably by the same hand as the " Yonker Ramp " of the Metropolitan Museum, New York. (App. 3.)

App. 5. WILLEM VAN HEYTHUISEN. Musée Royal des Beaux-Arts, Brussels. Pl. 156.
Panel : 18¼ by 14¾ inches (46·5 × 37·5 cm.).
The composition exists in three variants of different size, two on panel, one on canvas. I have not been able to see the two other variants.

App. 6. RENÉ DESCARTES. Louvre, Paris. Pl. 157.
Canvas : 30 by 26¾ inches (76 × 68 cm.).
There is but little doubt that Frans Hals has painted a portrait of Descartes which must have been frequently copied and repeated due to the popularity of both, the model and the artist. The original seems to be lost. None of the numerous variants which I was able to see is by the hand of Frans Hals. The portrait was engraved by J. Suyderhoef (1613–1686), G. Edelinck (1640–1707), J. Lubin (1659–c. 1703), E. Fiquet (1719–1794), J. B. Grateloup (1735–1817), J. Oortman (1777–1818).

App. 7. SELF-PORTRAIT. Denver Museum, Denver (Colorado). Pl. 158.
Panel : 10⅝ by 9 inches (27 × 23 cm.).
This portrait exists in more than fifteen variants. One of them has been engraved by C. van Noorde. At various times, various versions were supposed to be the original. None of those examined by me seem to be by the hand of Frans Hals. I must, however, admit that I have not been able to see all of them. The Denver variant was chosen for reproduction because it has not been published before, as far as I know.

App. 8. PORTRAIT OF A MAN. British Museum, London. Pl. 159.
Drawing, black chalk on blue-grey paper heightened with white : 7⁹⁄₁₆ by 6 inches (19·4 × 15·2 cm.).
According to Arthur M. Hind (Catalogue of Drawings by the Dutch and Flemish Artists in the British Museum, vol. III, p. 110, No. 3) : " Very uncertain attribution ; the name of Cornelius Saftleven has been suggested ". According to J. Q. van Regteren Altena (Frans Hals as Draughtsman, Oud Holland, XLVI, p. 149) : an original sketch by Frans Hals.
See also note to Cat. No. 96.

ACKNOWLEDGEMENTS

I want to express my deep gratitude to the Ryksbureau voor Kunsthistorische Documentatie, The Hague, to Dr. H. Schneider, Director of this institution and to his assistants Dr. H. Gerson and Heer B. Renckens. The collections of the Ryksbureau and the files of the late Dr. C. Hofstede de Groot, which I was permitted to consult, are invaluable for any research work in the domain of Dutch art.—At the Frick Art Reference Library, New York, probably the best organized art library in the world, I found many interesting dates and met with every possible assistance. I am sincerely obliged to the numerous universities, galleries, libraries, private collectors, and to all my friends both in Europe and in America, who supplied me with any kind of information and facilitated my research. Heer Bernhard F. Eilers, Amsterdam, was indefatigable and incomparable in making photographs under very difficult conditions.

N. S. T.

Sacramento, California.

March 1940

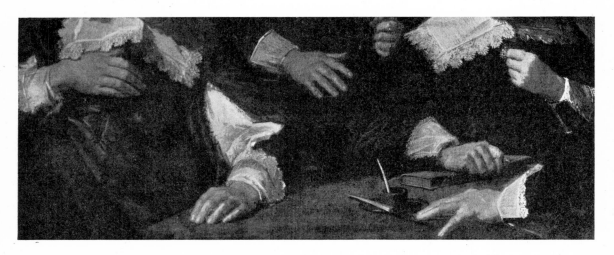

Seven hands. Detail from plate 108.

THE REPRODUCTIONS

Catalogue, see pages 24 and following. The corresponding Catalogue Numbers appear above the left-hand top corner of the reproductions.

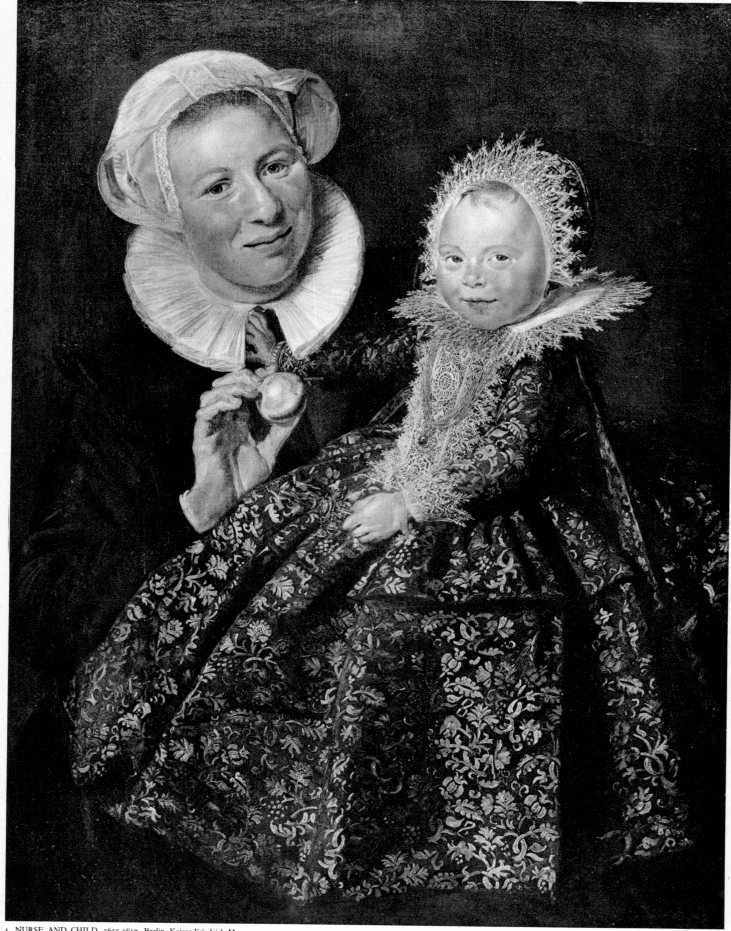

1. NURSE AND CHILD. 1615-1617. Berlin, Kaiser-Friedrich-Museum.

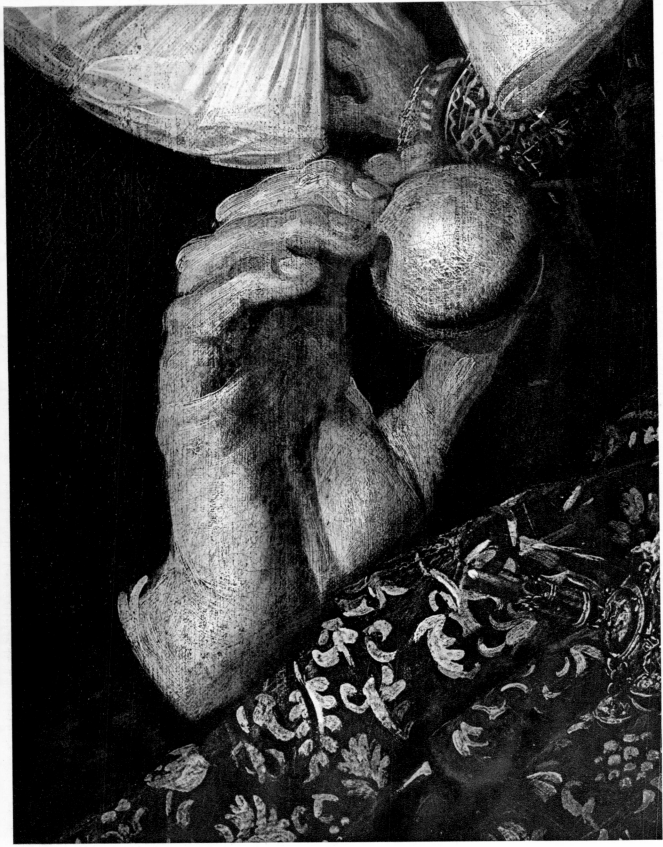

2. DETAIL FROM PLATE 1 (actual size).

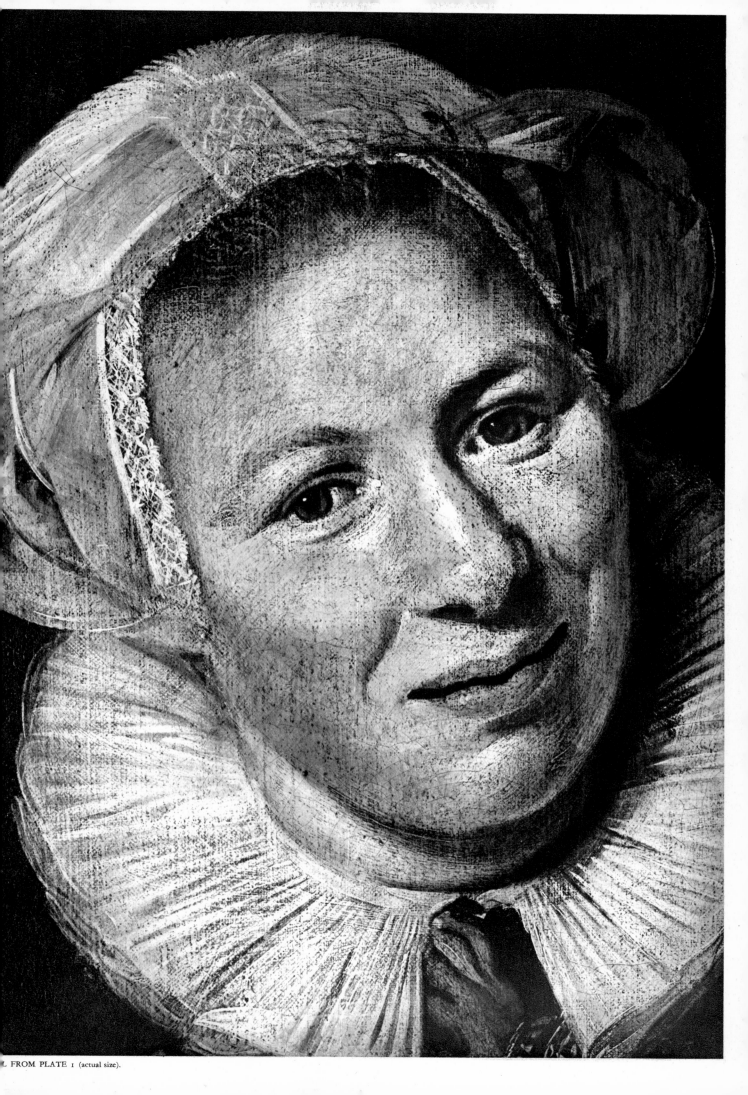

DETAIL FROM PLATE 1 (actual size).

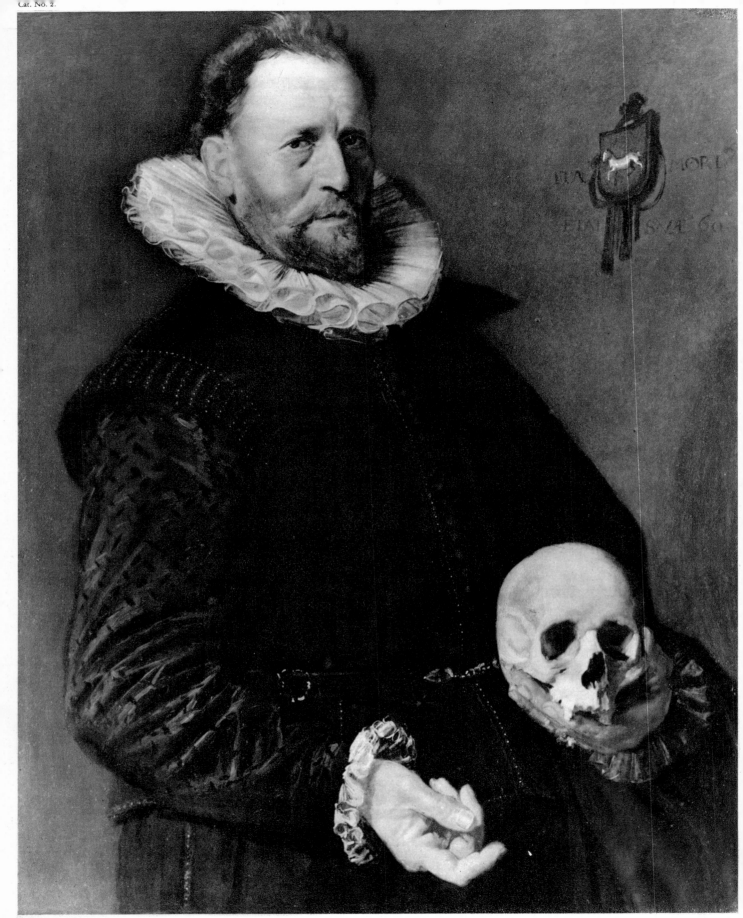

4. MAN HOLDING A SKULL. 1615-1618. Birmingham, The Barber Institute.

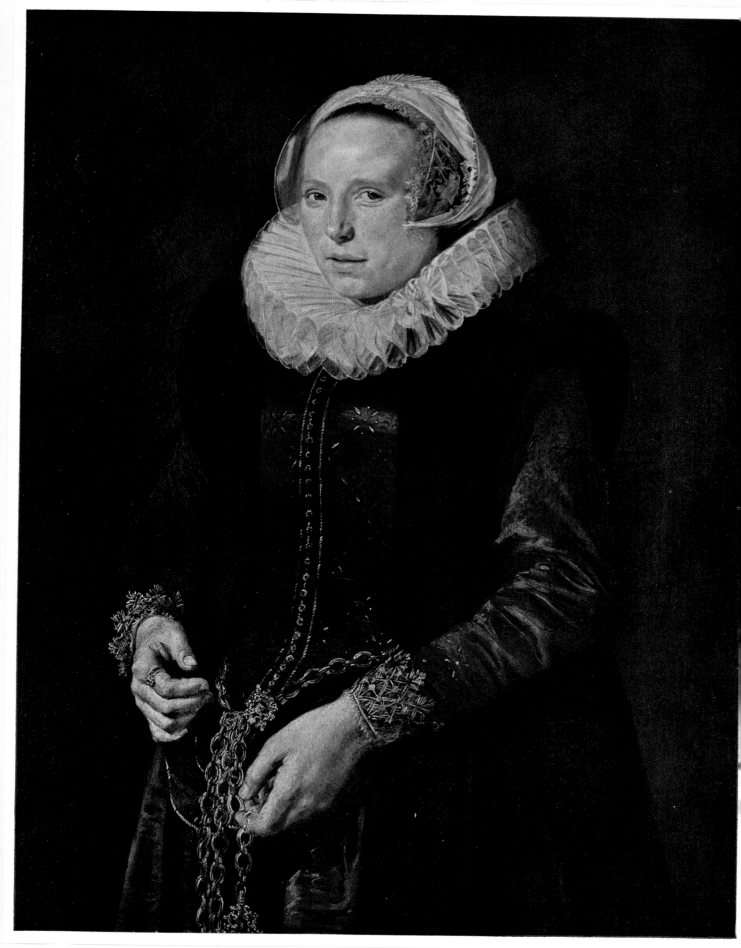

PORTRAIT OF A WOMAN. (cf. Plate 5, Cat. No. 3)

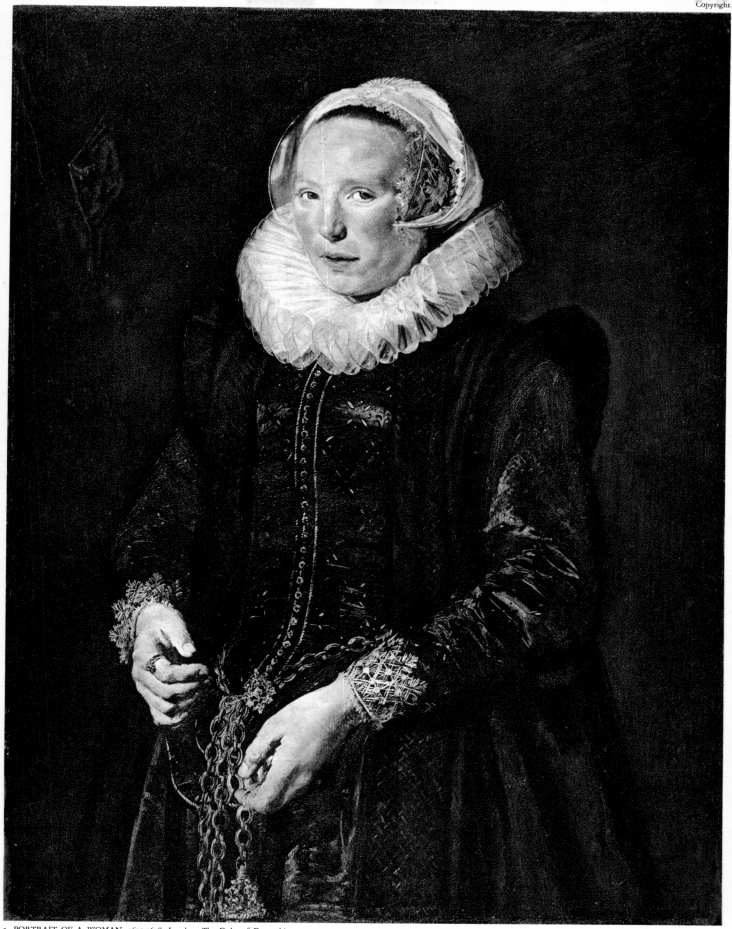

5. PORTRAIT OF A WOMAN. 1615-1618. London, The Duke of Devonshire.

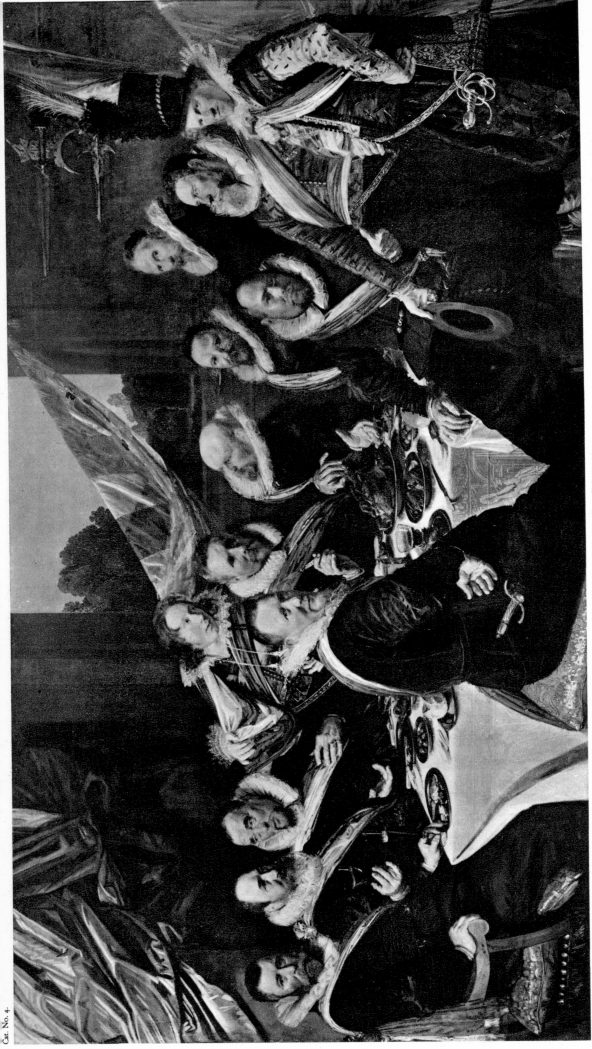

6. BANQUET OF THE OFFICERS OF THE ST. JORIS-DOELEN IN HAARLEM (The Civic Guard of Archers of St. George). 1616. Haarlem, Frans Hals Museum.

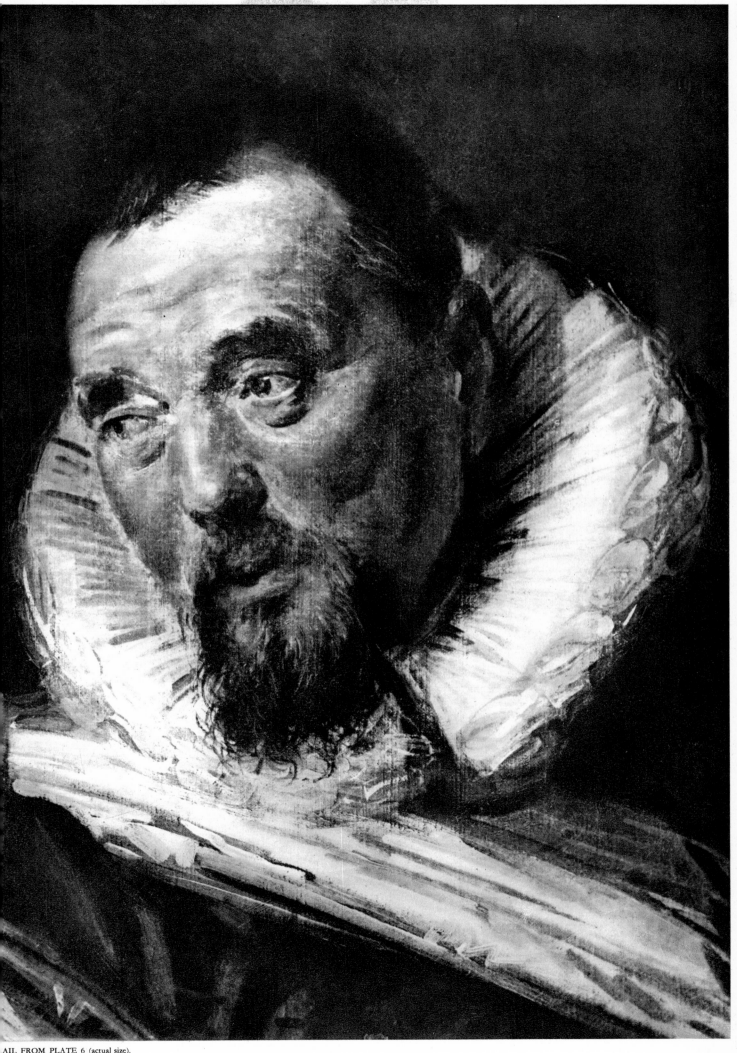

AIL FROM PLATE 6 (actual size).

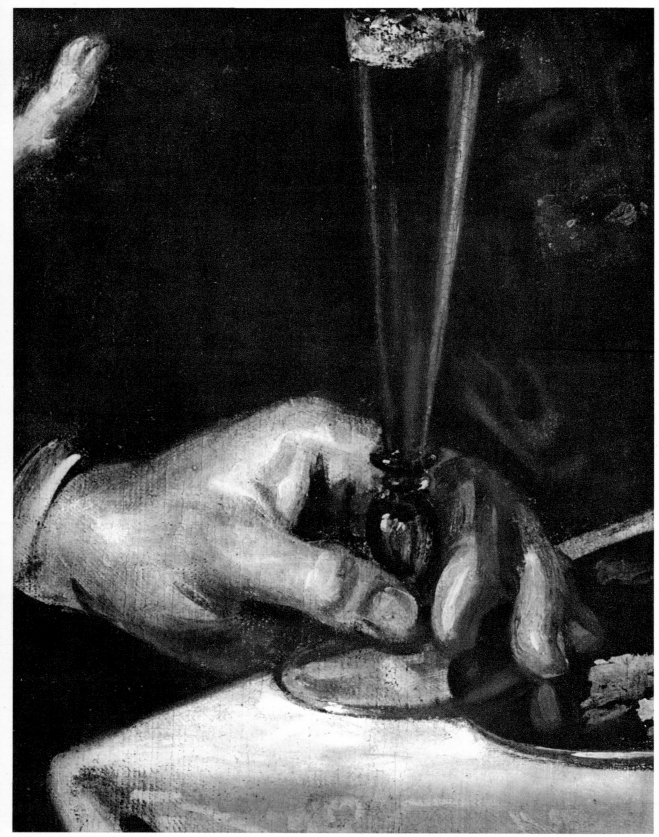

8. DETAIL FROM PLATE 6 (actual size).

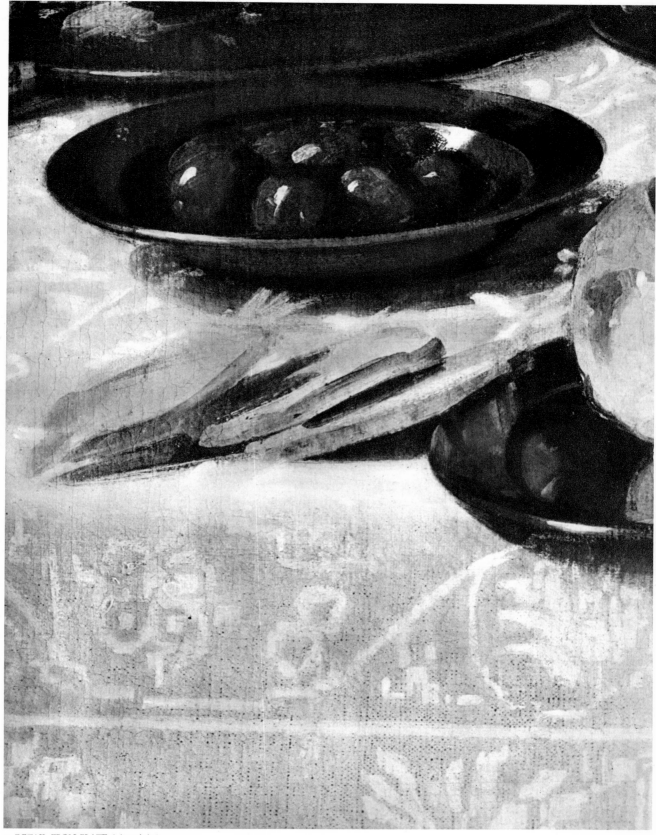

9. DETAIL FROM PLATE 6 (actual size).

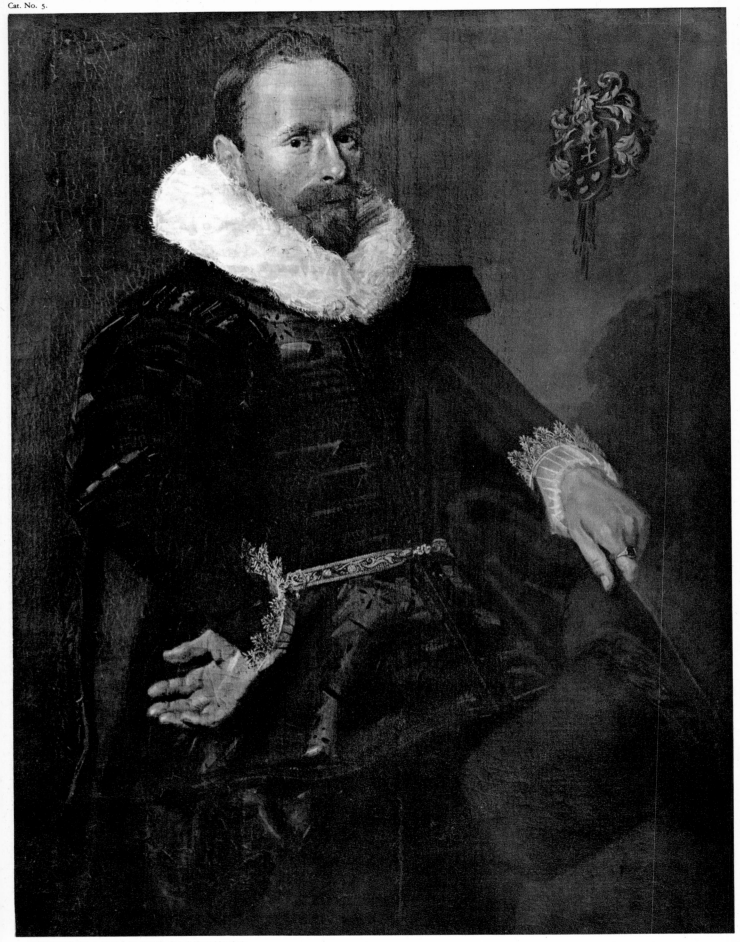

10. PORTRAIT OF A MAN. 1618-1620. Cassel, Gemäldegalerie.

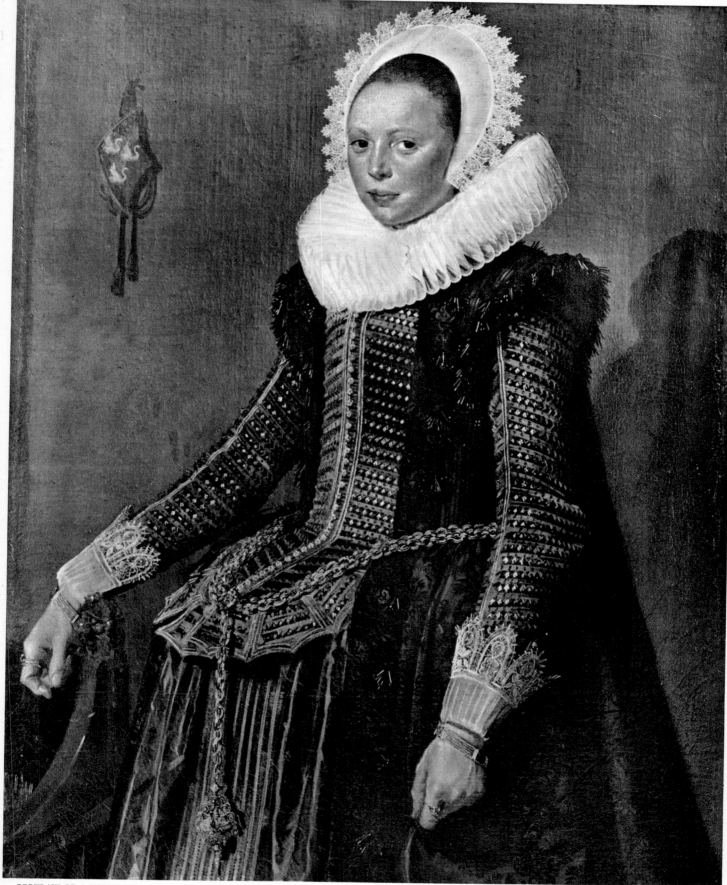

11. PORTRAIT OF A YOUNG WOMAN. 1618-1620. Cassel, Gemäldegalerie.

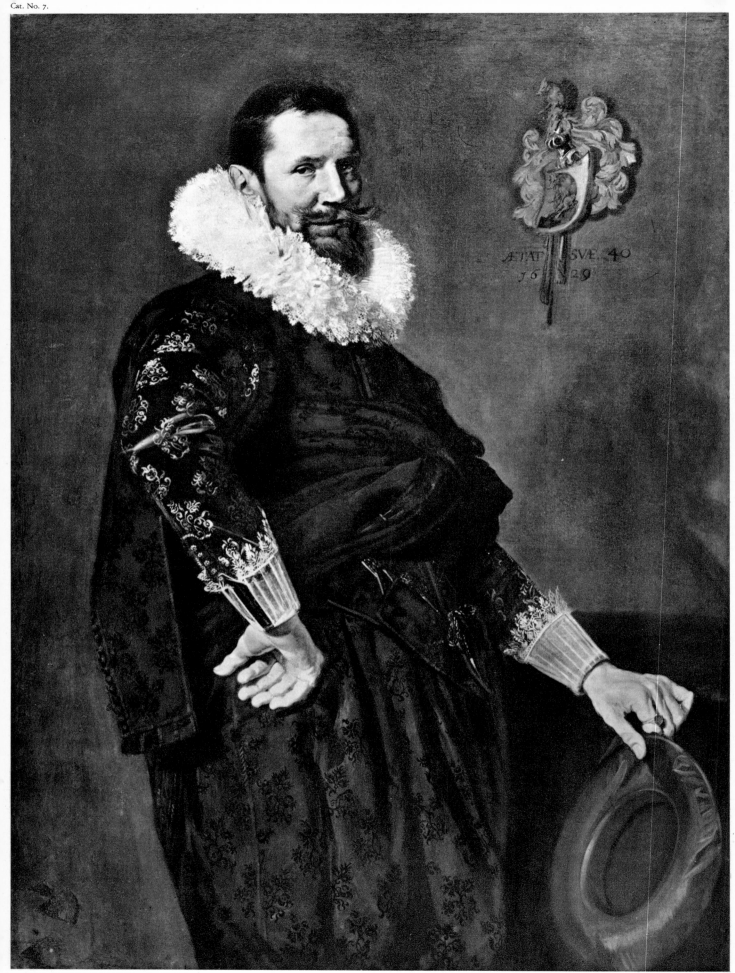

ÆTAT SVE 40
16 29

12. PAULUS VON BERESTEYN. 1620. Paris, Louvre

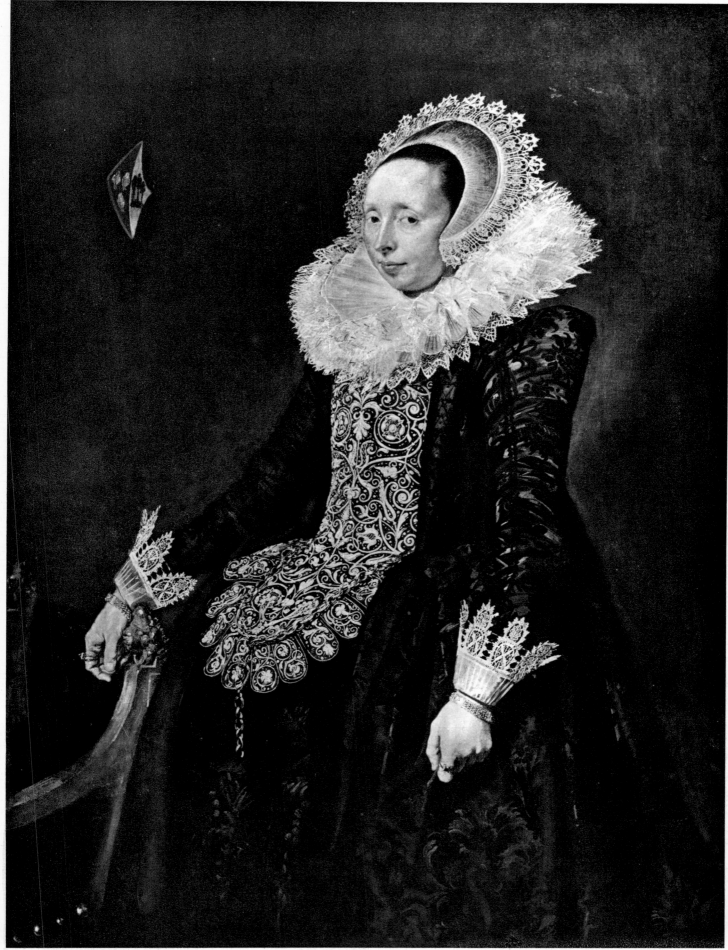

13. CATHARINA BOOTH VAN DEREEM, THIRD WIFE OF PAULUS VAN BERESTEYN. 1620. Paris, Louvre.

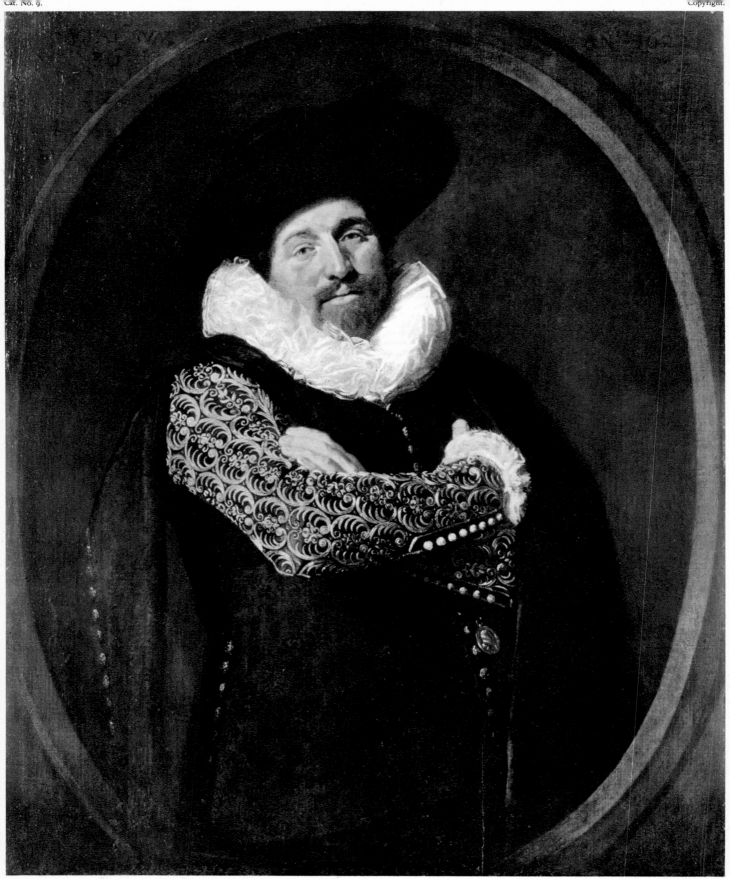

14. PORTRAIT OF A MAN. 1622. London, The Duke of Devonshire.

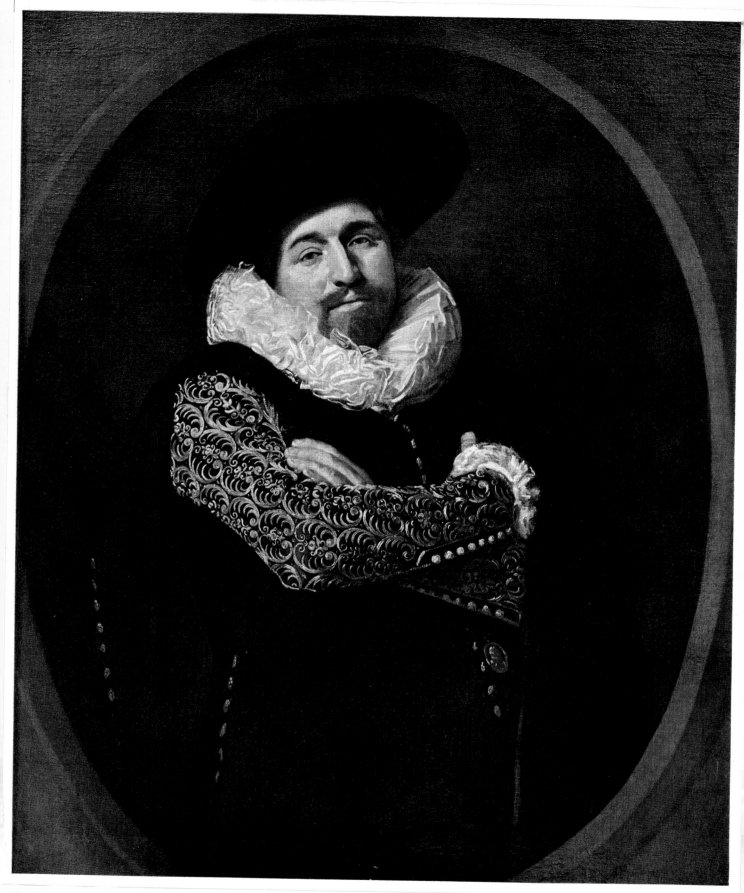

PORTRAIT OF A MAN. (cf. Plate 14, Cat. No. 9)

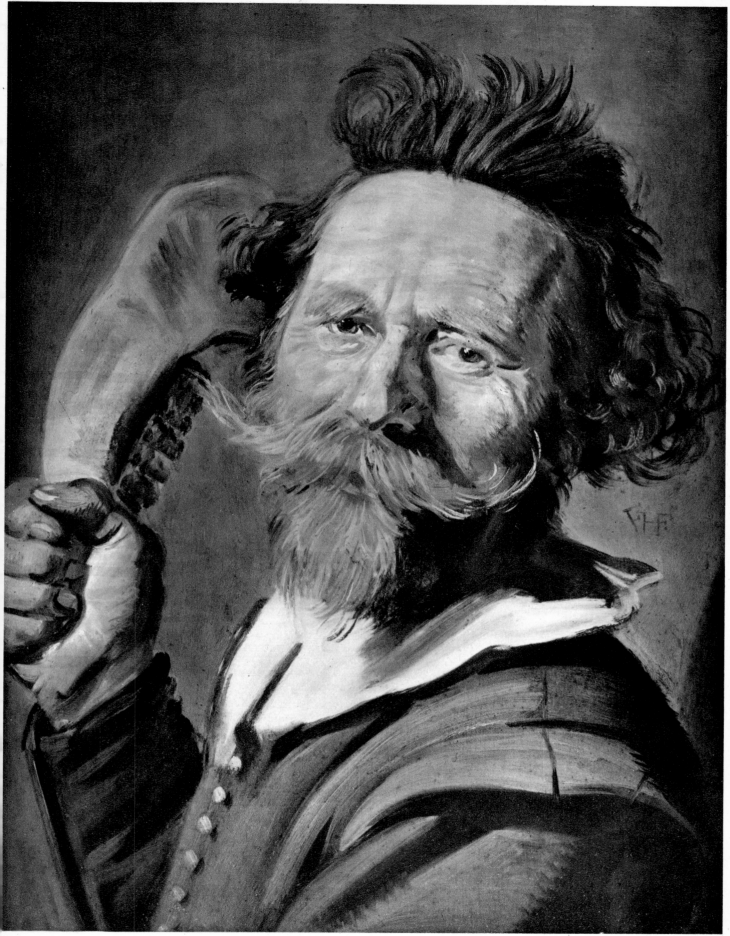

15. PORTRAIT OF VERDONCK. 1624-1627. Edinburgh, The National Gallery of Scotland.

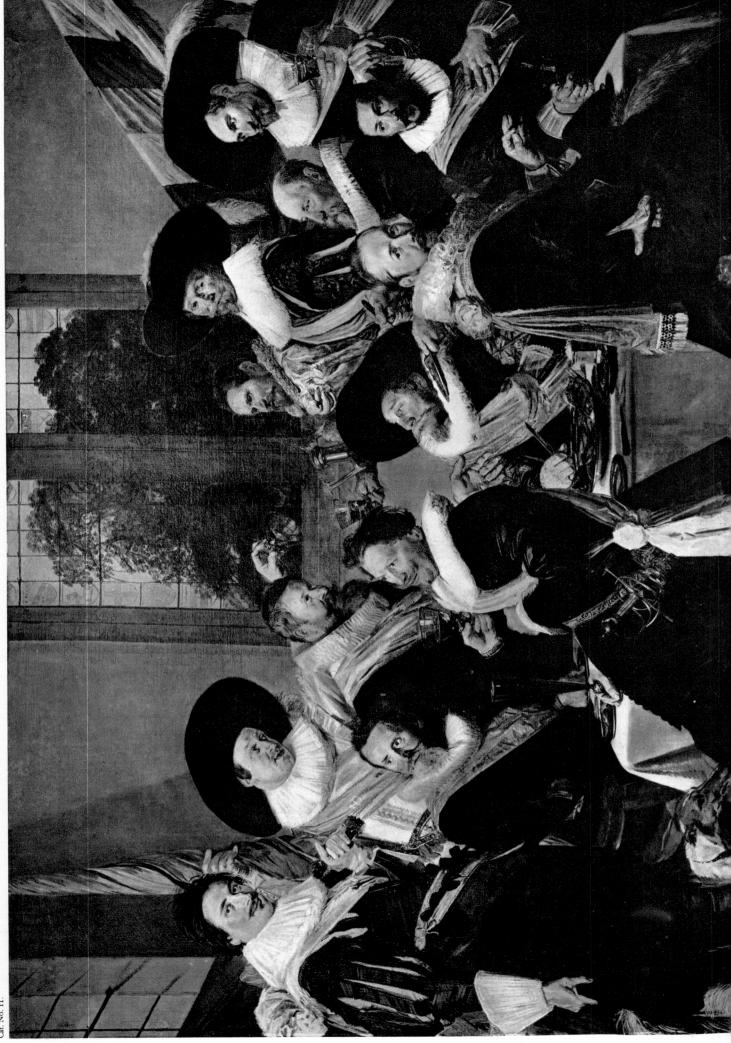

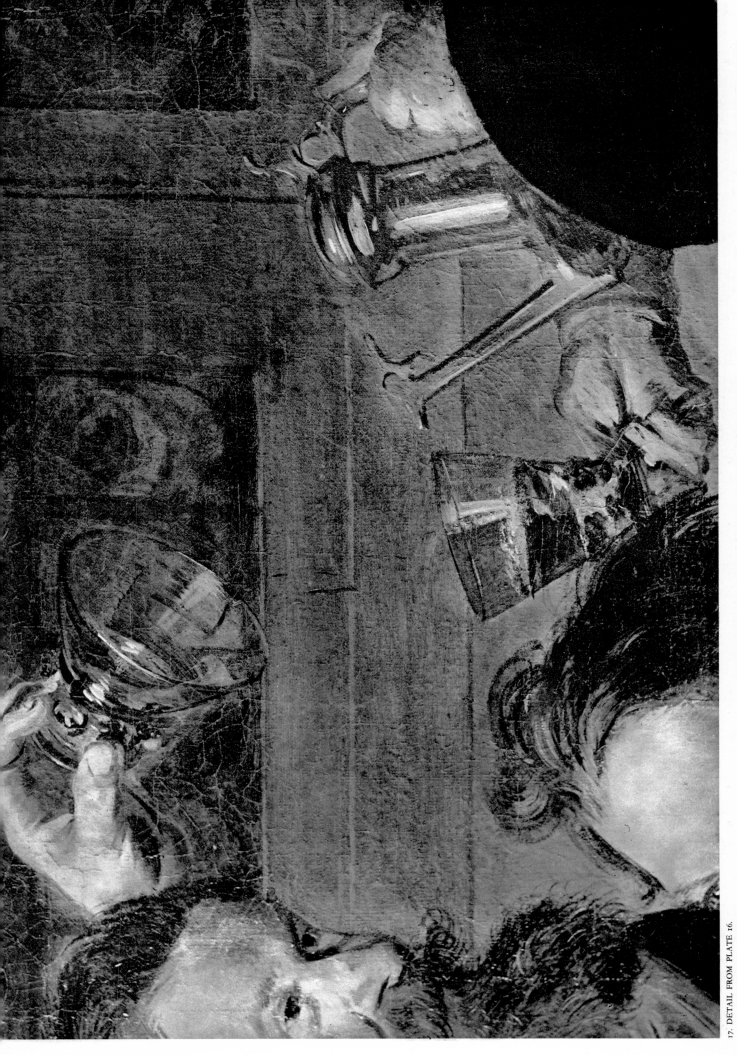

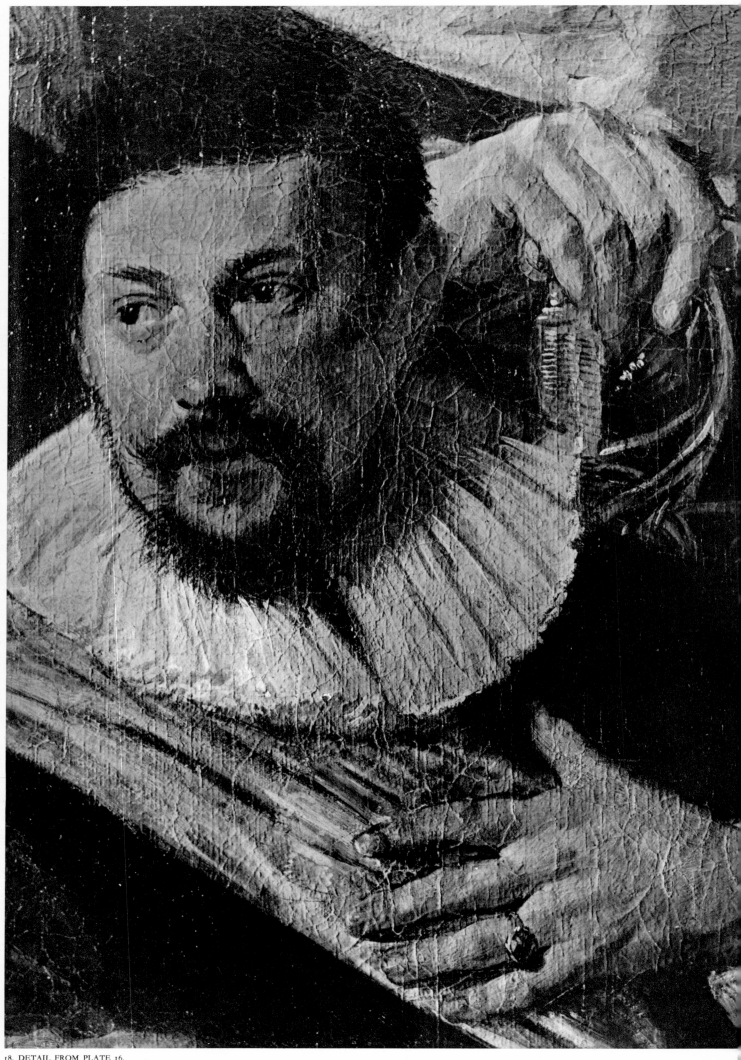

18. DETAIL FROM PLATE 16.

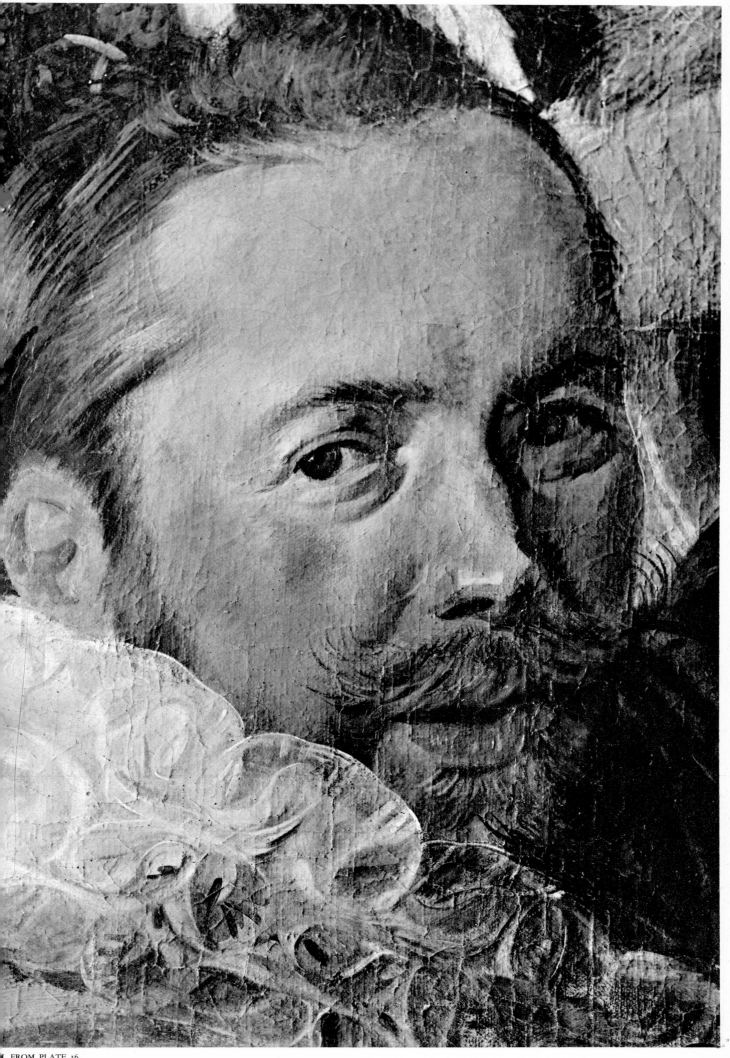

DETAIL FROM PLATE 16.

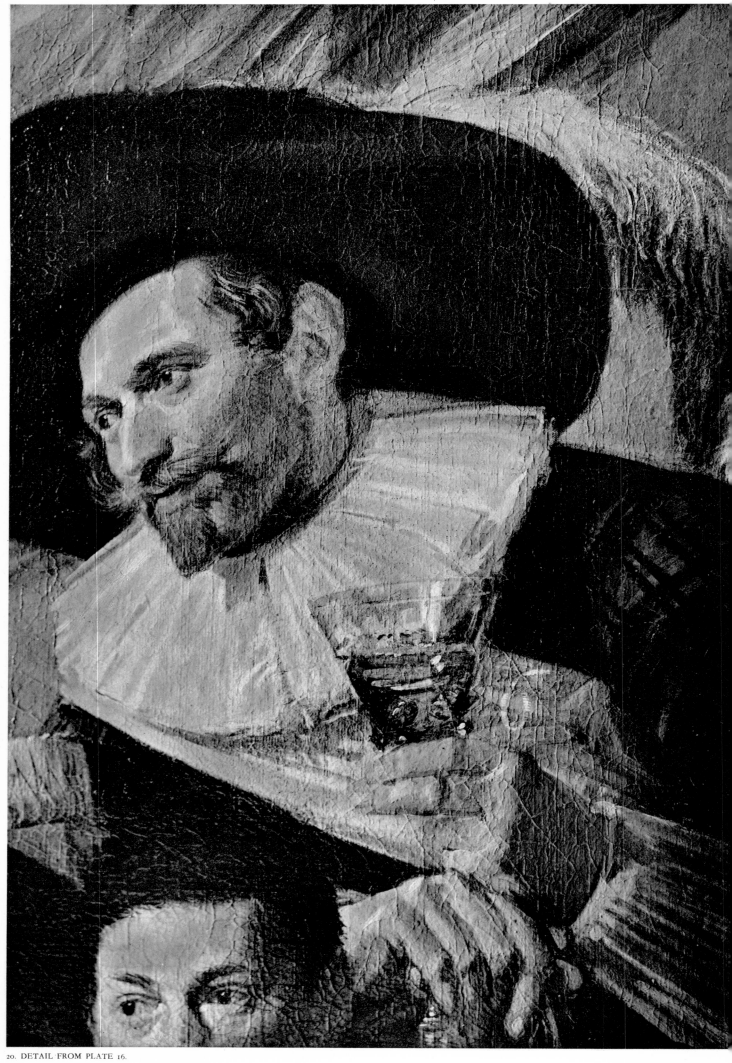

20. DETAIL FROM PLATE 16.

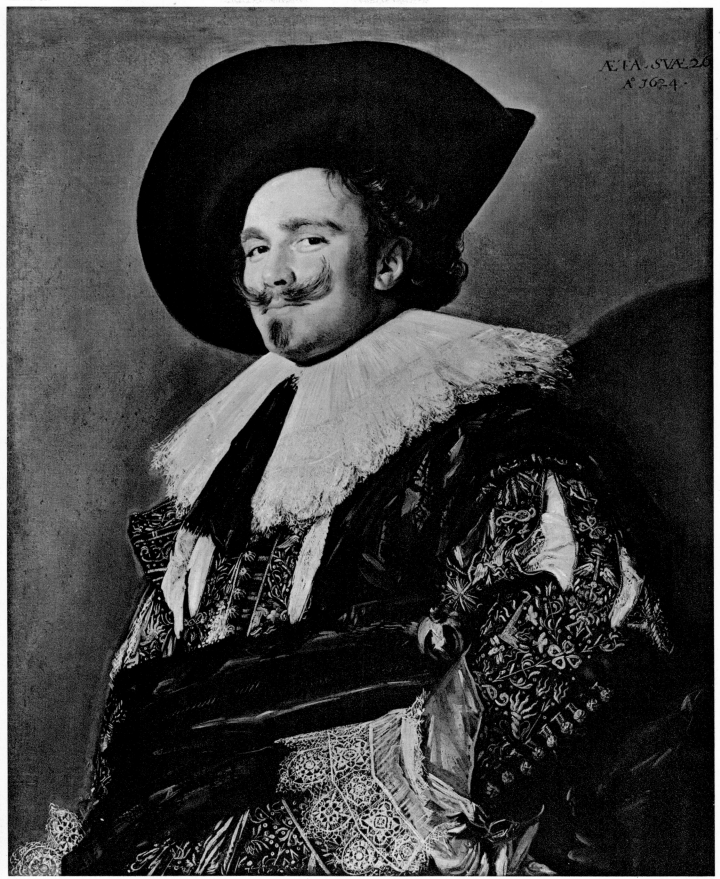

ÆTA·SVÆ·26
A° 1624·

21. PORTRAIT OF AN OFFICER, CALLED THE LAUGHING CAVALIER. 1624. London, Wallace Collection.

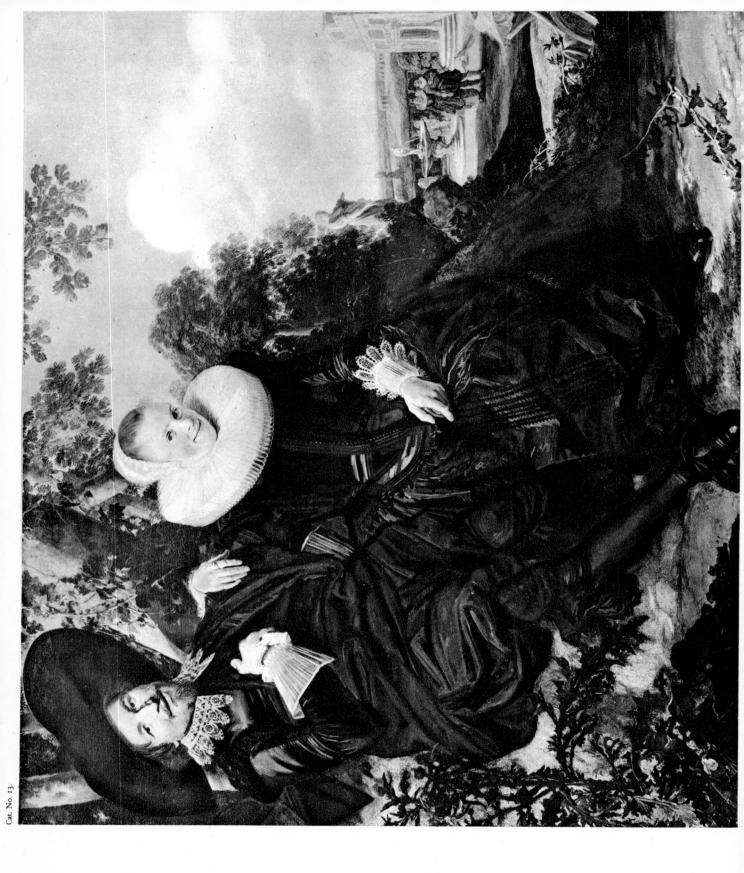

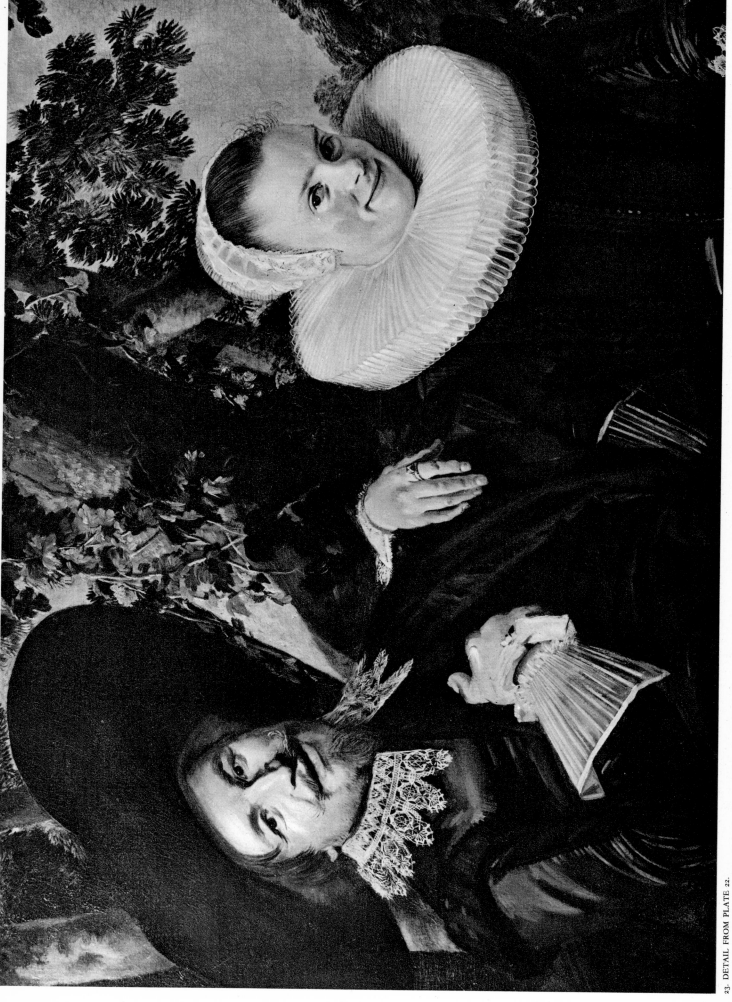

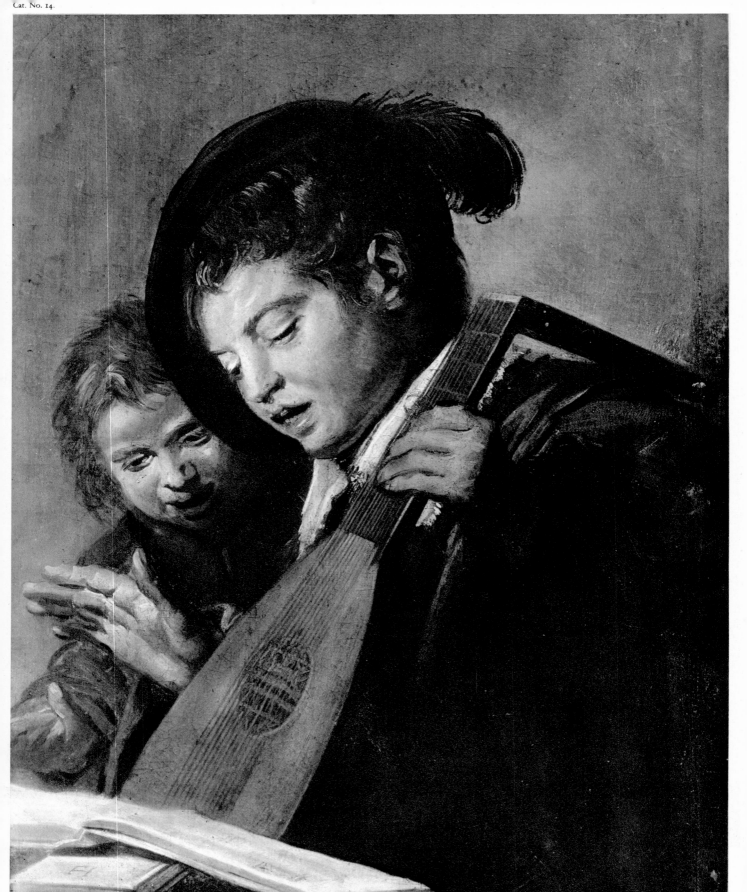

24. TWO SINGING BOYS WITH A LUTE. 1624-1627. Cassel, Staatliche Gemäldegalerie.

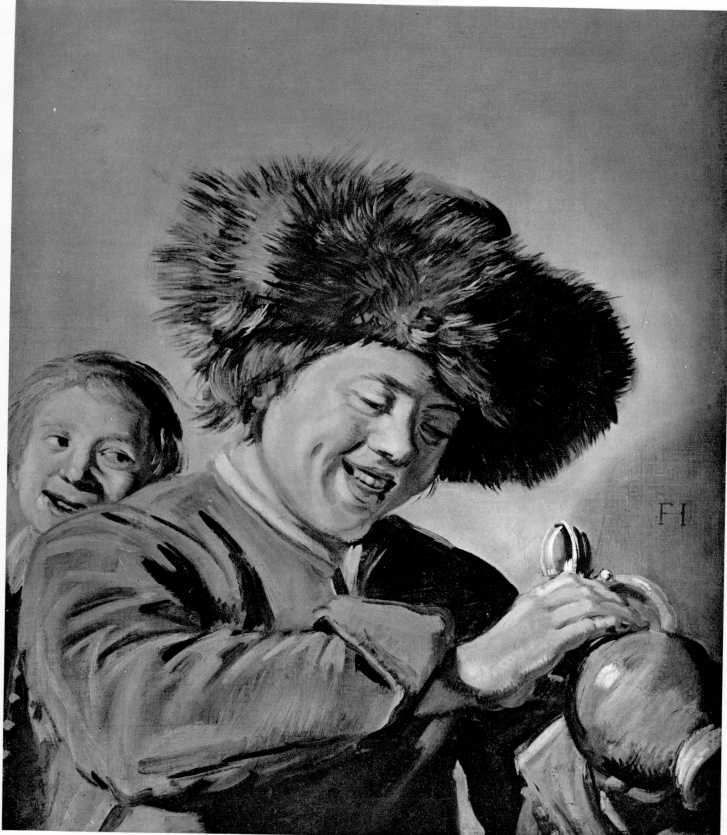

25. LAUGHING BOYS WITH A BEER JUG. 1624-1627. Leerdam, Holland, Hofje van Aarden.

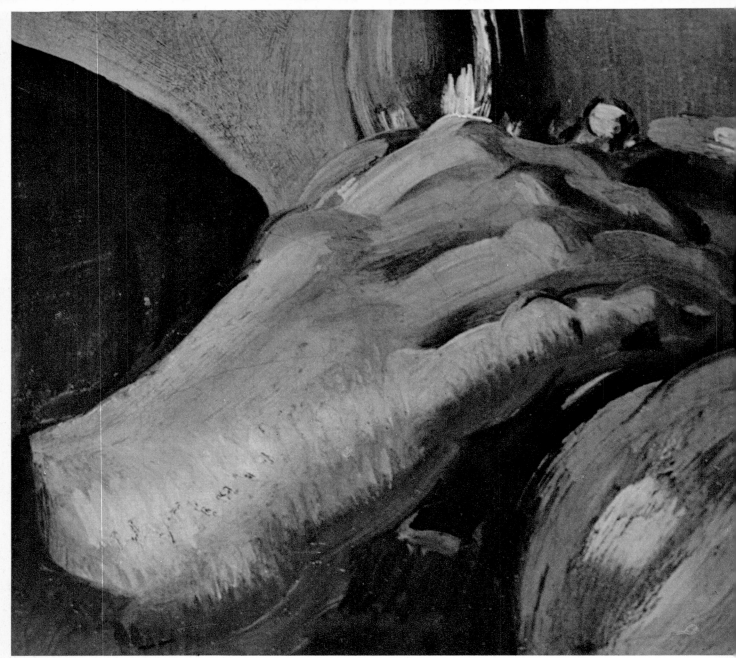

26. DETAIL FROM PLATE 25 (actual size).

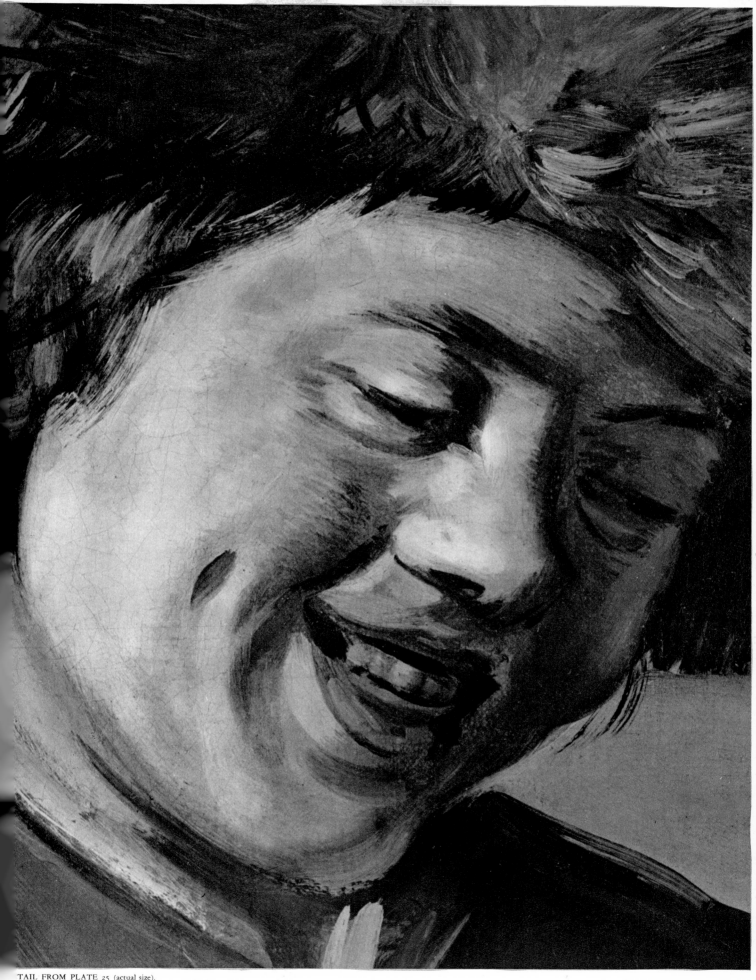

DETAIL FROM PLATE 25 (actual size).

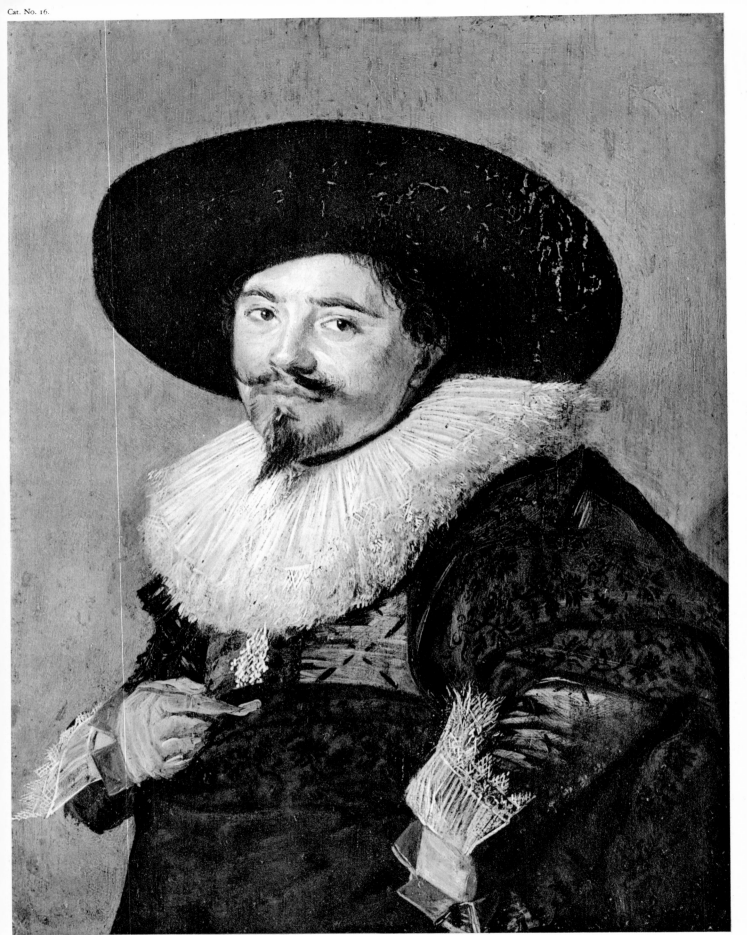

28. PORTRAIT OF A HUNCH-BACKED MAN. 1625. Berlin, Kaiser-Friedrich-Museum.

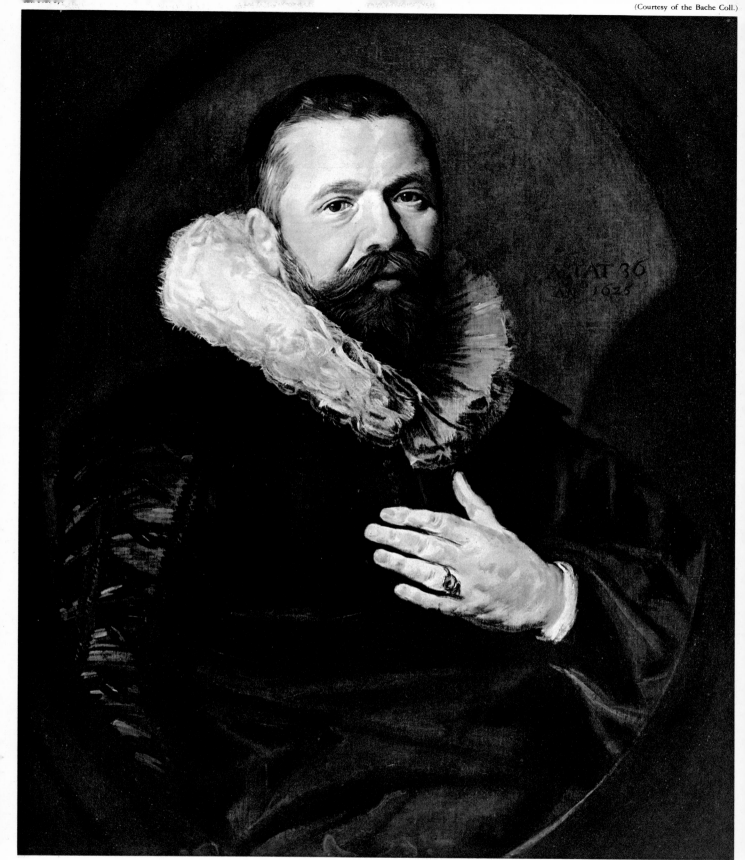

29. PORTRAIT OF A BEARDED MAN. 1625. New York, Mr. Jules S. Bache.

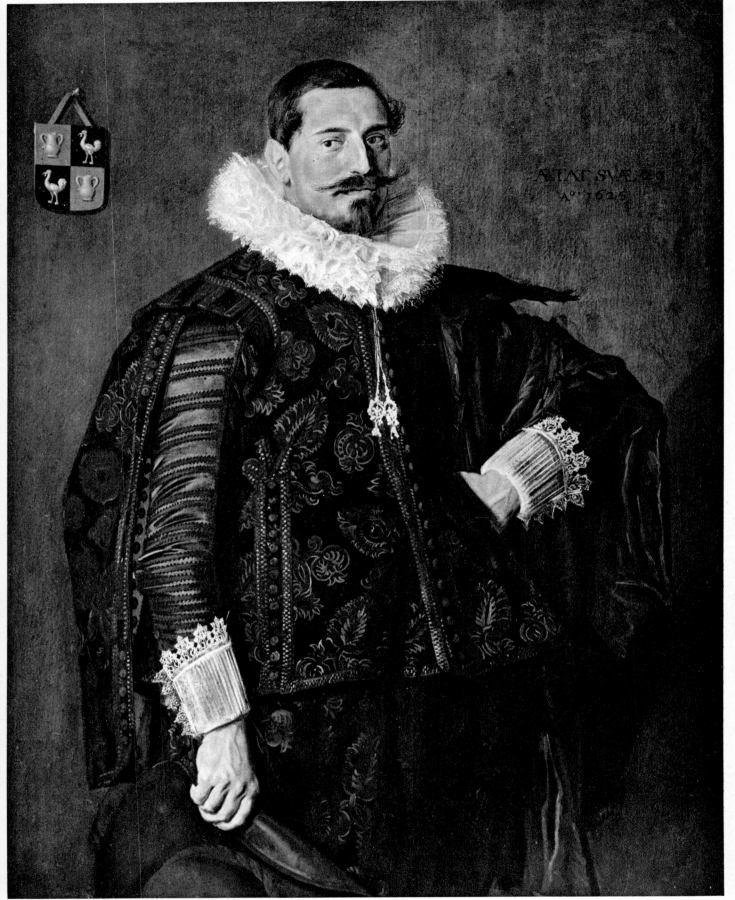

30. JACOB PIETERSZ OLYCAN. 1625. The Hague, Mauritshuis.

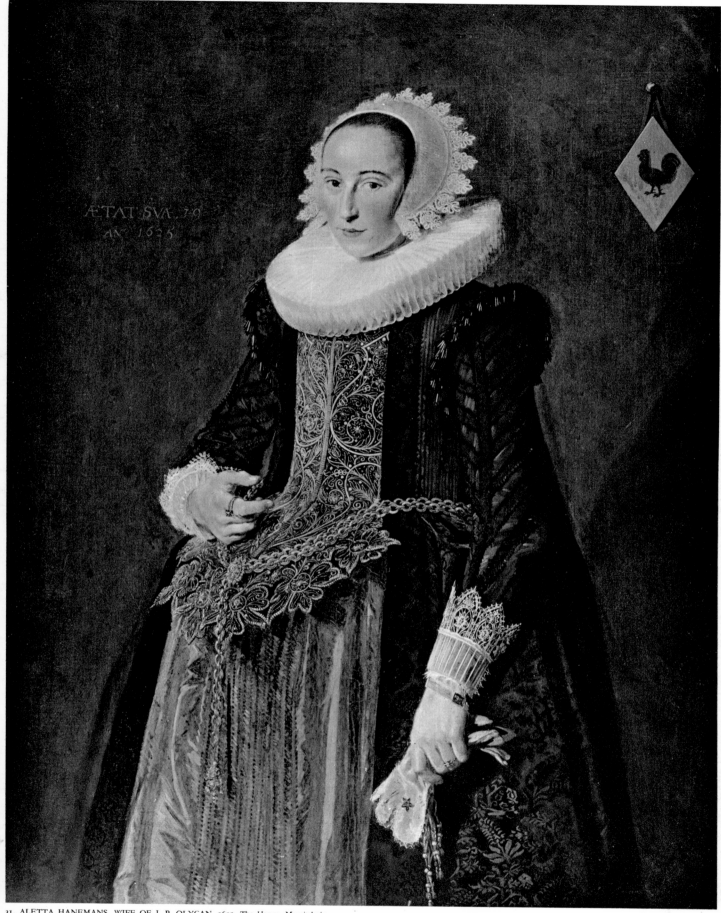

31. ALETTA HANEMANS, WIFE OF J. P. OLYCAN. 1625. The Hague, Mauritshuis.

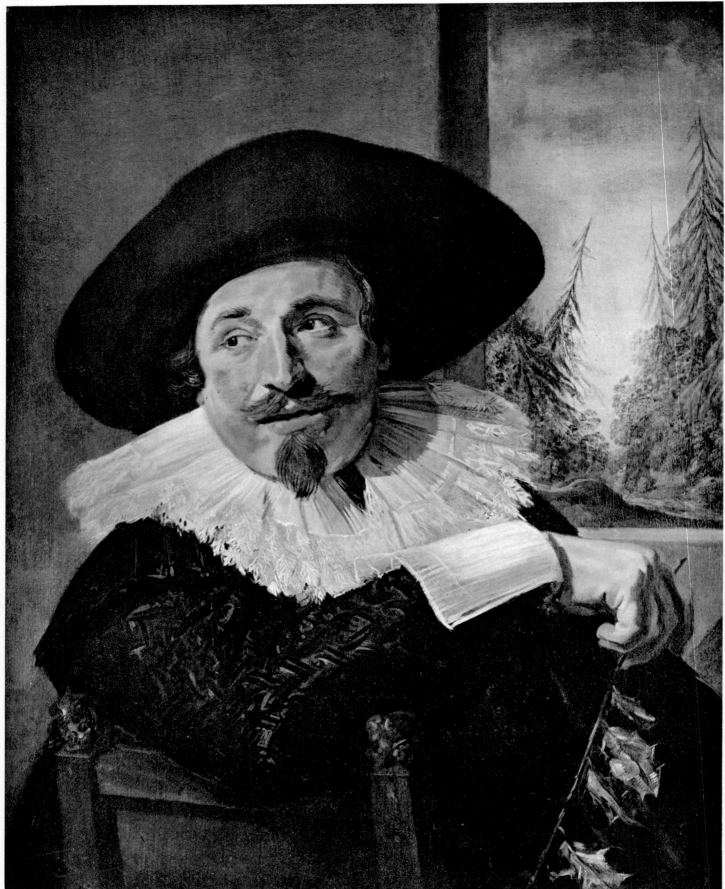

32. ISAAC ABRAHAMSZ. MASSA. 1626. Toronto, Canada, Mr. Frank P. Wood.

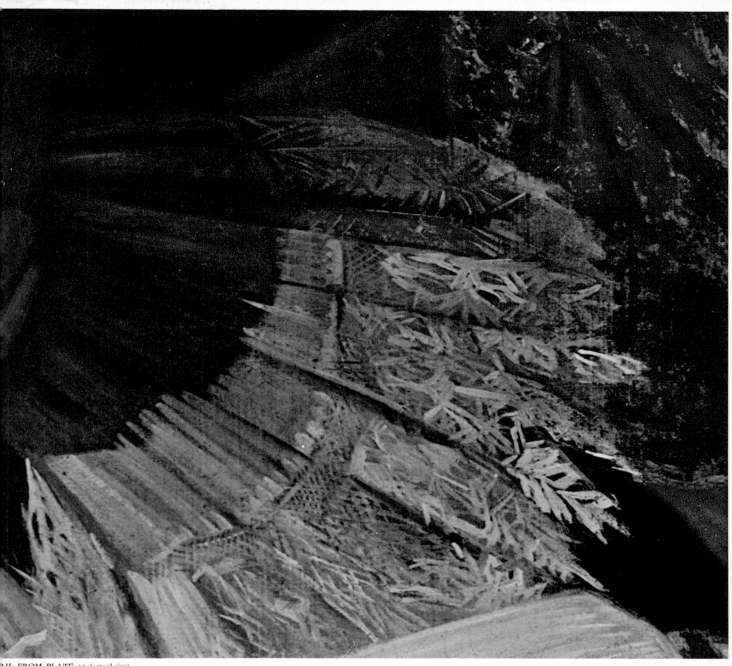

AIL FROM PLATE 32 (actual size).

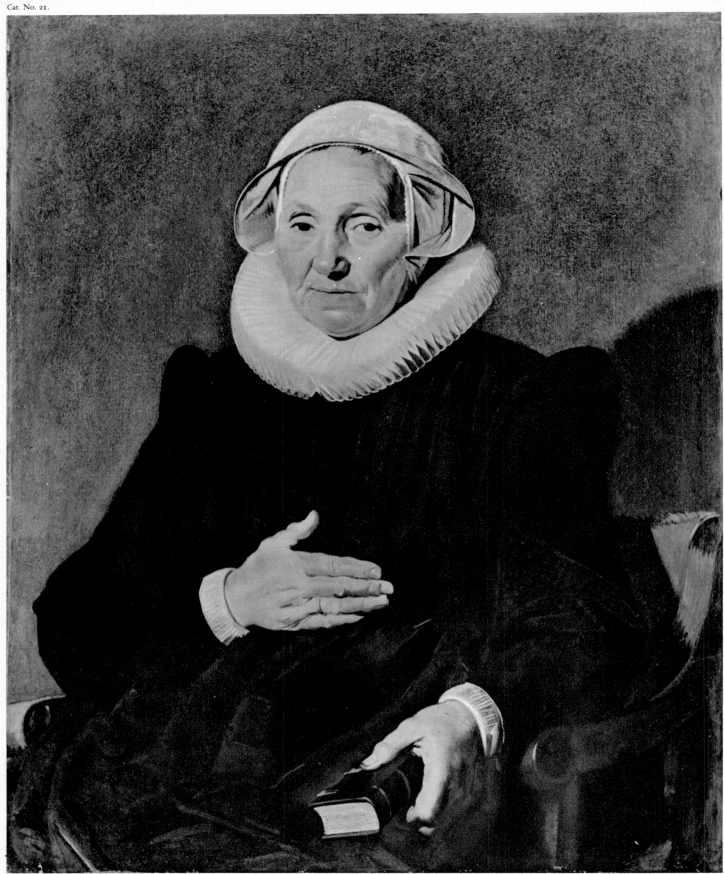

34. SARA ANDRIESDR. HESSIX, WIFE OF M. J. MIDDELHOVEN. 1626. Paris, Mr. C. S. Gulbenkian.

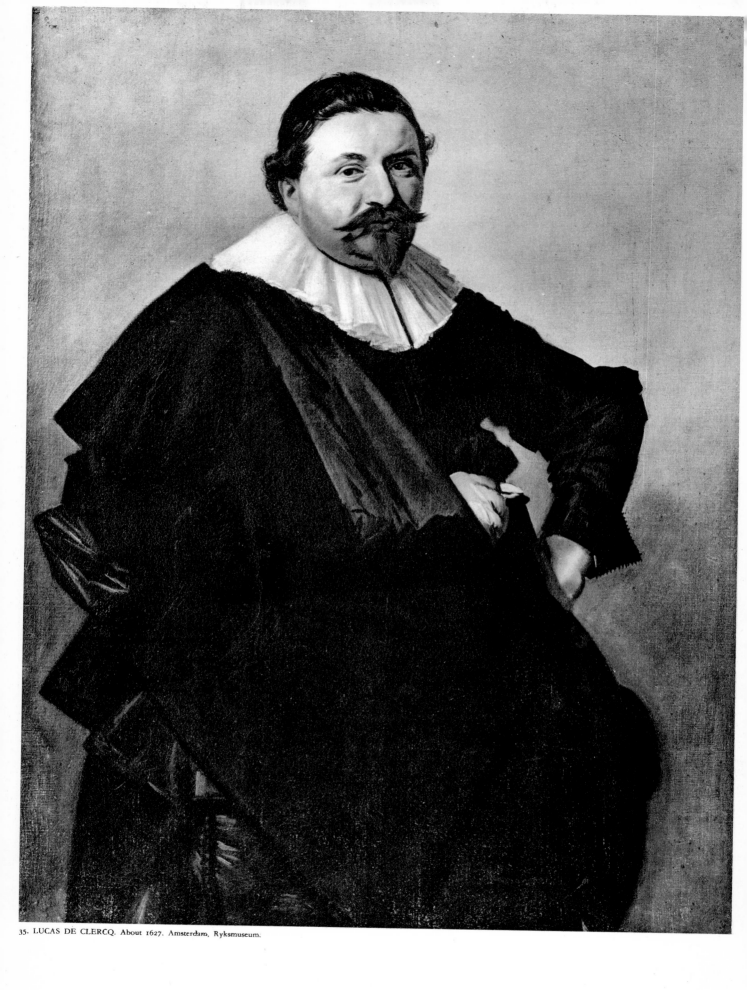

35. LUCAS DE CLERCQ. About 1627. Amsterdam, Ryksmuseum.

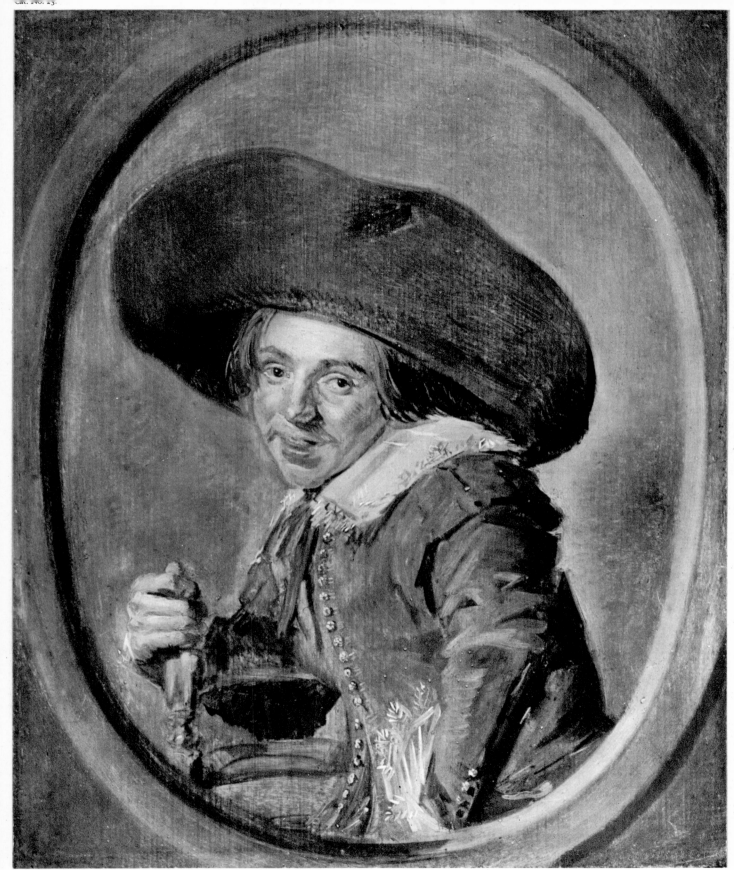

36. YOUNG MAN WITH A LARGE HAT. About 1627. Washington, D.C. (Courtesy of the A. W. Mellon Educational and Charitable Trust).

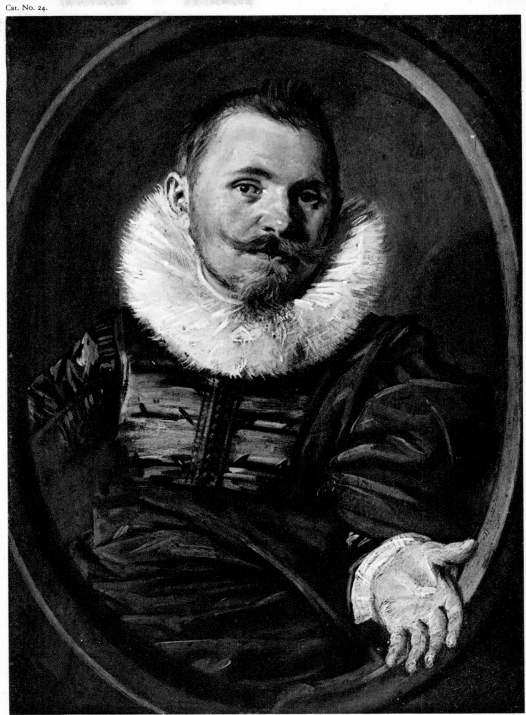

37. PORTRAIT OF A MAN, possibly N. Le Febure. 1627. Berlin, Kaiser-Friedrich-Museum (actual size).

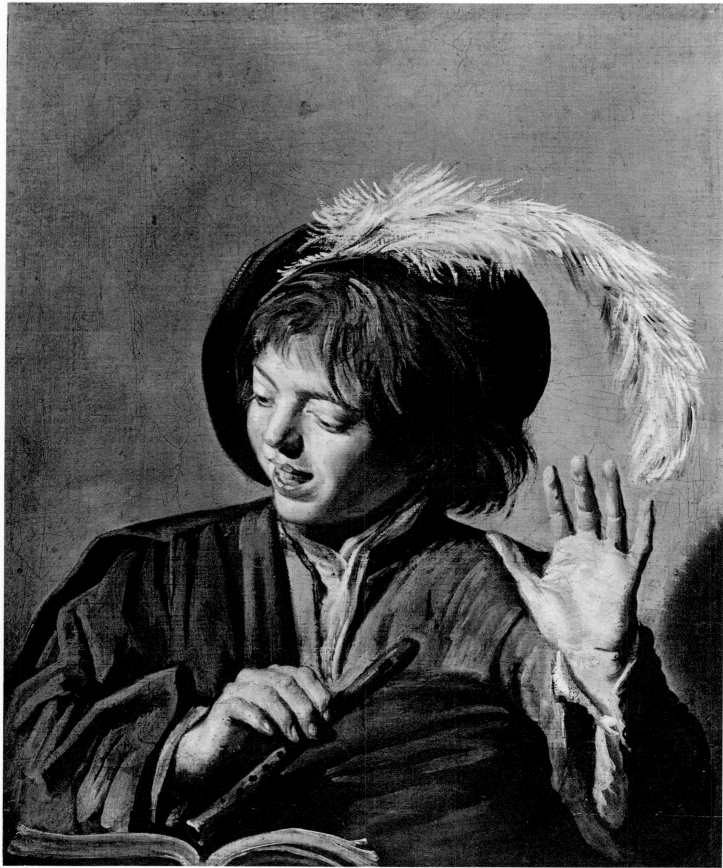

38. SINGING BOY WITH A FLUTE. 1625-1627. Berlin, Kaiser-Friedrich-Museum.

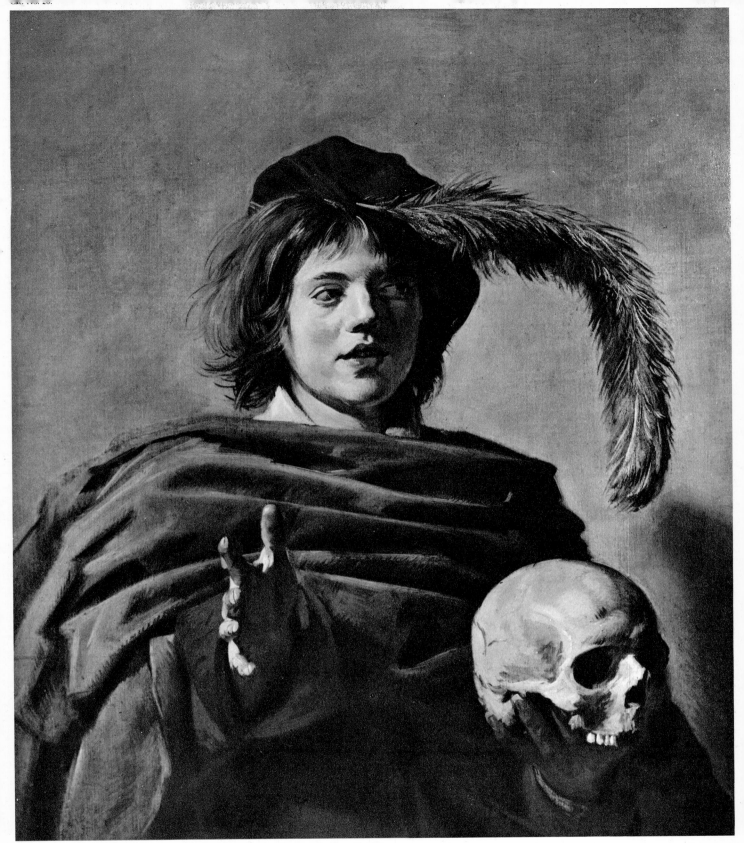

39. BOY WITH A SKULL, THE SO-CALLED HAMLET. 1625-1627. London, Mr. Granville Proby.

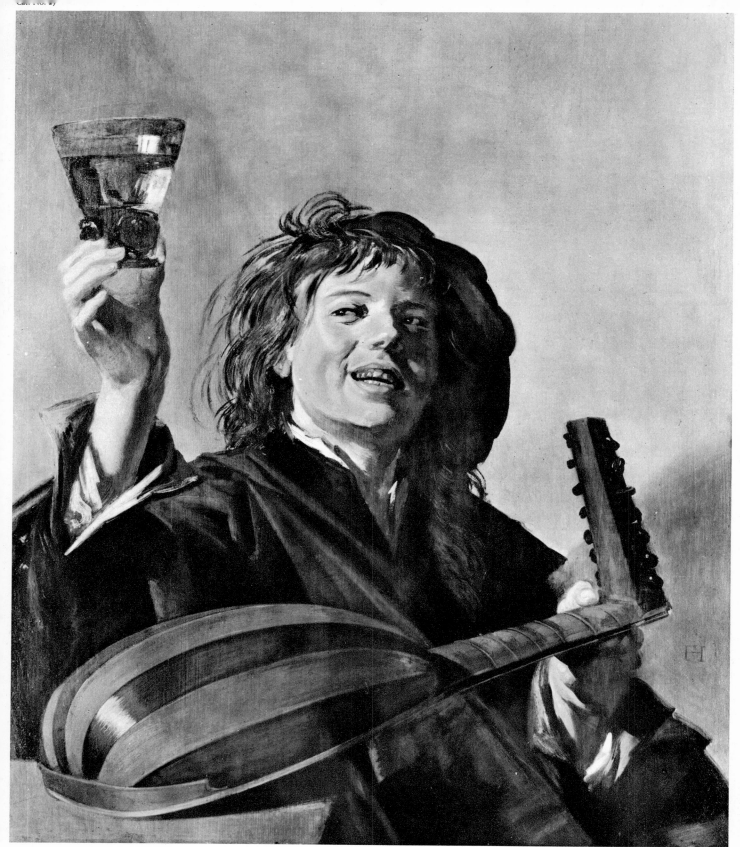

40. THE MERRY LUTE PLAYER. 1625-1627. Chicago, Mr. John R. Thompson, Jr.

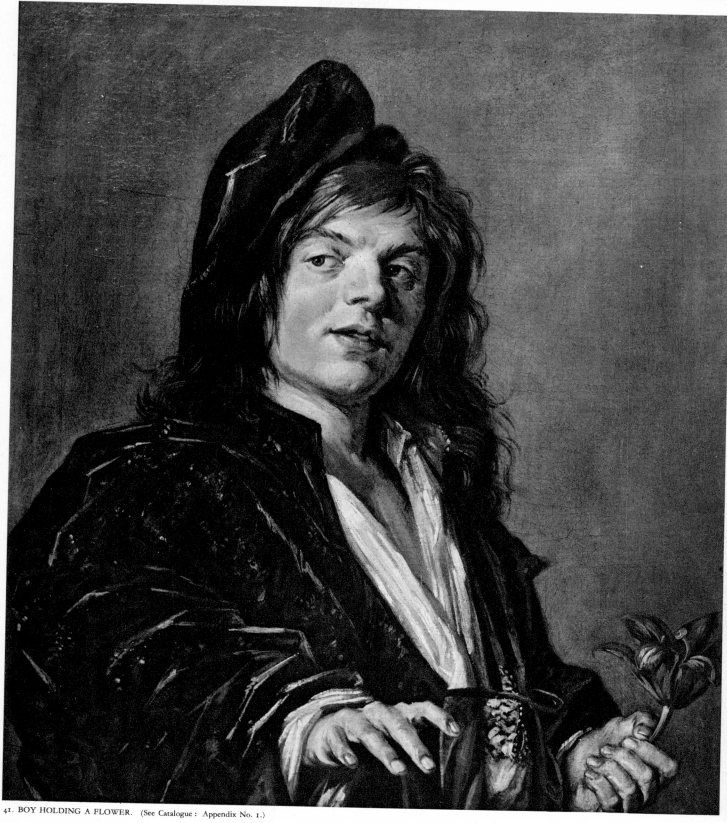

41. BOY HOLDING A FLOWER. (See Catalogue: Appendix No. 1.)

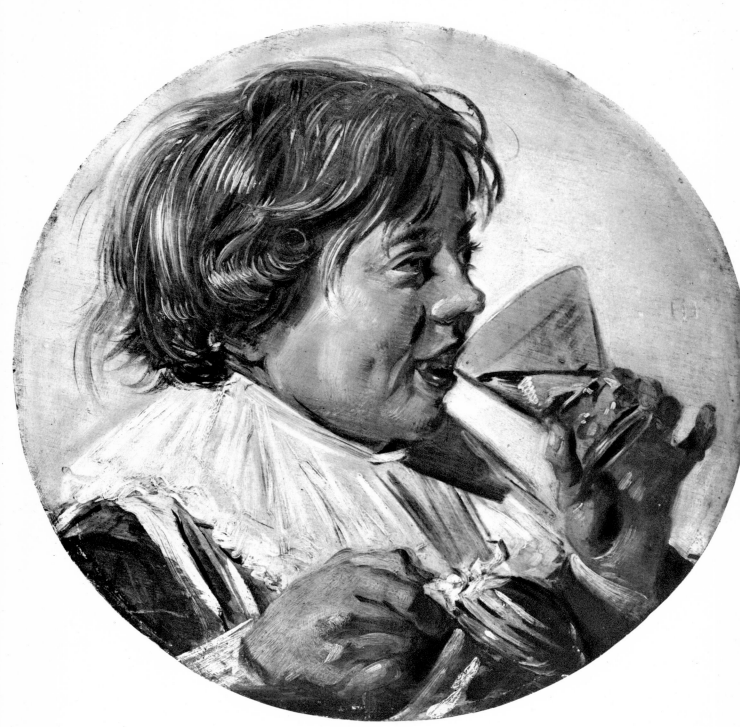

42. A BOY DRINKING. About 1627. Schwerin, Museum.

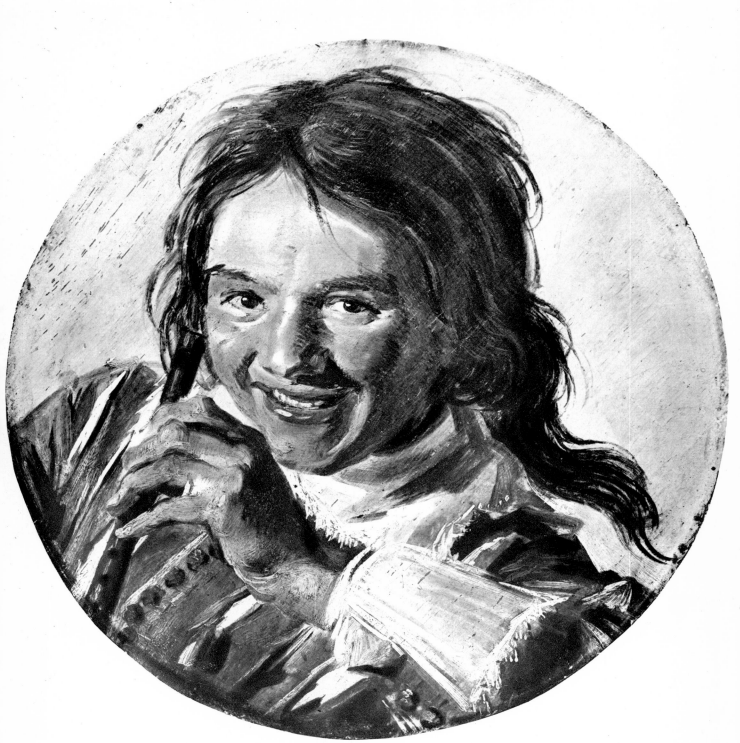

43. LAUGHING BOY WITH A FLUTE. About 1627. Schwerin, Museum.

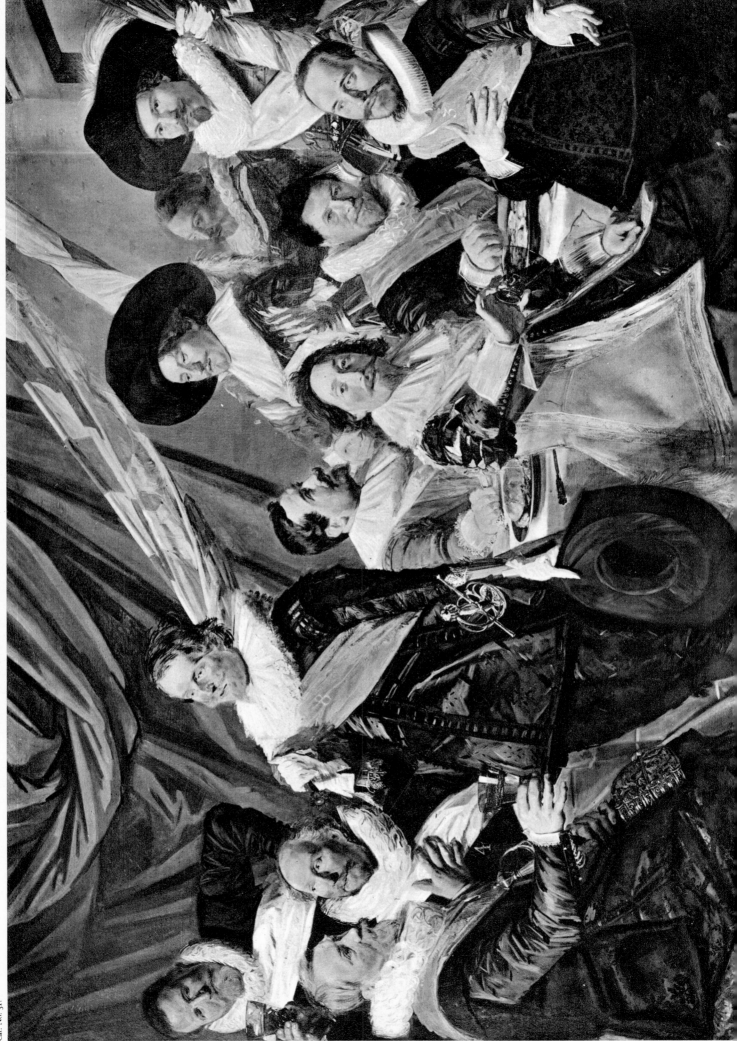

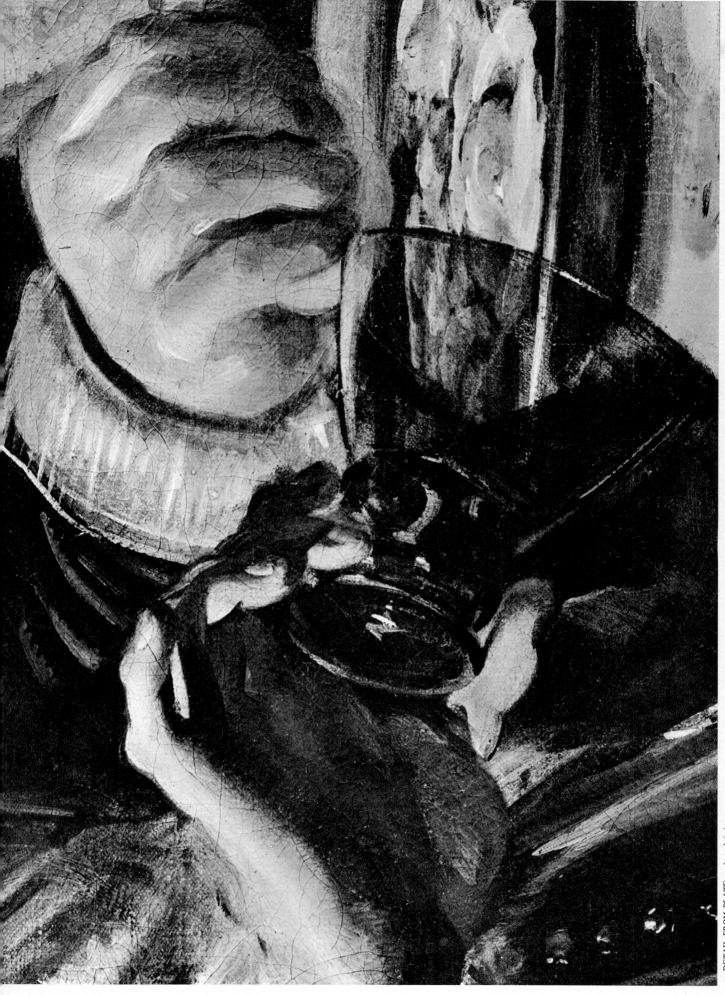

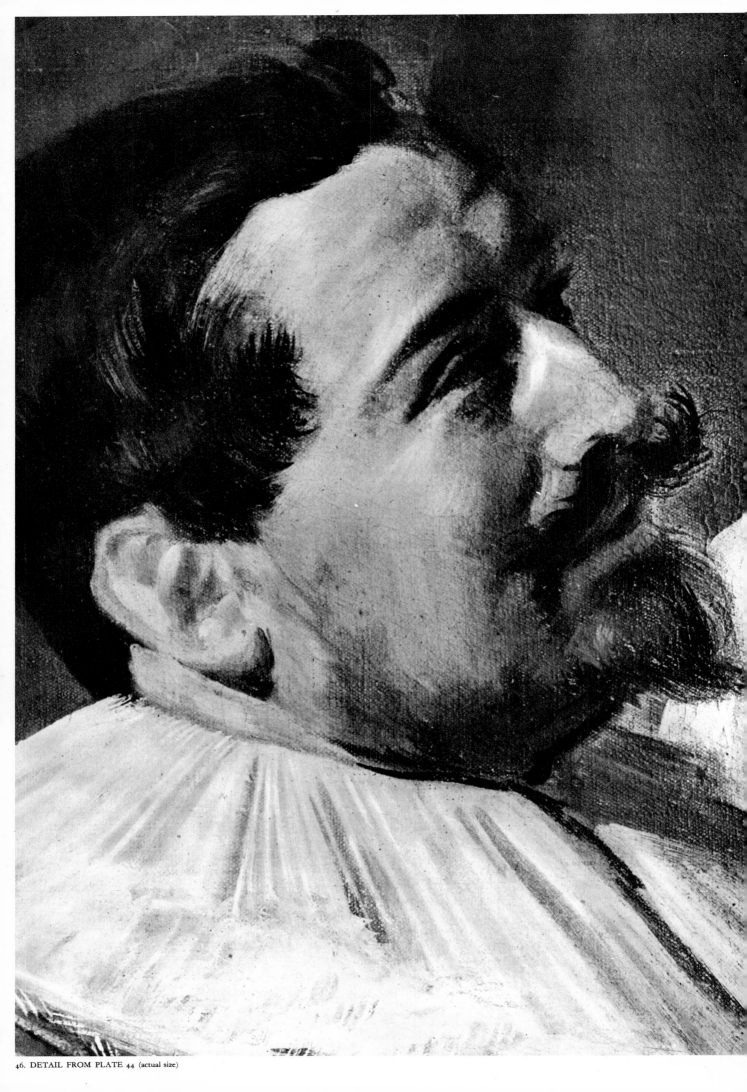

46. DETAIL FROM PLATE 44 (actual size)

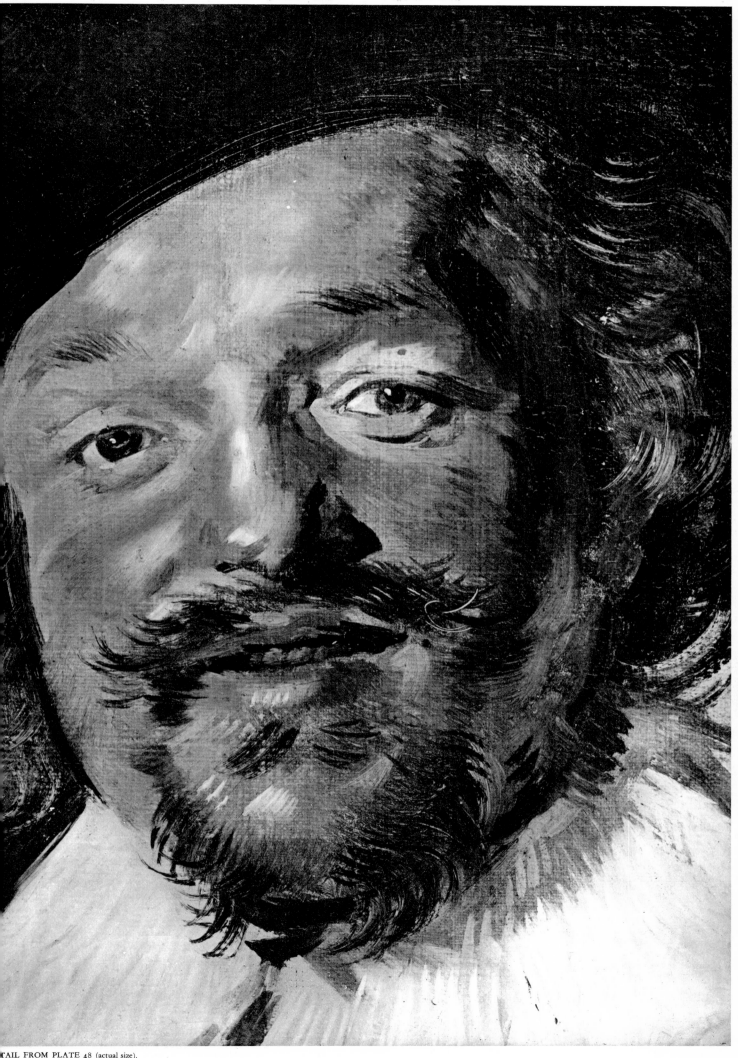

DETAIL FROM PLATE 48 (actual size).

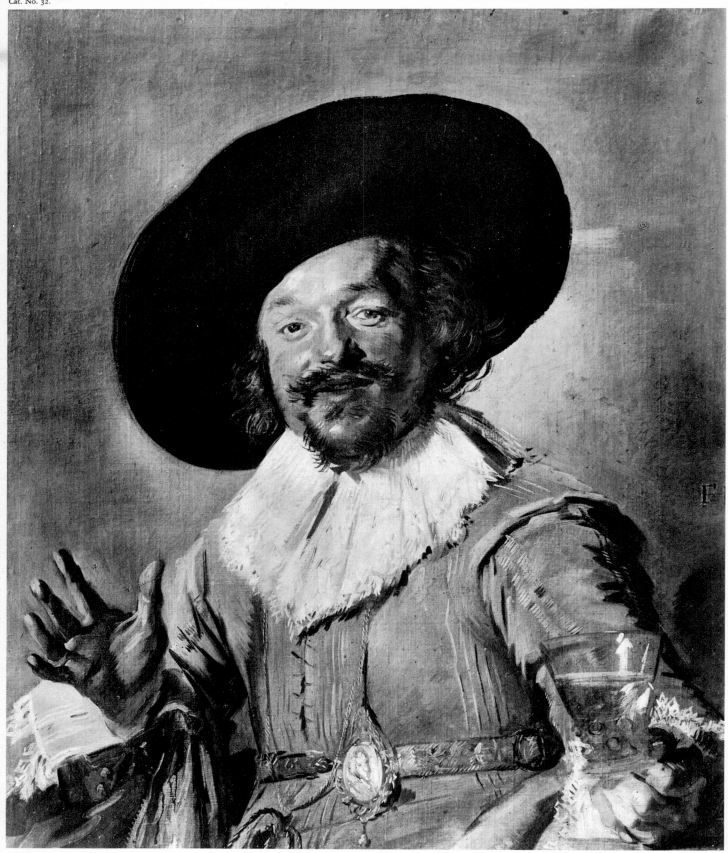

48. THE MERRY DRINKER. About 1627. Amsterdam, Ryksmuseum.

MALLE BABBE. (cf. Plate 49, Cat. No. 33)

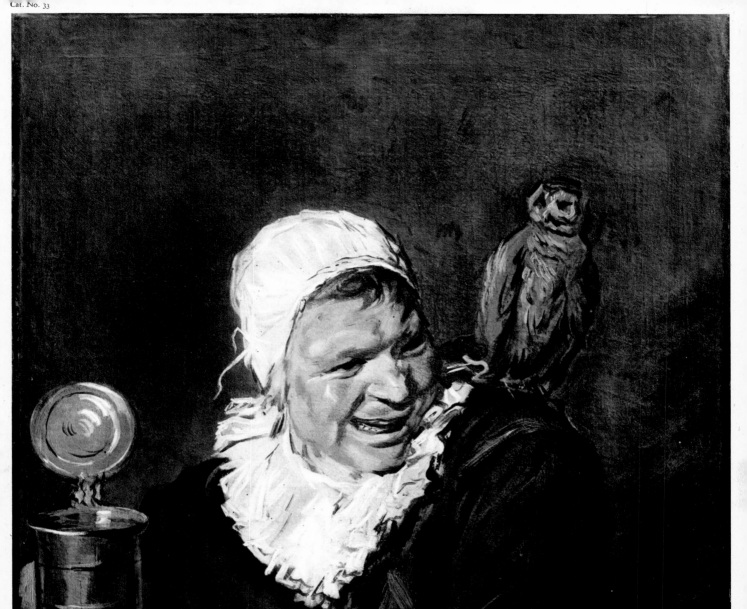

49. MALLE BABBE, THE WITCH OF HAARLEM. About 1628. Berlin, Kaiser-Friedrich-Museum.

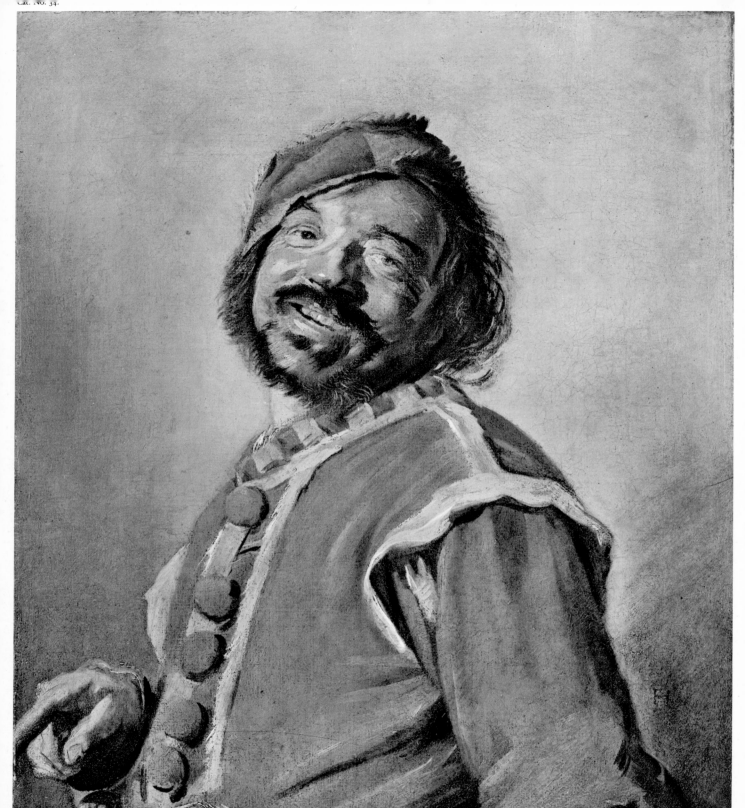

50. THE SO-CALLED MULATTO. About 1628. Leipzig, Museum der bildenden Künste.

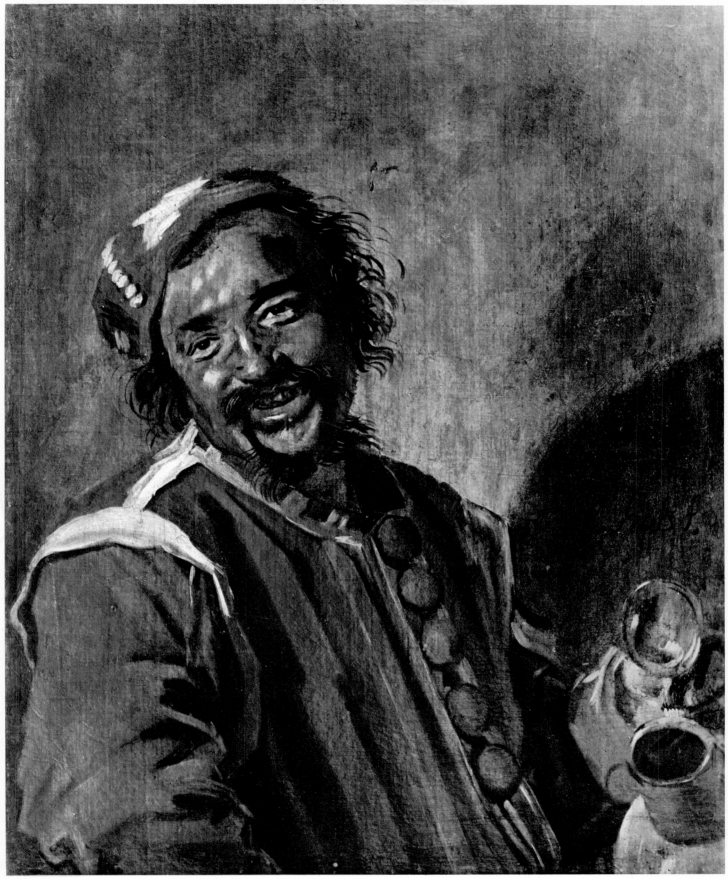

51. THE DRINKER, OR " MONSIEUR PEECKLHAERING." About 1628. Cassel, Gemäldegalerie.

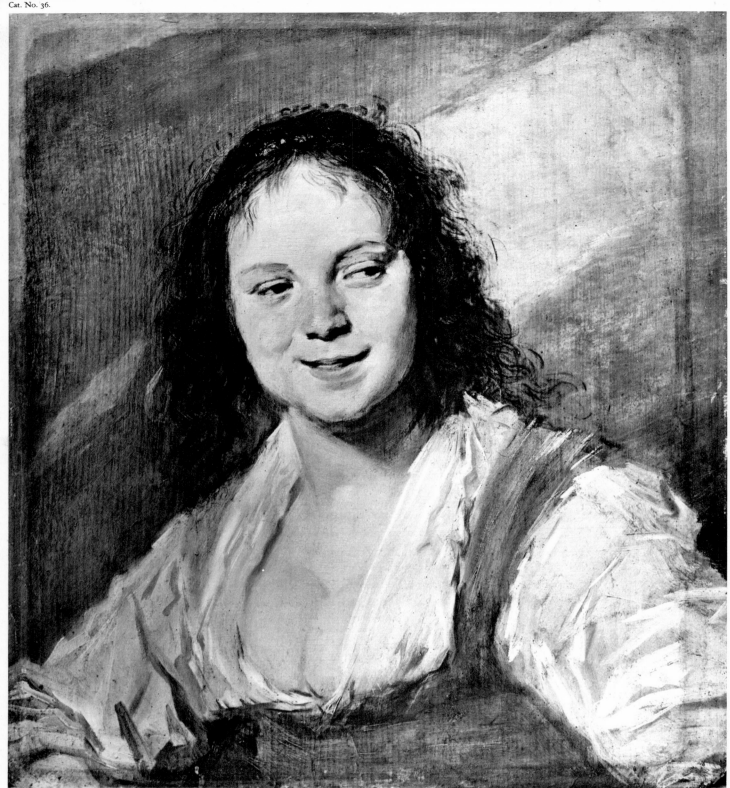

52. THE SO-CALLED GIPSY GIRL. About 1628. Paris, Louvre.

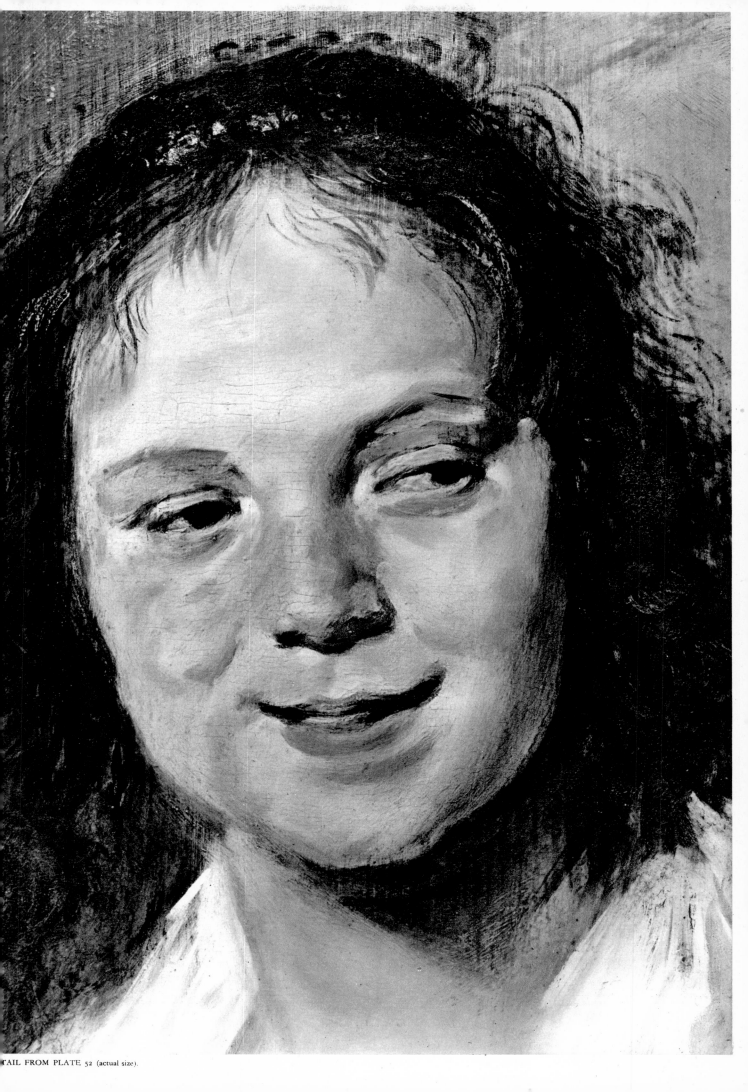

DETAIL FROM PLATE 52 (actual size).

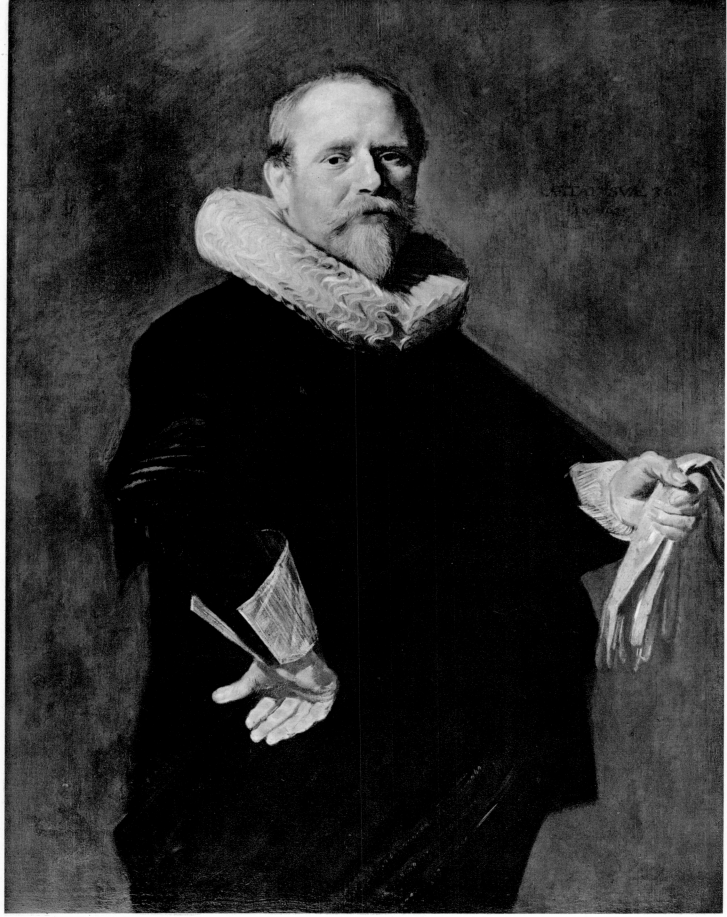

54. PORTRAIT OF A MAN. 1630. London, Buckingham Palace.

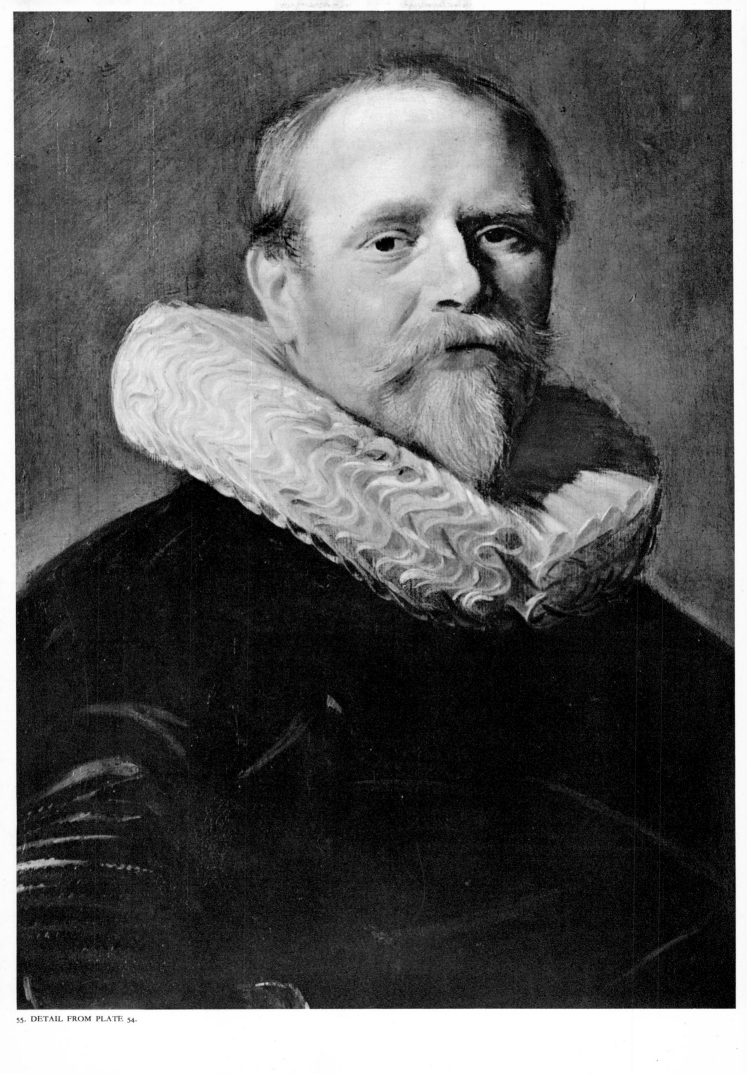

55. DETAIL FROM PLATE 54.

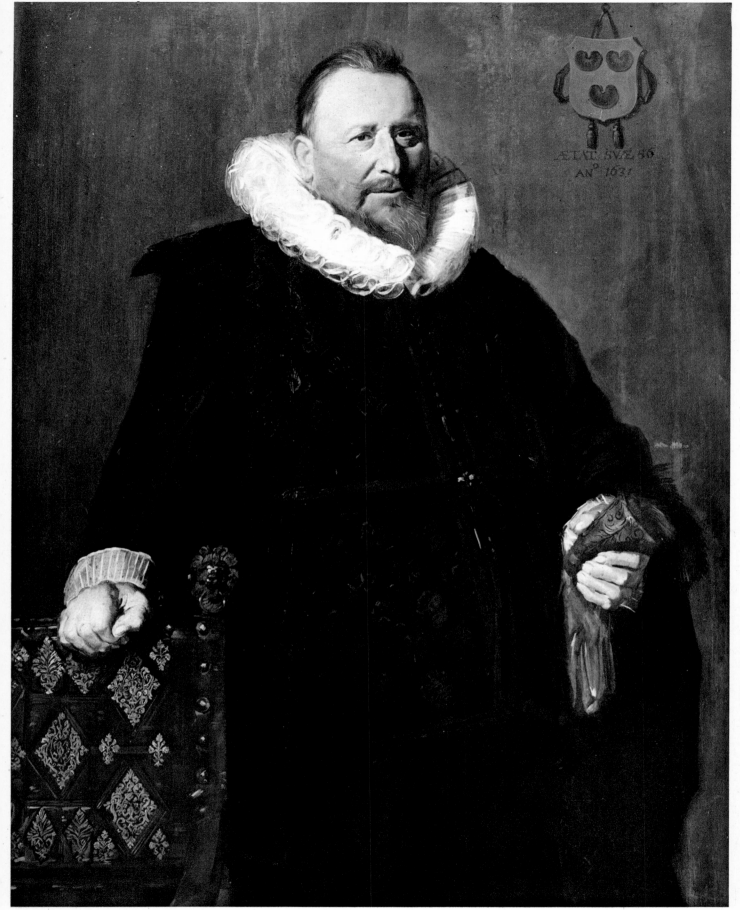

56. NICOLAES VAN DER MEER. 1631. Haarlem, Frans Hals Museum.

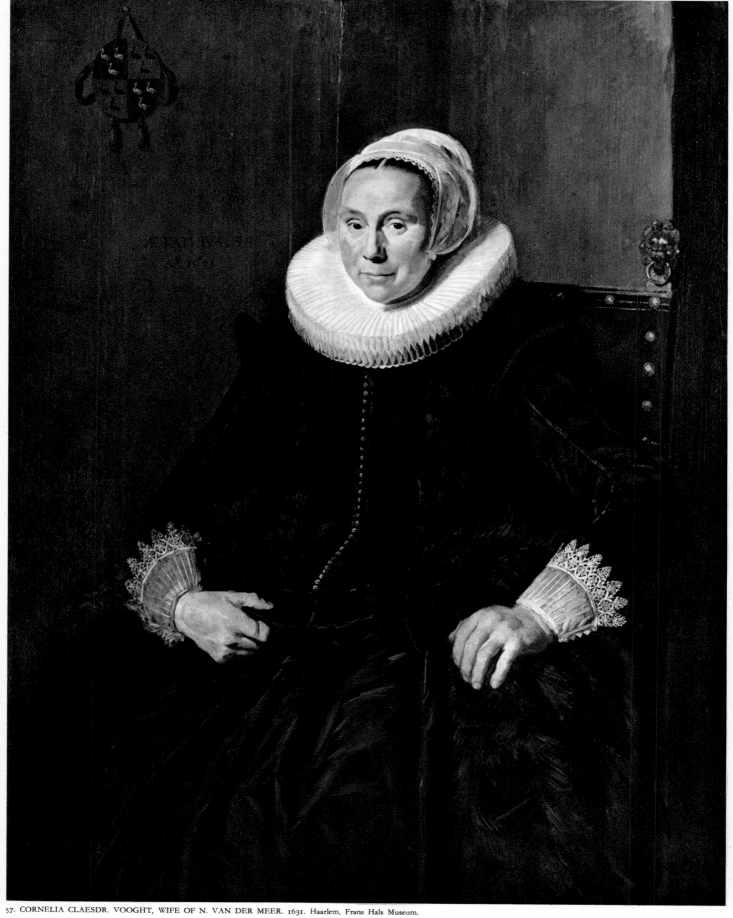

57. CORNELIA CLAESDR. VOOGHT, WIFE OF N. VAN DER MEER. 1631. Haarlem, Frans Hals Museum.

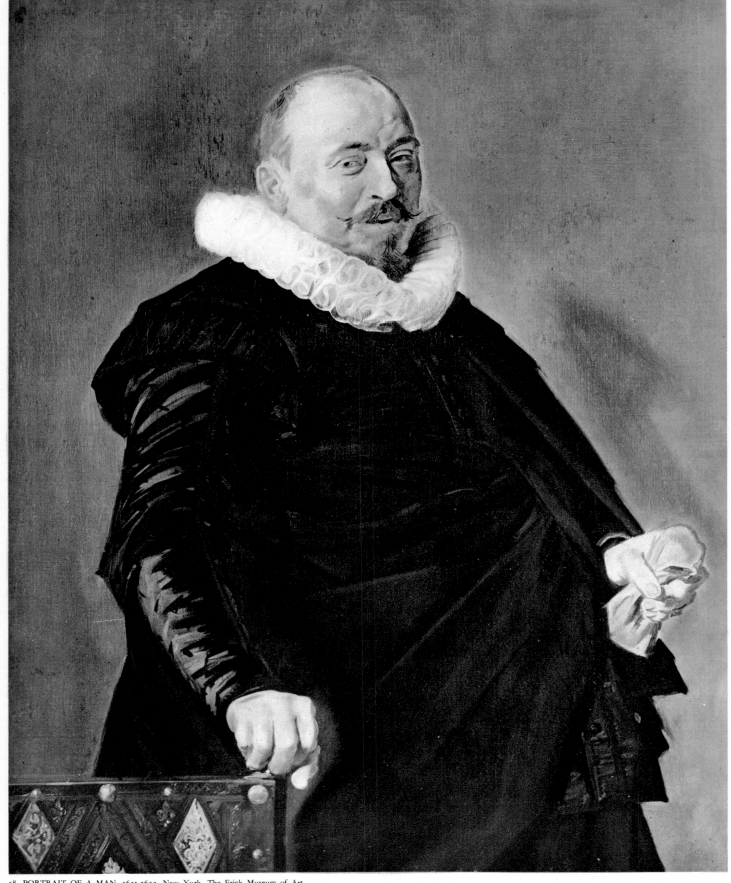

58. PORTRAIT OF A MAN. 1631-1633. New York, The Frick Museum of Art.

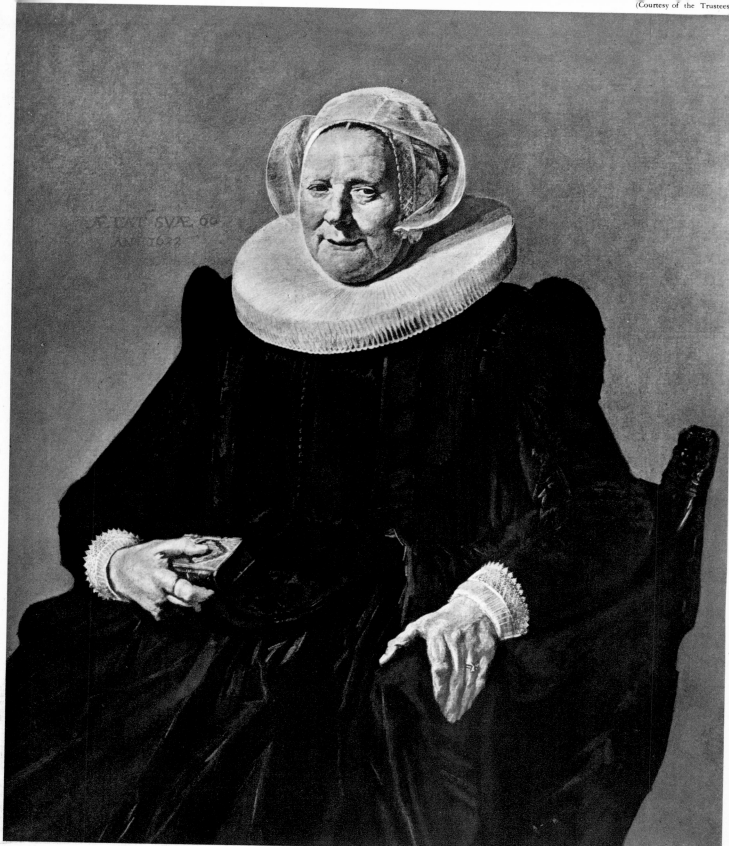

59. PORTRAIT OF AN ELDERLY WOMAN. 1633. Washington, D.C., National Gallery of Art.

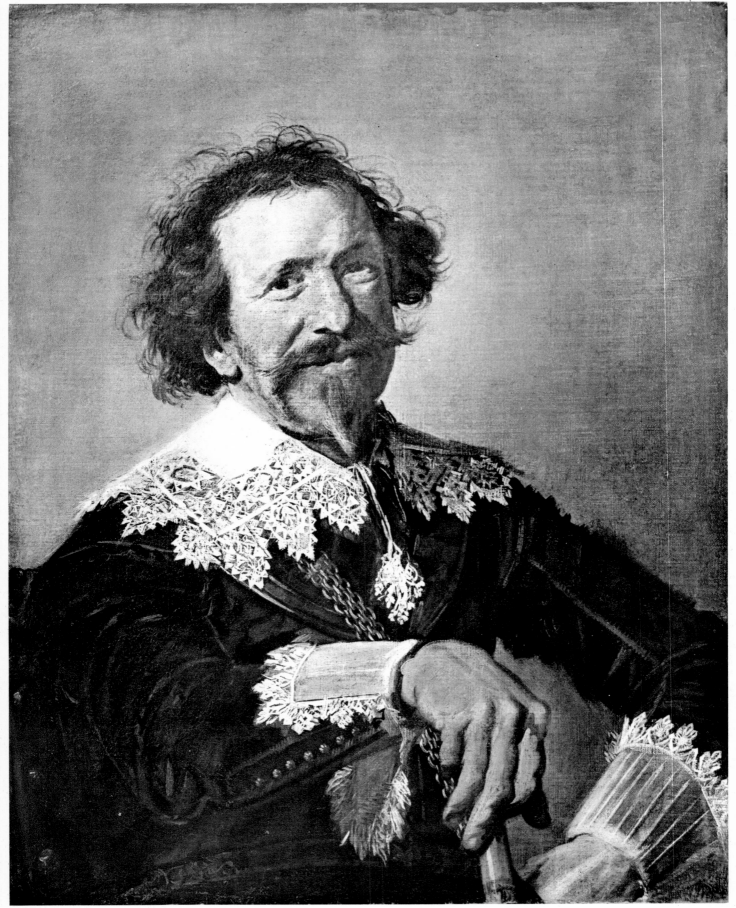

60. PIETER VAN DEN BROECKE. 1633. London, Kenwood, The Iveagh Bequest.

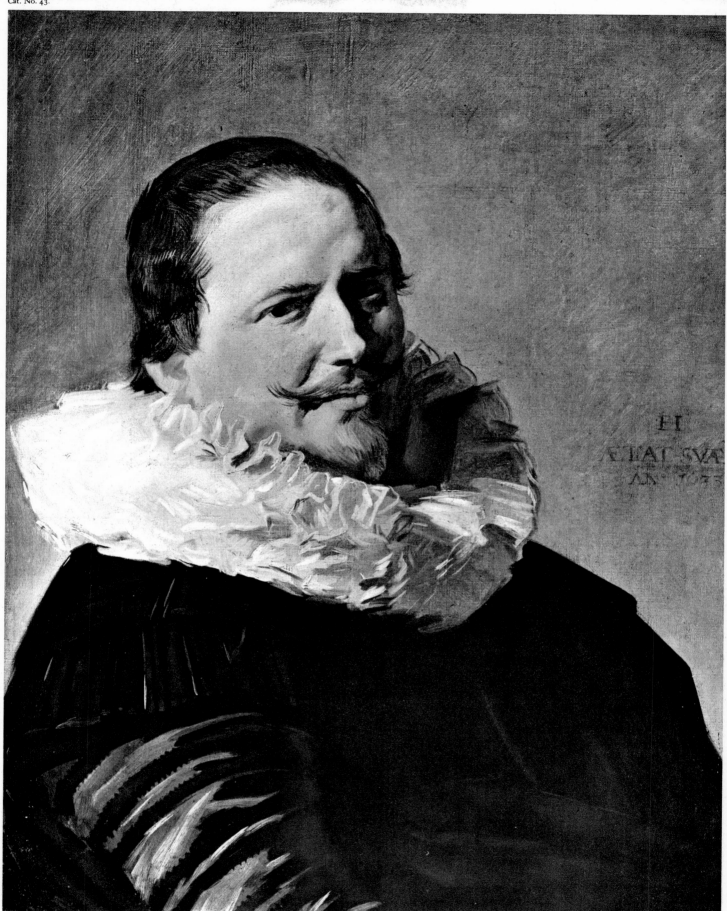

61. PORTRAIT OF A MAN. 1633. London, National Gallery.

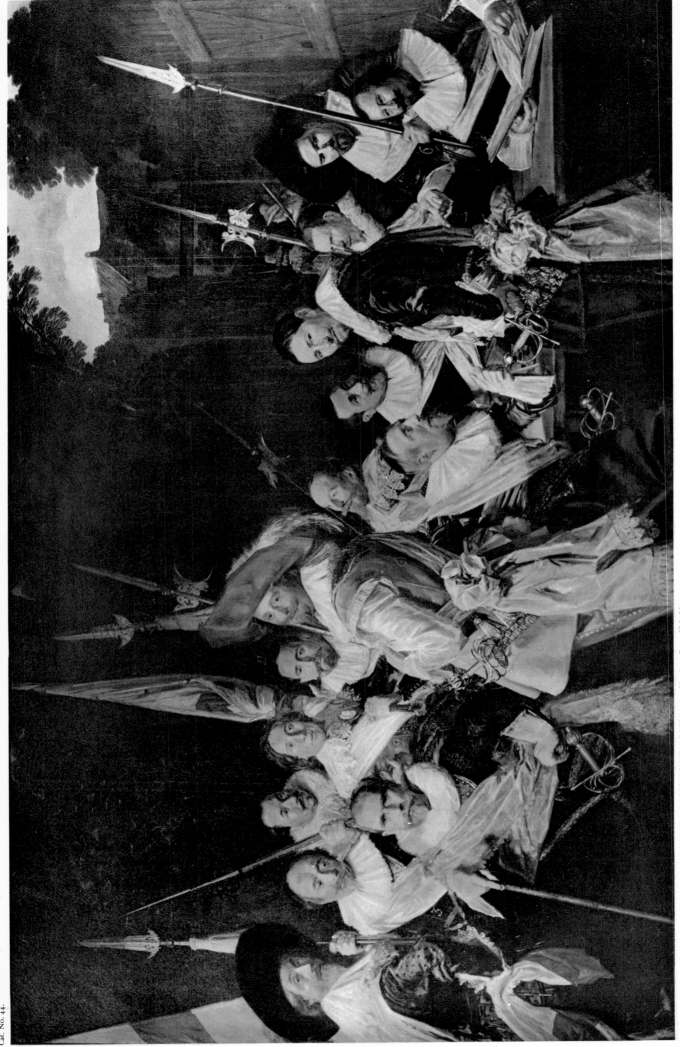

62. MEETING OF THE OFFICERS OF THE CLUVENIERS-DOELEN IN HAARLEM. 1633. Haarlem, Frans Hals Museum.

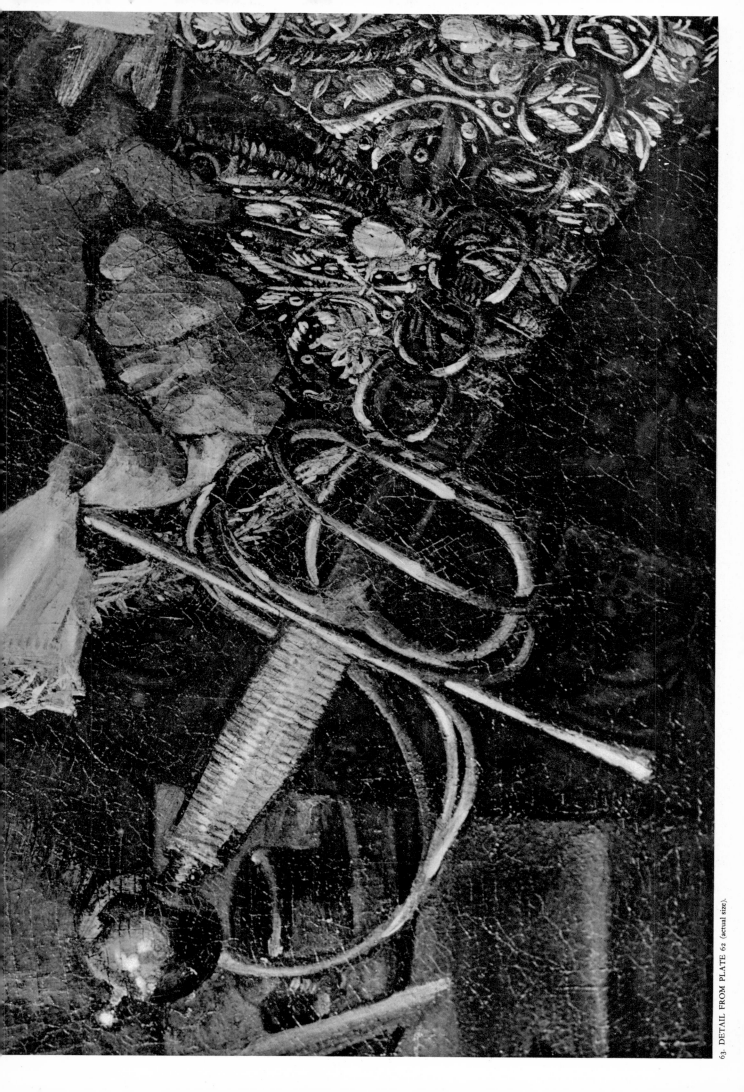

63. DETAIL FROM PLATE 62 (actual size).

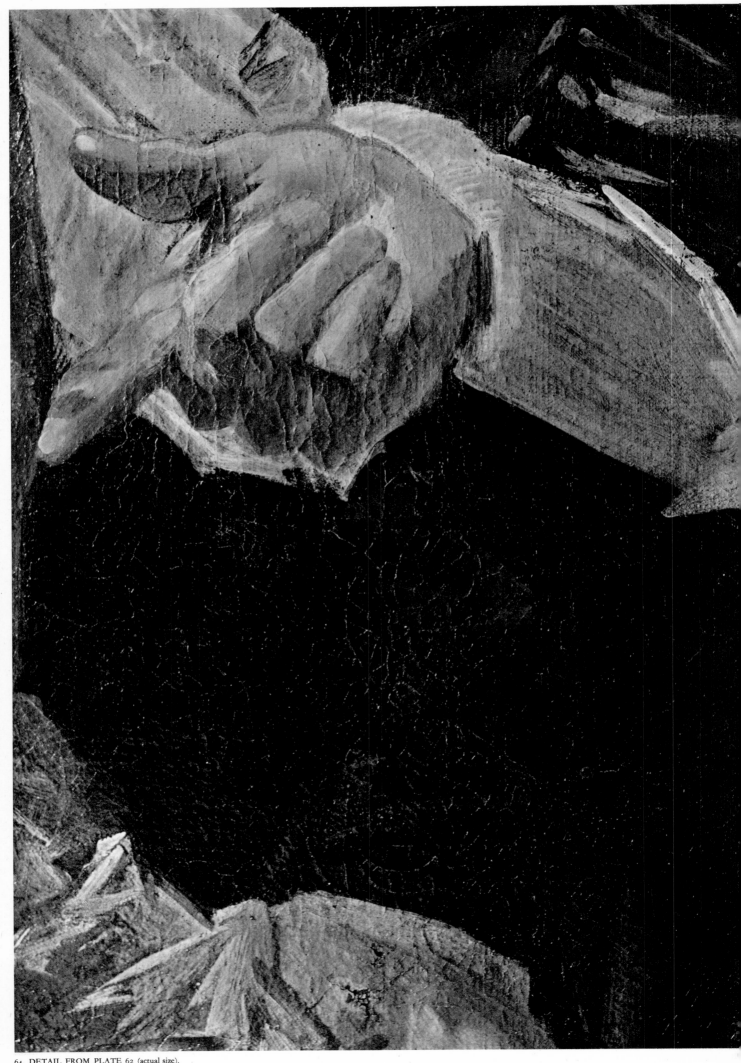

64. DETAIL FROM PLATE 62 (actual size).

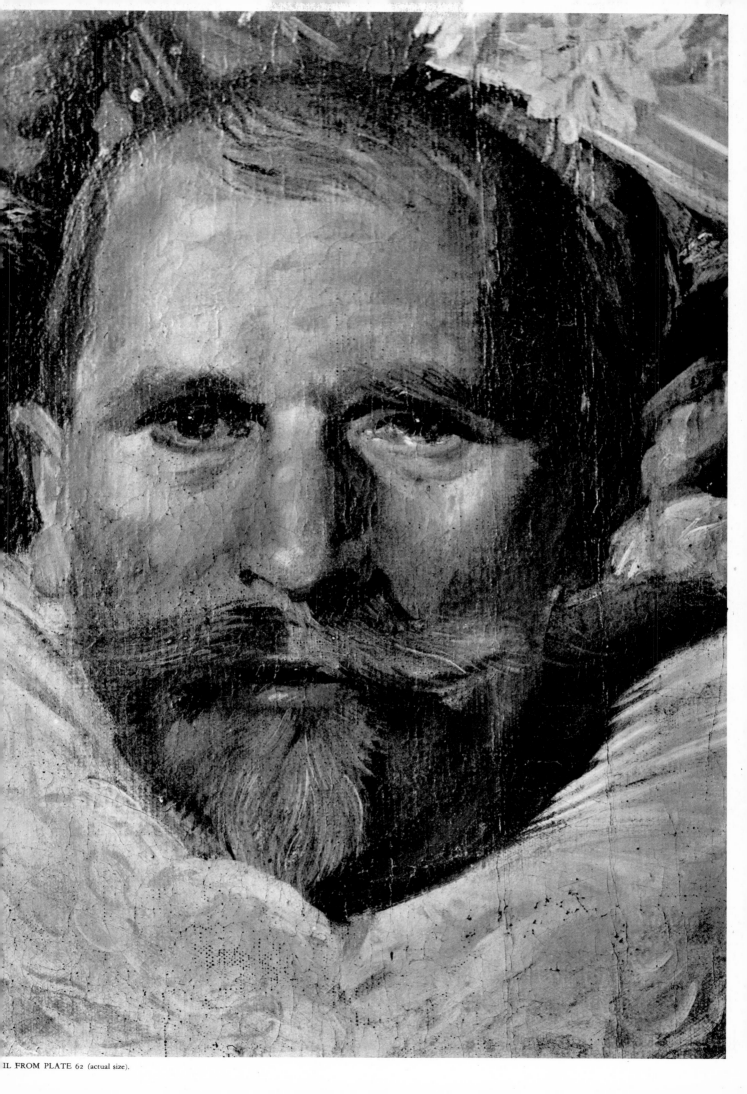

DETAIL FROM PLATE 62 (actual size).

Cat. No. 45.

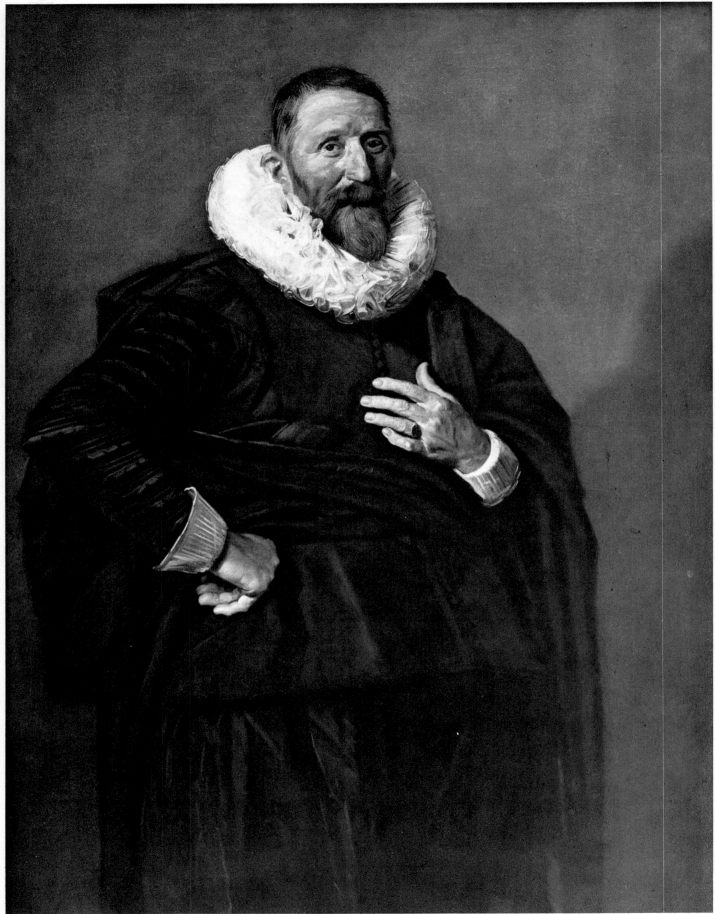

66. PORTRAIT OF A MAN. 1631-1635. Rotterdam, Museum Boymans.

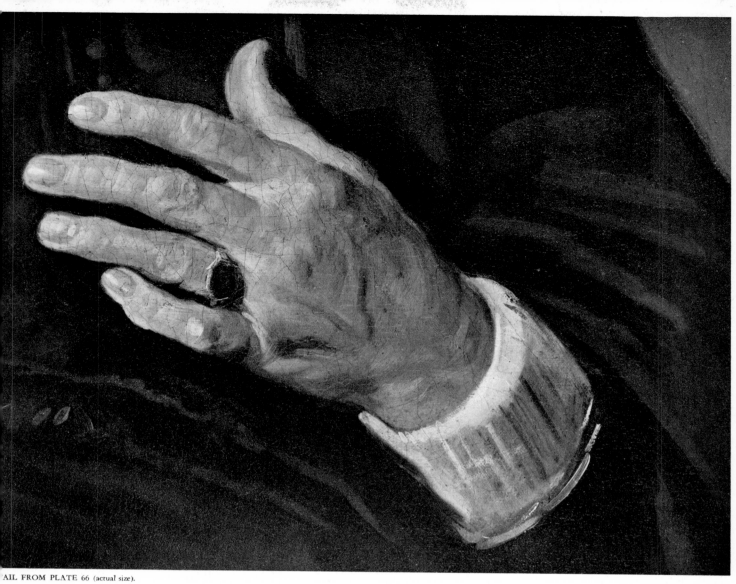

AIL FROM PLATE 66 (actual size).

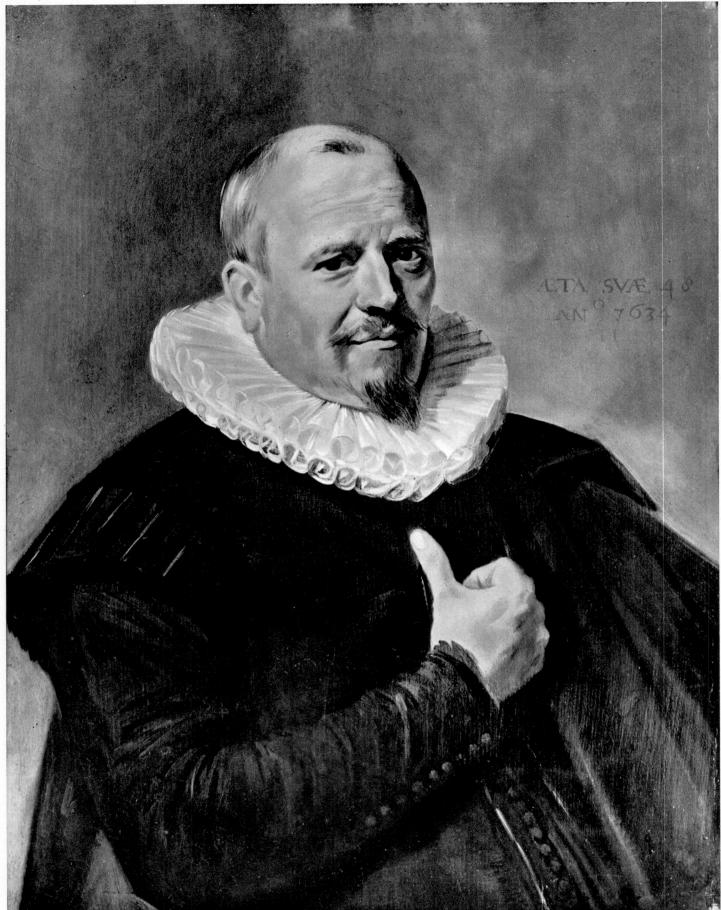

68. PORTRAIT OF A MAN. 1634. New York. Messrs. Wildenstein & Co.

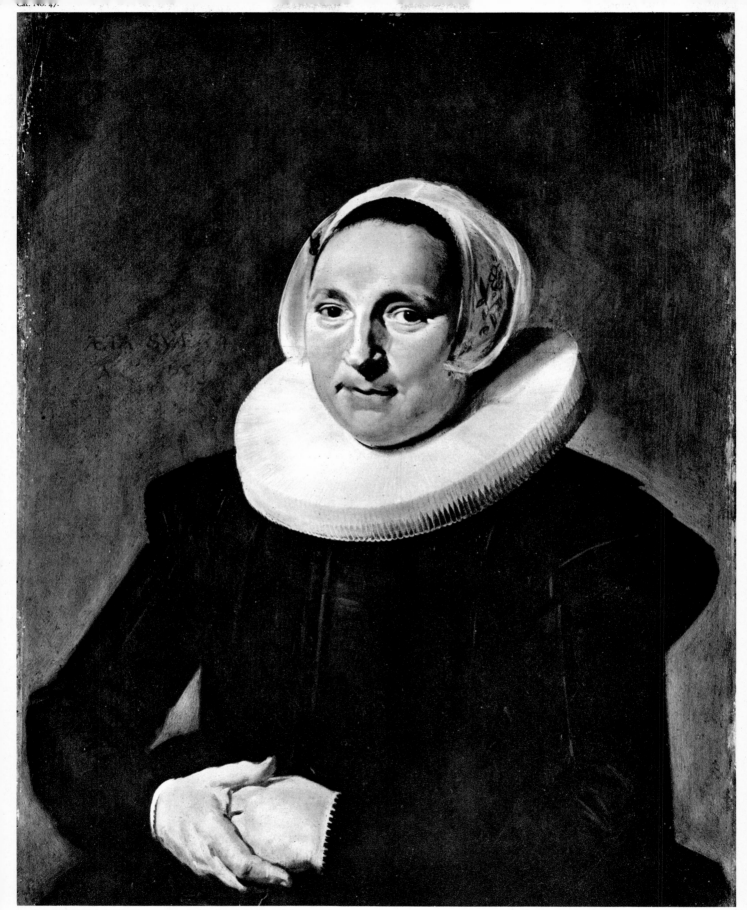

69. PORTRAIT OF A WOMAN. 1634. Detroit. The Detroit Institute of Arts.

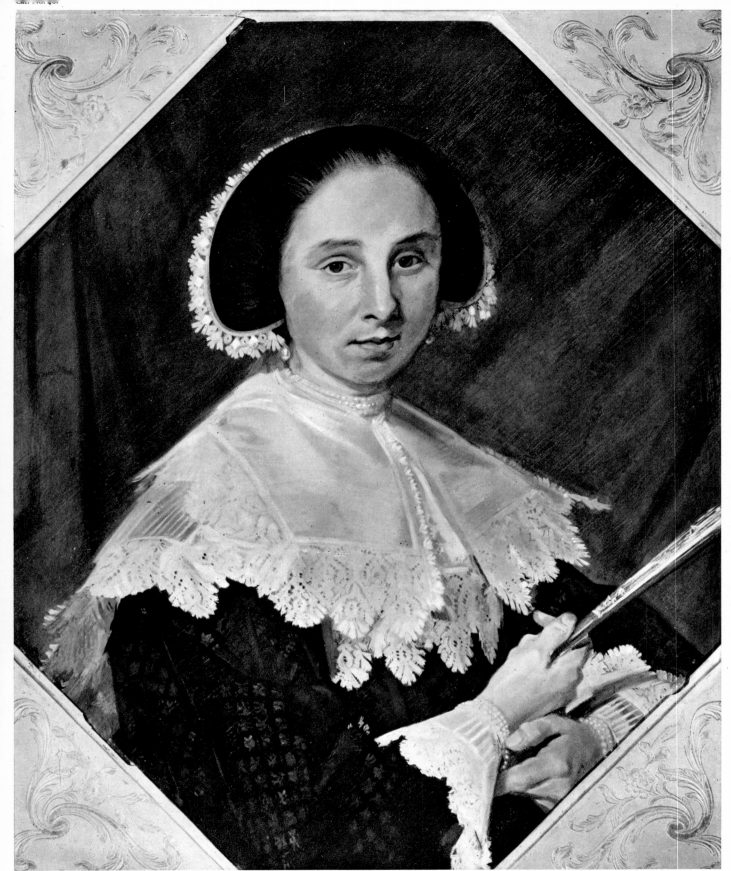

70 PORTRAIT OF A WOMAN. About 1634. Worms, Stiftung Heylshof.

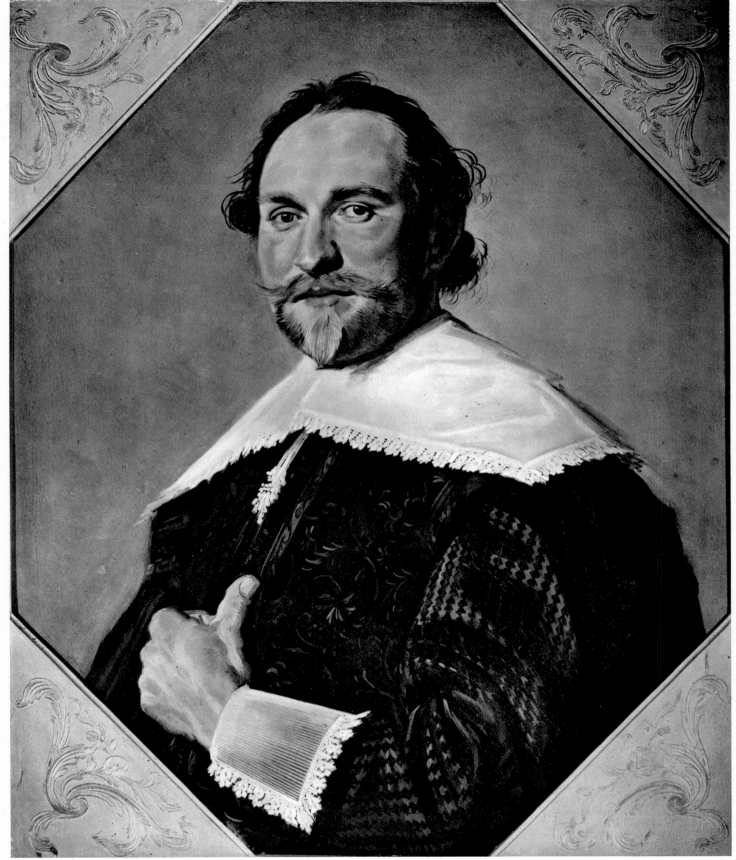

71. PORTRAIT OF A MAN. About 1634. Worms. Stiftung Heylshof.

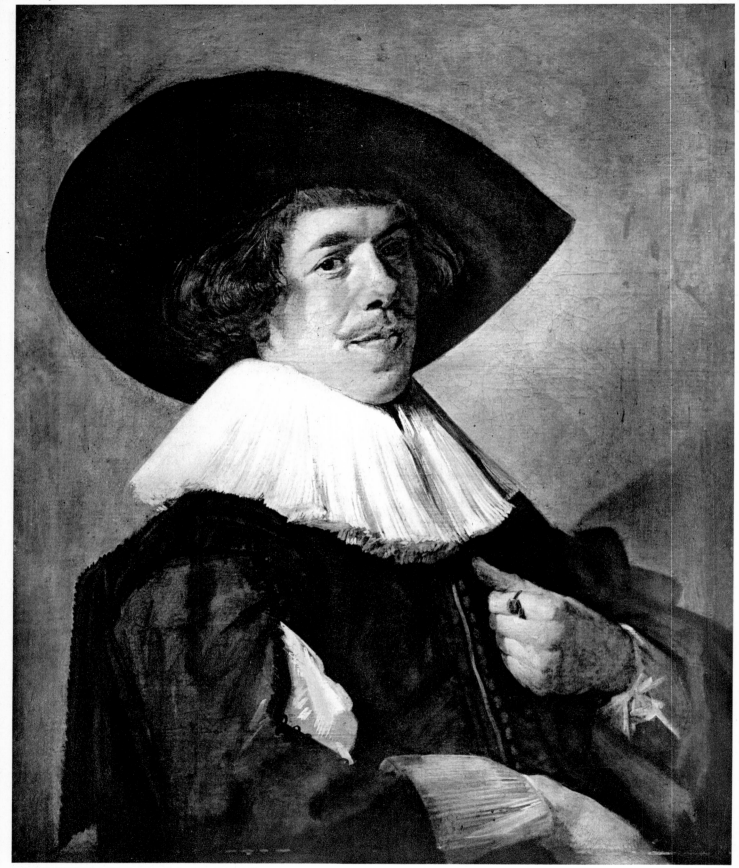

72. PORTRAIT OF A MAN. 1633-1634. Berlin, Kaiser-Friedrich-Museum.

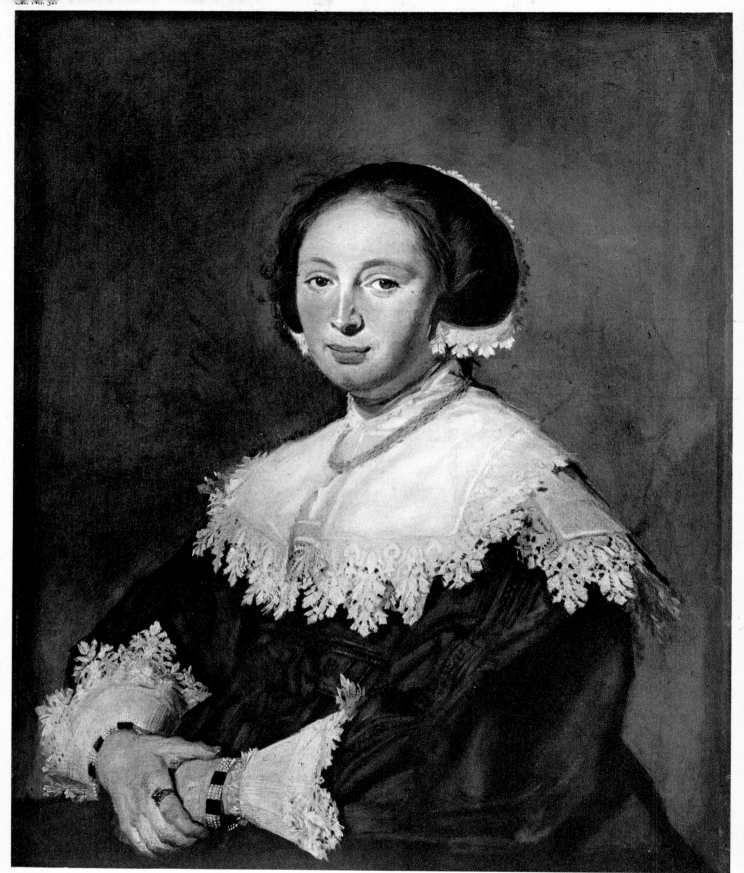

73. PORTRAIT OF A WOMAN. 1634-1635. Berlin, Kaiser-Friedrich-Museum.

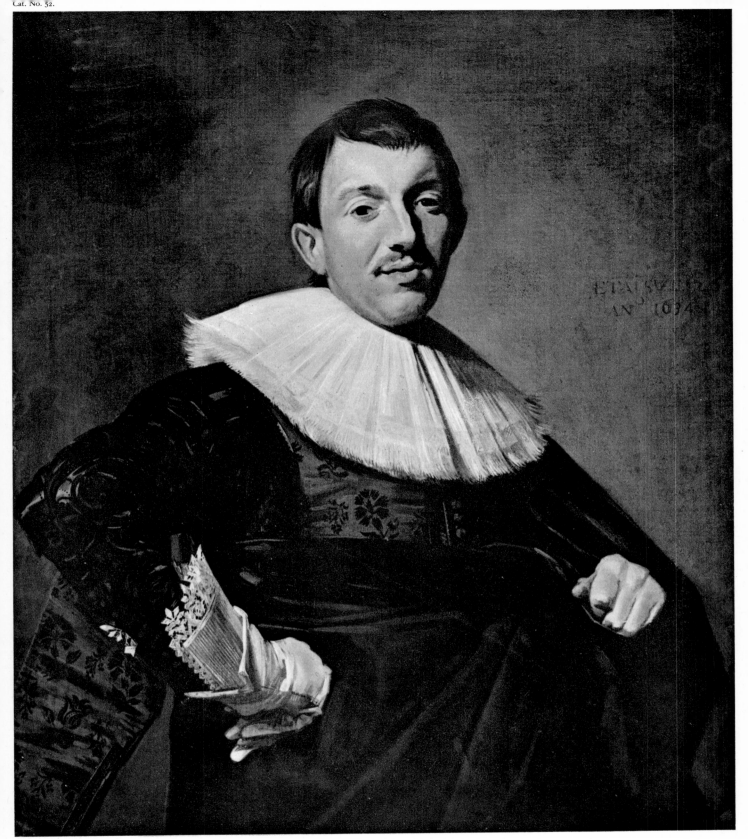

74. PORTRAIT OF A MAN. 1634. Budapest, Museum of Fine Arts.

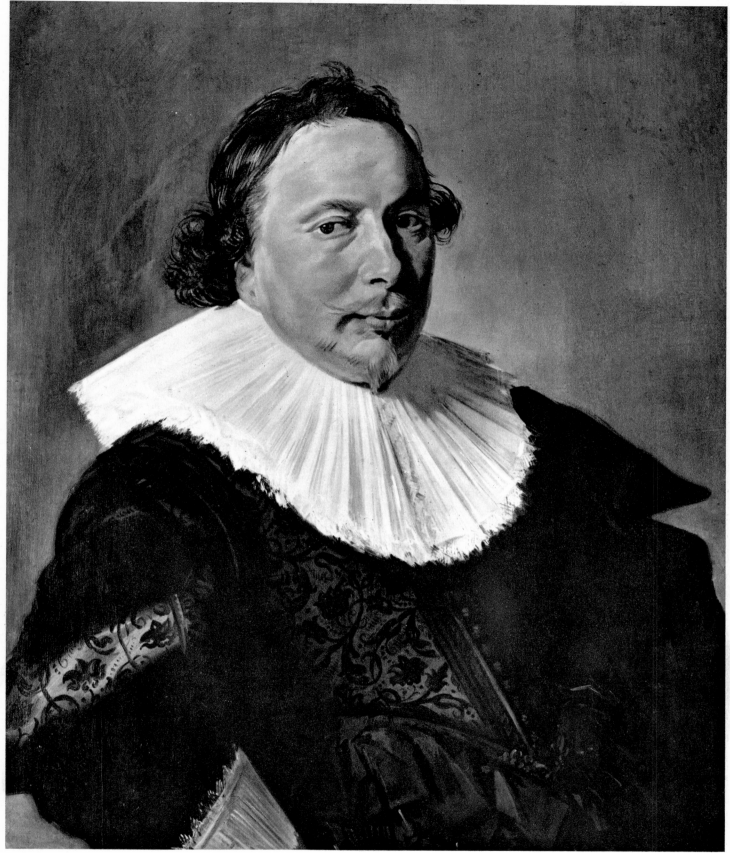

75. PORTRAIT OF A MAN. About 1634. Vienna, Austria, Mr. J. Priester.

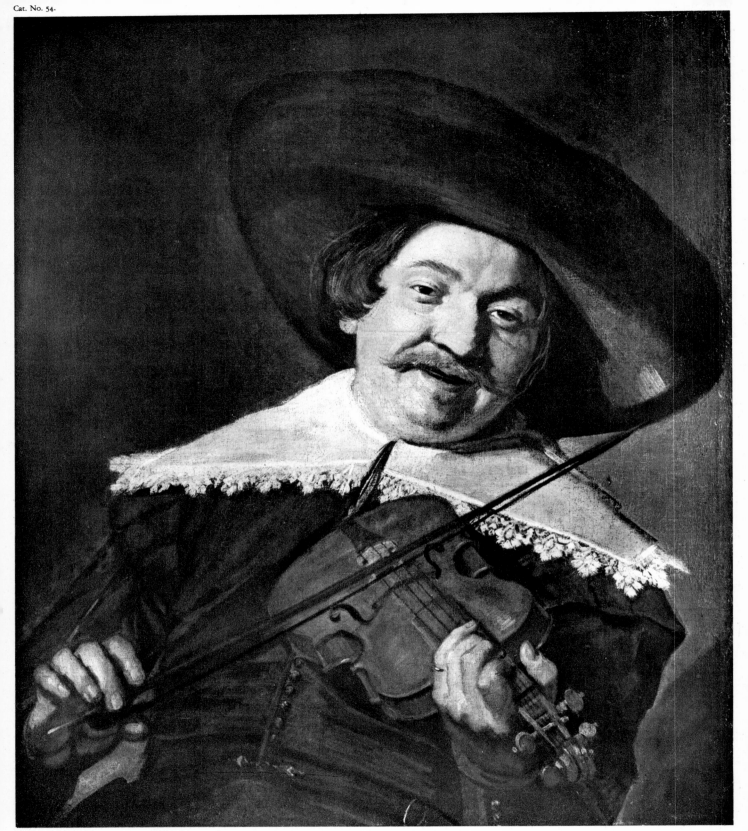

76. DANIEL VAN AKEN. About 1634. Stockholm, National Museum.

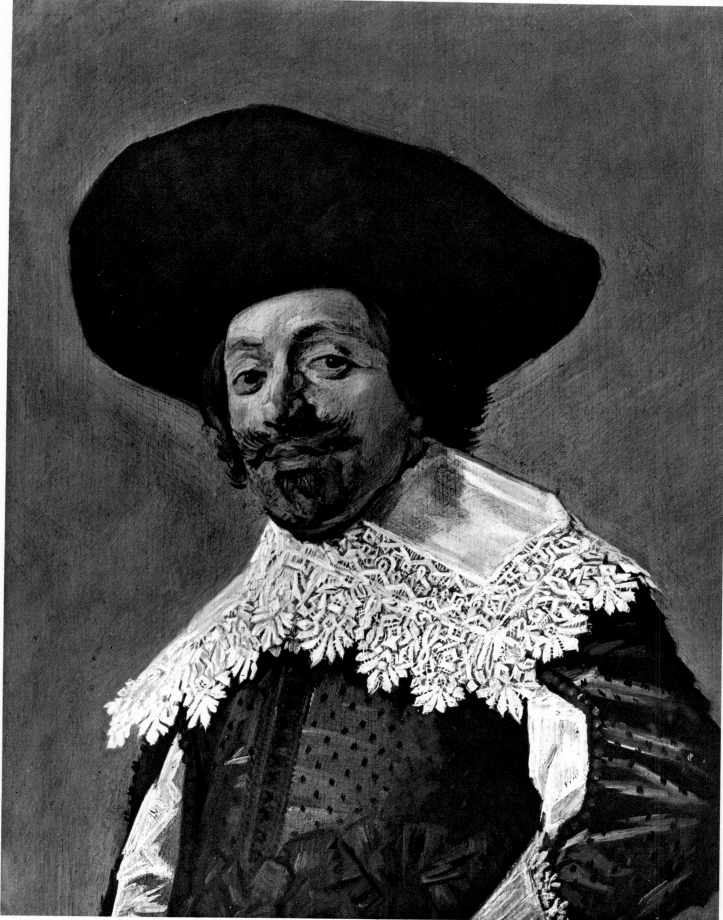

77. SMALL PORTRAIT OF A MAN. About 1635. The Hague, Mauritshuis.

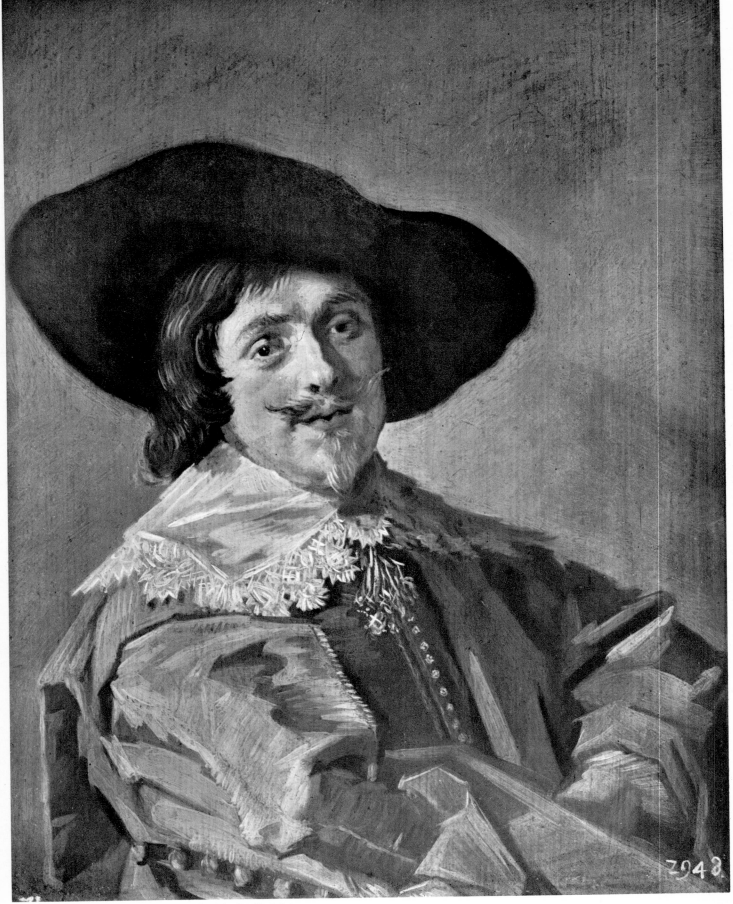

78. PORTRAIT OF MAN. About 1635. Dresden, Staatliche Gemäldegalerie.

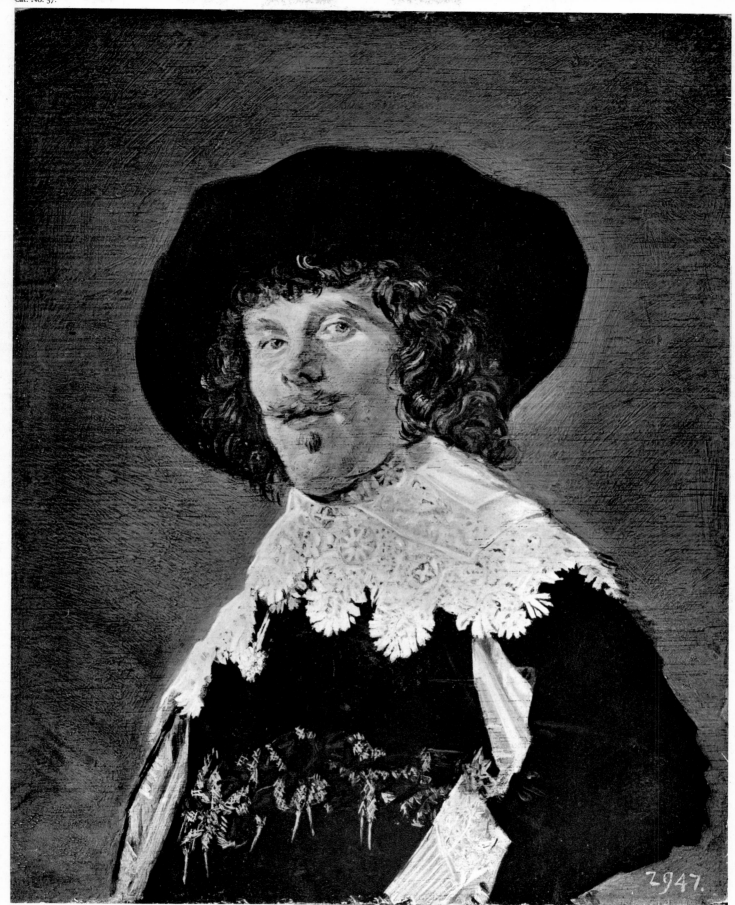

79. SMALL PORTRAIT OF A MAN. About 1635. Dresden, Staatliche Gemäldegalerie.

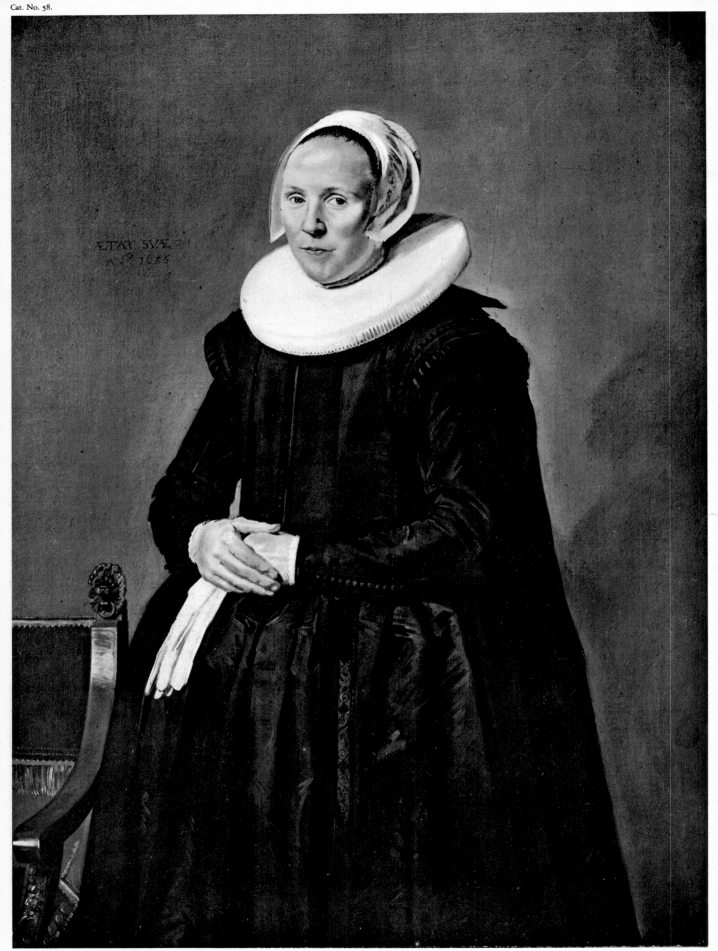

80. FEYNTJE VAN STEENKISTE. 1635. Amsterdam, Ryksmuseum.

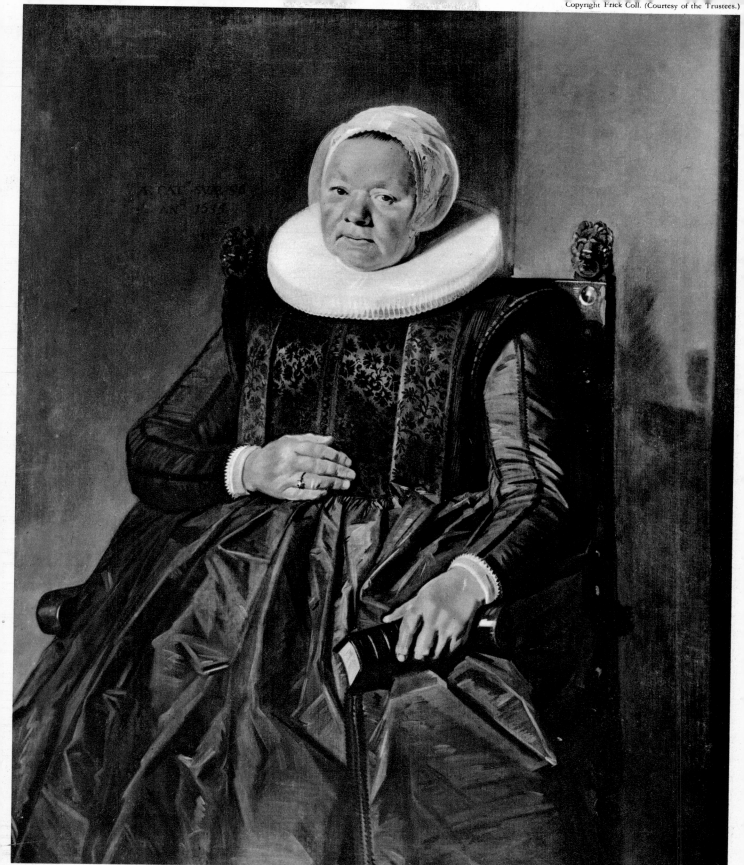

81. PORTRAIT OF AN ELDERLY WOMAN. 1635. New York, The Frick Museum of Art.

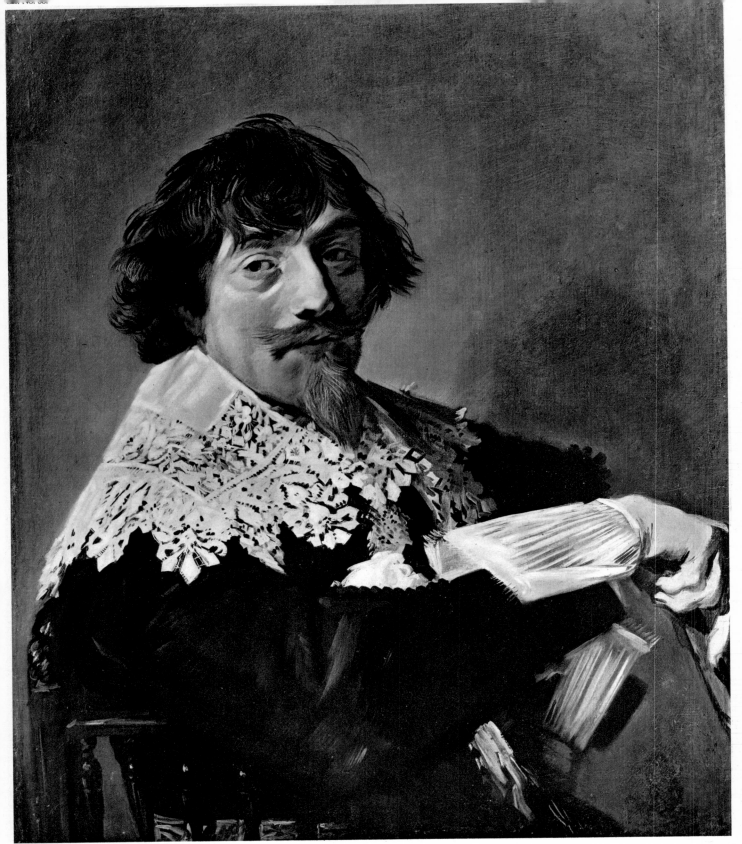

82. NICOLAES HASSELAER. About 1635. Amsterdam, Ryksmuseum.

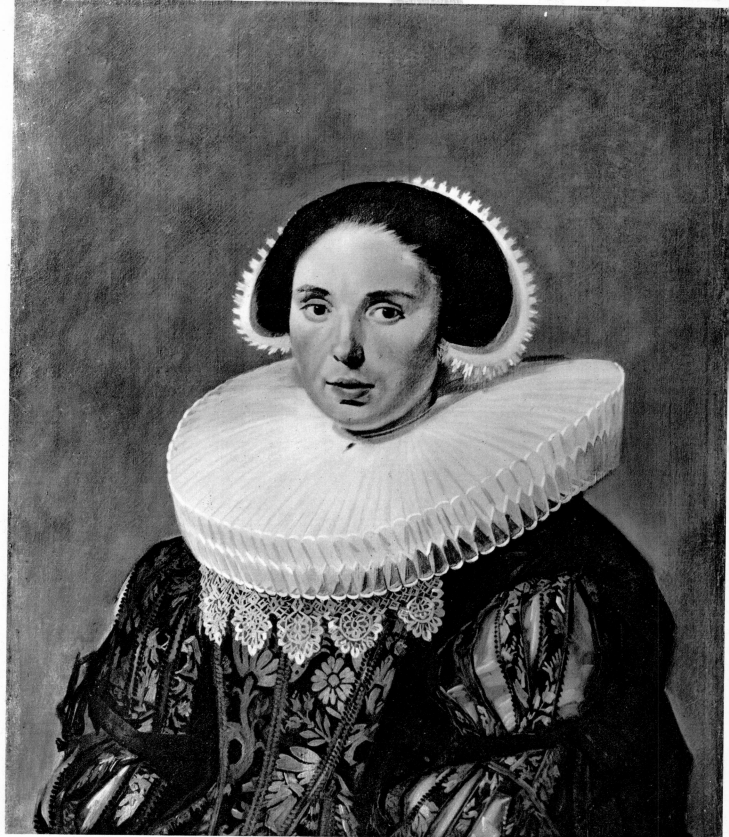

83. SARA WOLPHAERTS VAN DIEMEN, WIFE OF NICOLAES HASSELAER. About 1635. Amsterdam, Ryksmuseum.

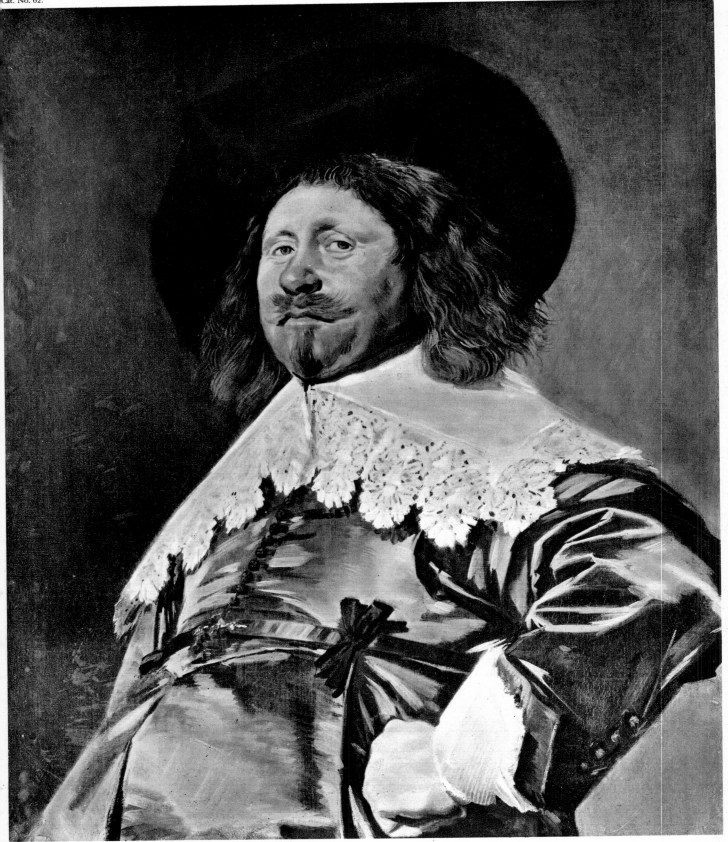

84. CLAES DUYST VAN VOORHOUT. About 1635. New York, Coll. Jules S. Bache.

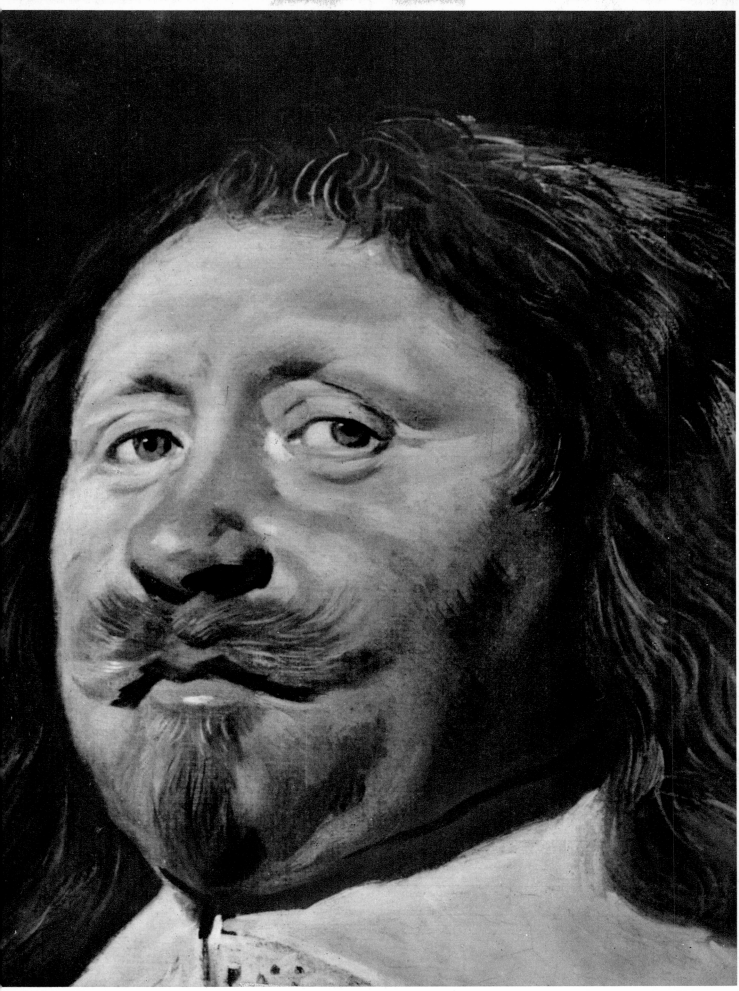

DETAIL FROM PLATE 84 (actual size).

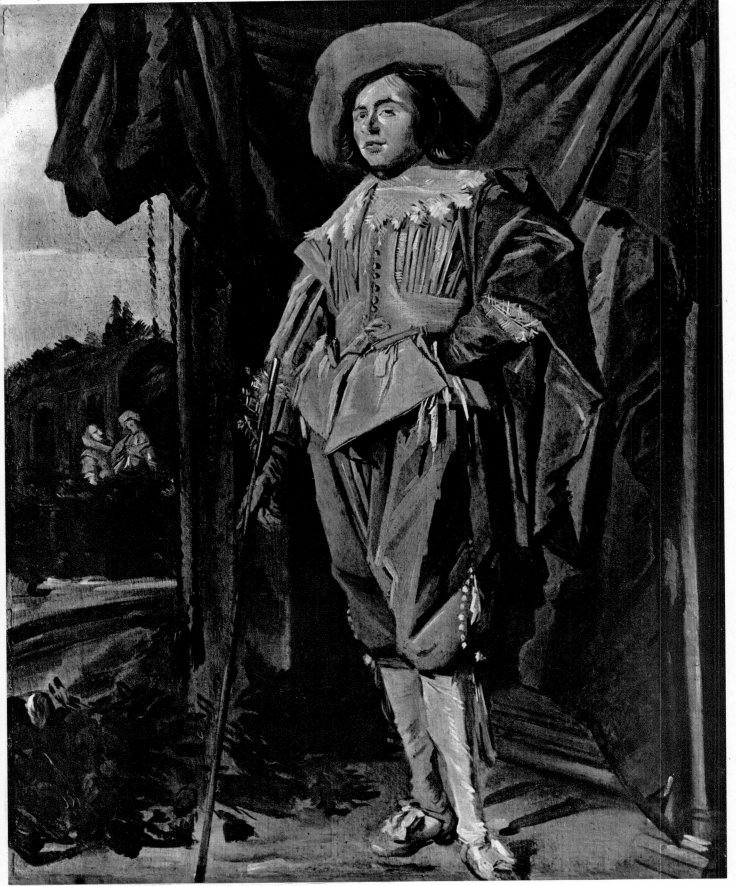

86. PORTRAIT OF A CAVALIER. Study. 1635-1636. London, Buckingham Palace.

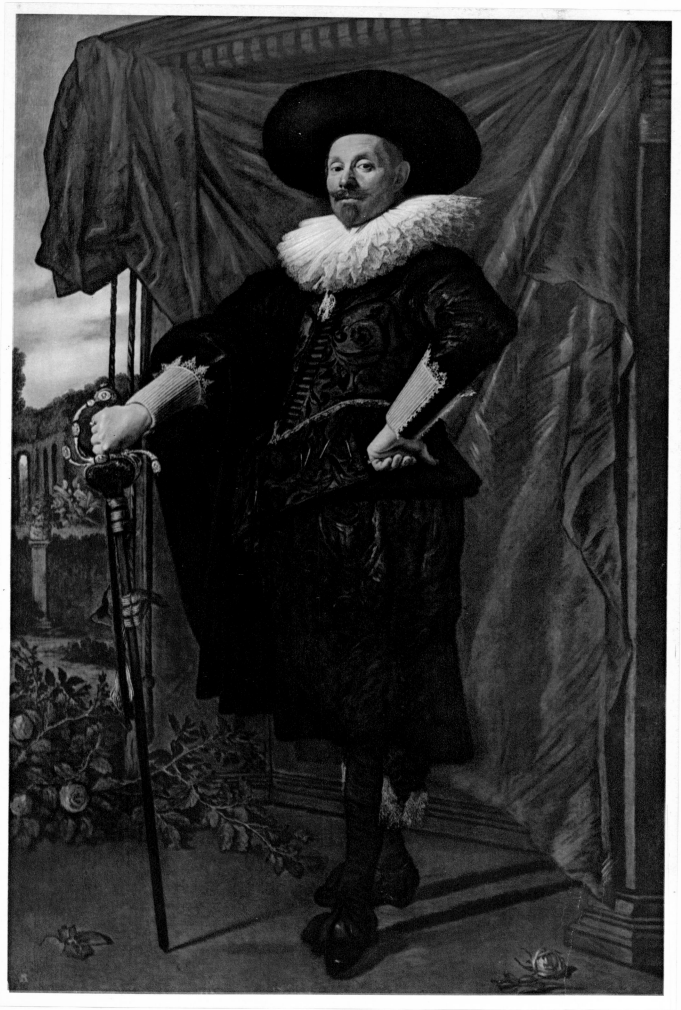

WILLEM VAN HEYTHUYSEN. (cf. Plate 87, Cat. No. 64)

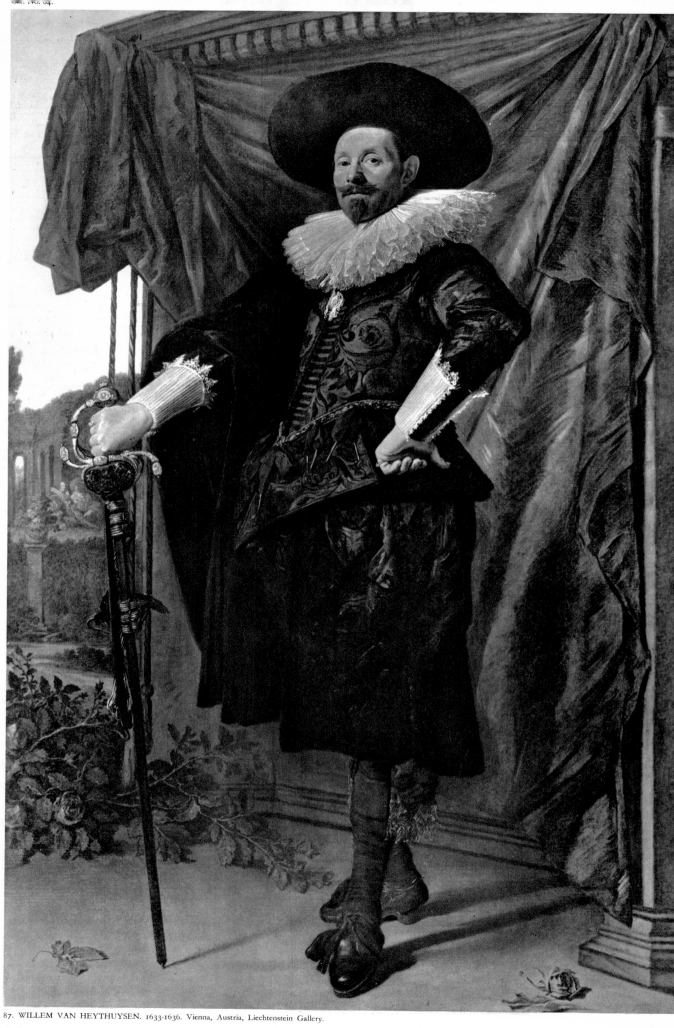

87. WILLEM VAN HEYTHUYSEN. 1633-1636. Vienna, Austria, Liechtenstein Gallery.

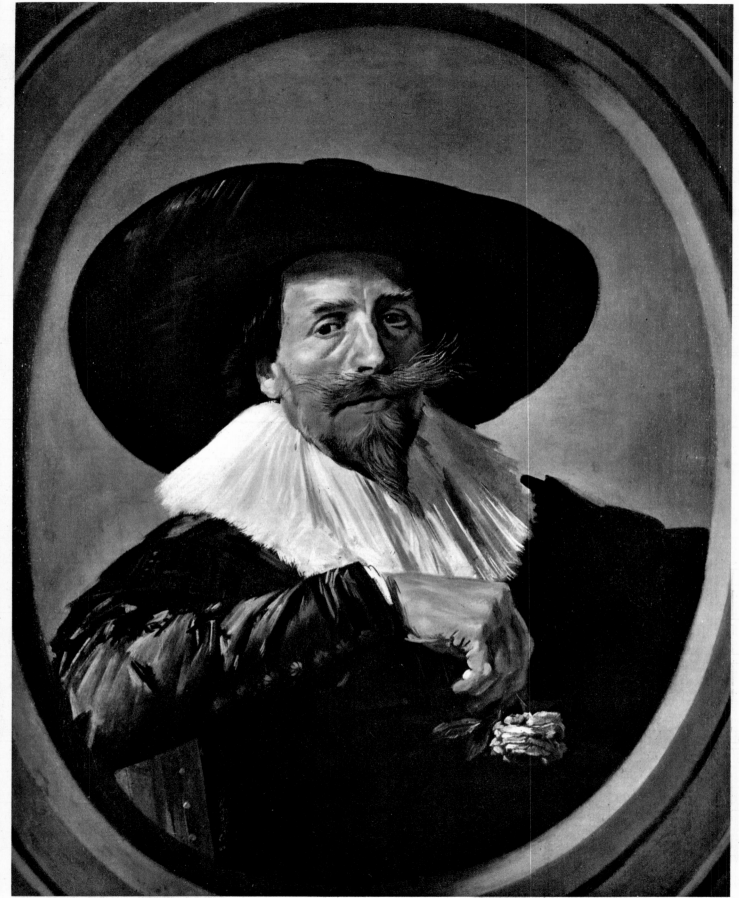

88. PIETER TJARCK. About 1638. Nassau, Bahamas, Coll., Harry Oakes.

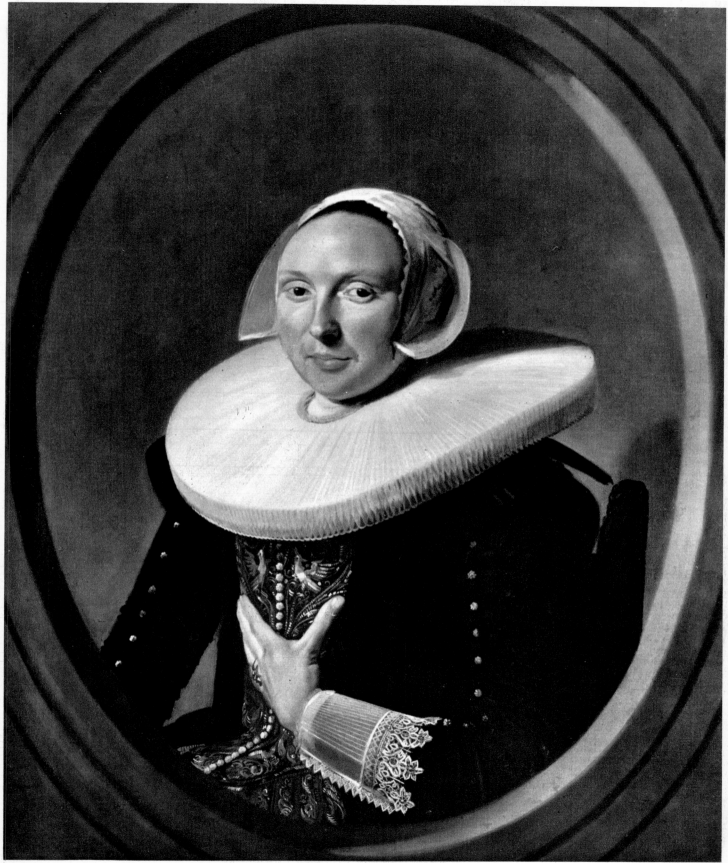

89. MARIA LARP, WIFE OF PIETER TJARCK. About 1638. London, Misses Alexander.

Cat. No. 67.

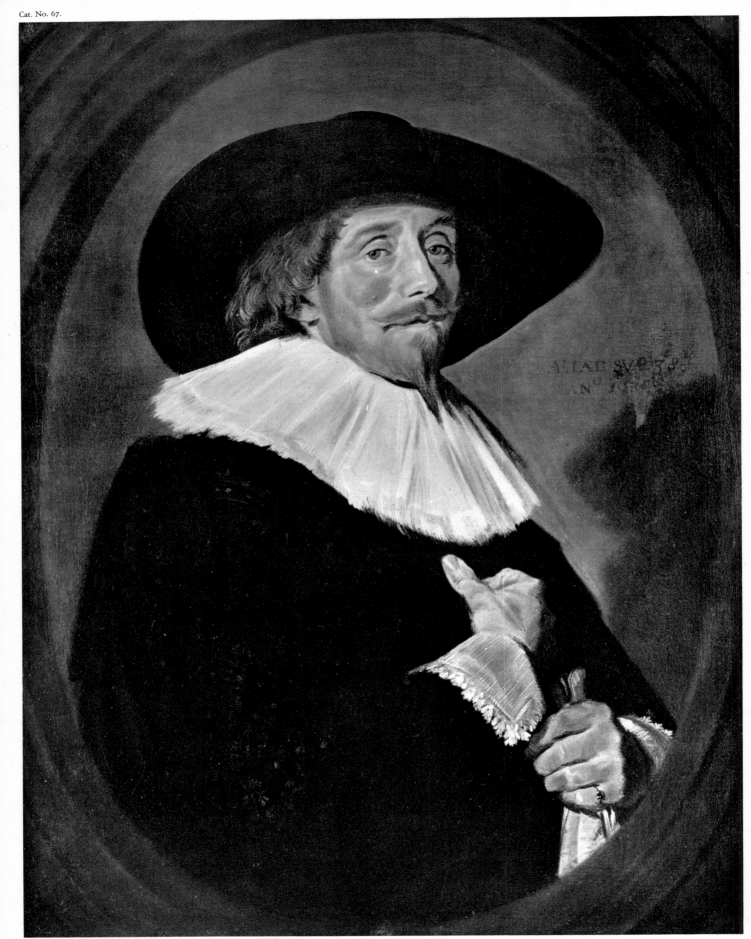

90. PORTRAIT OF A MAN. 1638. Stockholm, Royal Palace.

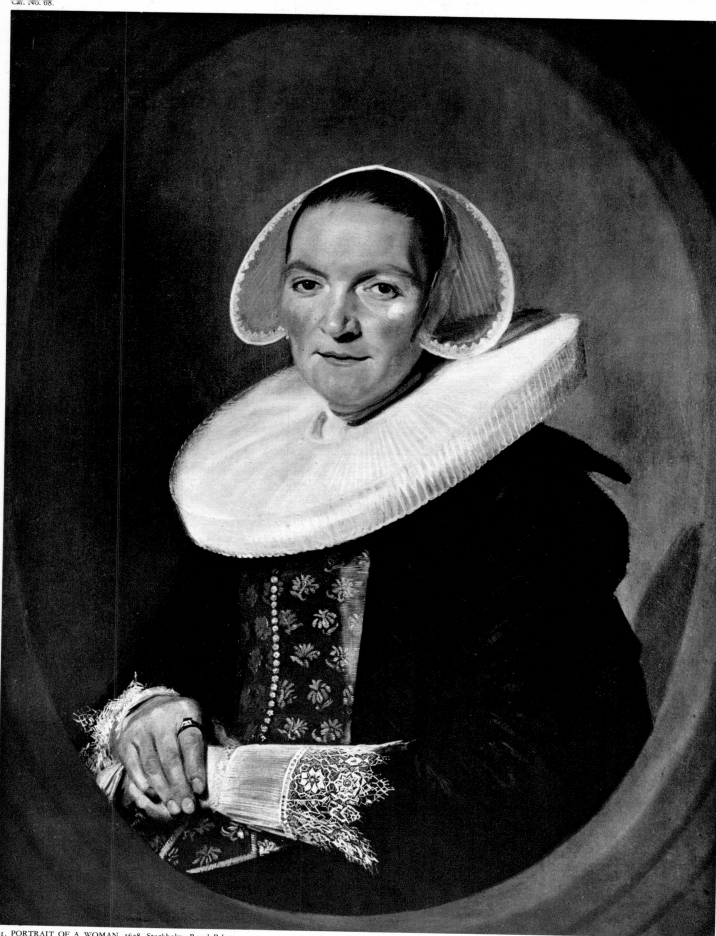

91. PORTRAIT OF A WOMAN. 1638. Stockholm, Royal Palace.

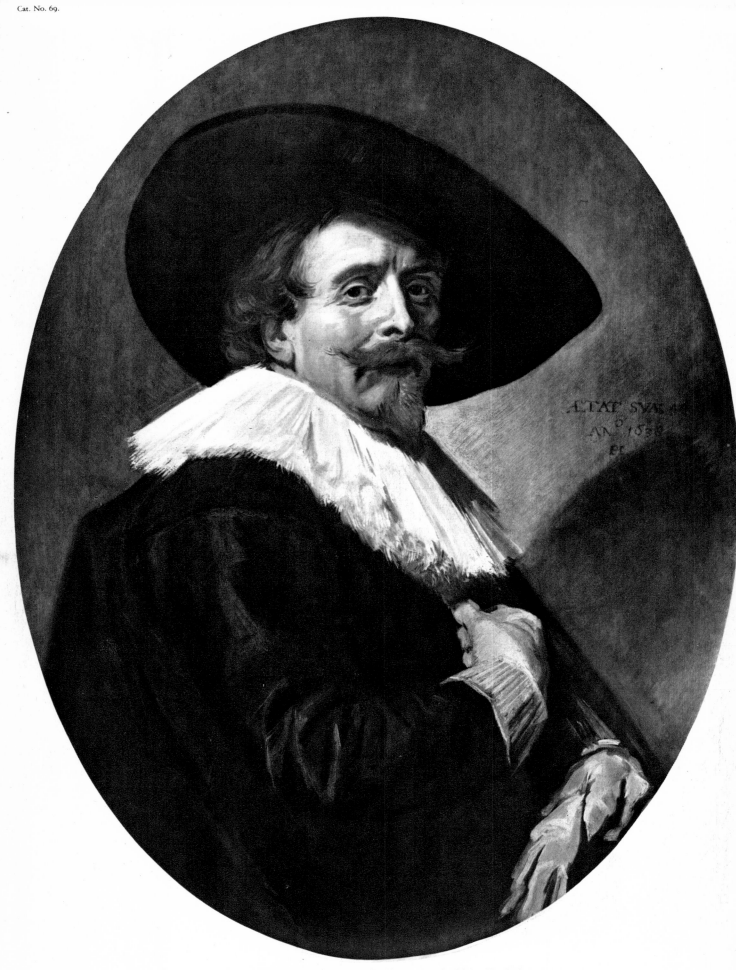

92. PORTRAIT OF A MAN. 1638. Frankfort o. Main, Staedelsches Kunstinstitut.

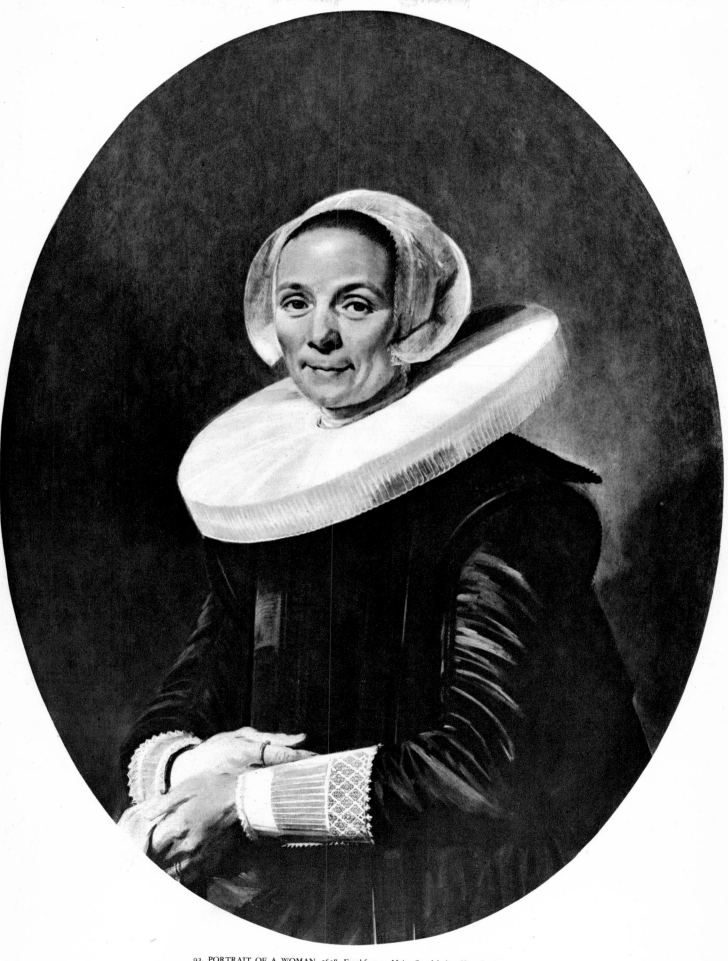

93. PORTRAIT OF A WOMAN. 1638. Frankfort o. Main, Staedelsches Kunstinstitut.

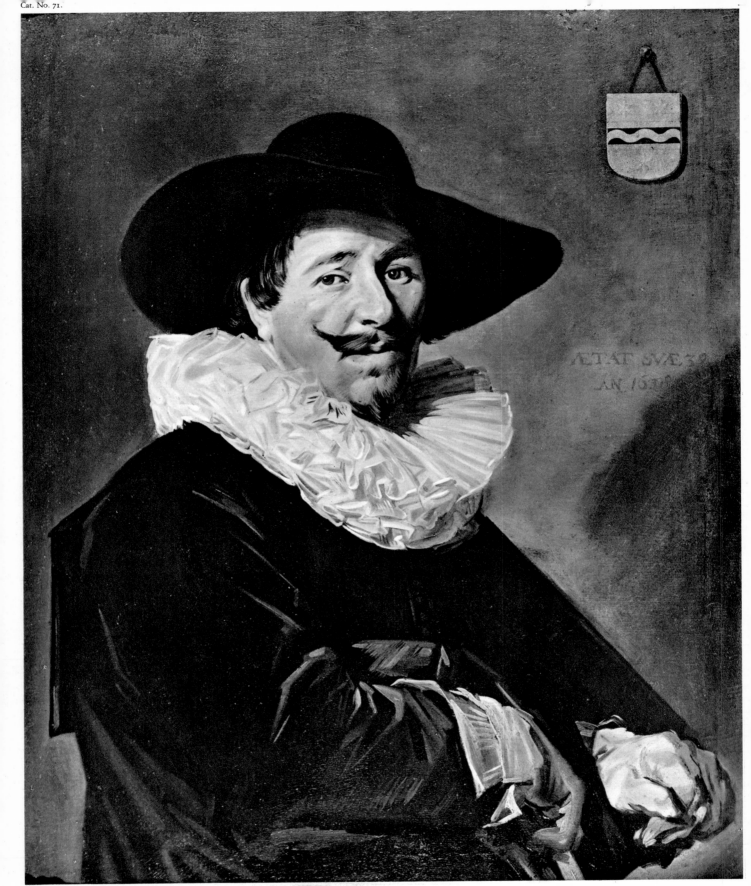

94. ANDRIES VAN DER HORN. 1638. Dieren, Holland, Messrs. D. Katz.

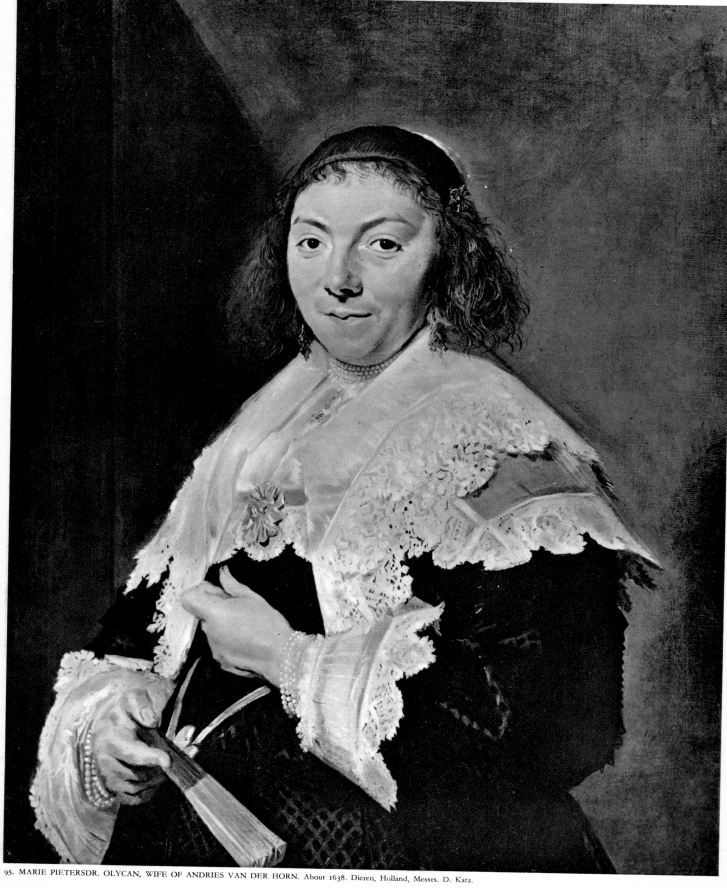

95. MARIE PIETERSDR. OLYCAN, WIFE OF ANDRIES VAN DER HORN. About 1638. Dieren, Holland, Messrs. D. Katz.

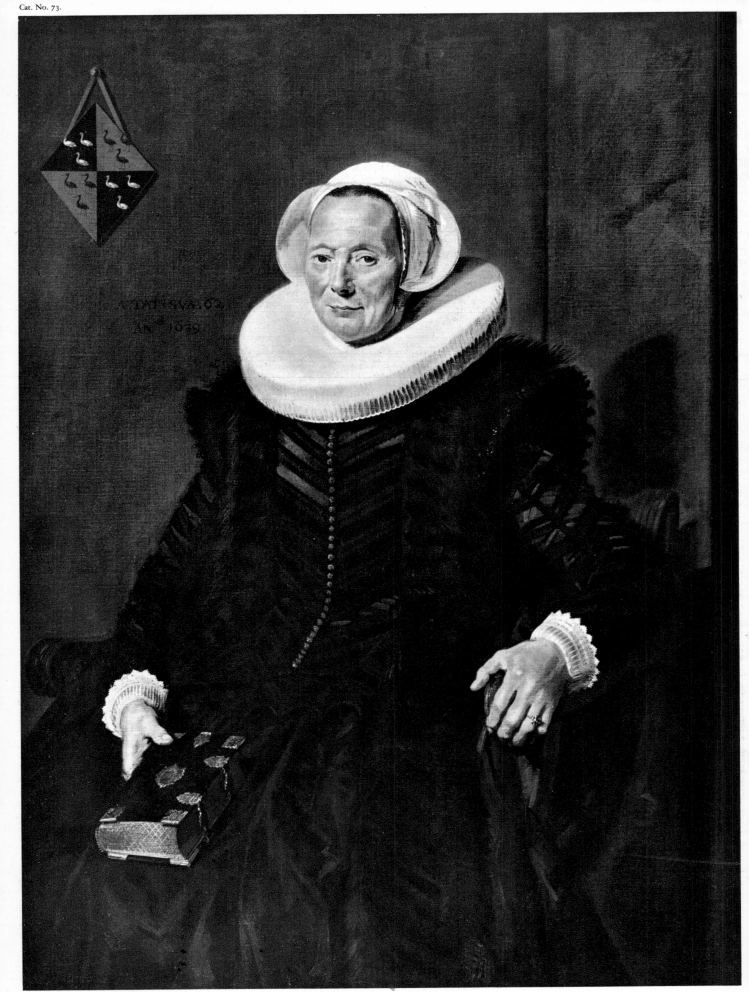

96. MARITGE CLAESDR. VOOGT. 1639. Amsterdam, Ryksmuseum.

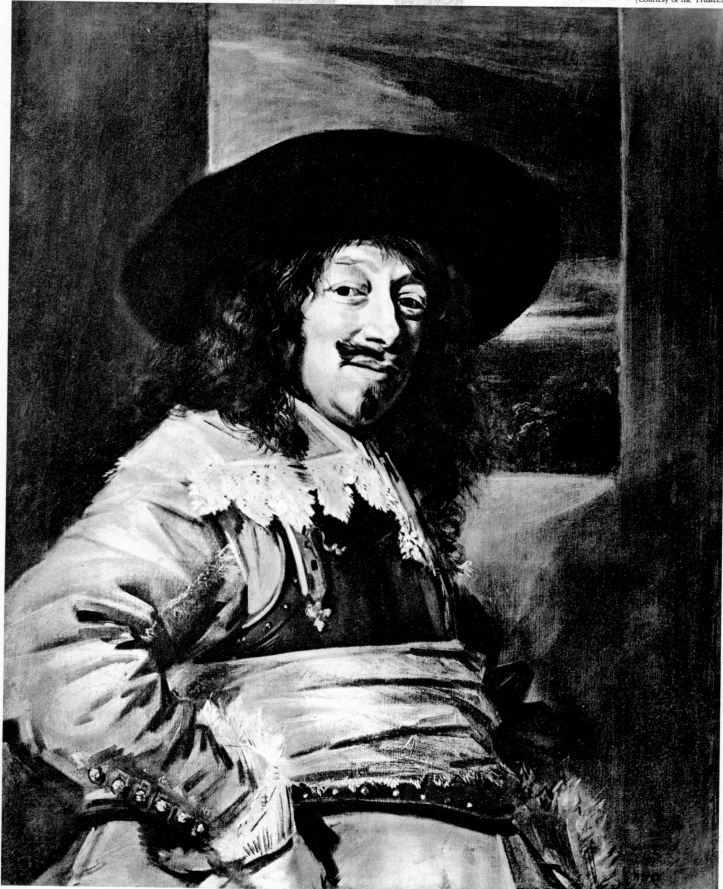

97. PORTRAIT OF AN OFFICER. About 1639. Washington, National Gallery of Art.

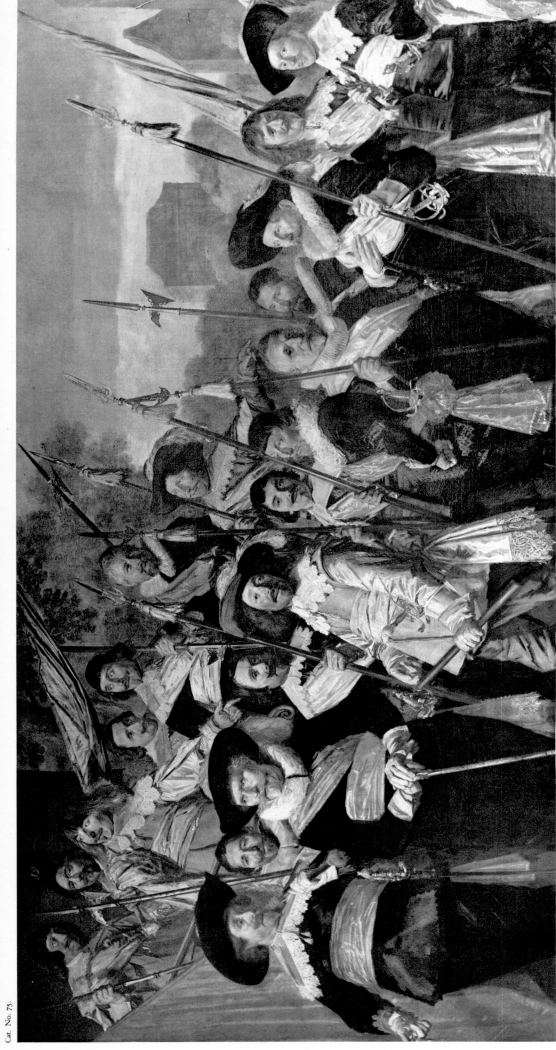

98. OFFICERS OF THE ST. JORIS-DOELEN IN HAARLEM. 1639. Haarlem, Frans Hals Museum.

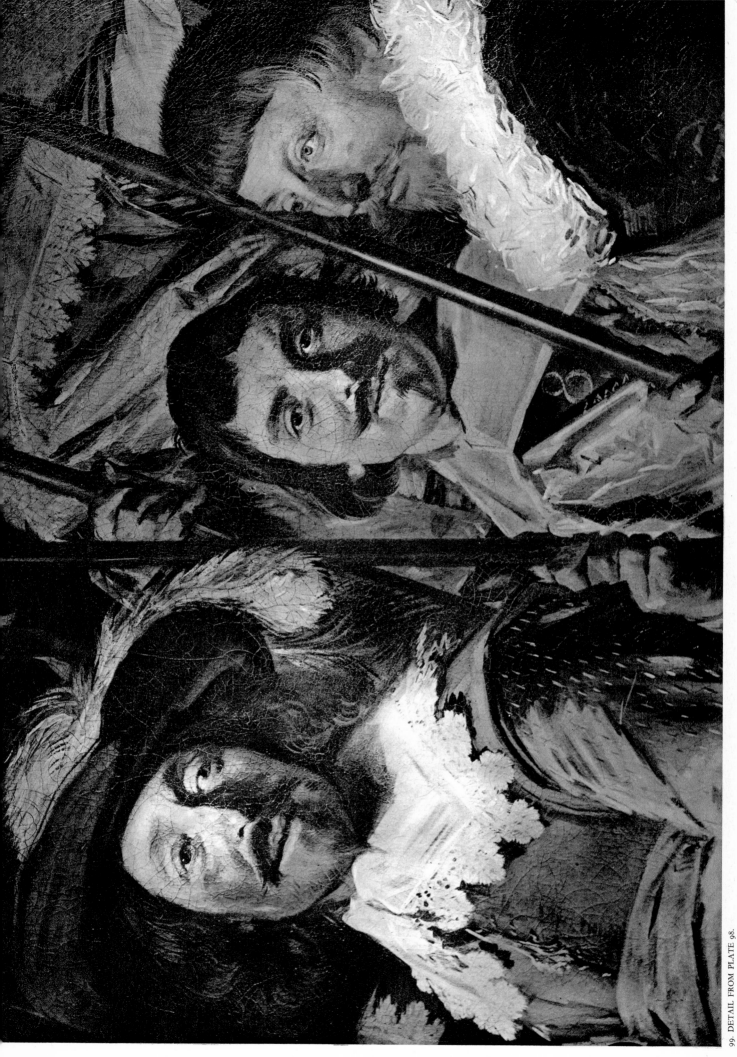

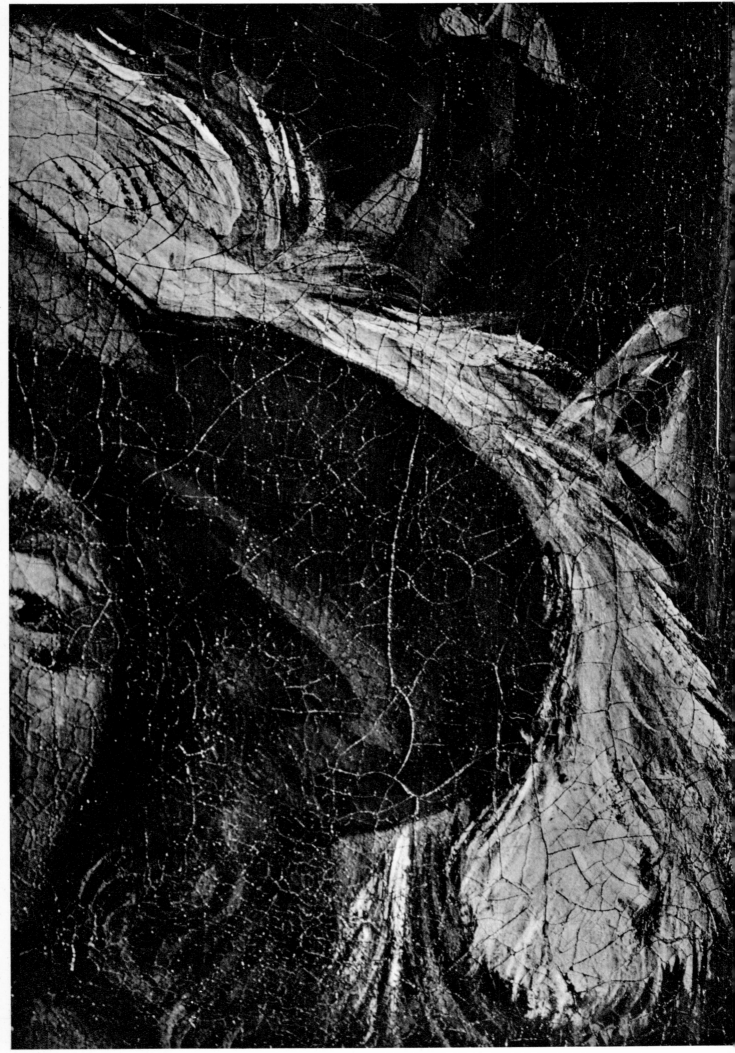

100. DETAIL FROM PLATE 98 (actual size).

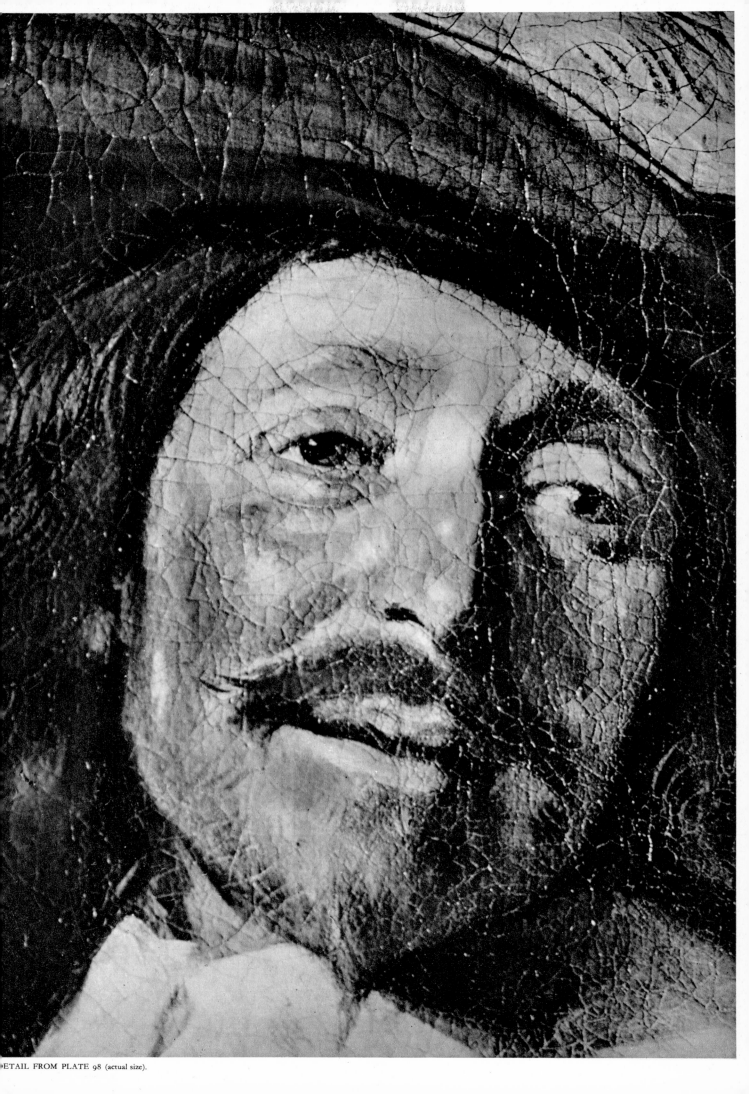

DETAIL FROM PLATE 98 (actual size).

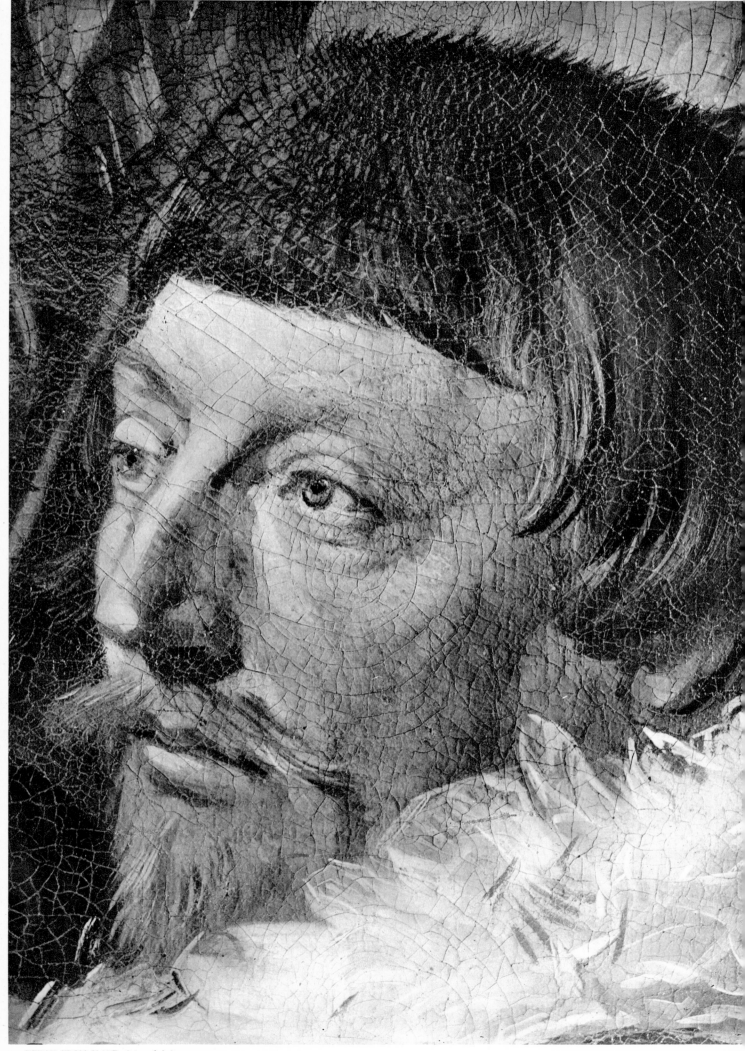

102. DETAIL FROM PLATE 98 (actual size).

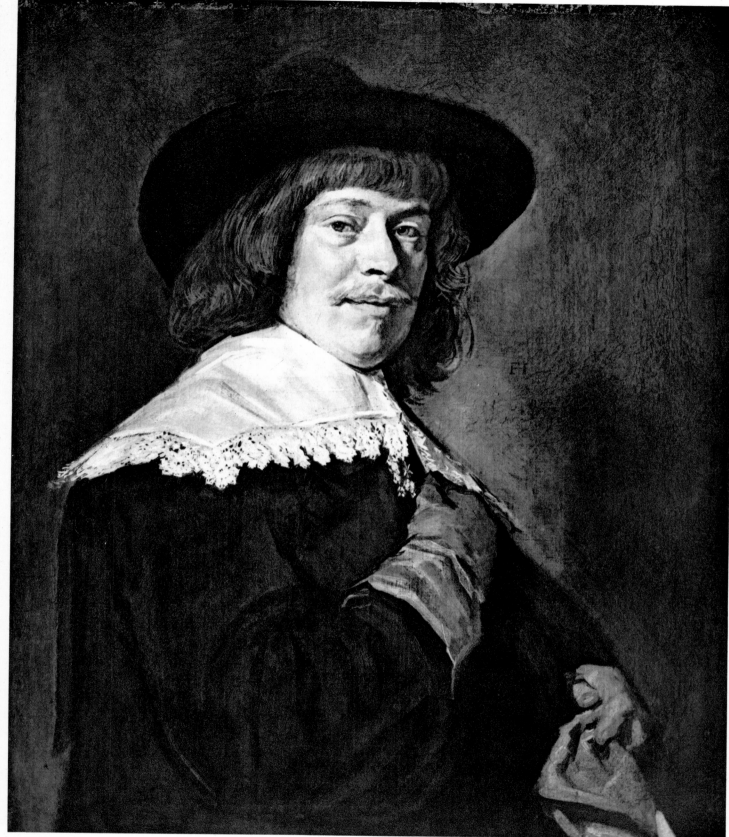

103. PORTRAIT OF A YOUNG MAN. About 1639. Leningrad, Hermitage.

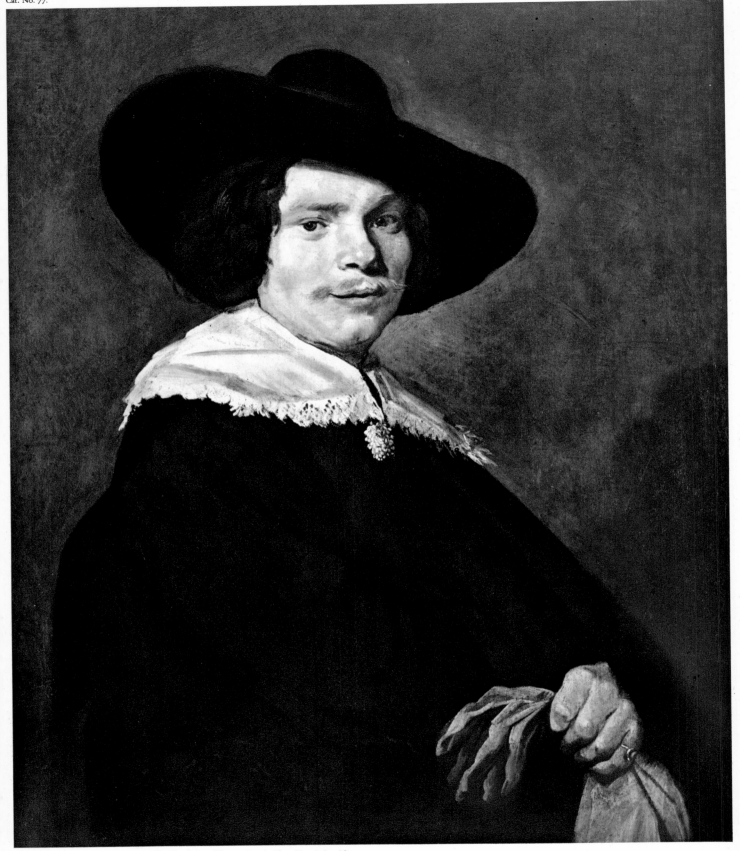

104. PORTRAIT OF A YOUNG MAN. About 1639. Vienna, Austria, Kunsthistorisches Museum.

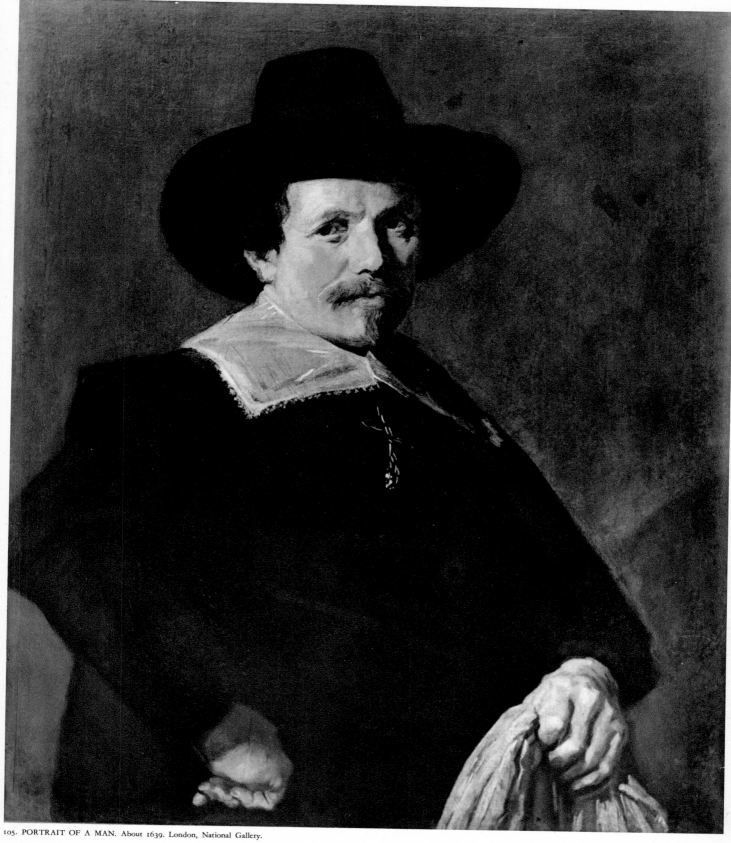

105. PORTRAIT OF A MAN. About 1639. London, National Gallery.

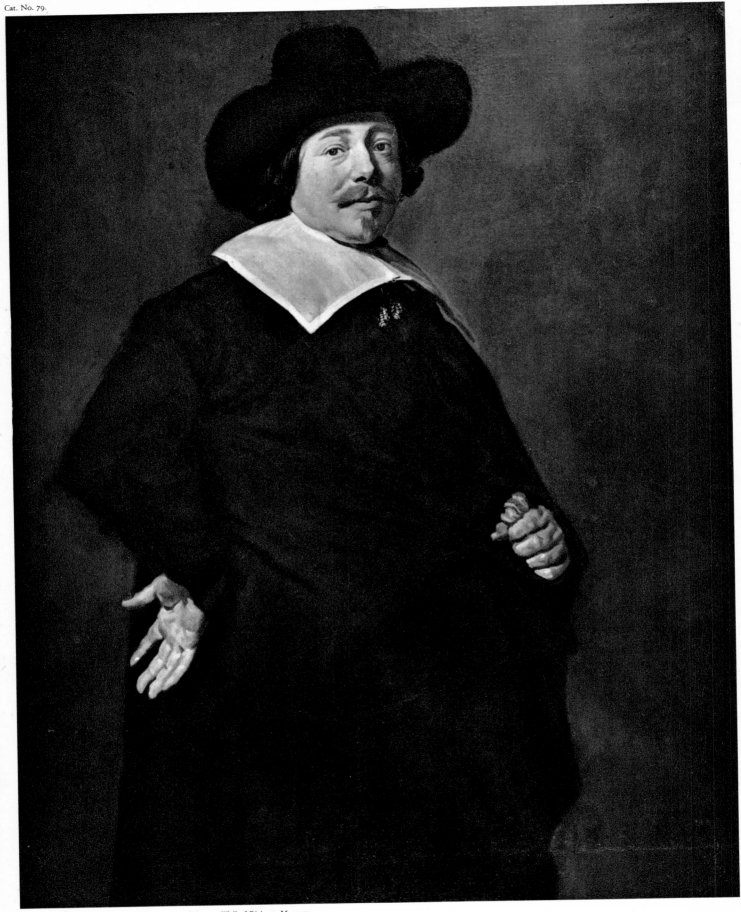

106. PORTRAIT OF A MAN. About 1640. Cologne, Wallraf-Richartz-Museum.

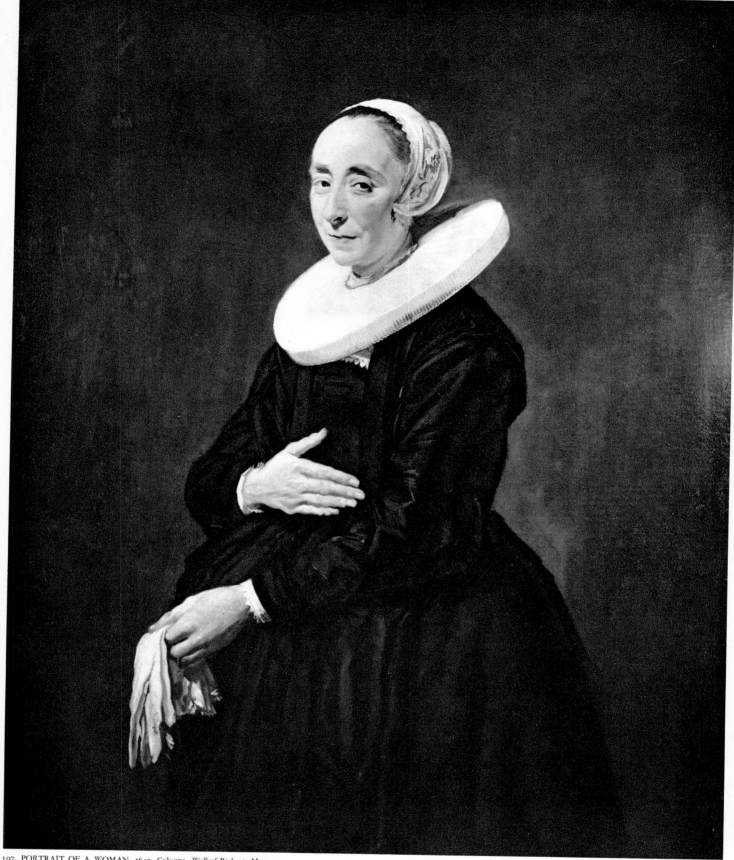

107. PORTRAIT OF A WOMAN. 1640. Cologne, Wallraf-Richartz-Museum.

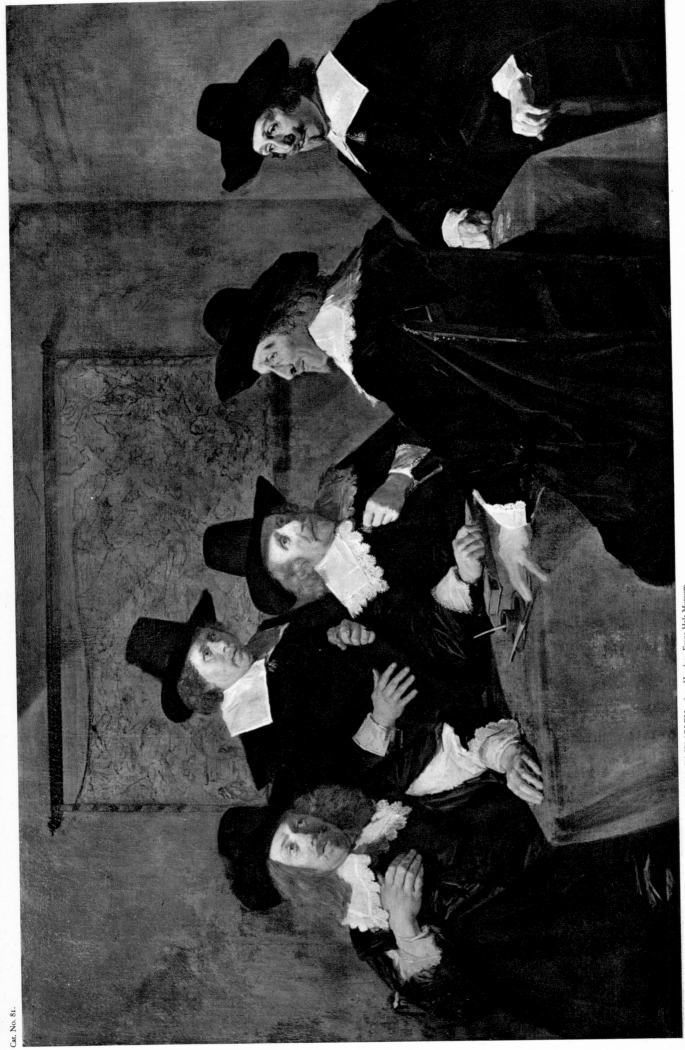

108. GOVERNORS ("REGENTEN") OF THE ELISABETH HOSPITAL IN HAARLEM. 1641. Haarlem, Frans Hals Museum.

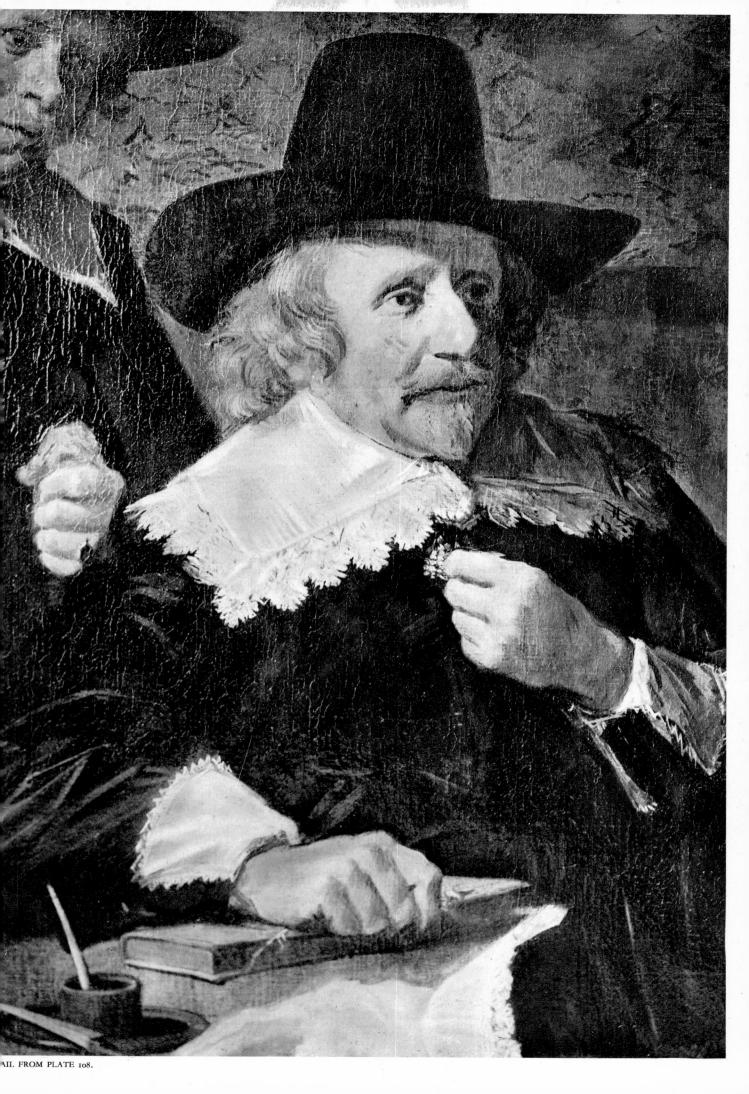

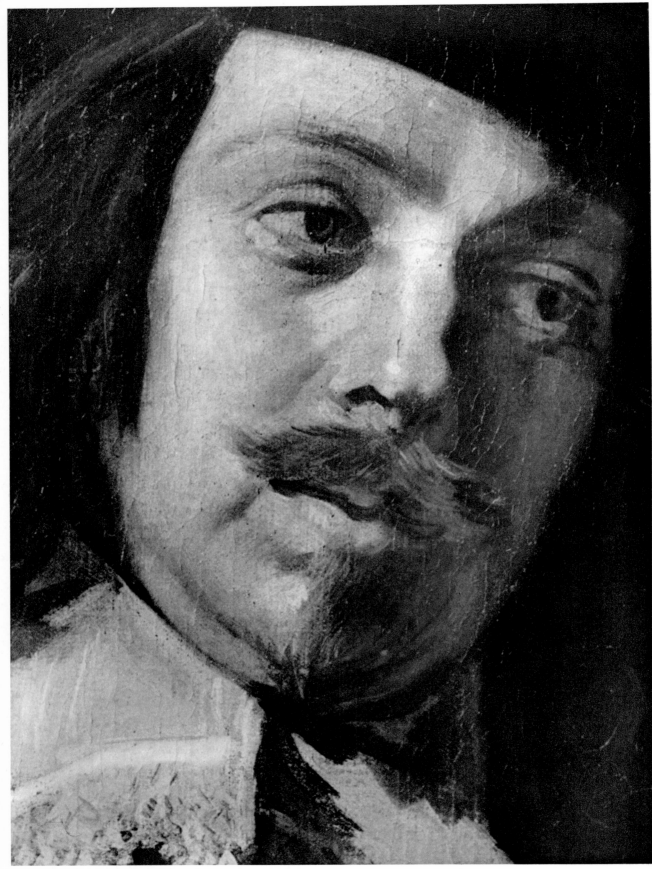

110. DETAIL FROM PLATE 108 (actual size).

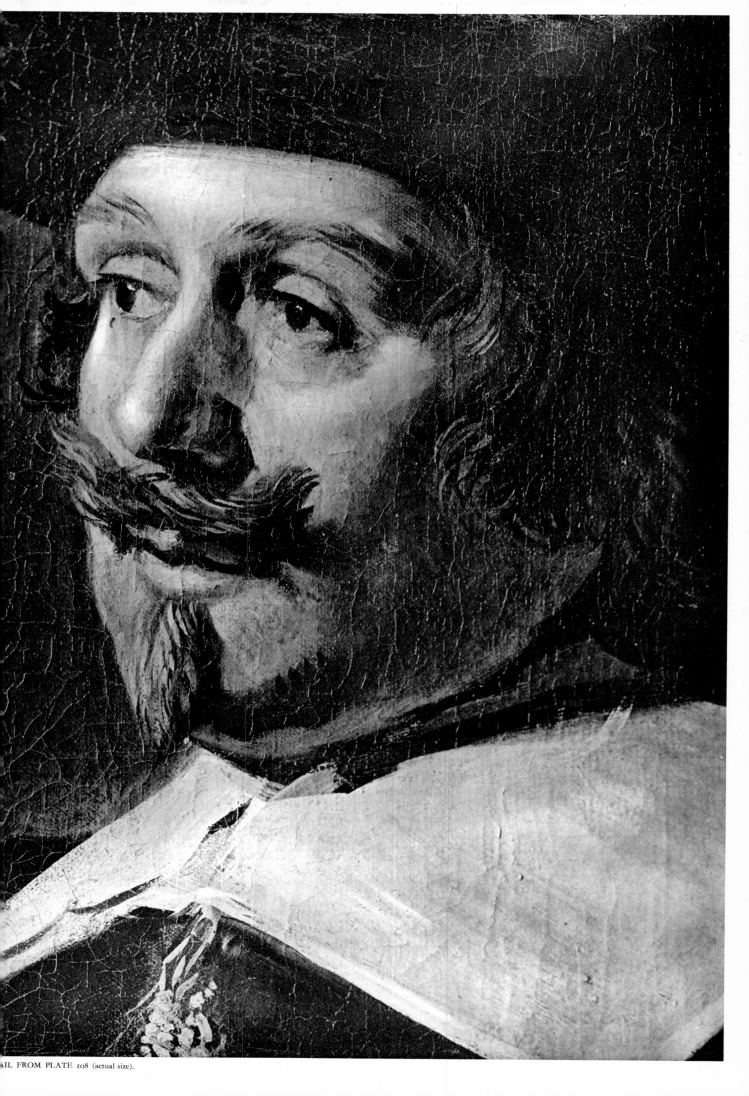

AIL FROM PLATE 108 (actual size).

112. PORTRAIT OF A MAN. 1641-1644. Cassel, Staatliche Gemäldegalerie.

113. PORTRAIT OF A MAN. 1641-1644. Cassel, Staatliche Gemäldegalerie.

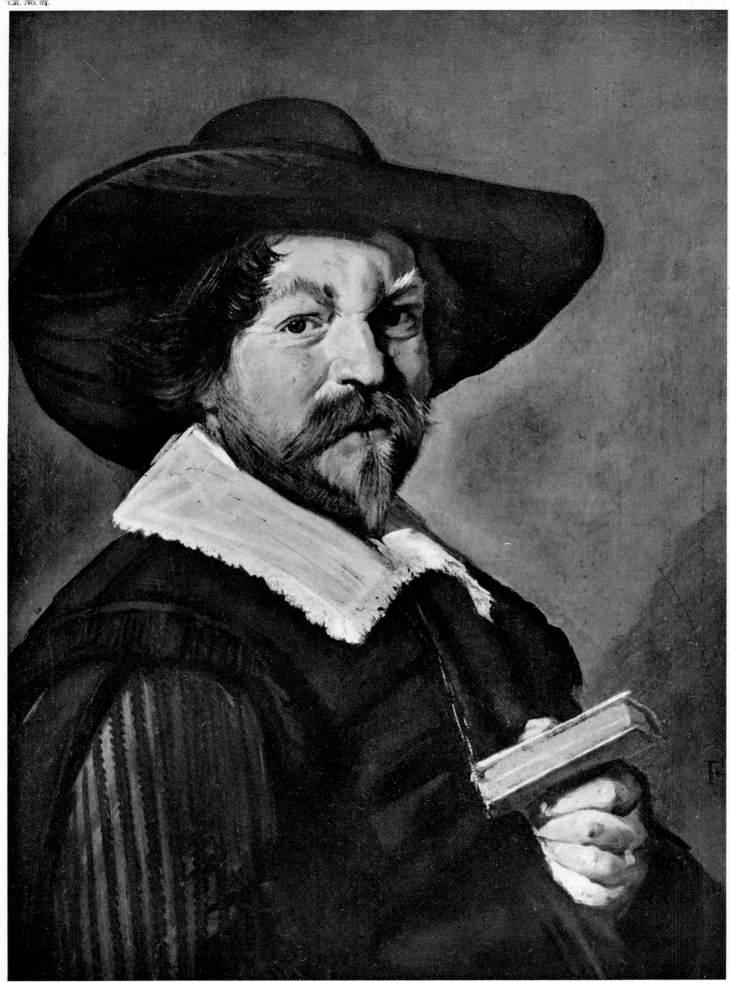

114. PORTRAIT OF A MAN. 1641-1644. Breda, Holland, Mrs. Goekoop de Jongh.

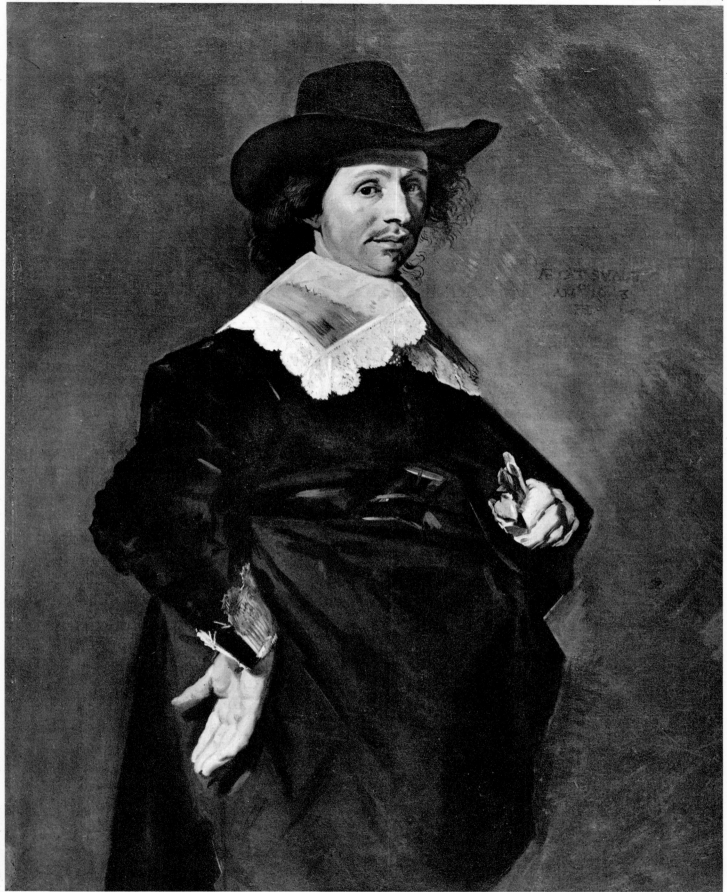

115. PORTRAIT OF A MAN. 1643. New York, Metropolitan Museum of Art.

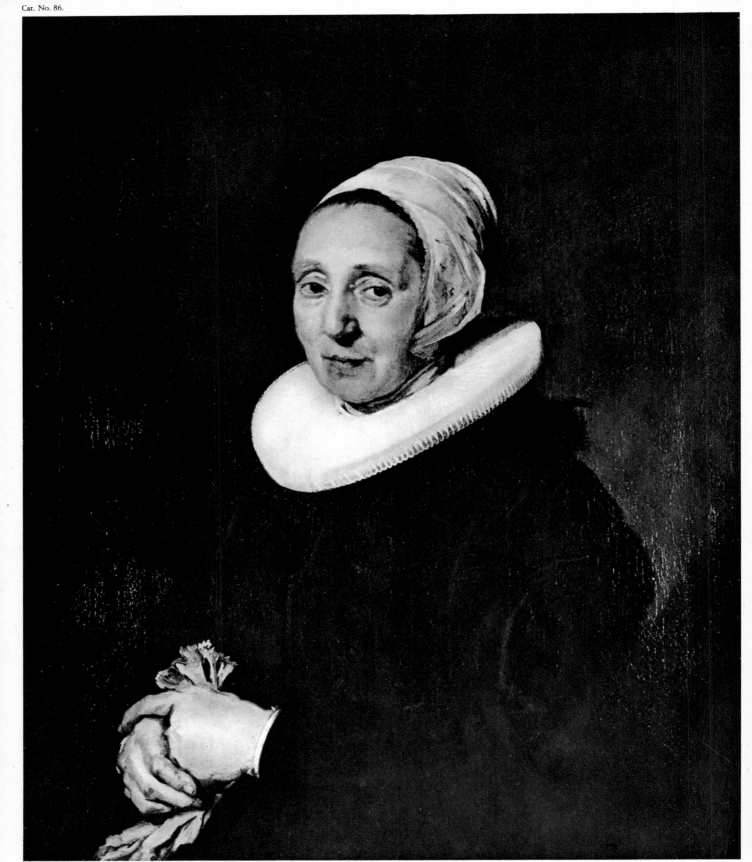

116. PORTRAIT OF A WOMAN. 1643. New York, Mrs. Charles S. Payson.

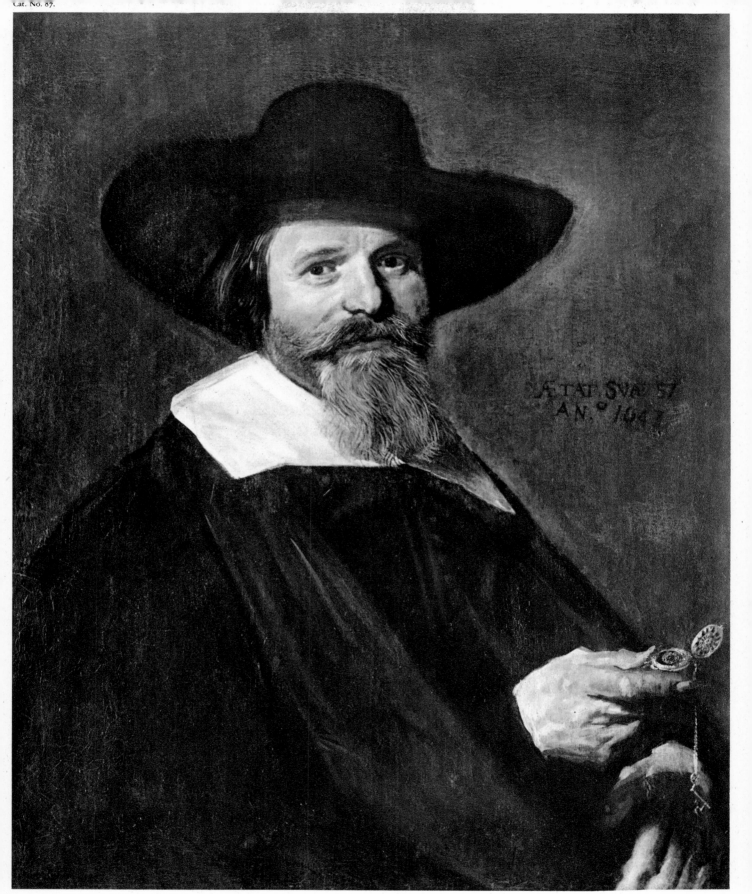

117. MAN HOLDING A WATCH. 1643. Merion, Pa., The Barnes Foundation.

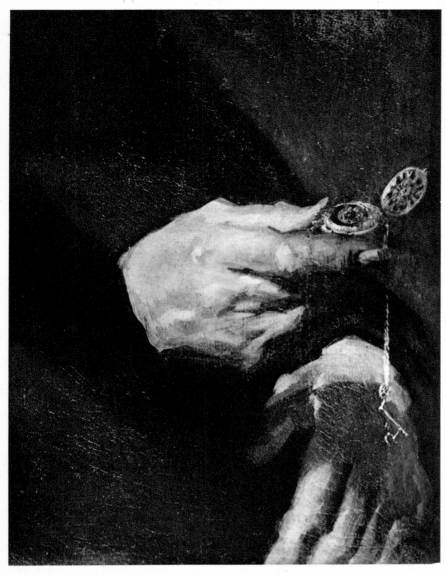

118a. DETAIL FROM PLATE 117.

118b. DETAIL FROM PLATE 119 (actual size).

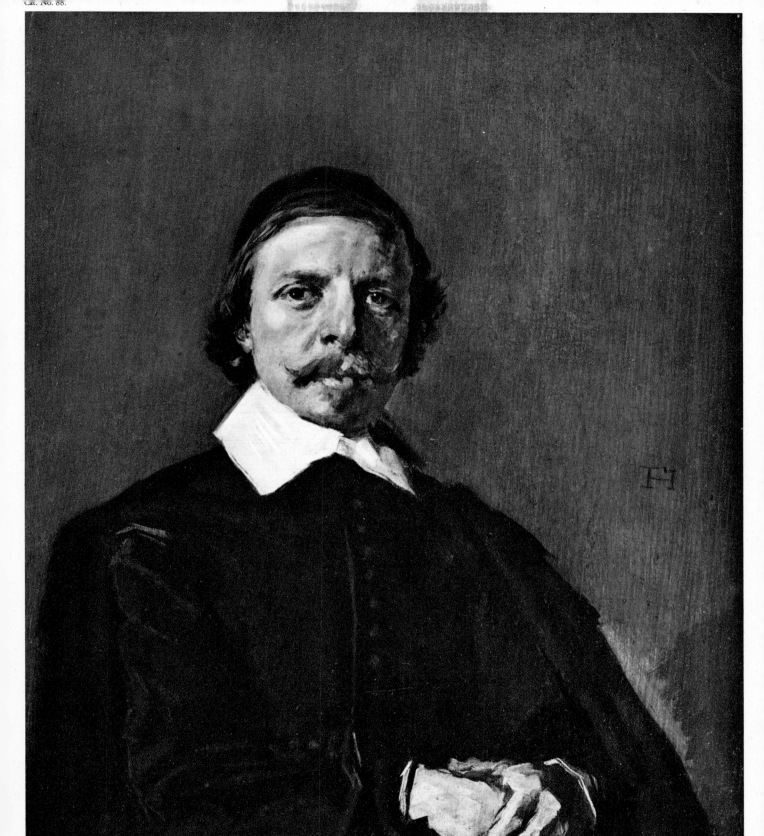

119. PORTRAIT OF A MAN. 1641-1644. Amsterdam, Ryksmuseum.

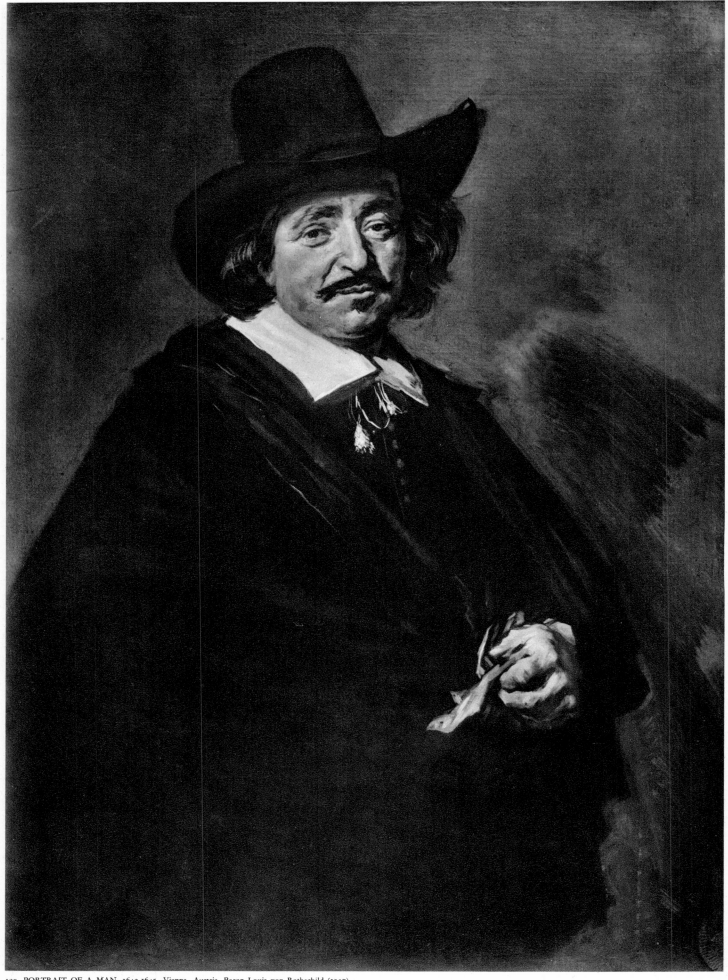

120. PORTRAIT OF A MAN. 1643-1645. Vienna, Austria. Baron Louis von Rothschild (1937).

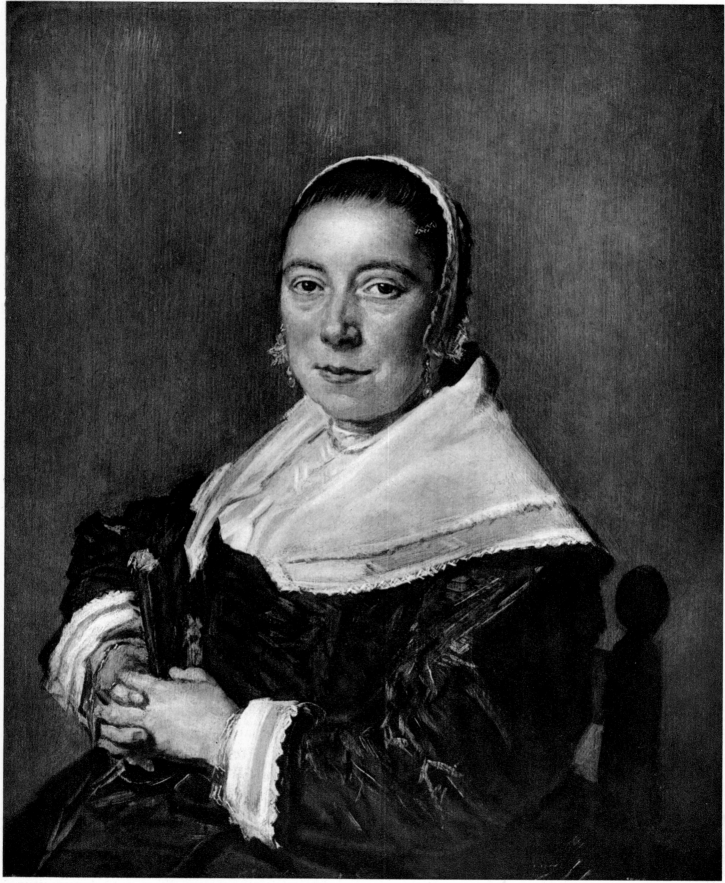

121. MARIA VERNATTI. 1644-1650. Heemstede, Holland, Mrs. Catalina von Pannwitz.

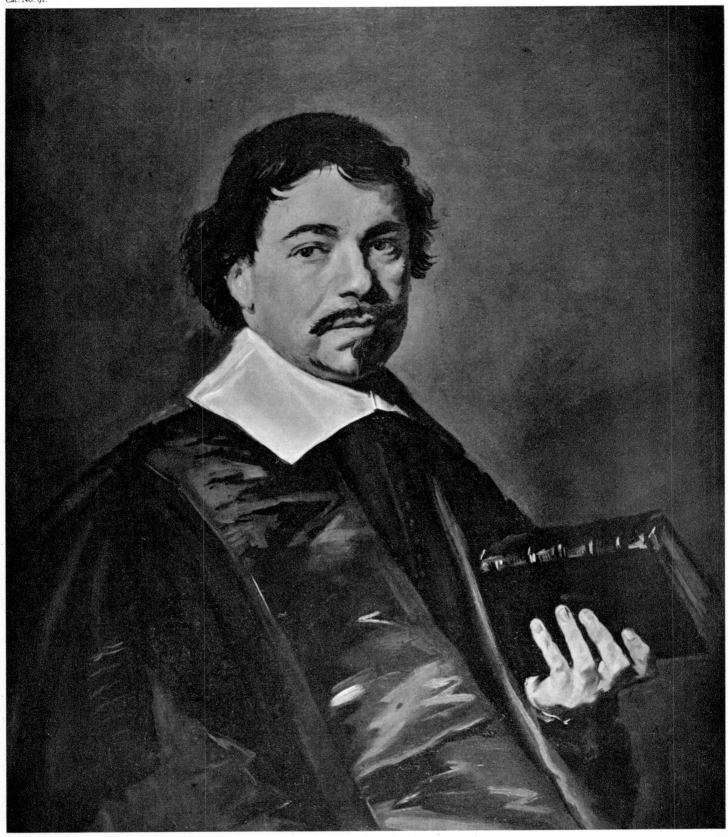

122. JOHANNES HOORNBEECK. 1645. Brussels, Musée des Beaux-Arts.

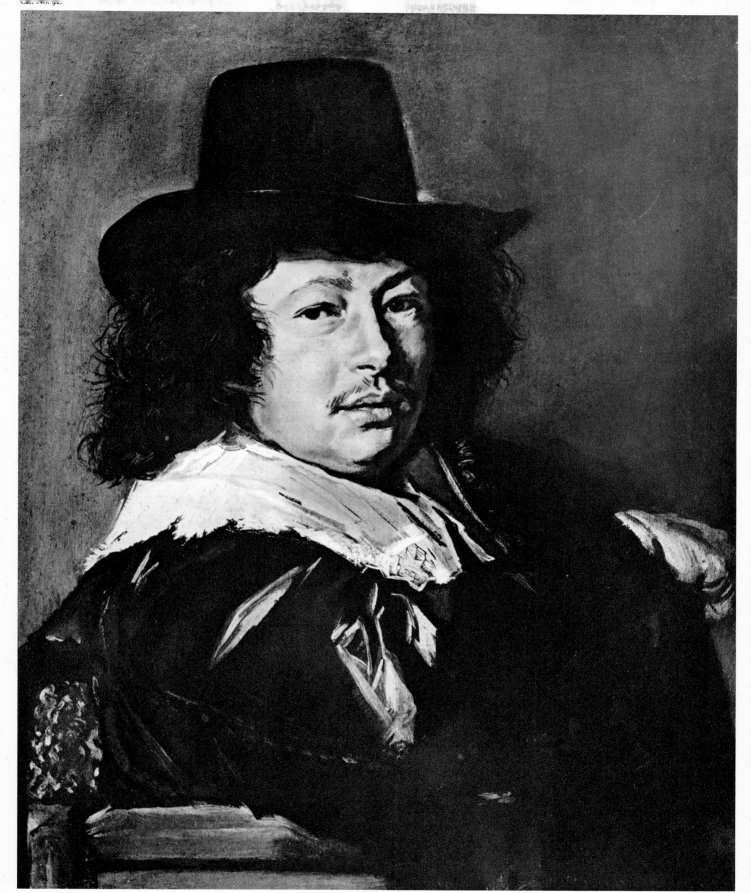

123. PORTRAIT OF A MAN. 1646-1647. Washington, D.C., National Gallery of Art.

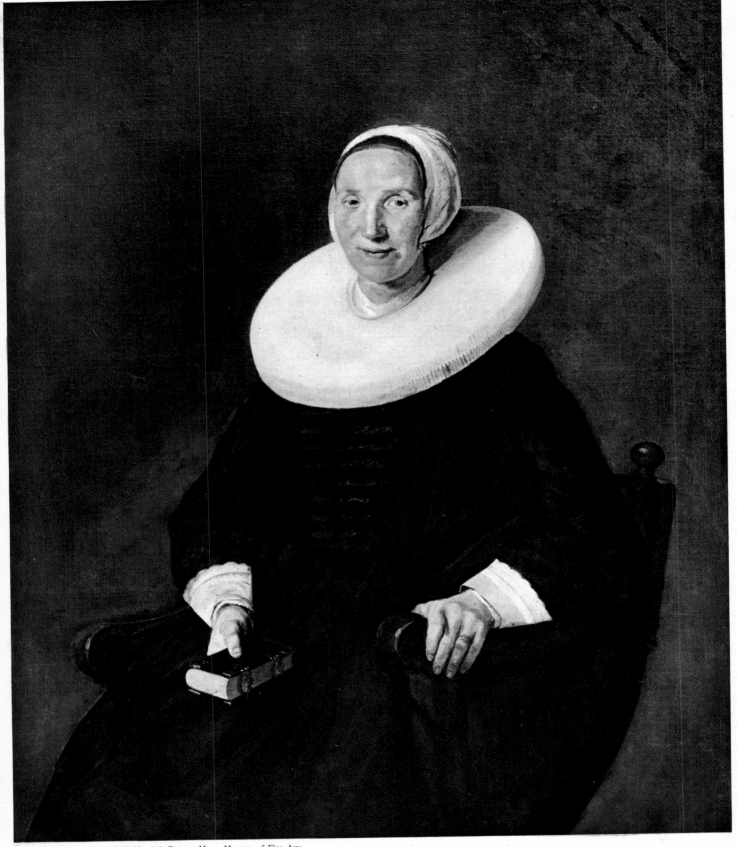

124. PORTRAIT OF A WOMAN. 1648. Boston, Mass., Museum of Fine Arts.

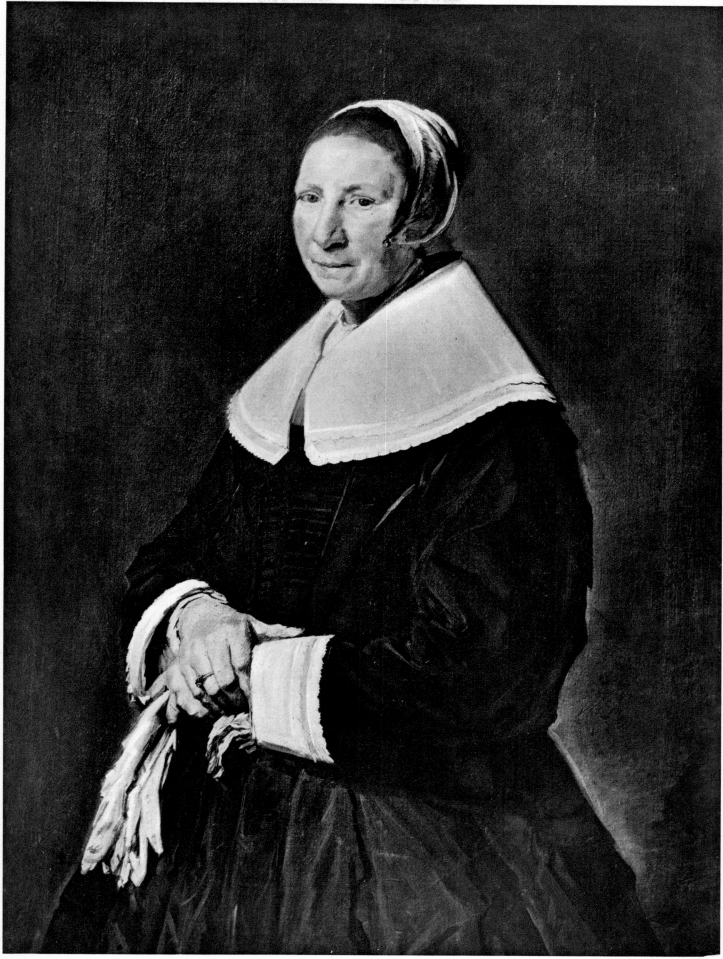

125. PORTRAIT OF AN ELDERLY WOMAN. 1647-1650. Paris, Louvre.

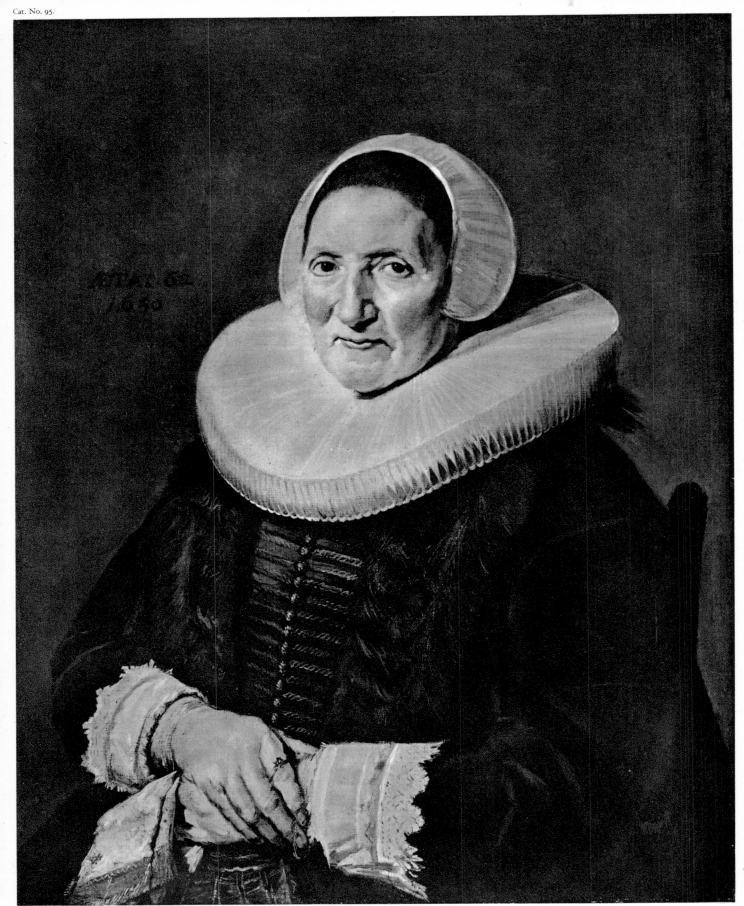

126. PORTRAIT OF AN ELDERLY WOMAN. 1650. Newport, R.I., Mr. Michael M. van Beuren.

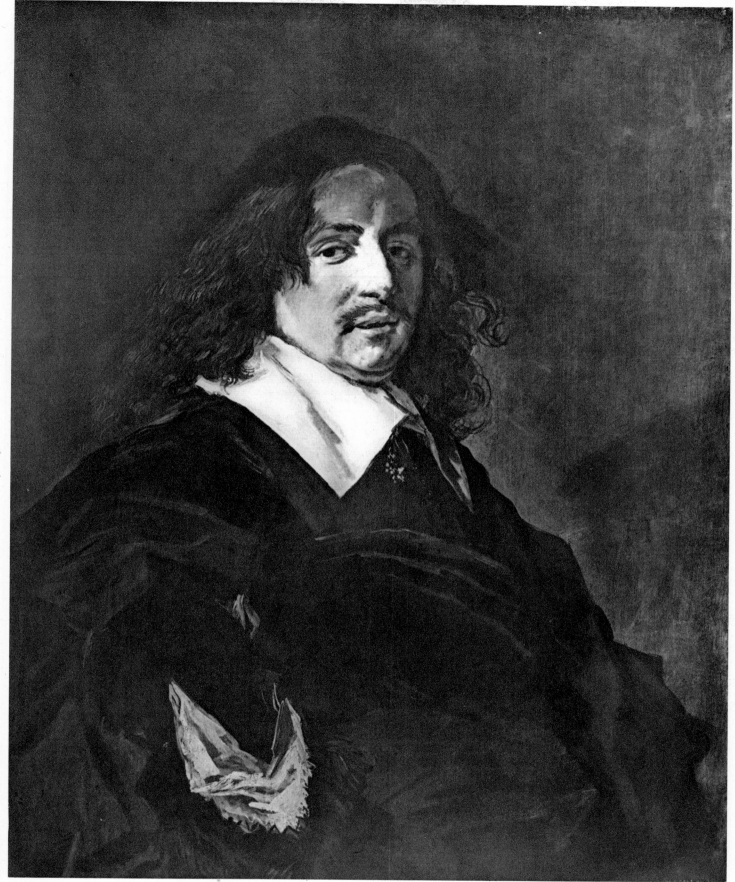

127. PORTRAIT OF A MAN. About 1650. Leningrad, Hermitage.

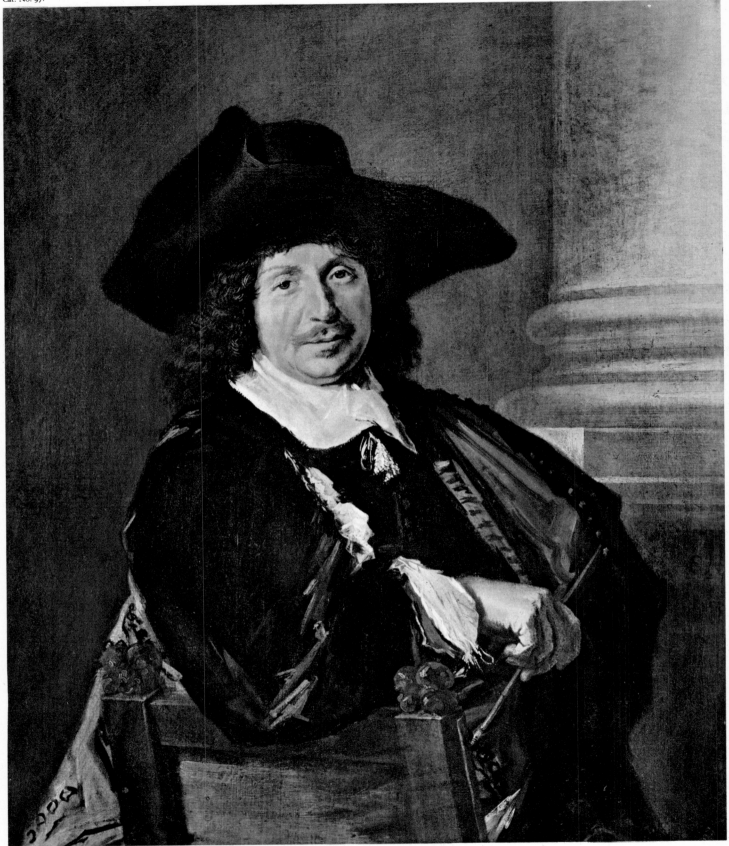

128. PORTRAIT OF A PAINTER (Self-Portrait?). About 1650. New York, The Frick Museum of Art.

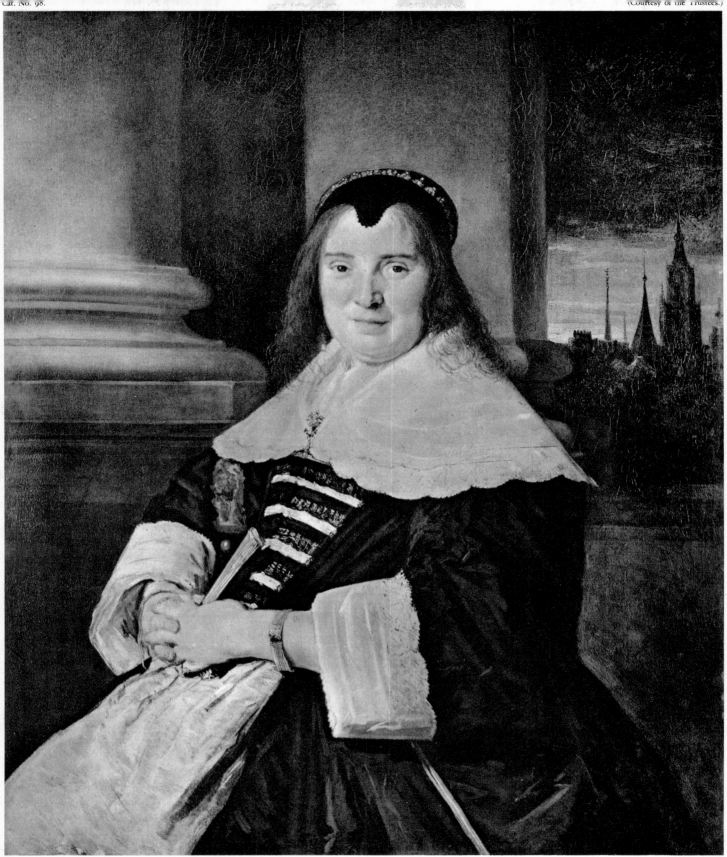

129. PORTRAIT OF A WOMAN (LYSBETH REYNIERS, WIFE OF THE ARTIST?). About 1650. New York, The Metropolitan Museum of Art.

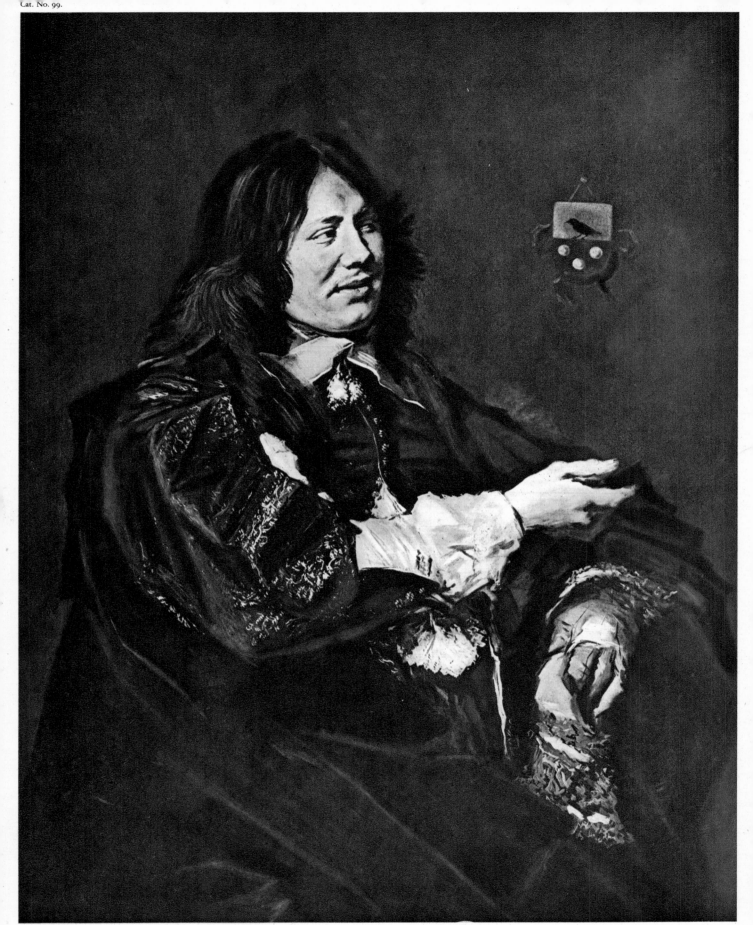

130. STEPHANUS GERAERDTS. 1650-1652. Antwerp, Musée Royal des Beaux-Arts.

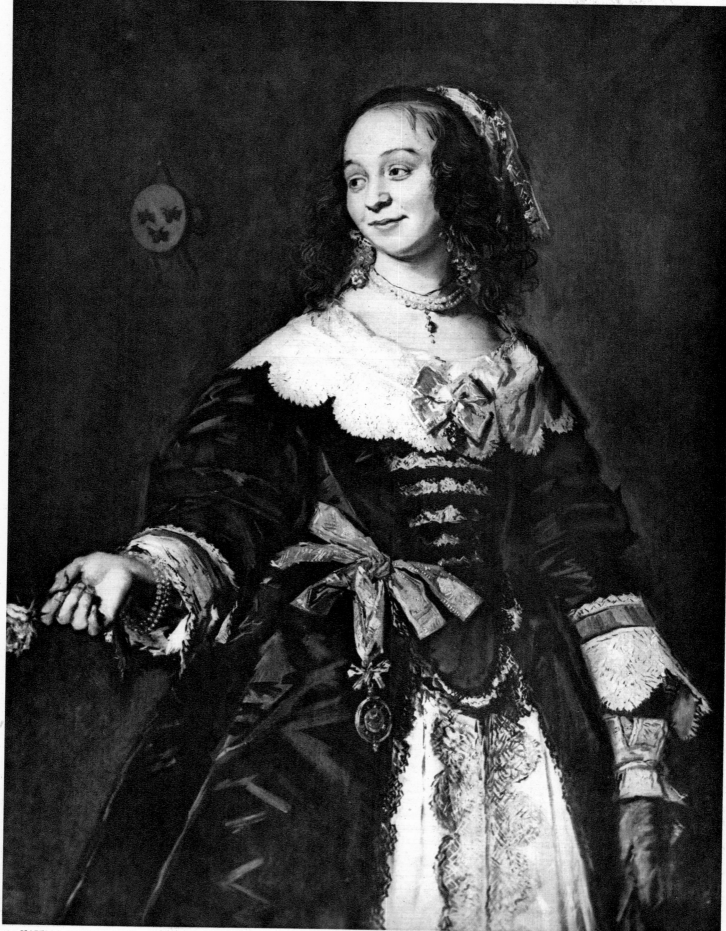

131. ISABELLA COYMANS, WIFE OF STEPHANUS GERAERDTS. 1650-1652. Ferrières, France, Baron Rothschild.

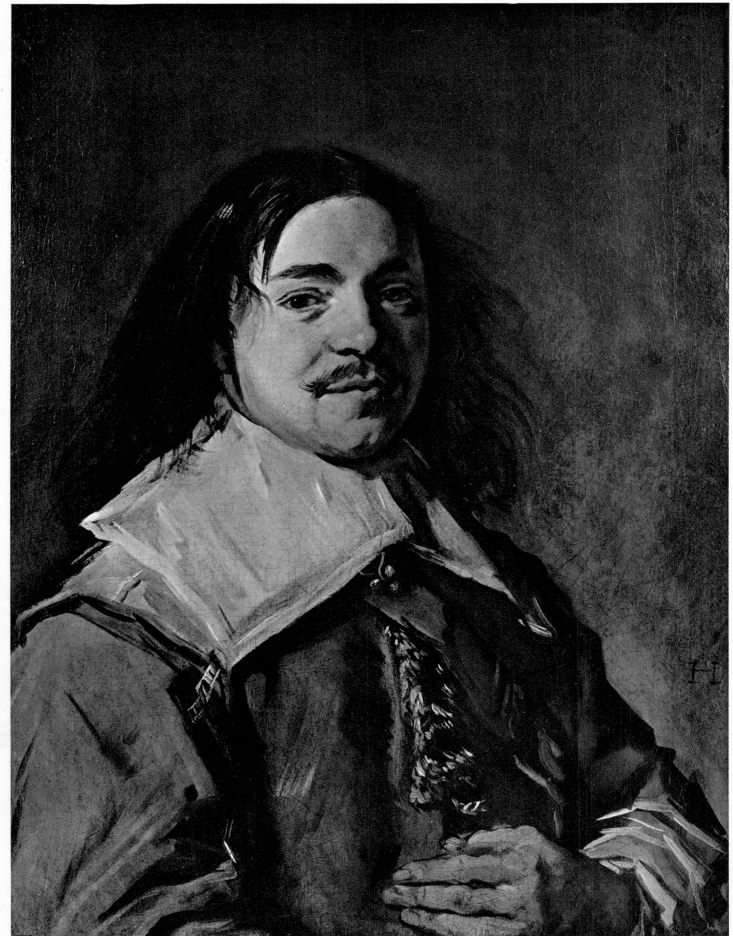

132. PORTRAIT OF A MAN. About 1655. New York, Mr. I. M. Stettenheim.

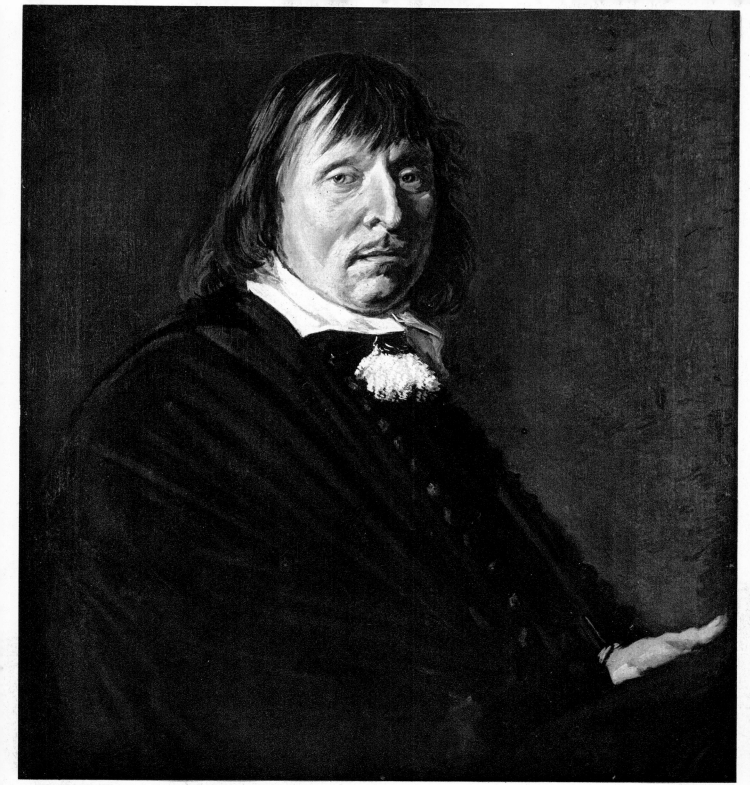

133. TYMAN OOSDORP. 1656. Berlin, Kaiser-Friedrich-Museum.

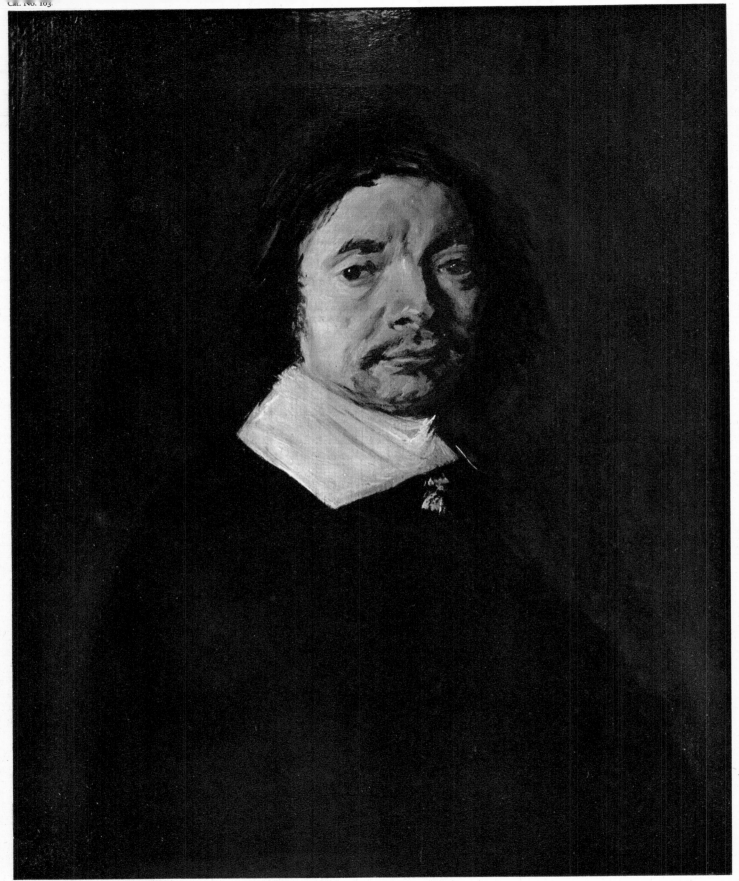

134. PORTRAIT OF A MAN. 1656-1660. St. Louis, Mo., Mr. W. H. Bixby.

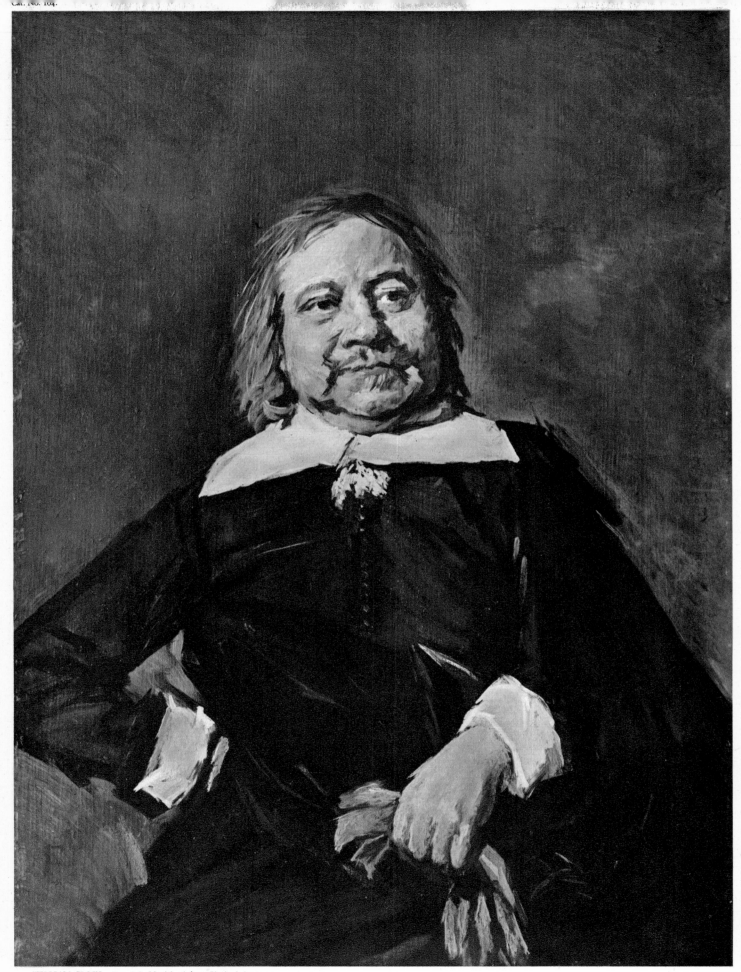

135. WILLIAM CROES. 1655-1658. Munich, Aeltere Pinakothek.

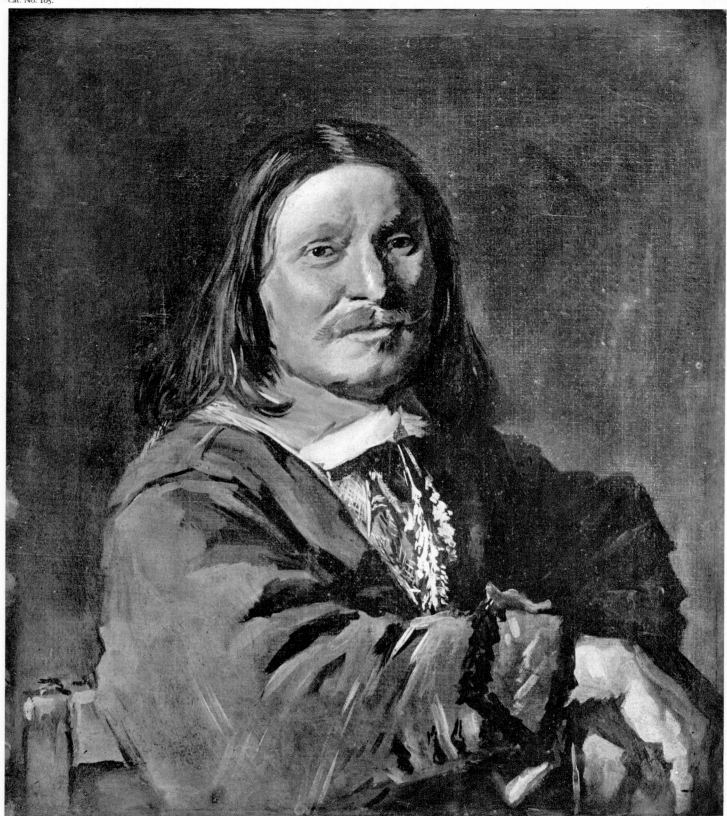

136. PORTRAIT OF A MAN. 1660-1663. Paris, Musée Jacquemart-André.

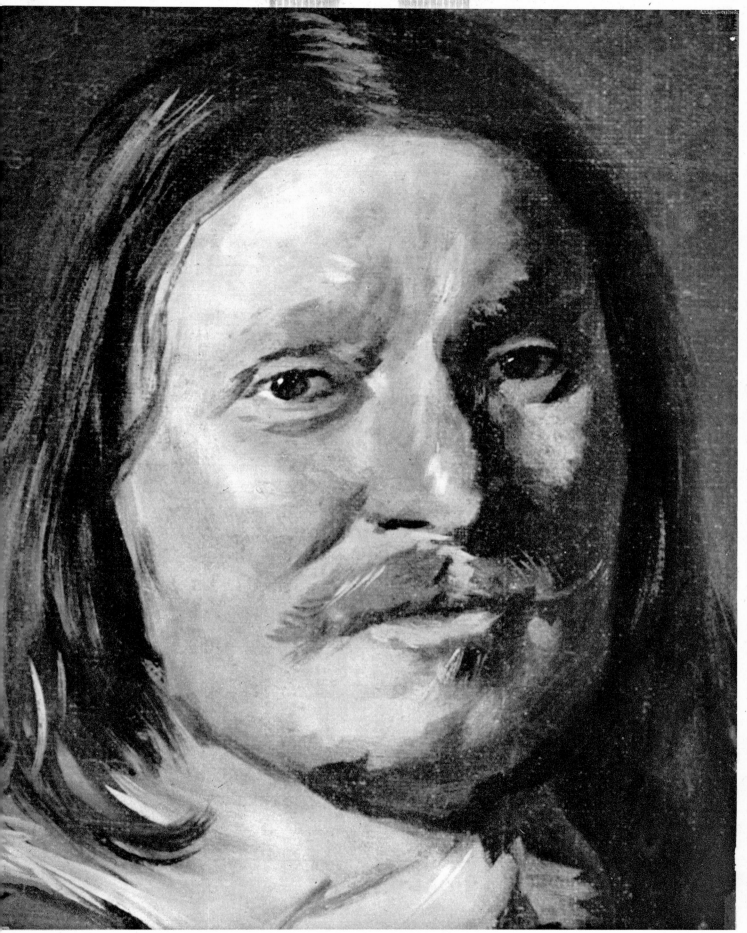

ETAIL FROM PLATE 136 (actual size).

Cat. No. 106.

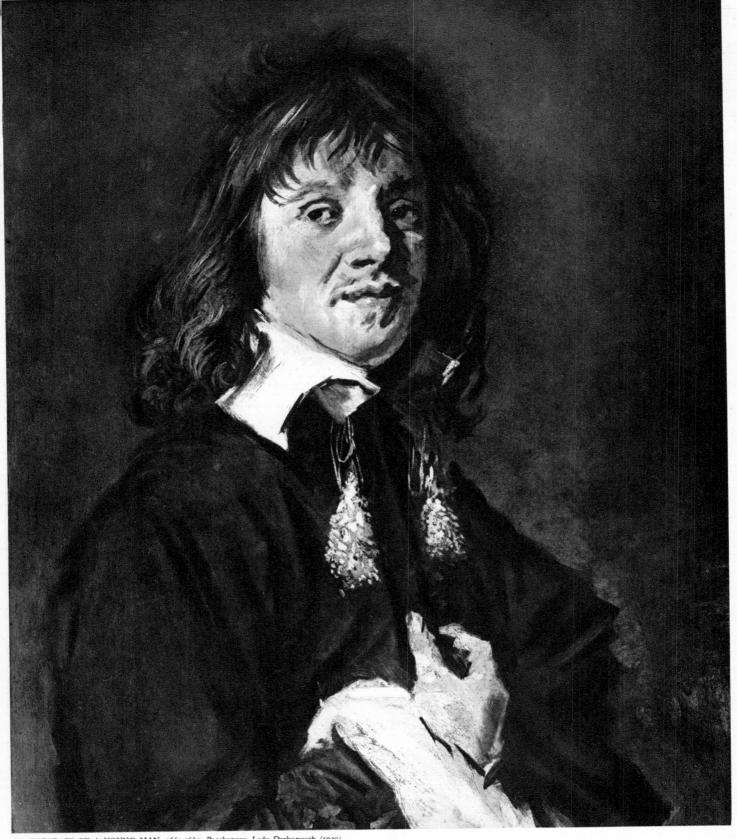

138. PORTRAIT OF A YOUNG MAN. 1661-1663. Panshanger, Lady Desborough (1929).

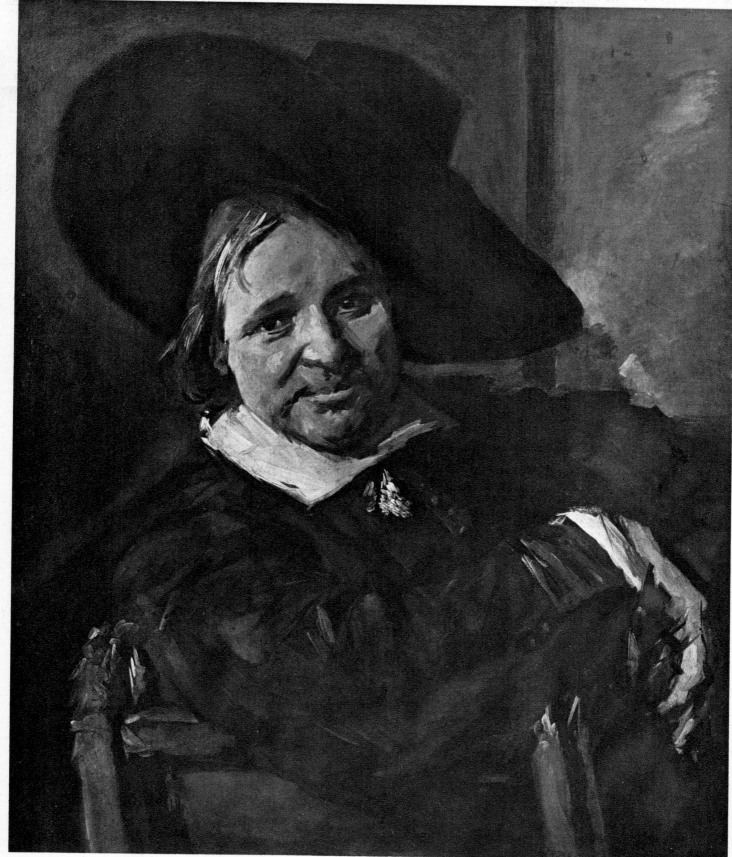

139. PORTRAIT OF A MAN. 1661-1664. Cassel, Staatliche Gemäldegalerie.

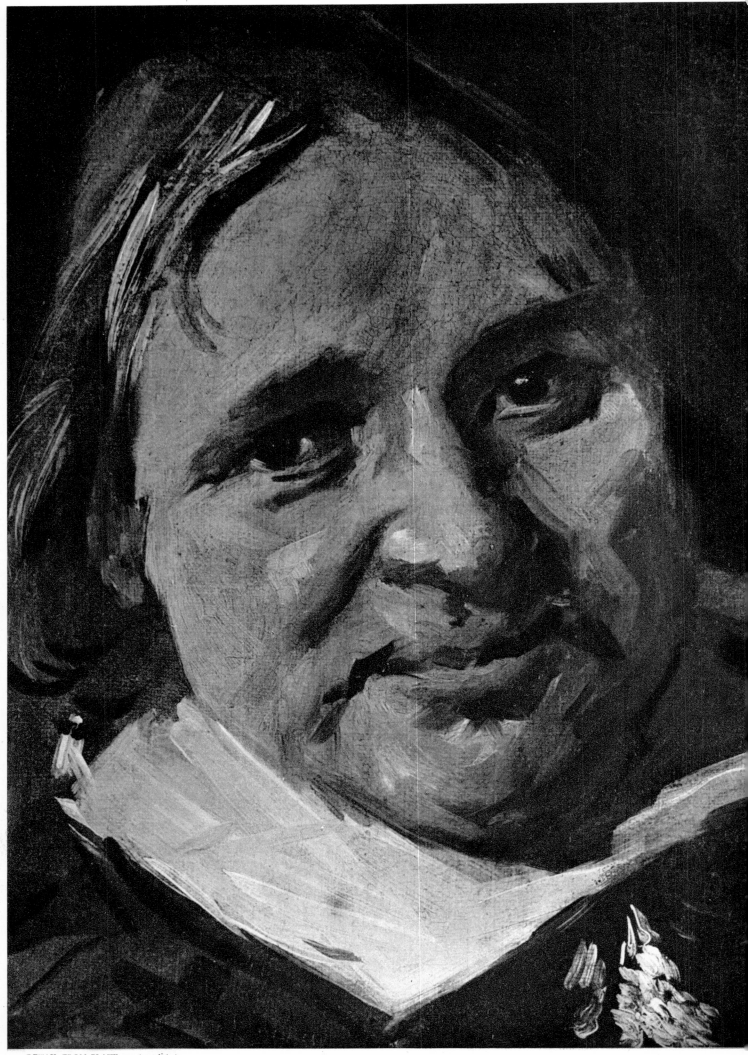

140. DETAIL FROM PLATE 139 (actual size).

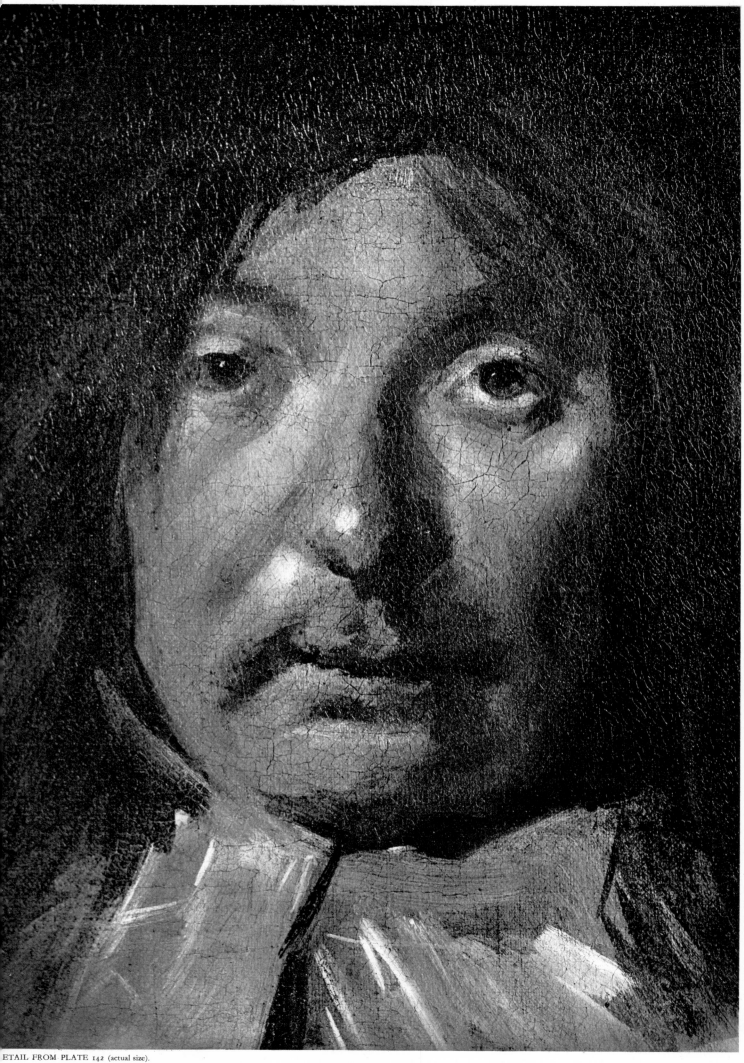

ETAIL FROM PLATE 142 (actual size).

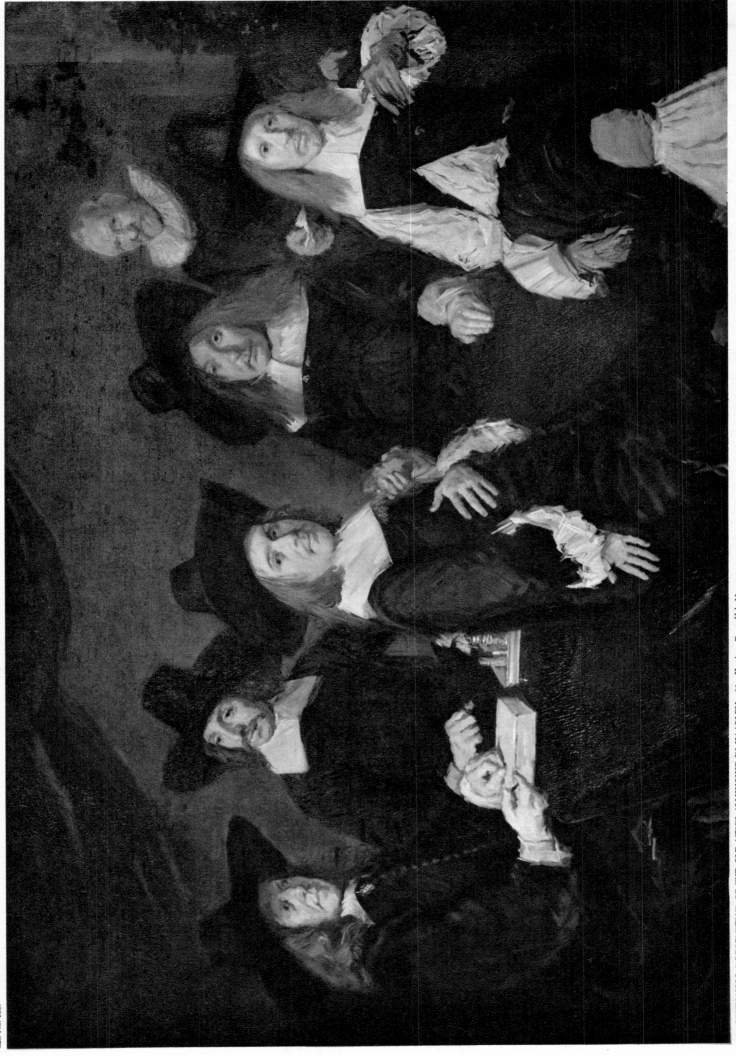

142. GOVERNORS ("REGENTEN") OF THE OLD MEN'S ALMSHOUSE IN HAARLEM. 1664. Haarlem, Frans Hals Museum.

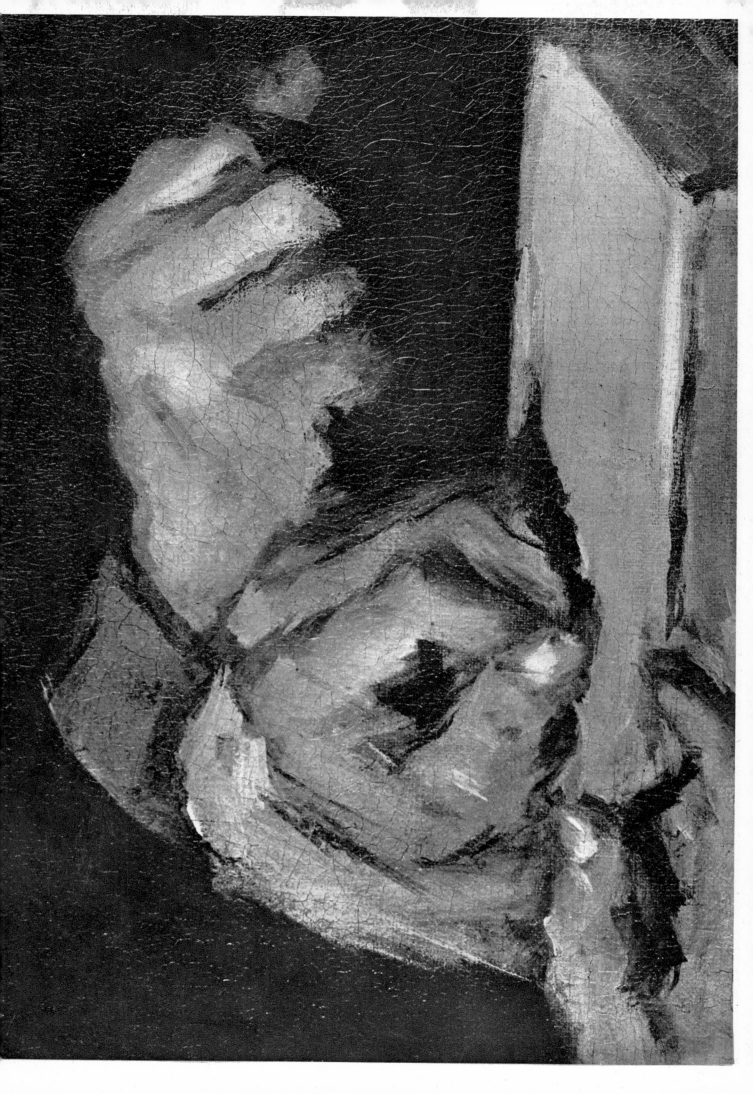

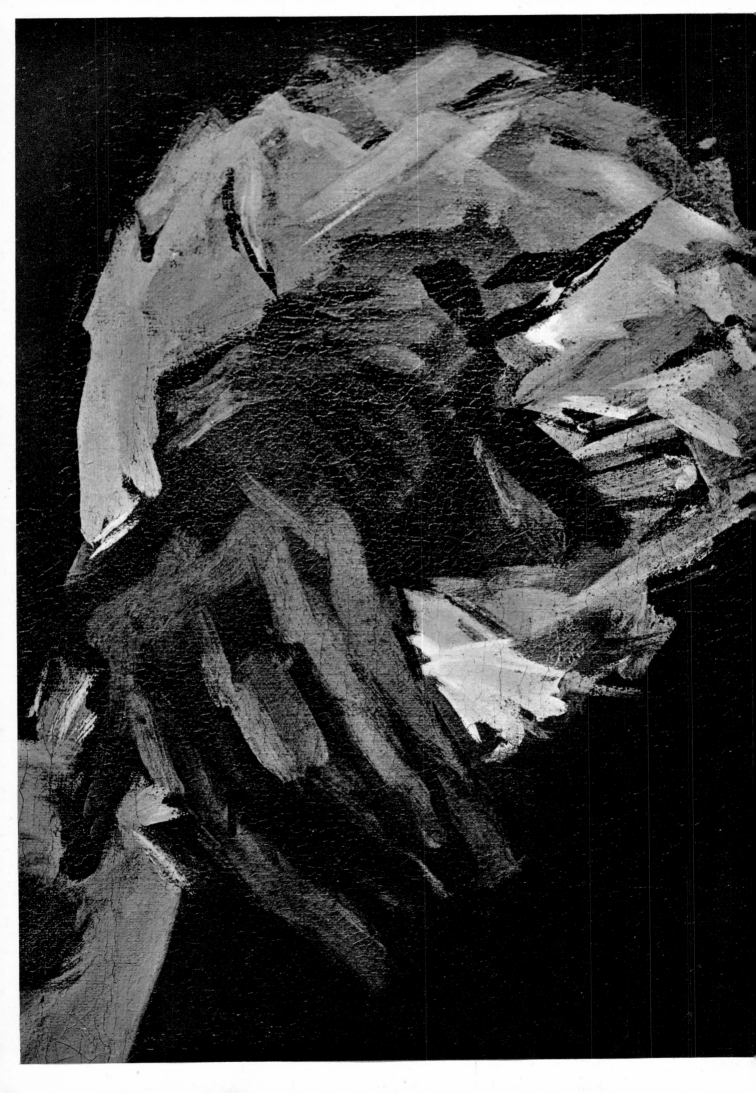

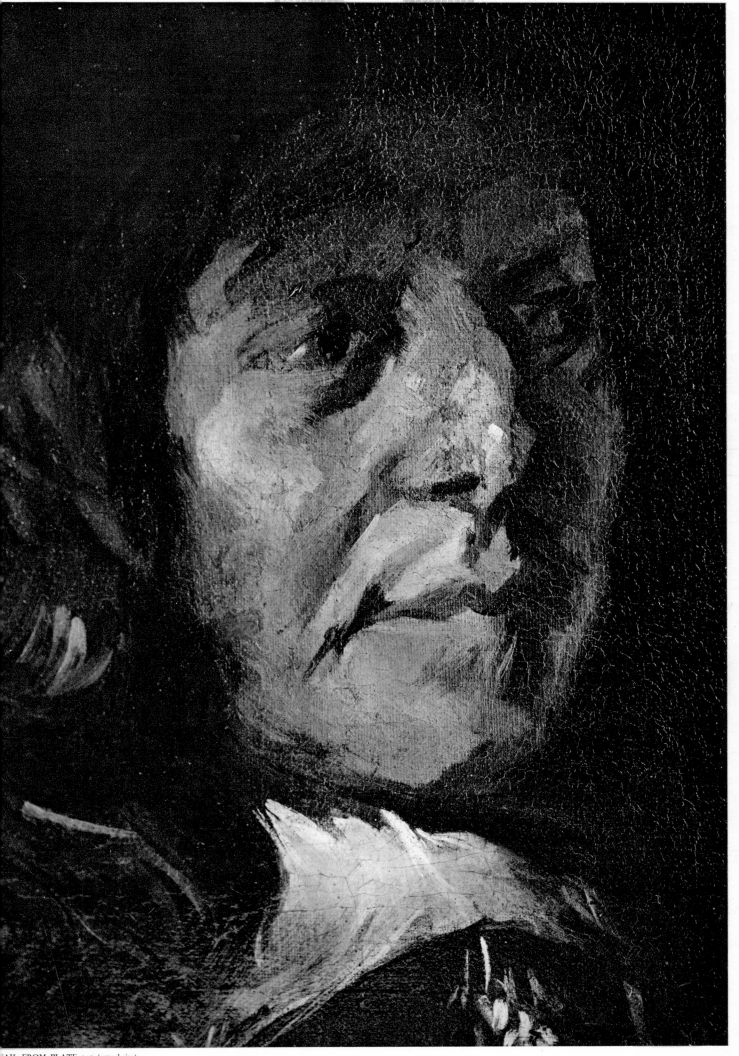

DETAIL FROM PLATE 142 (actual size).

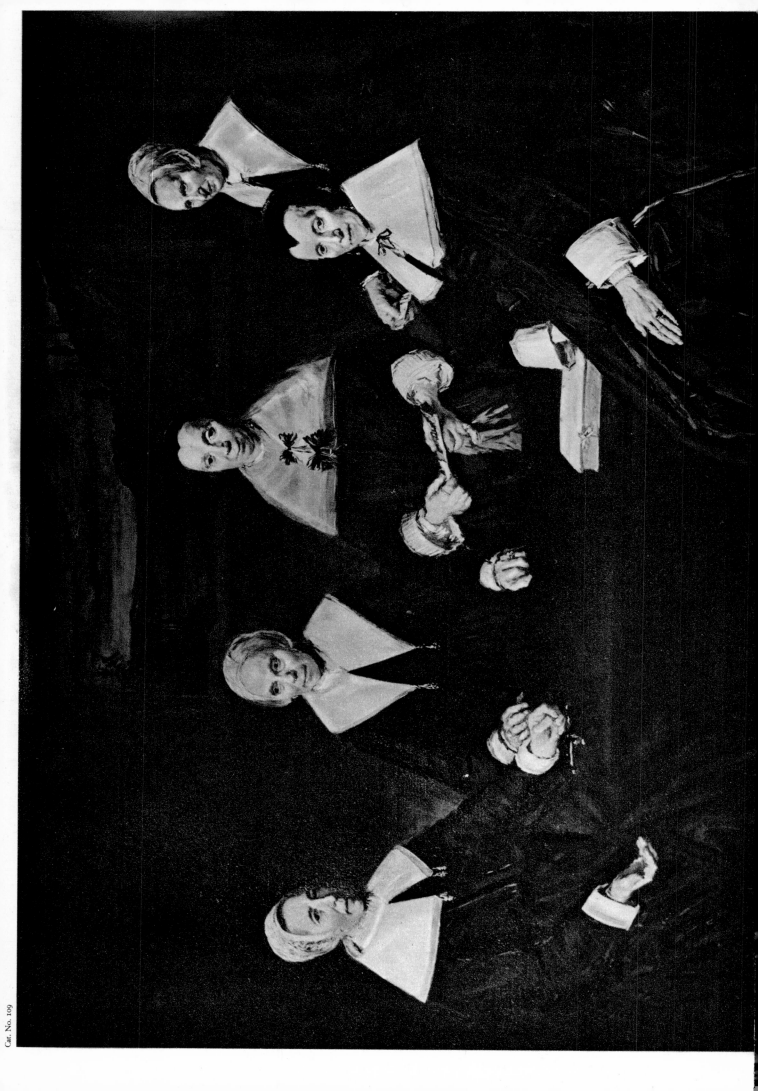

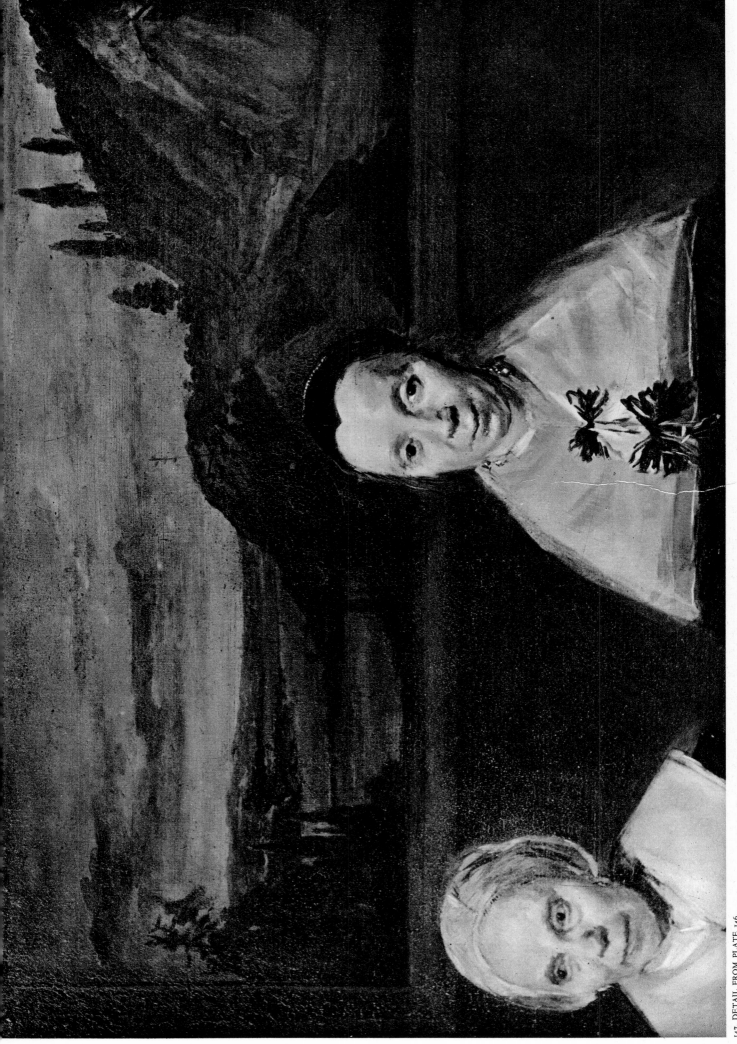

147. DETAIL FROM PLATE 146.

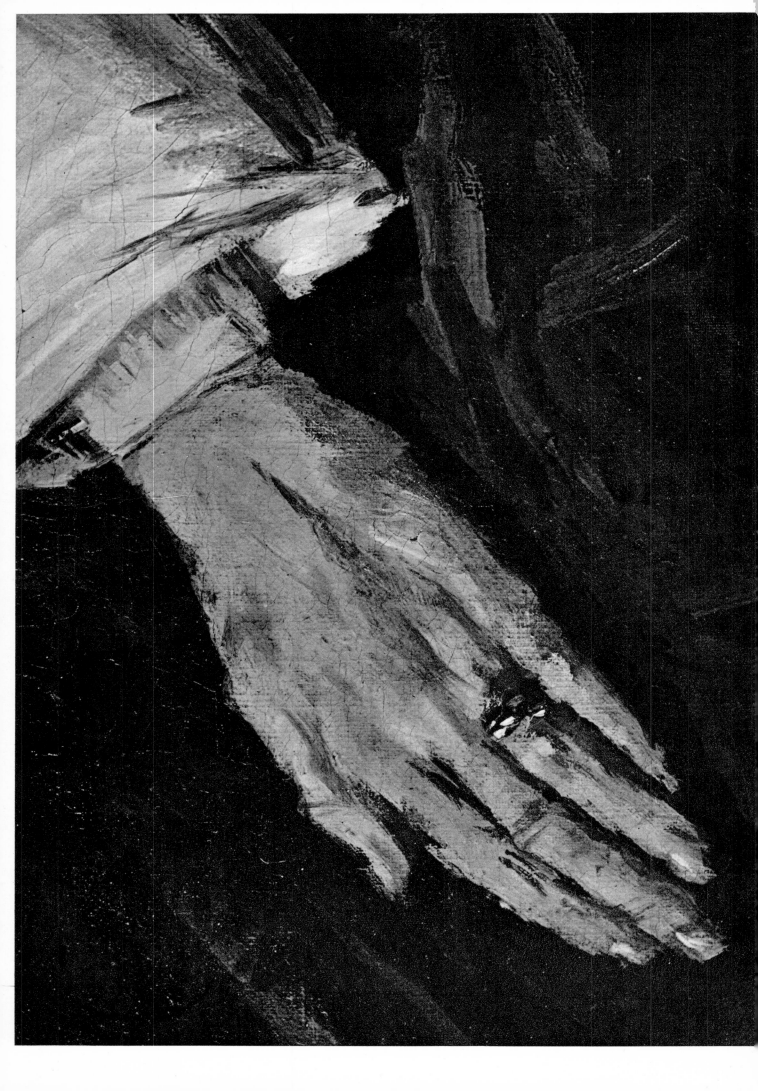

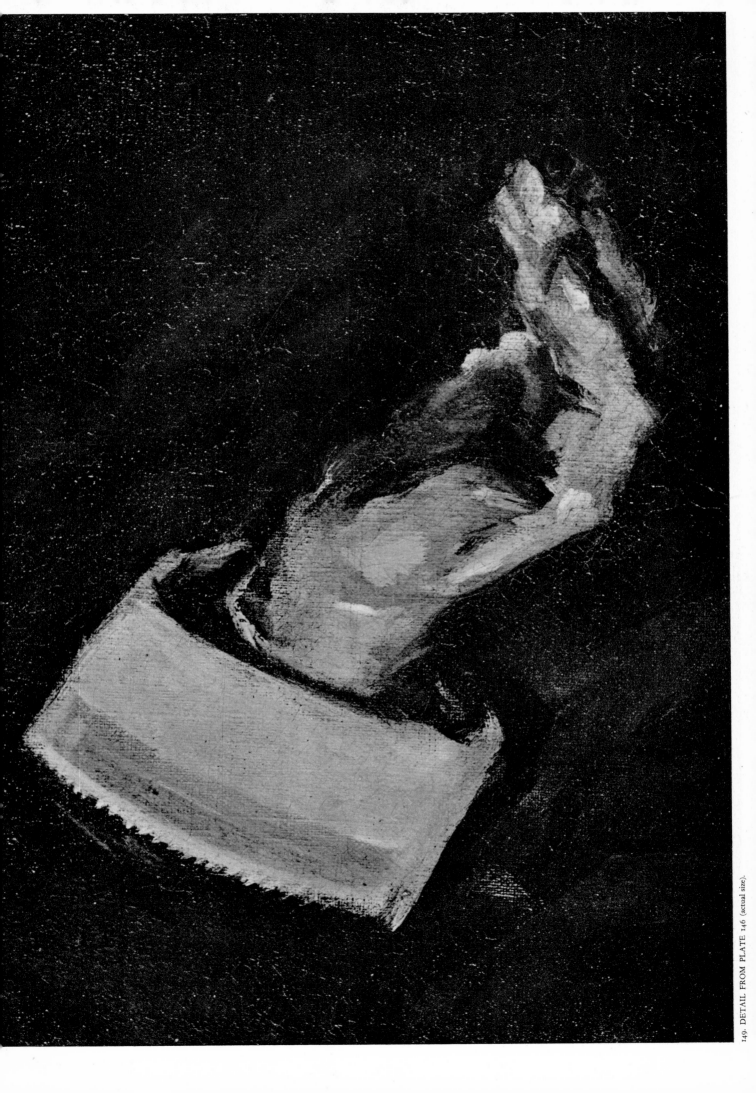

149. DETAIL FROM PLATE 146 (actual size).

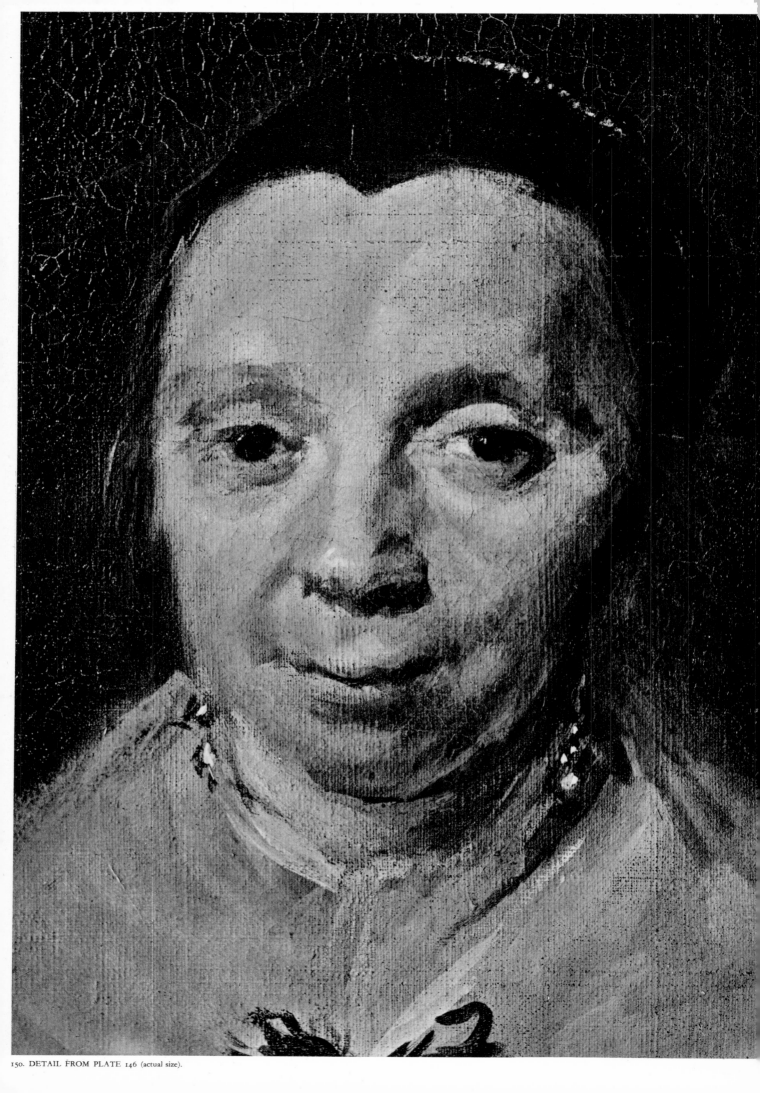

150. DETAIL FROM PLATE 146 (actual size).

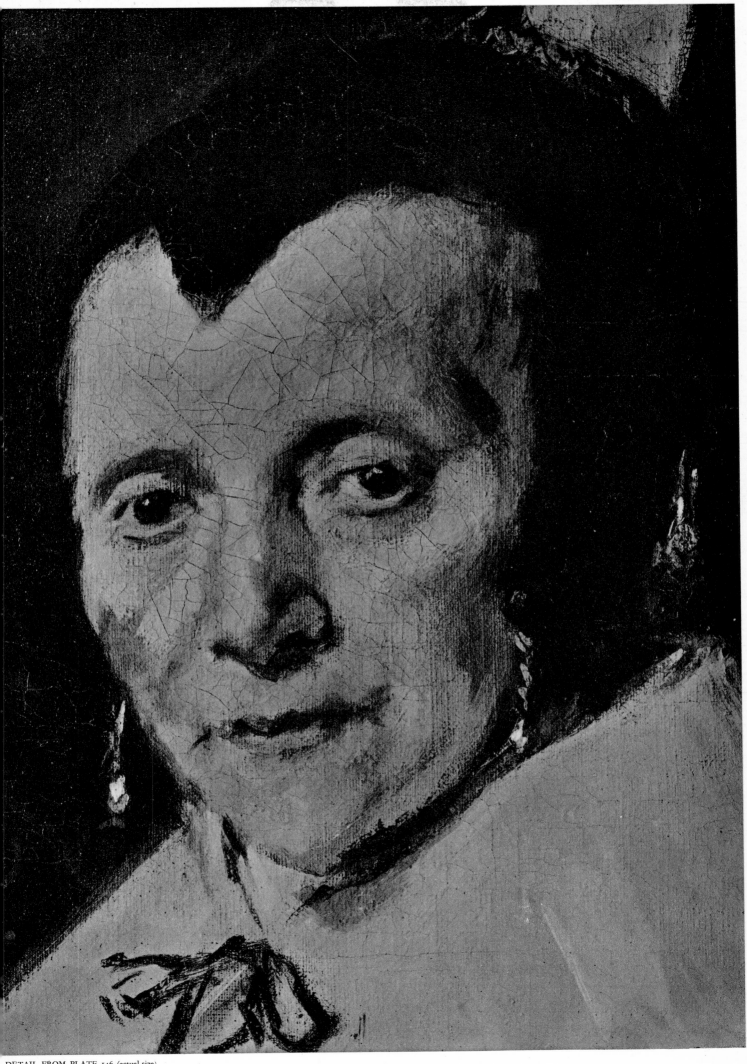

DETAIL FROM PLATE 146 (actual size).

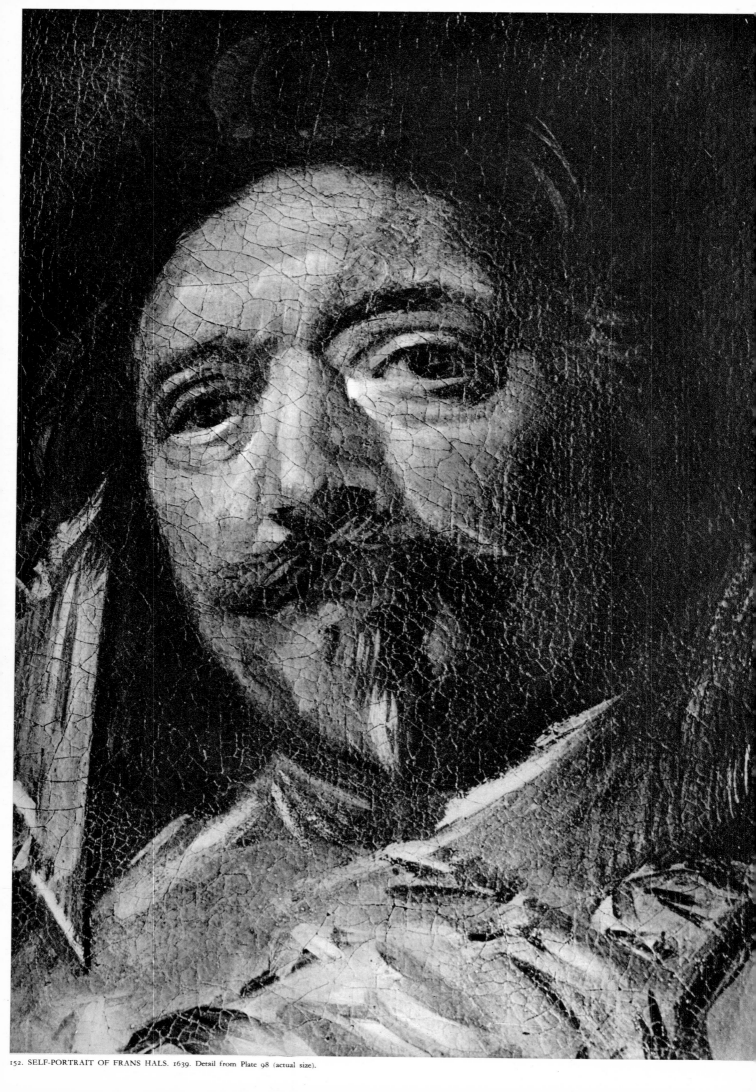

152. SELF-PORTRAIT OF FRANS HALS. 1639. Detail from Plate 98 (actual size).

APPENDIX

Reproduction of a variant in the appendix does not imply that the author considers the painting to be an original by Frans Hals.

153. THE SO-CALLED YONKER RAMP. New York, Metropolitan Museum of Art.

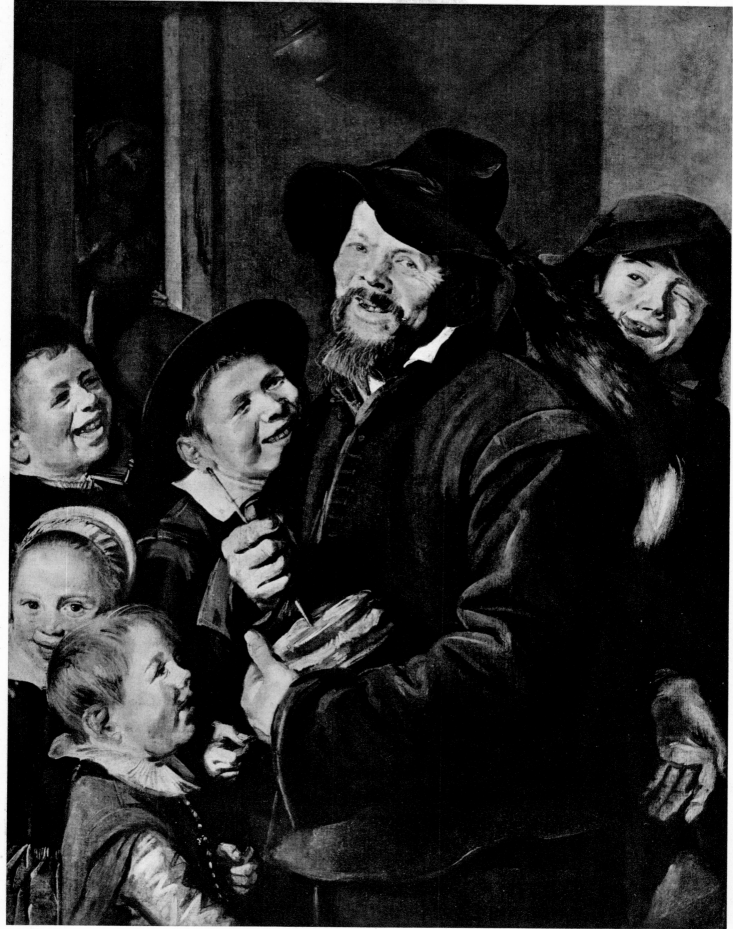

154. THE ROMMELPOT PLAYER. Richmond, Sir Frederick Cook

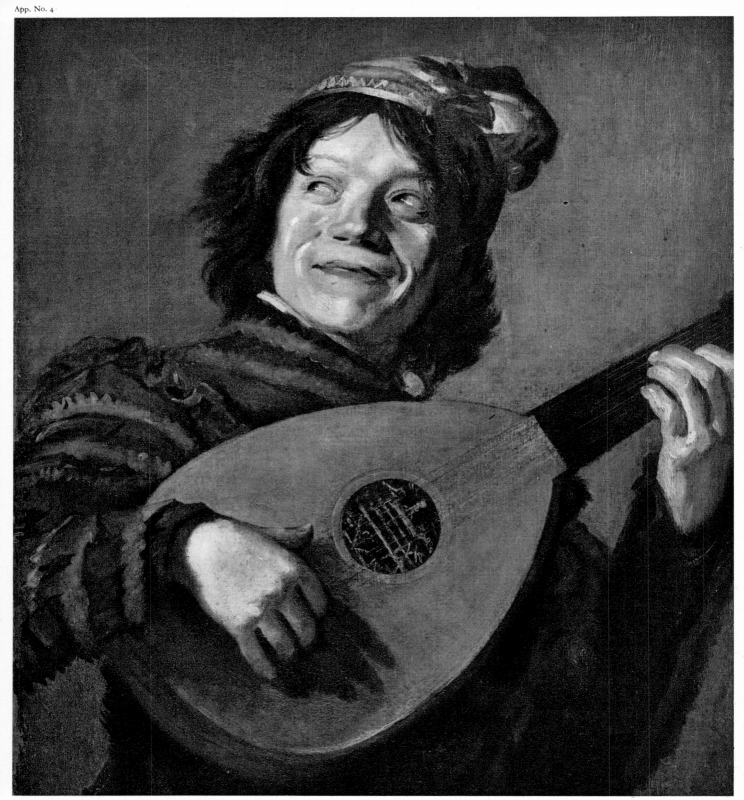

155. LUTE PLAYING BANTERER. Amsterdam, Ryksmuseum.

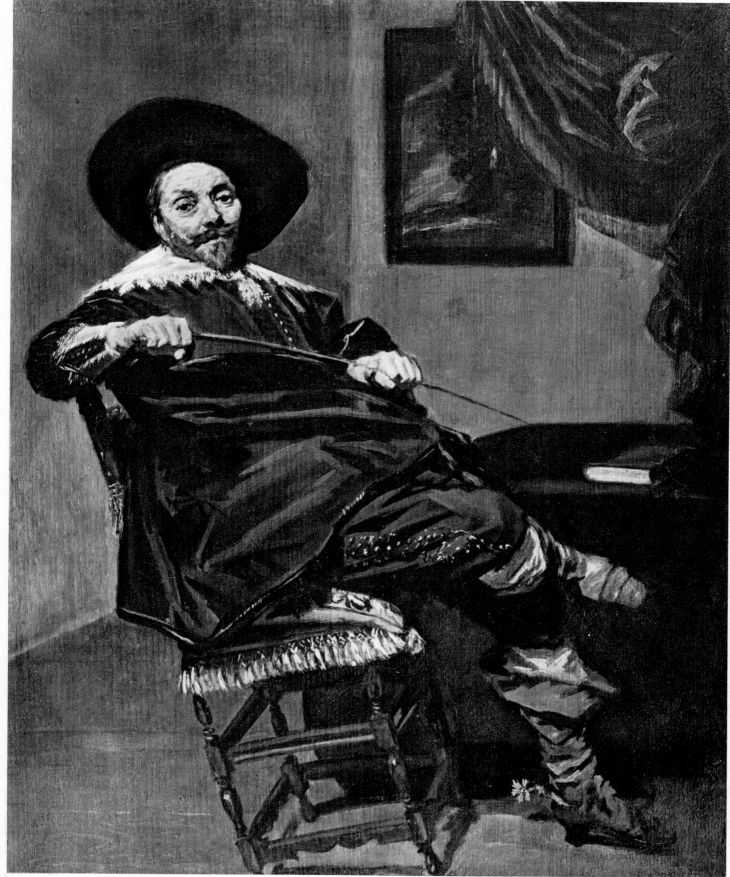

156. WILLEM VAN HEYTHUISEN. Brussels, Musée des Beaux-Arts.

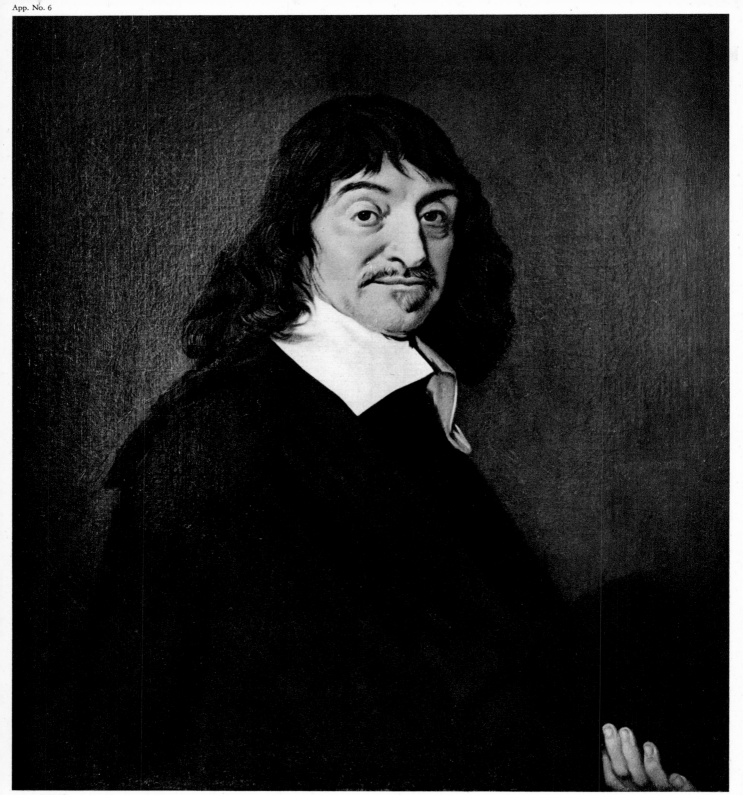

157. RENÉ DESCARTES. Paris, Louvre.

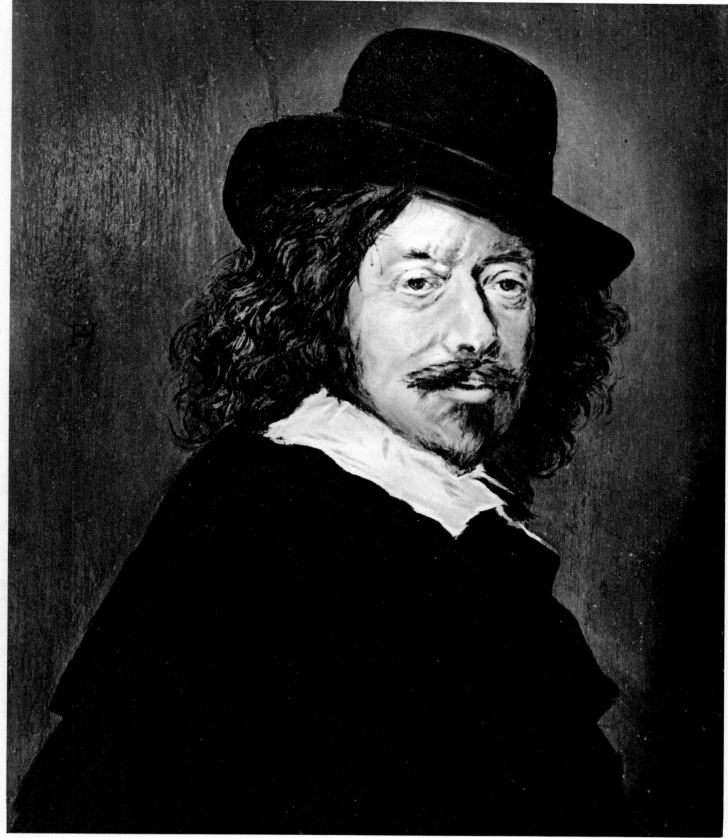

158. SELF-PORTRAIT. Denver, Colorado, Denver Museum.

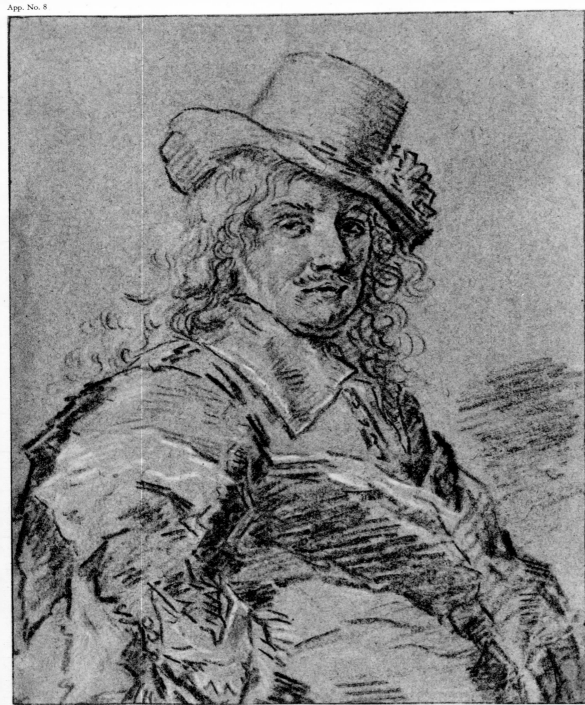

159. PORTRAIT OF A MAN. (Cf. plate 127.) Black and white chalk on blue paper (actual size). London, British Museum.

INDEX OF MUSEUMS
AND
GENERAL INDEX

INDEX OF MUSEUMS AND COLLECTIONS

(The numbers in this list are not those of the Catalogue but of the Plates. The Catalogue numbers are printed above the left-hand corner of each reproduction, and they are given in the General Index.)

INDEX

(Predicates " van ", " von ", " de ", " ten ", etc., are not listed alphabetically ; van Ostade will be found under " Ostade ", not under " van ", etc.)

CONTENTS

DATE DUE	

GAYLORD PRINTED IN U.S.A.